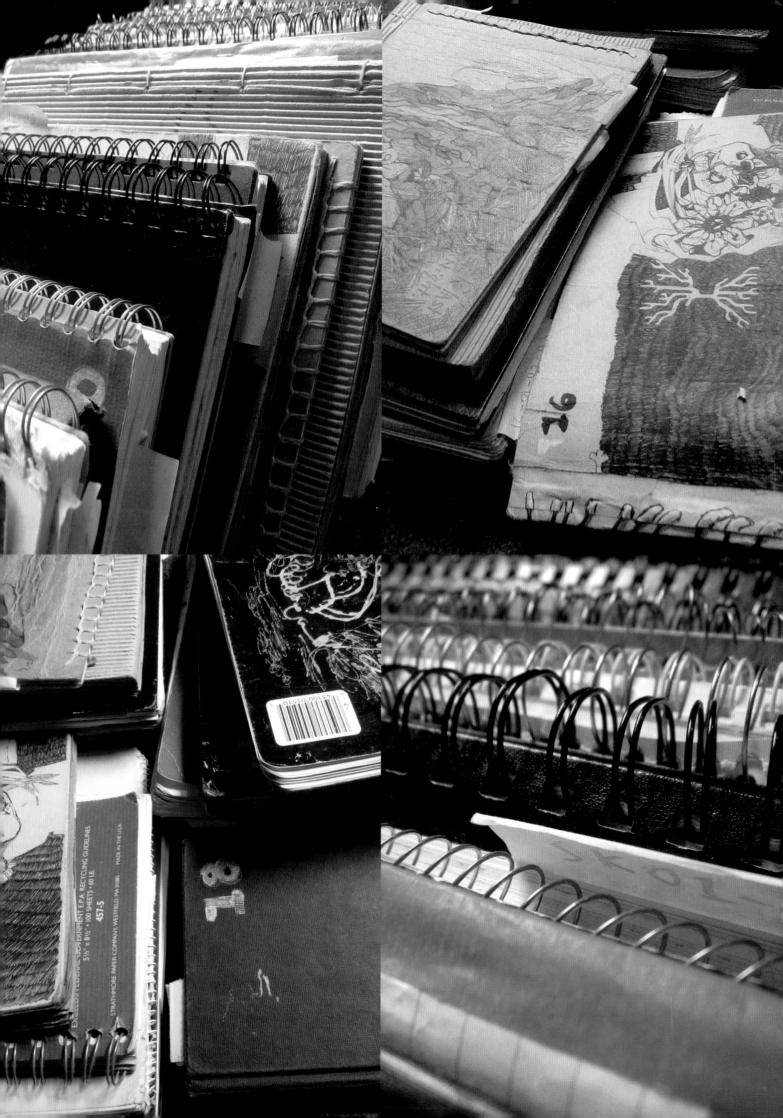

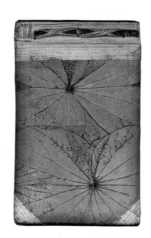

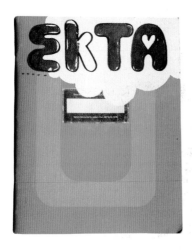

STREET SKETCH BOOK

BY TRISTAN MANCO

INSIDE THE JOURNALS OF INTERNATIONAL STREET AND GRAFFITI ARTISTS

CHRONICLE BOOKS
SAN FRANCISCO

This book is a documentary record and critique of a form of artistic
expression including graffiti and street art. Neither the author
nor the publisher in any way endorses vandalism or the use of
graffiti for the defacement of private and public property.

First published in the United States in 2007 by Chronicle Books LLC
First published in the United Kingdom in 2007 by Thames & Hudson Ltd

Page 270 constitutes a continuation of the copyright page.

Library of Congress Cataloging-in-Publication Data available.

ISBN-10: 0-8118-6138-4
ISBN-13: 978-0-8118-6138-0

Manufactured in China
Design by Sam Clark
Cover design by A. J. Purdy

10 9 8 7 6 5 4 3 2 1

Chronicle Books LLC
680 Second Street
San Francisco, California 94107

www.chroniclebooks.com

Contents

Introduction

Outlines

You are about to enter the secret world of the sketchbook.... We are lucky enough to have been granted access to books that usually remain private, where anything and everything goes. Declarations of love, typographic experiments, travel journals, mythological creatures, U-boats and pandas are just some of the visual gems set loose on the pages ahead.

This treasure trove of images has been drawn from hundreds of sketchbooks from more than sixty contemporary artists worldwide. Working across many fields, including illustration, graffiti, painting, design and animation, they are united by a love of drawing, originality and a prodigious output of personal work. On the street and in the studio these artists push themselves forward through constant experimentation. In their various activities they fly a flag of independence, following a DIY philosophy.

They may be dog-eared, paint-splattered or falling apart, but the unassuming appearance of sketchbooks belies their importance as an artist's storehouse for ideas and thoughts, a free space where creativity is unravelled. Inside their battered covers is a secret lab where plans, dreams and doodles flourish and develop page-by-page, and they are just as likely to contain drunken scribbles, risqué drawings and friends' telephone numbers as elaborate designs. This collection reveals an incredible variety in working methods, personal fixations and uses for books.

Sketchbooks retain an eternal fascination. The sketches of Michelangelo, Leonardo da Vinci and Picasso, for example, are regularly exhibited around the world's museums to huge audiences. Our reverence for them has endured through time, as has their role as repositories of ideas and as sanctuaries for drawing. Working out thoughts on paper may seem antiquated in this increasingly high-tech world but this process is far from dead, and original hand drawings can be a welcome antidote to bland 'clip art'.

Drawing is a sensation, a direct connection to thoughts and emotions translated into an image. Today, with computers becoming ubiquitous design tools, the natural human process of hand drawing for design solutions and images is often bypassed, but handcrafted artwork shines out. 'There is a growing role for designers who develop their own voice through their own work,' confirms sketchbook impresario Andy Rementer. A designer from New Jersey, he takes the handmade approach in his designs, both commercial and personal. His work and that of others featured here present a compelling case for a stronger sense of authorship in today's communication age.

The creative sparks that come from putting pen to paper are not only important in graphic design, of course. Sketchbooks are used day-to-day by people from all walks of life and professions including fine artists, architects, fashion designers and animators. The artists in this book come from a range of experiences, and working in different ways they reflect some of the broad potential of sketchbooks as a creative springboard.

A celebration of the humble sketchbook and the hand-drawn aesthetic is just one part of this story. Metaphorically speaking, the sketchbook represents the process of creativity. These artists are all passionate individuals who stamp their personality onto their work and would be inspiring even without their books. They embrace what could be described as 'the spirit of the street', which enables a creative flow from one medium to another – a drawing may develop into a graffiti piece on the side of a building, which may in turn inspire an animation or a sculpture in an endless range of possibilities.

This book's 'street' element, conveyed in its title, implies something beyond mainstream, with an independent voice, but does not necessarily refer to 'street art'. The connection literally with the street is significant, however, because artists who are making graffiti art for free are characteristically open-minded, experimental and creative. Finding out how some world-renowned street artists work is part of the attraction of looking at these sketchbooks. For example, Italian muralist and animator Blu, famed for his large-scale graffiti pieces, fills sketchbook after sketchbook with curiously inventive drawings which become fuel for all his artworks.

It was important for me not to pigeonhole each artist, but rather to explore the drawing process for works of different scales and purposes. Though the book has been split into two key sections – INSIDE and OUTSIDE – the distinction is by no means clear-cut, as many of the artists work both indoors and outdoors. However, this divide proved a useful way to approach this art, allowing me to focus on particular aspects of each artist rather than attempting to show their entire portfolio. INSIDE includes works on paper and sketchbook pages, and looks at how some of these drawings

have been developed further in fields such as animation, painting, interior murals, 'zines, illustrations, printmaking and comics. OUTSIDE puts a stronger emphasis on graffiti, including sketches that have formed the basis of art in public spaces.

In the process of making this book I have met as many artists as possible to understand their work and figure out how best to represent it. Meeting clusters of artists in cities such as Lille, Bologna and Barcelona gave me an insight into people's different working lives and a real appreciation for what they do. I hope you will experience some of the same sense of curiosity and discovery looking through this book as I did meeting the artists and delving into their sketchbooks.

Pen to Paper

Putting pen to paper is where it all begins. Capturing a thought or an image before it is lost. It could be a word, a drawing or a doodle; we take it for granted that with these simple acts we are free to express ourselves, to invent and to dream. With the same tools, line drawings and a lexicon of words, architects, artists and writers can illuminate infinite worlds of the imagination. It is hard to imagine our world without being able to communicate through words or pictures. The desires to record something, to create art and investigate the world are essentially timeless. As such, artists' drawings and writings can be seen to be both personal and cultural time capsules for future generations.

Sketchbooks were first adopted in Italy during the 14th century when they were used by artists

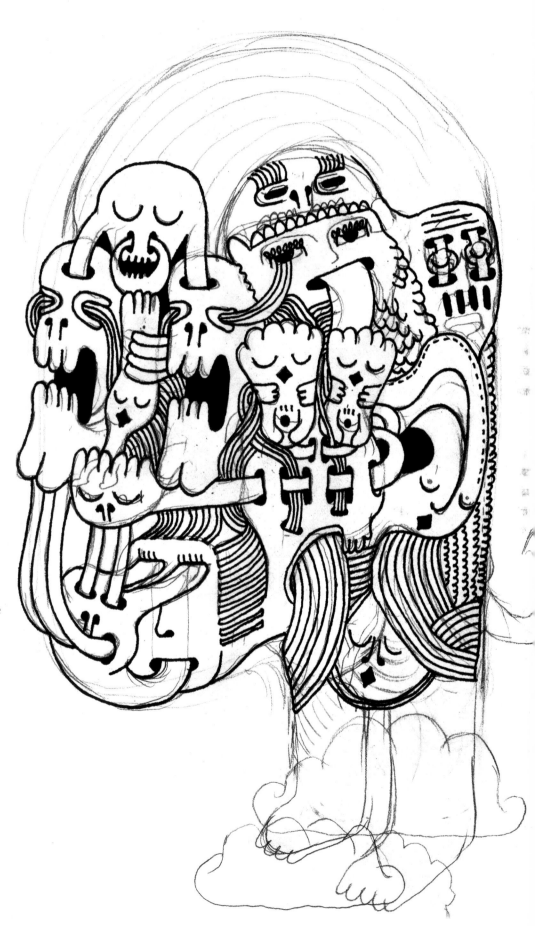

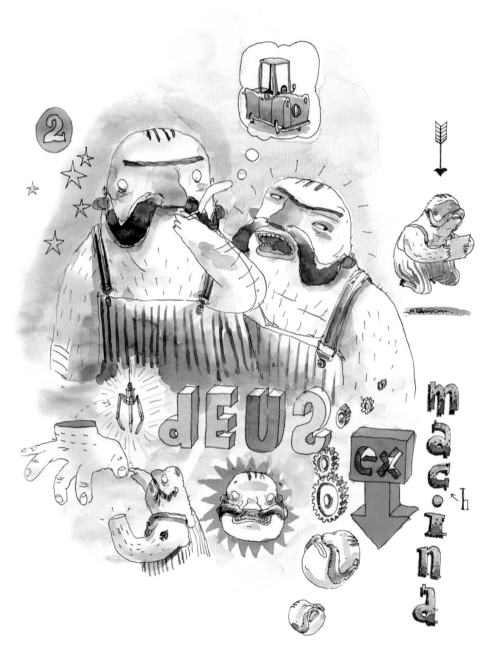

for their drawing studies. The materials were very different back then: the pencil had yet to be invented and paper was an expensive rarity. Typically sketchbooks consisted of loose sheets of parchment on which chalks, inks and metalpoint techniques were used. This era established the practice of study through observational drawing, which is still used today. Drawing, then and now, remains at the heart of design, a connection highlighted by Italian painter and architect Giorgio Vasari (1511–74) who regarded drawing as 'the father of the three arts' of painting, sculpture and architecture. Indeed, the Italian term for 'drawing', *disegno*, can also mean 'design'.

It was during this era that some of the most influential sketchbooks of all time were produced, most famously those of Italian Renaissance artist Leonardo da Vinci (1452–1519). Discovered after his death, his notebooks recorded observations on nature, architecture and anatomy, which he would then develop in his paintings and designs. As much a scientist as a draughtsman, his manuscripts were also filled with ideas for inventions, designs for machines and engineering projects, all notated with his signature mirror writing. His work, more than anyone else's, has helped to perpetuate the myth that sketchbooks are mysterious documents full of secret annotations.

In the modern age, artists such as Pablo Picasso (1881–1973) began to break away from realism to explore shapes and forms in more expressive and fluid ways of drawing. In Picasso's words, 'To draw, you must close your eyes and sing.' In the 1920s, the Surrealist art movement linked drawing with the philosophical thinking of the

time. The Surrealists, who included André Breton and Salvador Dalí, invented methods such as Automatism – the 'automatic' use of a brush or pencil, without rational control and therefore at the prompting of subconscious impulses – to tap into the riches of the unconscious and release its creative potential.

Over the centuries, sketchbooks and journals have been associated with many other key figures in the arts as well as the sciences, including evolutionary theorist Charles Darwin and British engineer Isambard Kingdom Brunel. Painters, scientists, philosophers and explorers have all used notebooks and sketchbooks. They may not appear to have an immediate connection to the sketchbooks of today, but many of our visual references have been shaped by the past. Picking up a pen and paper, artists have the potential to draw on centuries of knowledge, history and culture. Add to that an artist's personality, observations and vision and you begin to appreciate the potential of writing and drawing.

As each sketchbook is a melting pot of different inspirations and influences, there is no such thing as a typical sketchbook. They can be drawing pads, journals, scrapbooks or all of these rolled into one. In this book I have tried to contrast as many styles and uses as possible, and a range of materials, from luminous marker pens and collage to fine pencil drawings. Each page is a window into an artist's life, with personal and professional highs and lows, bursts of activity for shows or commissions contrasting with more introspective moments.

As German artist Wayne Horse suggests, 'A sketchbook is like a diary; even if there are no words at all, time and situation are glued to every line.' Although the intention of the artist may or may not be to keep a journal, unintentionally a sketchbook becomes one. Through an artist's accumulated books, phases of work can be identified. Marginalia give clues to formulating ideas and day-to-day existence such as shopping lists – 'must buy cheese!'

Artists use and abuse sketchbooks with varying degrees of intent and purpose. The drawings themselves can be functional, such as working out a composition, or simply a way to let the brain run loose for a while. For some, using a notebook is an essential ritual, for instance drawing every day at a particular time, perhaps on the commute home or at the end of a day's work; others rarely use them, concentrating instead on completing works with little sketch preparation.

The physical limitations of sketchbooks also affect their usage. On the plus side a book is portable and protected, and has its own particular tactile feeling, bringing with it a sense of occasion or personal ownership. And yet, because it is bound, you have to flick between pages if you want to refer from one sketch to another. For this reason, artists such as Kafre (Spain), Amose (France) and Melvin (Belgium) work mostly with mountains of loose papers, which have also been included here.

Both sketches and drawings are core elements in this book. Sketches are generally seen as simple drawings or paintings, often rough drafts for future works. The *Oxford English Dictionary* defines a drawing as 'a picture or diagram made with a pencil, pen, or crayon rather than paint, especially one drawn in monochrome'; generally a drawing is a more finished or nurtured piece of work. If you excuse the cliché, there is a fine line between sketching and drawing, and in the context of this book neither one is more valued than the other. The simplest sketch may turn out to be the perfect mark or all an artist needs to commit to memory a visual idea. The concepts are subjective: one person's sketch could be a final drawing to someone else.

Whether it's in a sketchbook or not, whatever makes you reach for a giant pink marker pen or a fine calligraphy brush has a lot to do with frame of mind or instinct. The inspiration to draw could manifest itself on a scrap of paper, a sketchbook or a wall – whichever is practical or conducive to a drawing spree. Materials and methods match not only your mood but also your message, depending on what you wish to communicate. Take, for example, styles of lettering: fine scripts whisper while big block letters shout out. Some of the sketchbooks here are loud and unruly, including those of French artist Turbo who uses brightly coloured marker pens to explore hip-hop-influenced letterforms which burst out of the pages. Others are much more subtle, like the carefully observed drawings of Italian graffiti artist Hitnes.

Sketchbooks are personal musings or externalizations of thoughts and ideas. The sketchbook and the act of drawing itself can be a refuge to experiment or draw meditatively without any particular purpose. British graffiti artist and designer Eco describes his process as 'therapy...getting lost, almost going under and coming out the other end with a mass of lines that sing true to you and your personal idea of form and weight. Graffiti is all about this, and only when you know the basics can

you then smash it up. When the aesthetic of graffiti is inbred in every shape you create, then rocking out is just about letting go.'

Eco's sentiments are echoed in one of the most famous quotes about drawing from the Swiss painter Paul Klee (1879–1940), whose varied paintings, watercolours and drawings often refer to nature, poetry, music and fantasy. As a teacher at the Bauhaus school of art and architecture, Klee developed his own theories. In his *Pedagogical Sketchbook* (1925), he describes drawing as 'an active line on a walk, moving freely, without a goal. A walk for a walk's sake.' While Klee was not anticipating the aesthetic of graffiti when he wrote this, he was calling for artists to express themselves freely: the work of art should be allowed to evolve naturally, subconsciously guided by the artist rather than consciously controlled.

Nowadays, the ability to draw unselfconsciously is highly prized; in this way an artist can enter the spirit of a drawing. A drawing can have a rhythm or flow as the artist directs the feeling of the pen and power of the line within a space. Drawing within strict parameters of optical realism carries with it the risk of losing this spontaneity. Equally, a spontaneous drawing doesn't necessarily mean either unconsidered or lacking observation, style or form. The balance between conscious guidance and observation and more expressive movements and actions is therefore a key equation in a drawing. In other words, imagination plus flow equals funky drawing.

To make truly unselfconscious drawings one would have to return to a childlike state. When children draw they create their own

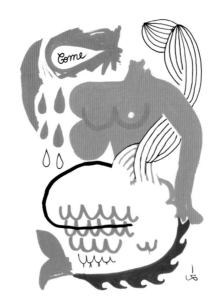

visual language, often expressionistic and uninfluenced by accepted rules of drawing or painting. When Picasso visited an exhibition of children's drawings he is said to have observed, 'When I was their age, I could draw like Raphael, but it took me a lifetime to learn to draw like them.' While a certain amount of naiveté in a drawing may not be the holy grail for everyone, by creating your own drawing style you can get closer to expressing yourself as an individual.

A person's first sketch or drawing often outshines attempts to refine it. For this reason some artists prefer the doodle or sketch stage and try to retain that freshness in their finished work. For example, British artists Duncan Jago and Will Barras both tend to retain traces of their exploratory sketches in their finished illustrations and paintings.

A final composition is an interplay between imagination and reasoning. Different artists find their own ways to draw and compose; knowing where to begin or where to stop comes with practice (and there are no rules). From the way they hold their pen to their use of pattern and line, artists discover their own way to create art. Sketchbooks give us a glimpse of that process with its practical and personal considerations. These strategies and approaches are explored further in INSIDE and OUTSIDE.

Looking back through history it is clear that drawing is fundamental to communication. It's an activity shared by everyone, from children to adults, scientists to established artists. Drawing is everywhere in the fabric of our lives, connecting us with science, nature and our heritage. As the work in this book goes on to show, drawing lets us express our thoughts and visions in a liberating way by bringing them to life. By the end of the book I hope you too are inspired to start drawing.

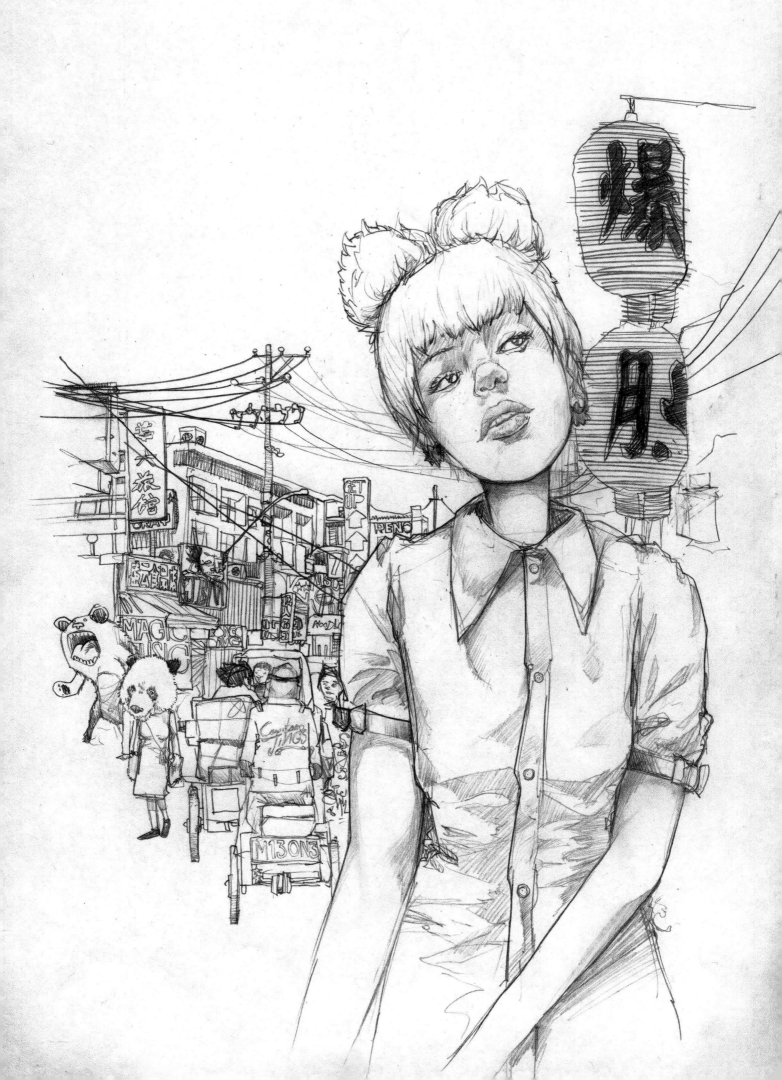

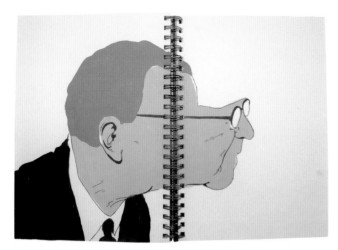

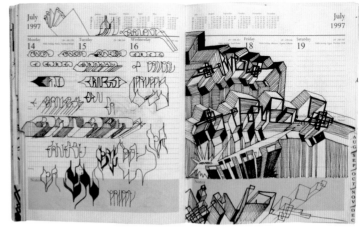

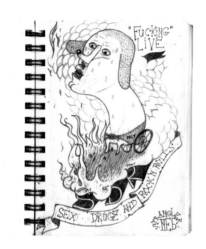

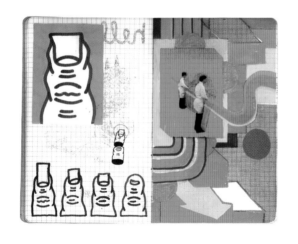

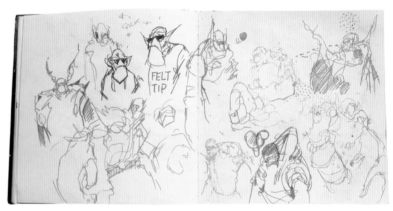

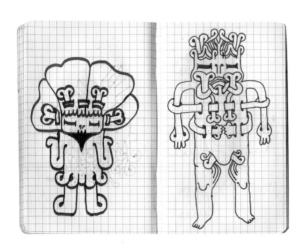

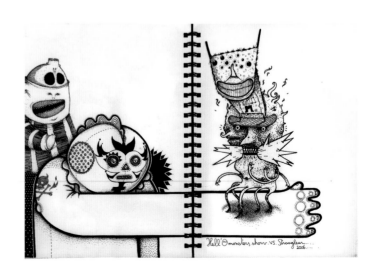

 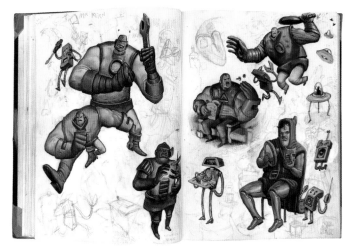

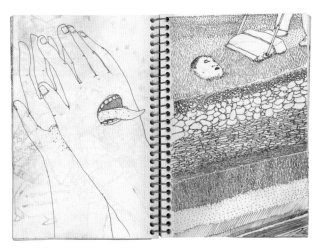 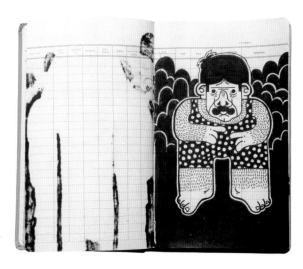

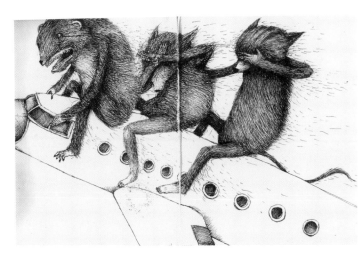 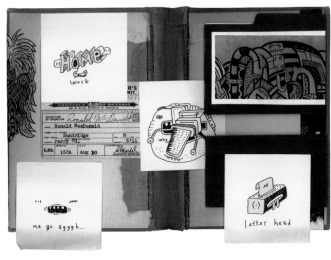

 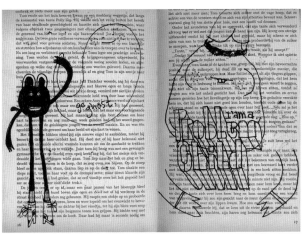

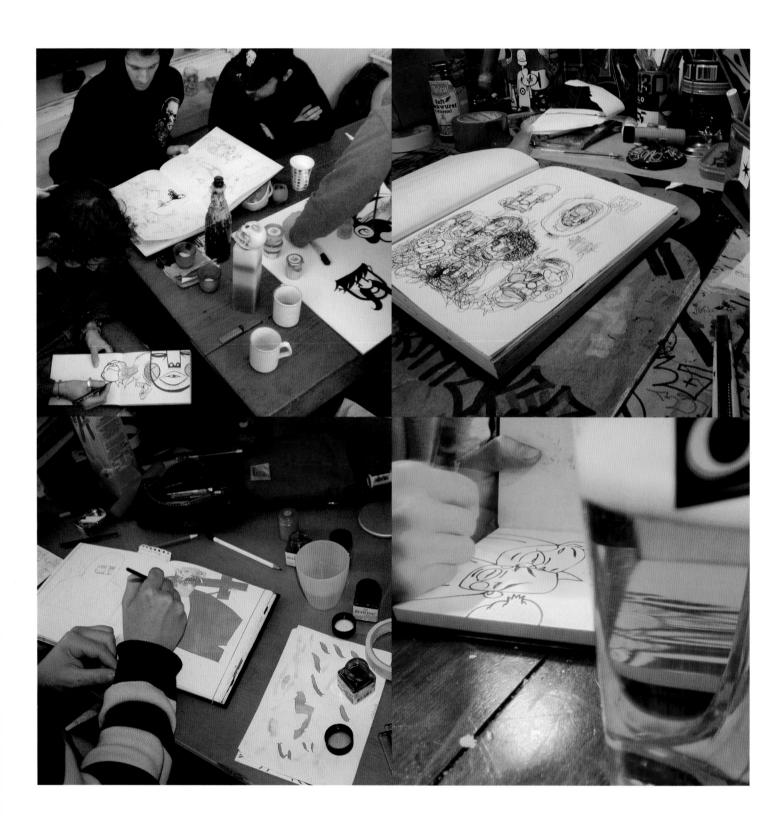

Inside

Drawing is the ultimate low-budget medium; you don't need huge resources or even a studio space to start making your mark. An image can be drawn simply with your hand on any surface, even a dusty window, or with a pen on a cheap exercise book. The following pages celebrate the potential magic of simple tools such as ballpoints and pencils to conjure up an artwork on a previously blank sheet of paper. In the selection of these images I have tried to show pages from sketchbooks as you would find them in real life, as well as collating and condensing some pages to reveal the progression of an idea.

Paintings, drawings and sketches on paper form the bulk of this chapter, but I have also focused on the interior applications of sketches such as gallery works and illustrations. Some of the sketches may remain undeveloped, perhaps even forgotten by the artist, as he or she moves on to new ideas; others form the basis of finished works. In my interviews with artists my aim has been to understand how and why artists use sketchbooks and how, if ever, sketches evolve and cross over into associated fields such as printmaking.

Print techniques are a perfect example of an extension of the drawing process, requiring the artist to draw, scratch or gouge into a medium that can then be used to make an imprint. Italian artist Ericailcane's finely hatched drawings are well-suited to his etchings, while Lille-based Eroné has developed his sketches into linocut prints. Many other artists represented here, including Remed (France), Bfree (Netherlands) and Andy Rementer, use screen prints as a way of producing refined editions of their drawn work.

Other artists, such as A. J. Purdy (United States), Ekta (Sweden) and Luke Ramsey (Canada), collate their sketchbook drawings directly into small photocopied magazines, which are then sold cheaply as a form of promotion for their art. 'I use sketches for 'zines and ideas for future art/design projects,' confirms Purdy. '[They are] just a pile of needlessly complex surreal pattery stuff and characters. I like the idea of them serving no use, but as I'm now selling and creating more and more 'zines I feel more of a civic/philosophical duty to have more of a message than just "weird".' In Ekta's 'zine, *Charming Suicide*, the drawings are reproduced more or less in their original form. By retaining the errors, the crossed-out words and unfinished drawings, the 'zines stay true to their moment of creation.

While the majority of sketches assembled here have been developed for two-dimensional applications, such as paintings and illustrations, a few artists have also branched out into three dimensions. Dutch illustrator and graffiti artist Erosie's long-running *Eroded City Cycles* campaign, which celebrates the humble bicycle, includes street art, graffiti and drawings to accentuate the battered forms of abandoned bicycles. Taking this idea one step further, he has worked with the sculptor Bram Tuns to realize these sketches into extreme sculptural caricatures.

From the 3D to the moving image, animation is also a field in which some of the artists work, and sketches are an essential part of the process. Even the most high-tech computer animation requires thousands of handmade drawings for storyboarding, character design and final production. Russian artist Edik Katykhin, for example, works in many media including plasticine and 2D animation, using his sketchbook to invent and define his characters: 'When I am drawing, I can sense the volume of the figure. Inside my head, everything has a volume – I see a complete 3D picture and everything is spinning.'

Animation illustrates the narrative potential of drawing over a series of frames. While most of the drawings in this chapter are not specifically designed for animation, they often have a story to tell. For Melvin, the sketches presented here are working drawings and character development for a storybook. Hand-drawn illustrations have long been linked with storytelling. From medieval illuminated manuscripts to *Alice in Wonderland*, the images and the story go hand in hand. Drawing connects us to imaginative worlds from our childhood onwards through books and cartoons.

Naturally the transformation of a drawing into other projects varies from artist to artist, partly driven by personal processes, preferences and strategies. A drawing might purposefully or accidentally provide the idea for a story, a mural, an animation or an earth-shatteringly new invention. Planned, unplanned, commercial, non-commercial, conscious and unconscious – all these opposing approaches are equally valid in creating work or developing ideas.

For many artists sketching and drawing are about gathering a critical mass of material. Take Ekta, who likes to draw in periods of about three to four months compulsively until he reaches saturation point. Using the doodles and drawings, he then puzzles together new paintings. He also tends to work on two or three books and paintings at the same time, leaving them for a while before returning to them with fresh ideas. While some of these methods are fairly standard practice, others have been individually fine-tuned over time.

Similar strategies manifest themselves differently with each artist. British artist Mudwig also goes through a gathering process, treating his sketchbooks 'like factories where all the initial "parts" are made.' His many sketchbooks 'contain drawings of boat hulls, animal legs, fingers, trees, petrol tankers, cartoon eyes, etc., which litter the white pages like plane-wreck debris being catalogued in a hangar.' These drawings are scanned into a computer and are 'assembled into more composed dynamic models'. As the bank of interchangeable images grows, so too do possibilities for the surreal juxtaposition of objects.

As sketches accumulate, an artist's sketchbook can be like a film casting, with the casting director jotting down ideas as the actors read their lines. This is literally the case for painter and moving-image maker Wayne Horse, who sketches out and describes every detail of a cast of characters before deciding on an animated or filmed script for them to take part in. In a comparable way, Blu constantly draws in his sketchbook as a diary and library of ideas, which then work their way into both his films and murals. With Blu and many other artists, the sketched-out ideas are not always directly referred to but become part of the artist's visual vocabulary, to be drawn on at any time.

Blu, Wayne Horse, Mudwig and Ekta all point to different ways that artists approach their sketchbooks and drawings in relation to their other work. These organizational processes are not always immediately apparent by simply looking at a sketch page. Often what is more noticeable is how an artist draws or uses the space on the page. Every artist has his or her own touch, from a particular brand of pen to the way a line

is executed. 'Sometimes the line is very loose and other times it's tight,' explains Will Barras, describing his own drawing style. 'Sometimes I move the paper around the pencil – plus I'm left-handed so I try to avoid smudging the drawing! I really like drawing with a very short pencil, using it right down to the end, so it's at my fingertips.... I've got an electric sharpener (I'm sure Sigmund would have something to say about this...).'

Eco takes a different approach to line work, but his spontaneity and use of line highlight the influence that graffiti has had on his development as an artist: 'I don't like sketching out first and then dropping a pen line over the top. I believe it should be a one-hit affair. You need to draw it straight down, straight from the gut – this, I think, makes for that beautiful and full expression of a line. This approach is a direct descendant of graffiti, especially tags and throws. It's a one-hit deal.' Even in this chapter, which does not focus on mural work, we can see the inspiration of graffiti lettering and graffiti culture in the sketches of Wayne Horse and Remed.

While not every artist profiled here has a graffiti background, a good number have had the experience of painting on a large scale, which undoubtedly influences the way they produce work. 'I'm not a street artist – I just do large-scale paintings sometimes,' says Barras. 'A painted line behaves differently from a pencil or pen line, and the scale drastically affects what comes out. If I'm standing up or sitting down, this changes things too. I feel like I'm in charge of a pencil, but what I paint is out of my control and it makes interesting things happen.'

What distinguishes the artists in this chapter, and indeed the book, is this willingness to

experiment, whether it's with the use of line, the approach to materials or in the ideas themselves. Partly this is because in sketchbooks there are no clients to please or conventions to be upheld and this work can remain the private domain of the artist. All these artists also have an independent spirit, a need to create their own style of work rather than suit the conventional marketplace. As a result many of the eventual outlets for their work tend to be self-initiated, creating their own market and appreciative fanbase.

Many have coincidentally worked together in different ways, including Andy Rementer and A. J. Purdy who have co-published 'zines. Sometimes these collaborators are friends and neighbours, but increasingly the virtual world of the Internet has drawn people together through photo-sharing sites such as Fotolog and Flickr. Artists may post sketchbooks to each other or send artwork files electronically to work on each other's books or drawings. Partnerships can also take off in real life as artists travel to make murals together or group exhibitions.

At a global level artists from different backgrounds and disciplines are more aware of each other's work and in greater numbers, and they are able to contact each other for encouragement, group projects and a sense of community. A graffiti artist might be invited to contribute to an animation project, an illustrator might be persuaded to paint graffiti. By drawing in different contexts artists can develop in ways they didn't think possible.

But while the virtual world is changing the way artists communicate and work, the raw act of creation still involves getting your fingers dirty with paint, pen and ink.

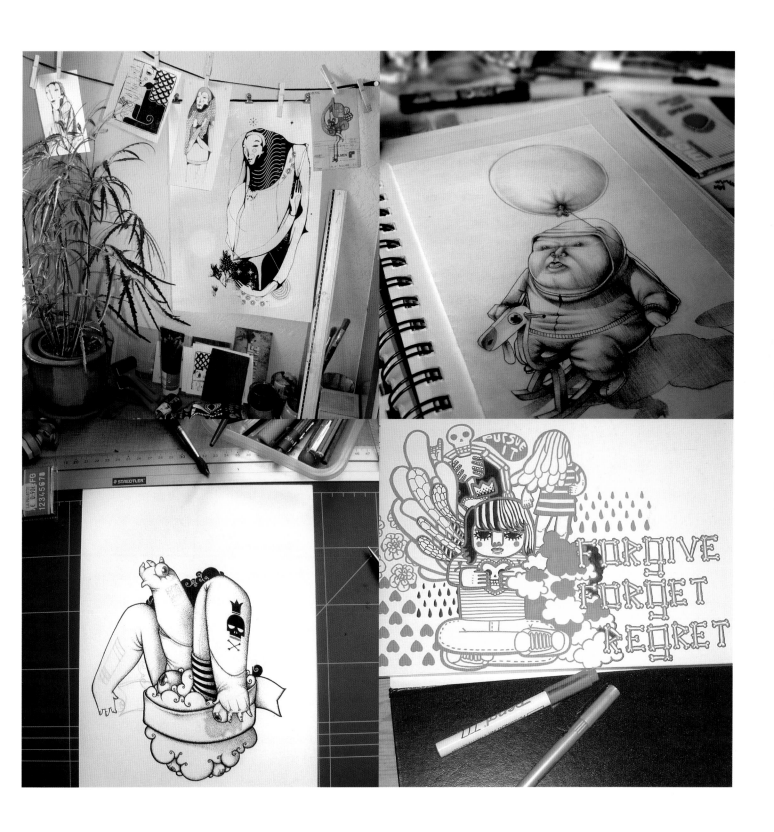

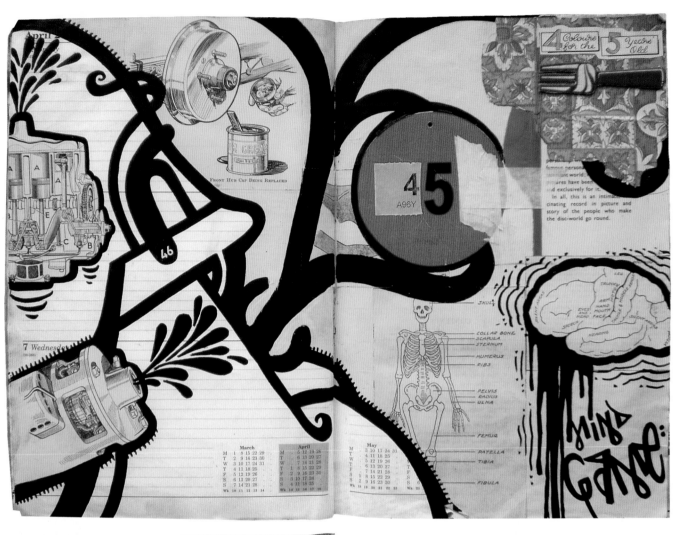

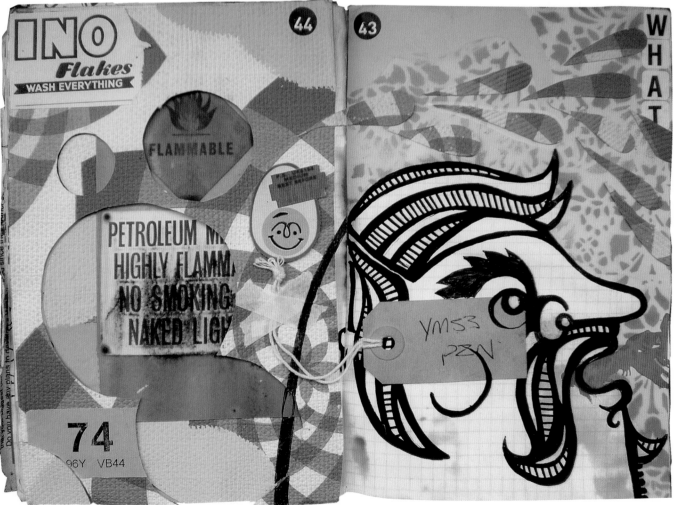

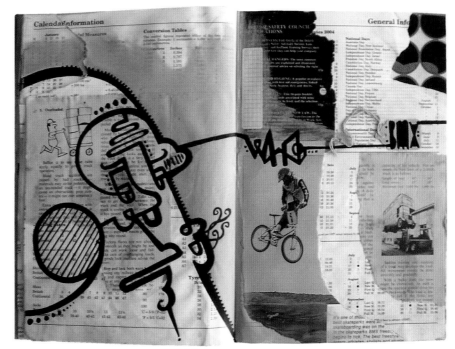

45rpm

--

45rpm is a member of the What collective who are part of Bristol's vibrant art scene. Sketchbooks are integral to his work: he uses them to store odd items which he collects day-to-day and then integrates into his drawings, creating interesting juxtapositions. 'Chalk and cheese is my drawing style,' he says. 'Messy old backgrounds with clean lines…. I sketch until I hate five things I've drawn but love one.'

His books are packed with ephemera: wallpaper, photos, shopping lists, old adverts and newspapers. If he finds something stained, torn and faded, it goes in the sketchbook. The collage aesthetic runs throughout his work: 'If I like a page from my sketchbook, I will replicate it on canvas. Sometimes only a bit will change. I take just as much time on a sketchbook piece as I do on a canvas for a show.'

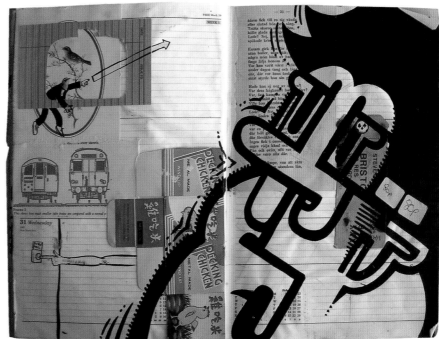

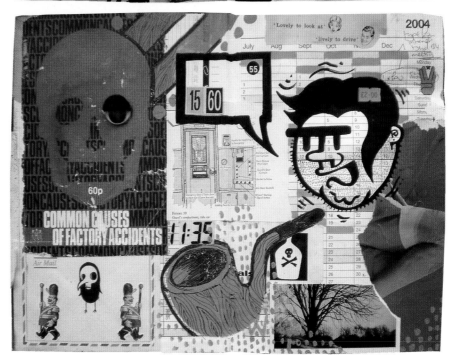

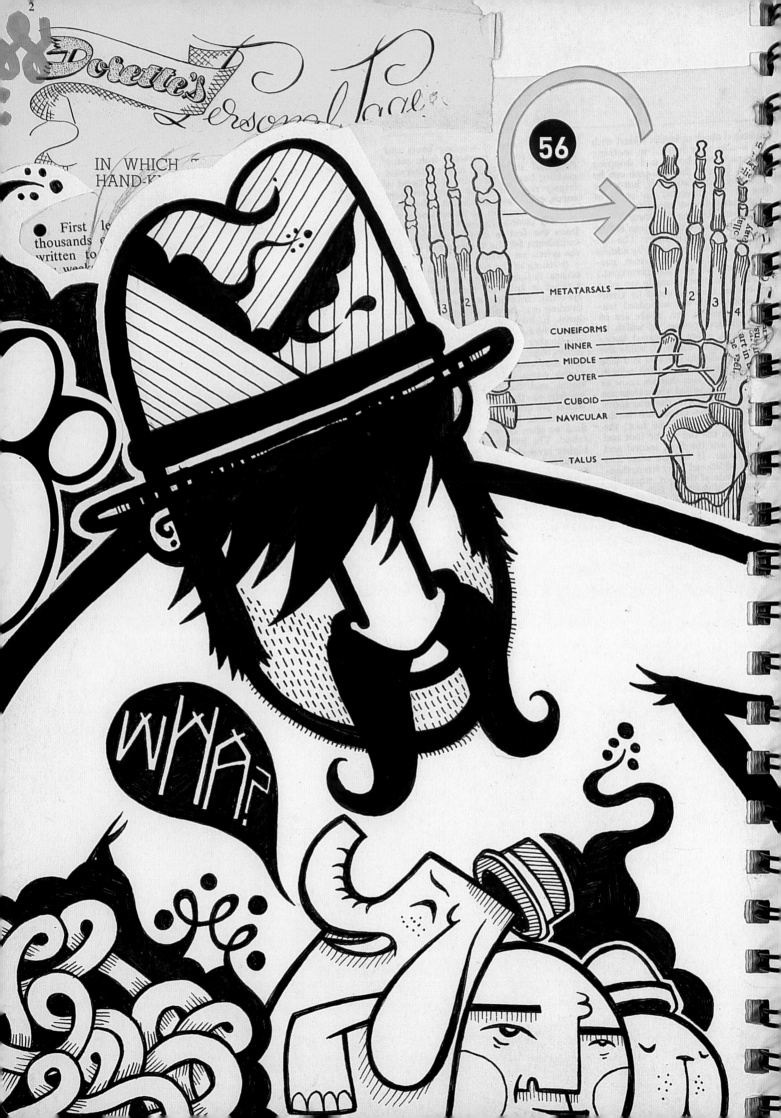

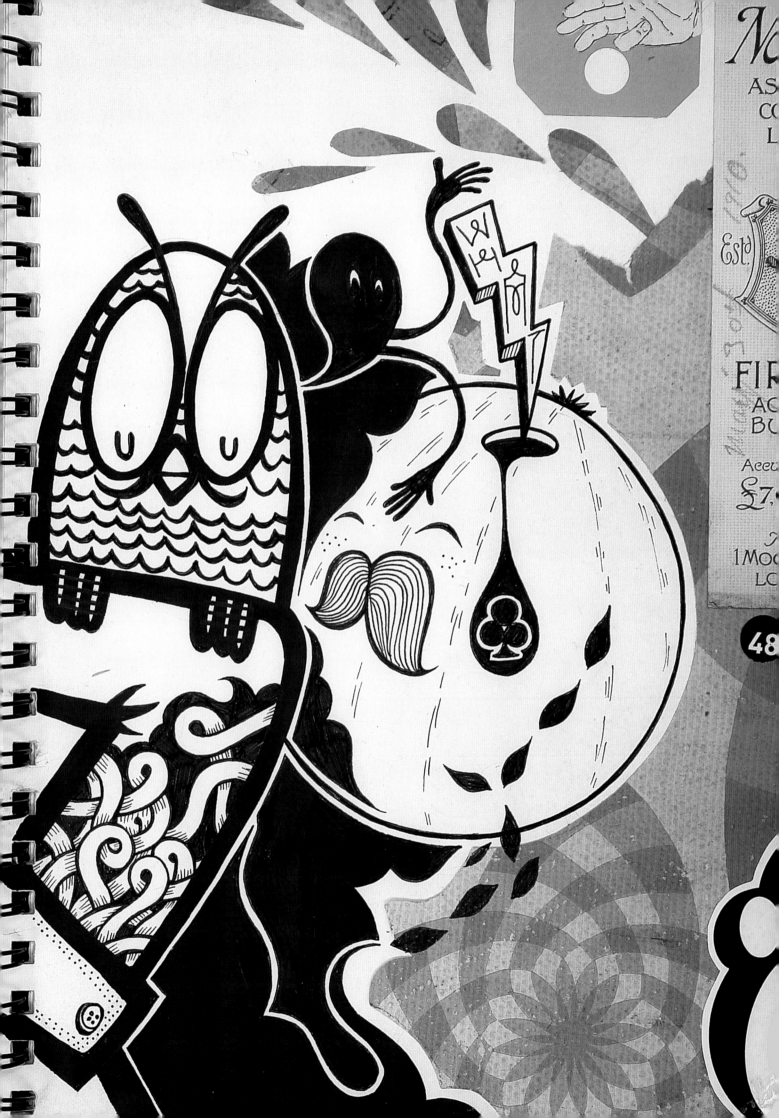

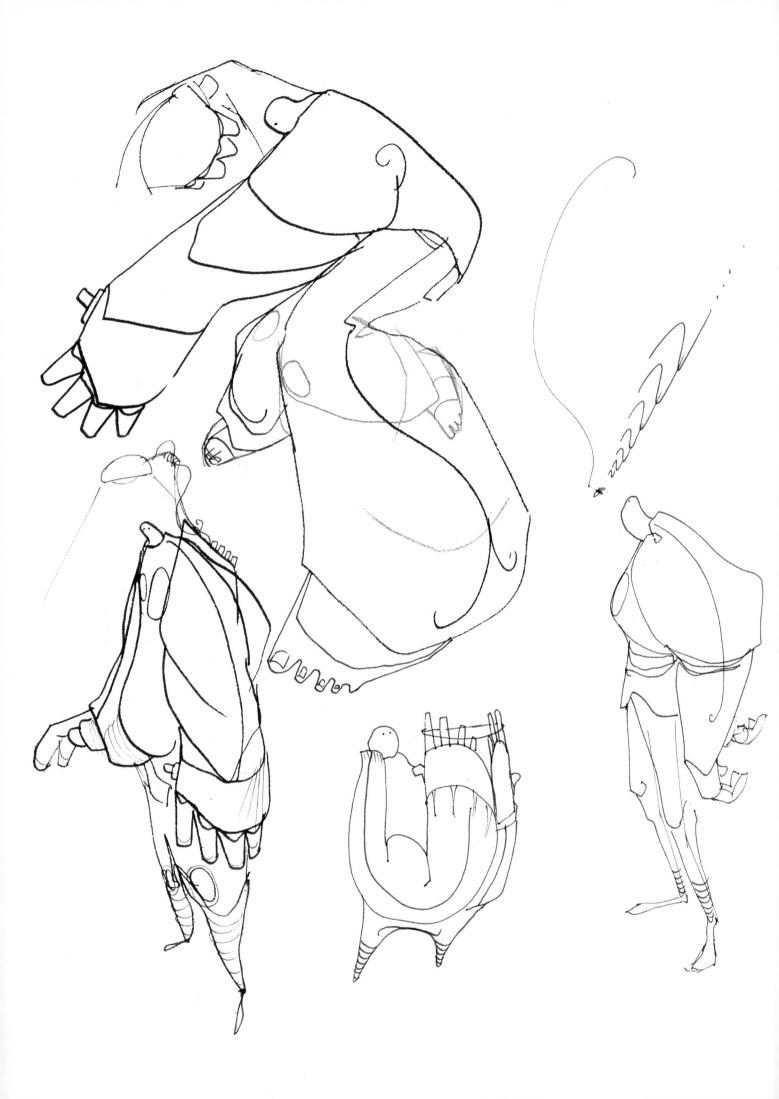

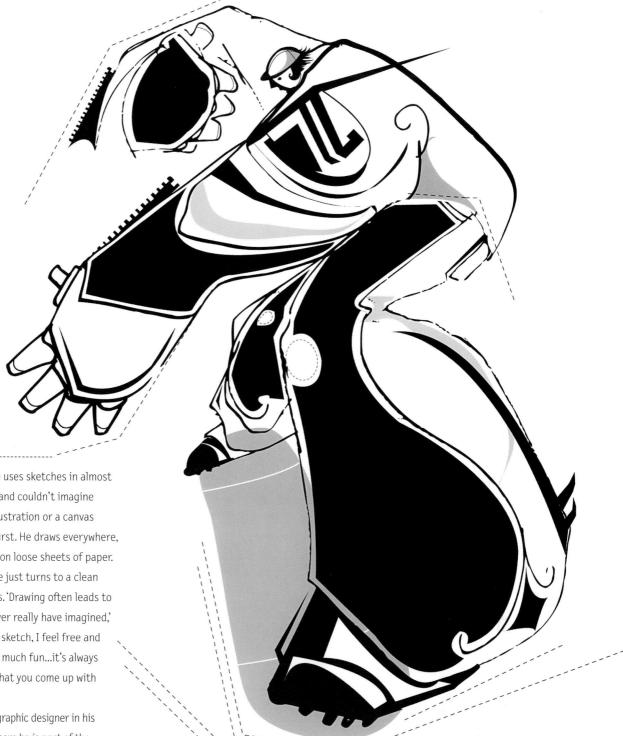

Amose

French artist Amose uses sketches in almost everything he does and couldn't imagine starting a digital illustration or a canvas without drawing it first. He draws everywhere, but generally works on loose sheets of paper. If he's ever bored, he just turns to a clean page and off he goes. 'Drawing often leads to places you could never really have imagined,' he observes. 'When I sketch, I feel free and unrestrained. It's so much fun...it's always through sketching that you come up with new ideas.'

Amose works as a graphic designer in his home town of Lille, where he is part of the Mercurocrom collective, along with Spher, Eroné, Nada and Spear. Together they work on various productions, including graffiti painting, installations, graphic design and screen prints. Amose's work shifts between handmade and digital, from spraypaint on walls to computer imaging. He often scans his sketches as a base and then adds other materials and motifs to them. To him, spraypaint seems primal and childlike: faced with a wall and a row of spraycans in different colours is like being a kid with felt-tip pens and a huge sheet of blank paper.

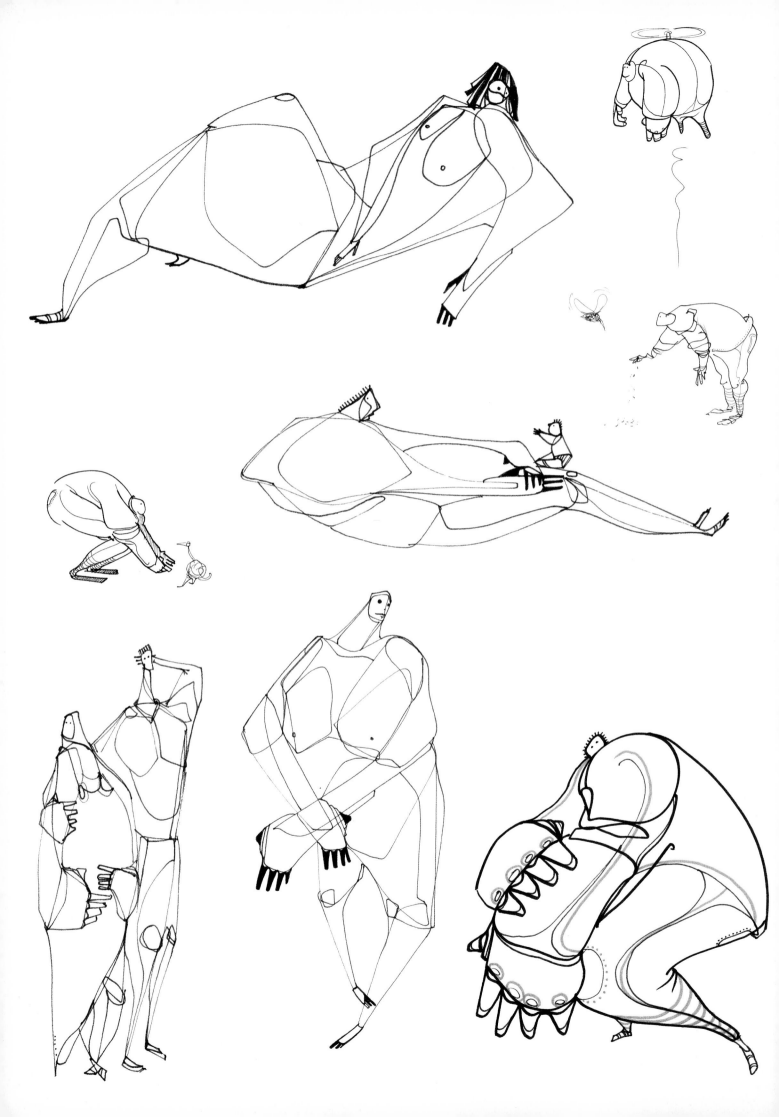

AMOSE

Will Barras

As a kid growing up in Halesowen, near Birmingham, UK, Will Barras read *Eagle* and *Judge Dredd* comics and drew nothing except cars. This was partly due to the influence of his dad, who would build racing cars in the garage, drawing his sketch concepts on the back of envelopes. Today Barras is an animator for Bermuda Shorts and a member of the Scrawl collective, citing friends Duncan Jago and Steff Plaetz and comic artists Moebius, Bill Sienkiewicz and Frank Miller among his main artistic influences. He lives in London.

Drawing is all part of the job and, even though he loves it, it feels like work. However, it has taught him to draw in different ways and to address all sorts of subjects, which has benefited his personal work. His sketches often begin with figures or vehicles but develop into stories or scenarios. Generally these scenes are very fluid, full of movement, atmosphere and energy.

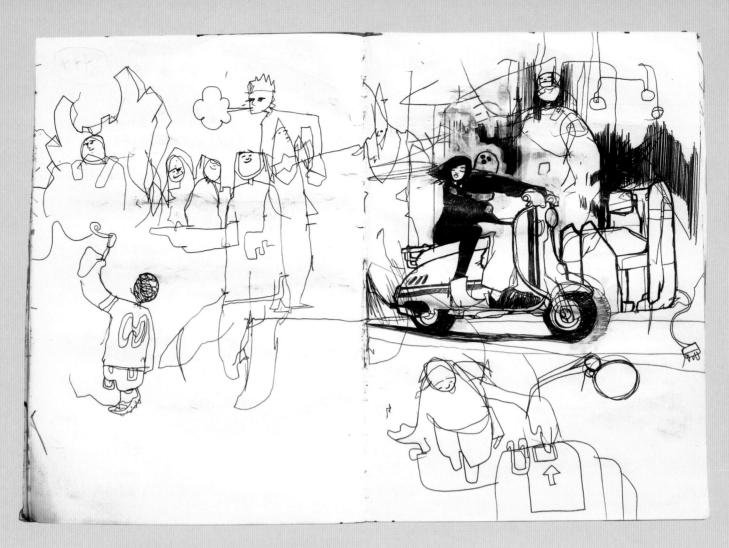

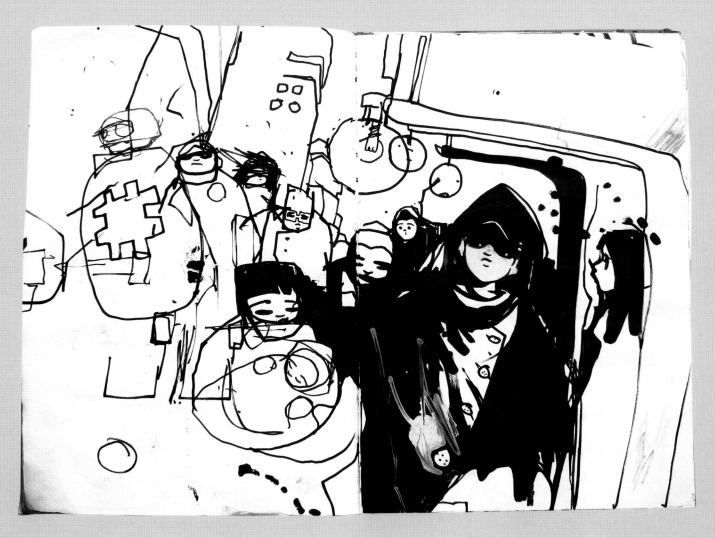

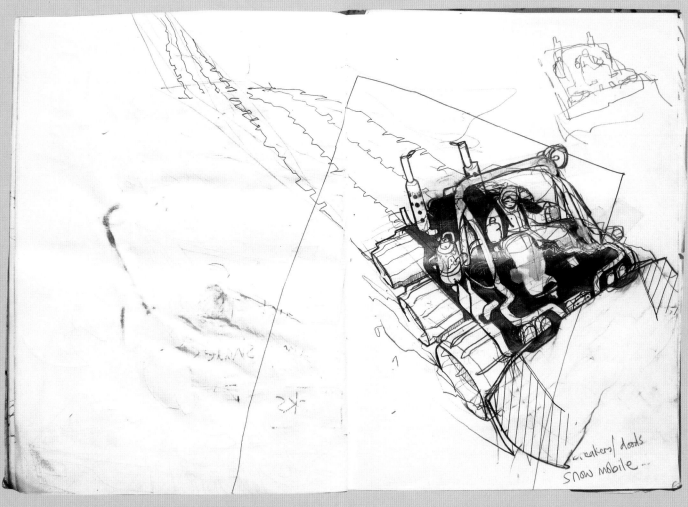

freakers/ doods
snow mobile...

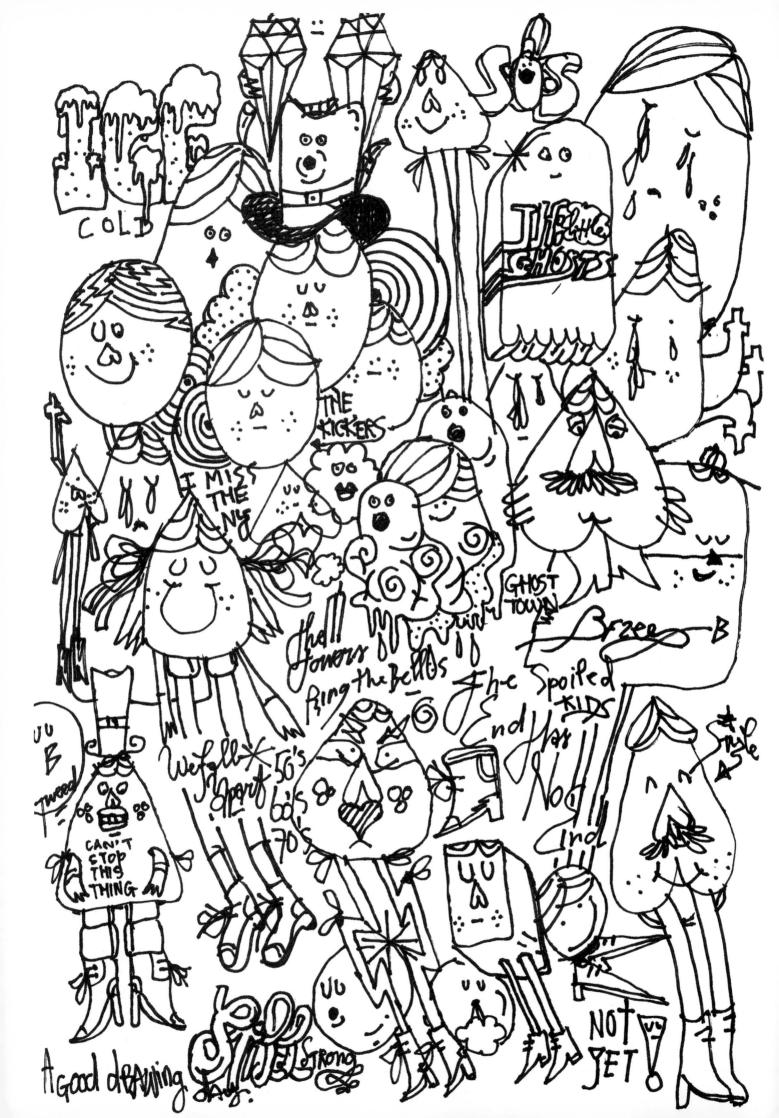

I'M ~~~~ you WITH

don't worry
I haven't
forgot you.

Bfree

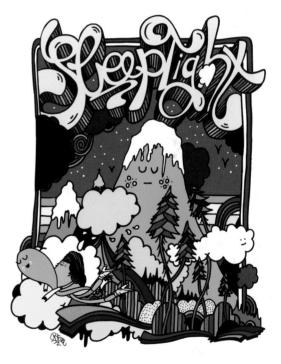

Bfree's sketchbooks are the perfect place to see his work take shape. Many of his sketches become the final artwork as his style is characterized by a loose touch. He starts off without any idea of what he is drawing; the first couple of lines determine the end result. By his calculations one in every ten turns out well. He always draws with a Nashua CD/DVD writer pen: 'Nothing else will do! It will end my career if they stop producing this pen!' If he decides to develop one of his sketches as an illustration, he streamlines and colours it on the computer.

As well as working as a freelance illustrator in his home town of Utrecht, Bfree is also involved in mural painting, exhibitions and his own projects, but sketching remains central to all his work — a kind of training process for his impressive spontaneity. He doesn't refer to a previous drawing when he paints a canvas or mural but approaches it in the same way as his sketchbook, drawing the final image directly onto the surface.

I DREAM ABOUT HAVIN' A PAIR LIKE THESE.

I HAD MORE THAN ENOUGH

I LOVE YOU

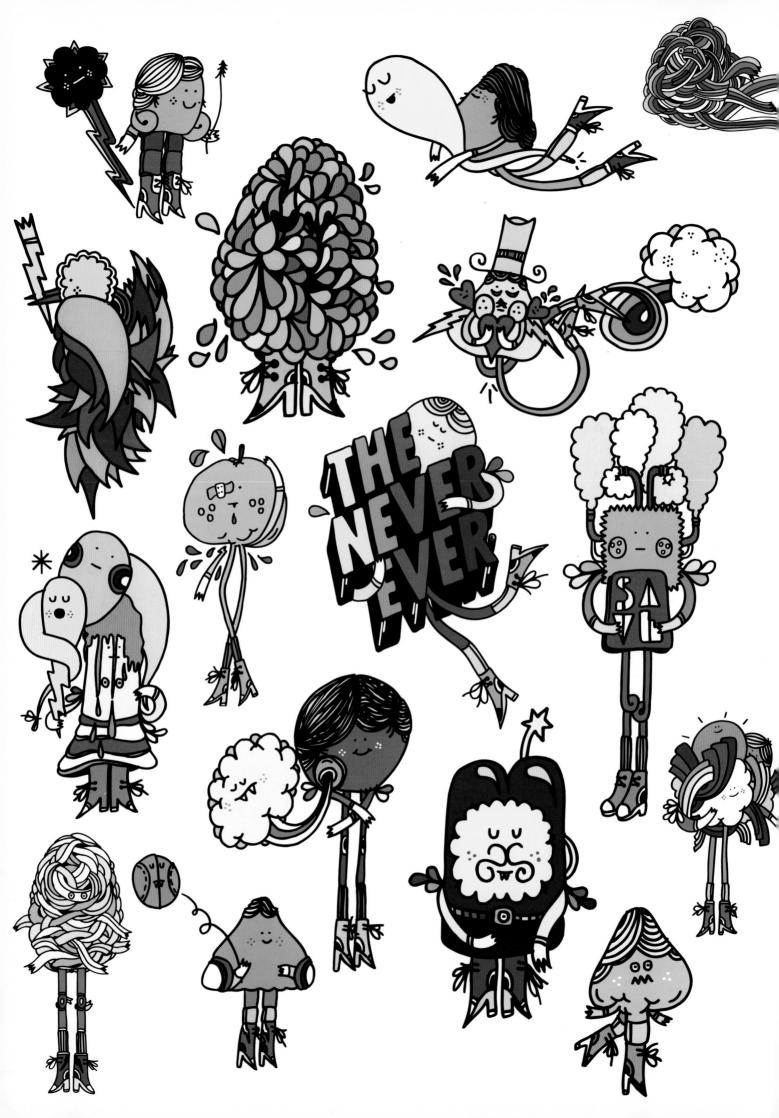

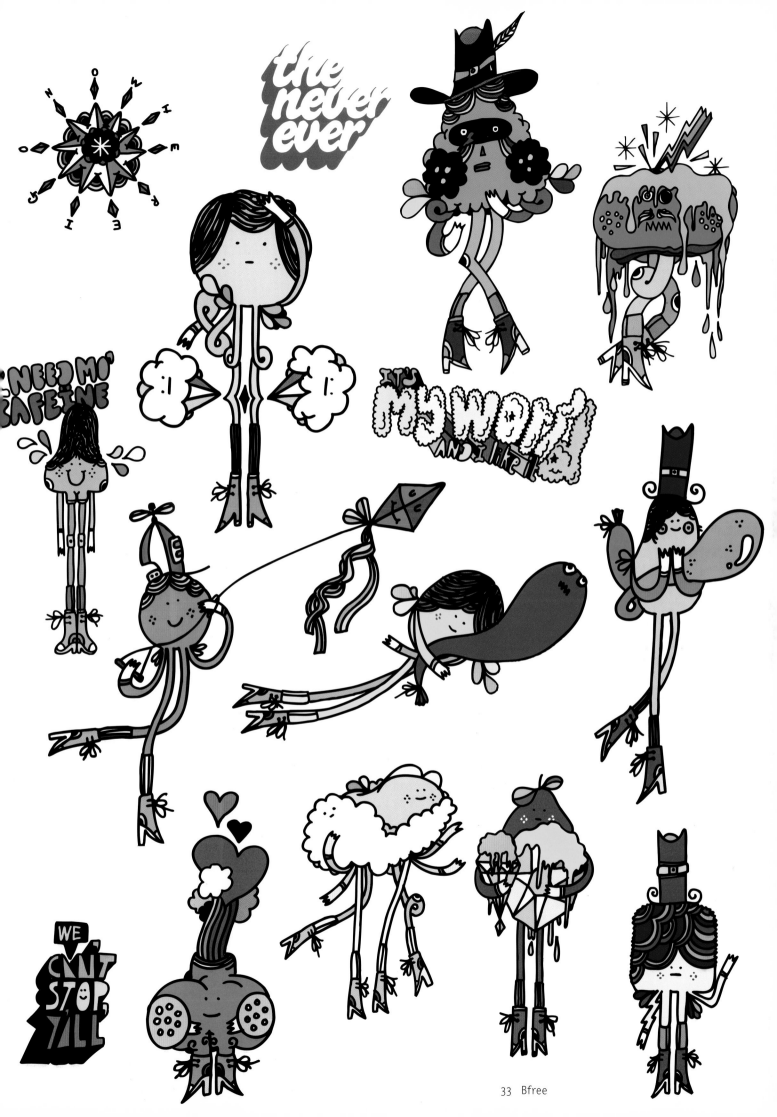

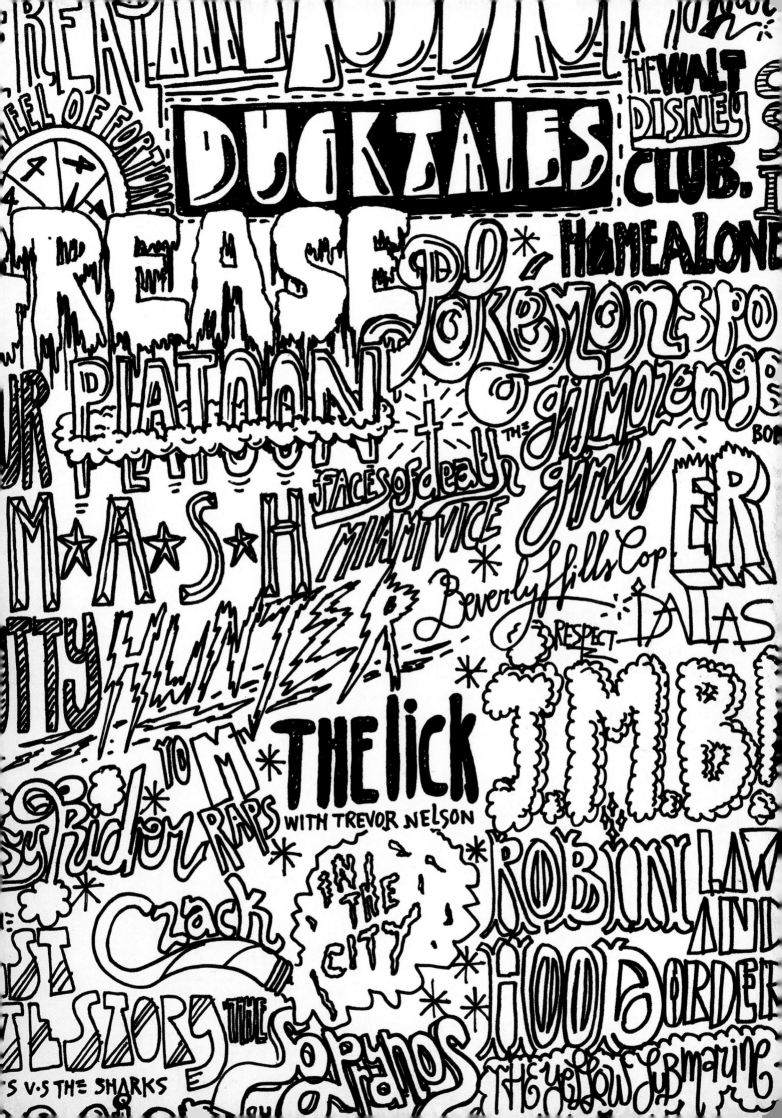

Blu

Best known for his large-scale graffiti murals and accomplished animations, Blu always has a sketchbook in use and fills one every few weeks or months. Like his murals and animations, his sketches are often stories without words, executed with a clean line and a rare imagination. The Bolognese artist also uses sketchbooks as journals on his trips to places such as South America and India, but even his observational drawings have added narrative twists. After coming across a sign painter in the street, for example, he drew a painter filling a whole sketchbook page with signs.

Wherever his ideas come from, Blu usually draws without much conscious planning. He often starts by coming up with an anatomical idea or viewpoint to explore, sometimes with a visual pun or message in mind, but often his images take on a life of their own.

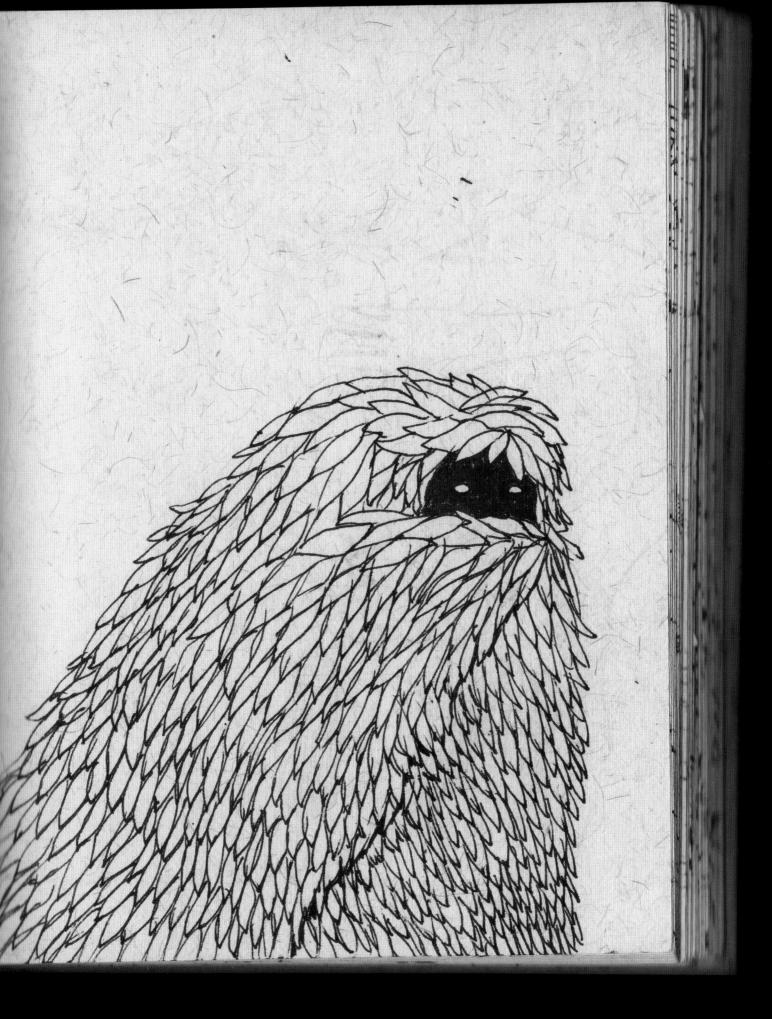

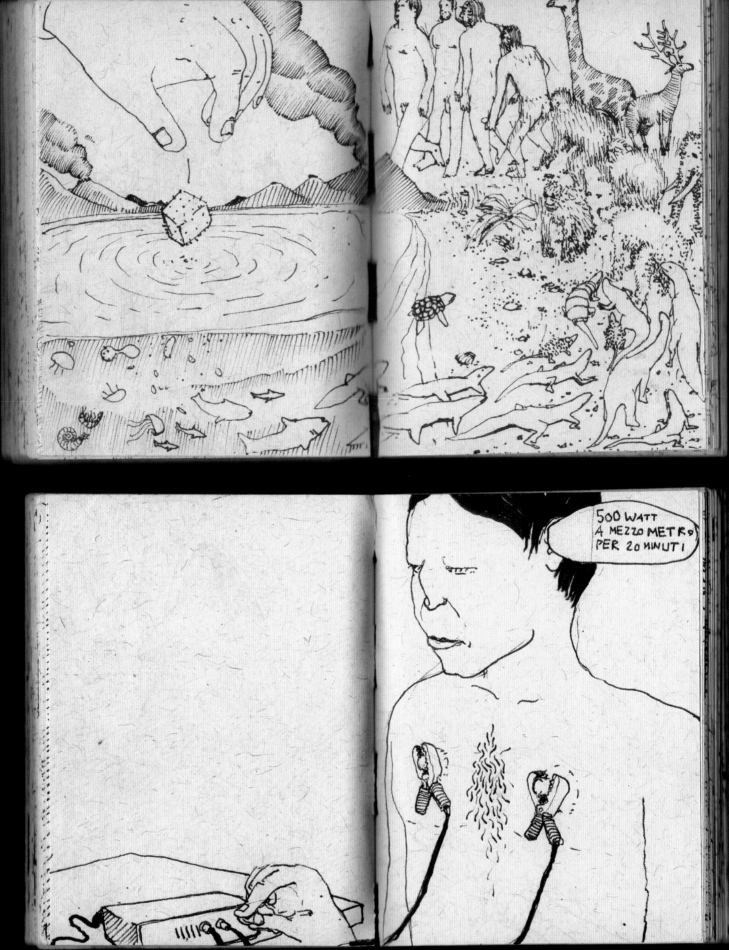

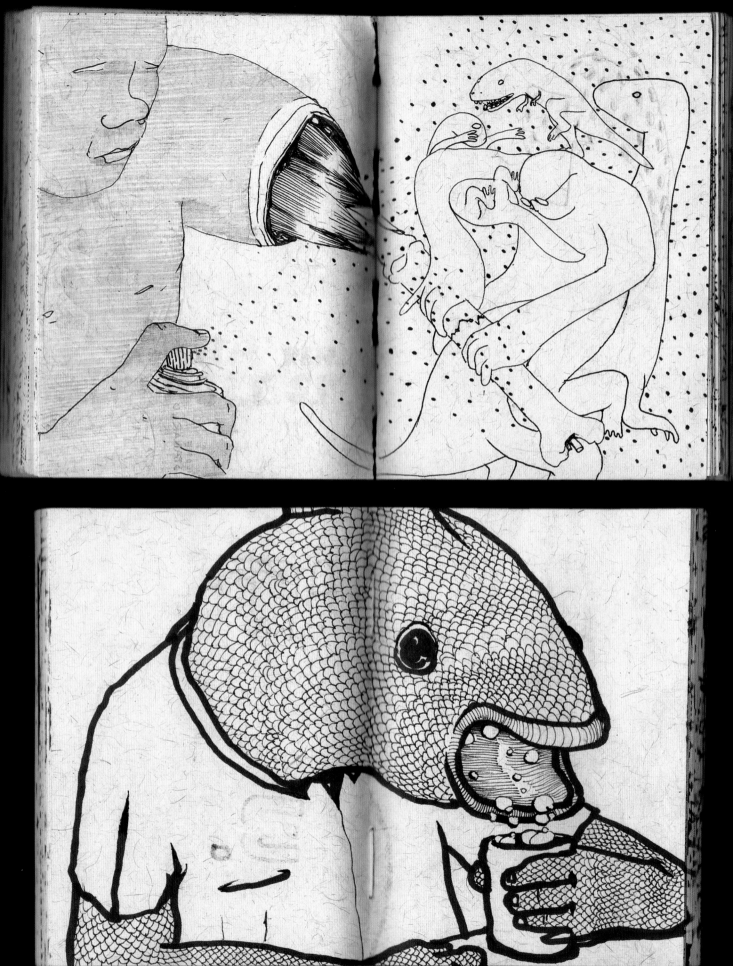

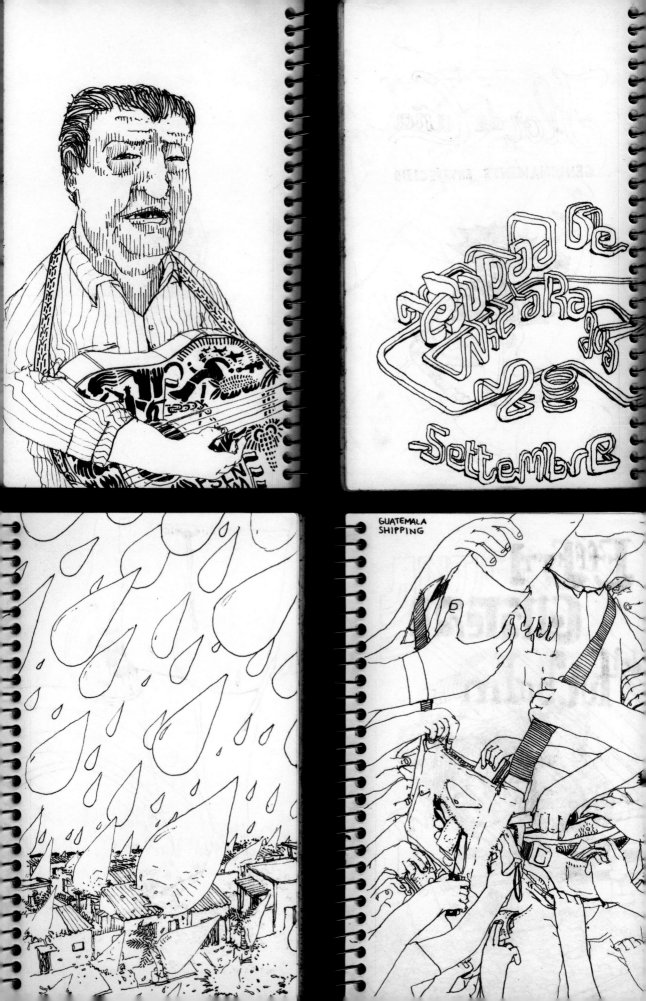

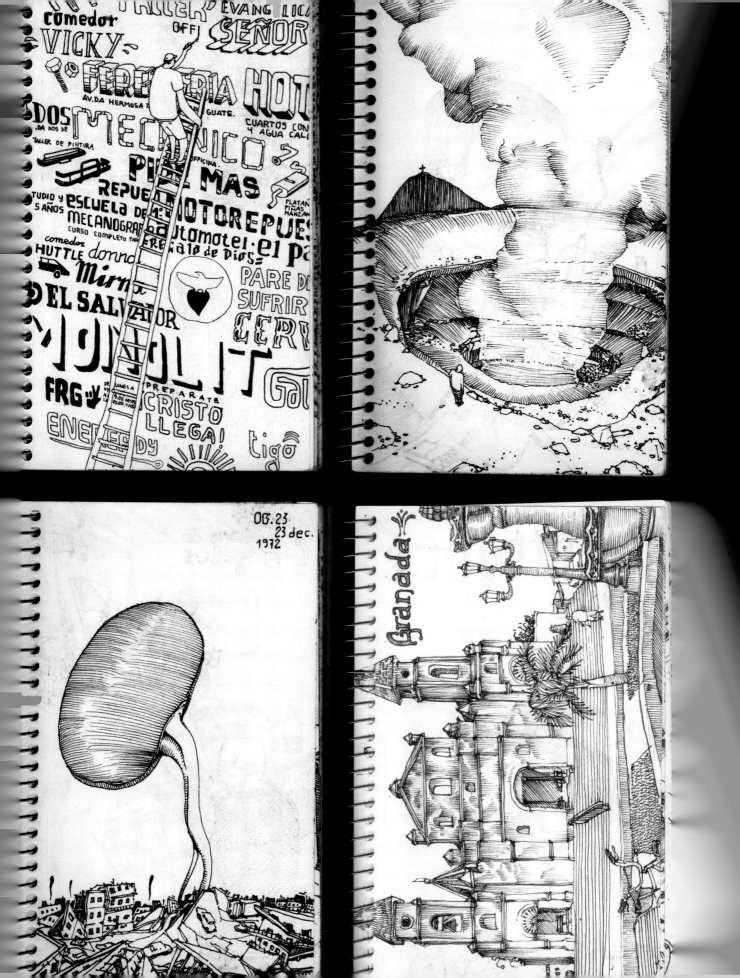

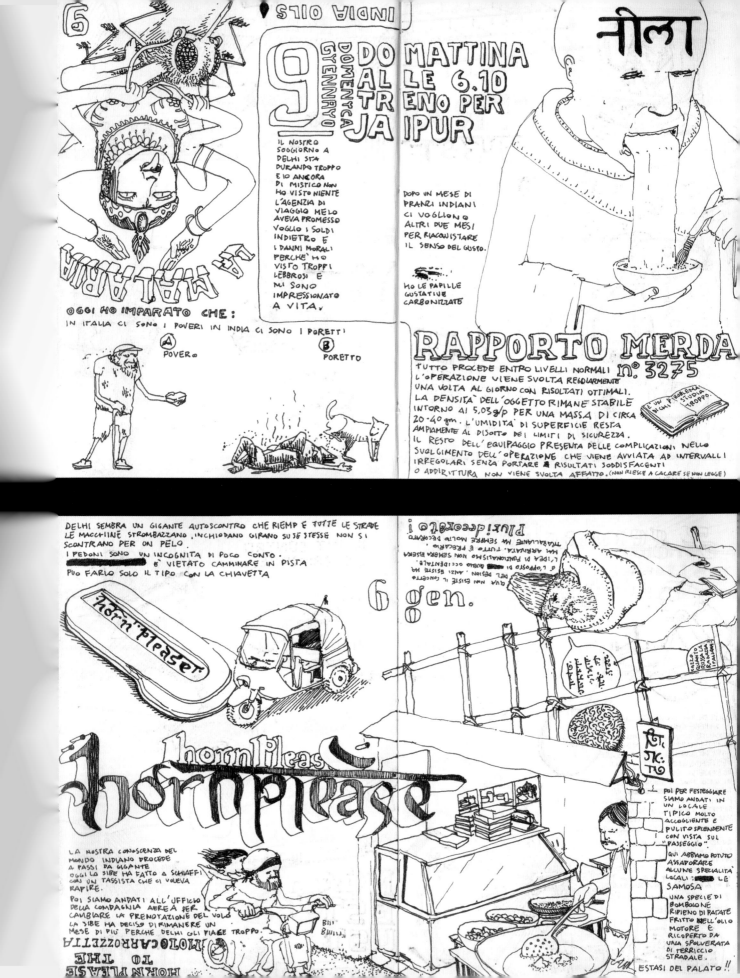

9

नीला

9 DOMENICA GENNAYO — DOMATTINA ALLE 6.10 TRENO PER JAIPUR

IL NOSTRO SOGGIORNO A DELHI STA DURANDO TROPPO E IO ANCORA DI MISTICO NON HO VISTO NIENTE L'AGENZIA DI VIAGGIO ME LO AVEVA PROMESSO VOGLIO I SOLDI INDIETRO E I DANNI MORALI PERCHE' HO VISTO TROPPI LEBBROSI E MI SONO IMPRESSIONATO A VITA.

MALARIA

OGGI HO IMPARATO CHE:
IN ITALIA CI SONO I POVERI IN INDIA CI SONO I PORETTI
(A) POVERO
(B) PORETTO

DOPO UN MESE DI PRANZI INDIANI CI VOGLIONO ALTRI DUE MESI PER RIACQUISTARE IL SENSO DEL GUSTO.

HO LE PAPILLE GUSTATIVE CARBONIZZATE

RAPPORTO MERDA n° 3275
TUTTO PROCEDE ENTRO LIVELLI NORMALI L'OPERAZIONE VIENE SVOLTA REGOLARMENTE UNA VOLTA AL GIORNO CON RISULTATI OTTIMALI. LA DENSITA' DELL'OGGETTO RIMANE STABILE INTORNO AI 5,03 g/p PER UNA MASSA DI CIRCA 20-40 gm. L'UMIDITA' DI SUPERFICIE RESTA AMPIAMENTE AL DISOTTO DEI LIMITI DI SICUREZZA. IL RESTO DELL'EQUIPAGGIO PRESENTA DELLE COMPLICAZIONI NELLO SVOLGIMENTO DELL'OPERAZIONE CHE VIENE AVVIATA AD INTERVALLI IRREGOLARI SENZA PORTARE A RISULTATI SODDISFACENTI O ADDIRITTURA NON VIENE SVOLTA AFFATTO. (NON RIESCE A CACARE SE NON LEGGE)

E' UN PROBLEMA DI CHI STUDIA TROPPO

DELHI SEMBRA UN GIGANTE AUTOSCONTRO CHE RIEMPIE TUTTE LE STRADE LE MACCHINE STROMBAZZANO, INCHIODANO GIRANO SU SE STESSE NON SI SCONTRANO PER UN PELO.
I PEDONI SONO UN INCOGNITA DI POCO CONTO.
E' VIETATO CAMMINARE IN PISTA
PUO FARLO SOLO IL TIPO CON LA CHIAVETTA

6 gen.

Più decorato!

QUA NON ESISTE IL CONCETTO DEL DESIGN, ANZI ESISTE MA È L'OPPOSTO DI QUELLO OCCIDENTALE. L'IDEA DI FUNZIONALISMO NON SEMBRA ESSERA MAI ARRIVATA. TUTTO È PRECARIO, TRABALLANTE MA SEMPRE MOLTO DECORATO.

horn please

hornplease

LA NOSTRA CONOSCENZA DEL MONDO INDIANO PROCEDE A PASSI DA GIGANTE OGGI LA SIBE HA FATTO A SCHIAFFI CON UN TASSISTA CHE CI VOLEVA RAPIRE.
POI SIAMO ANDATI ALL'UFFICIO DELLA COMPAGNIA AEREA PER CAMBIARE LA PRENOTAZIONE DEL VOLO LA SIBE HA DECISO DI RIMANERE UN MESE DI PIU PERCHE DELHI GLI PIACE TROPPO

POI PER FESTEGGIARE SIAMO ANDATI IN UN LOCALE TIPICO MOLTO ACCOGLIENTE E PULITO SPLENDENTE CON VISTA SUL "PASSEGGIO"

QUI ABBIAMO POTUTO ASSAPORARE ALCUNE SPECIALITA LOCALI: LE SAMOSA

UNA SPECIE DI BOMBOLONE RIPIENO DI PATATE FRITTO NELL'OLIO MOTORE E RICOPERTO DA UNA SPOLVERATA DI TERRICCIO STRADALE.

ESTASI DEL PALATO!

MOTOCARROZZETTA

HORN PLEASE TO THE

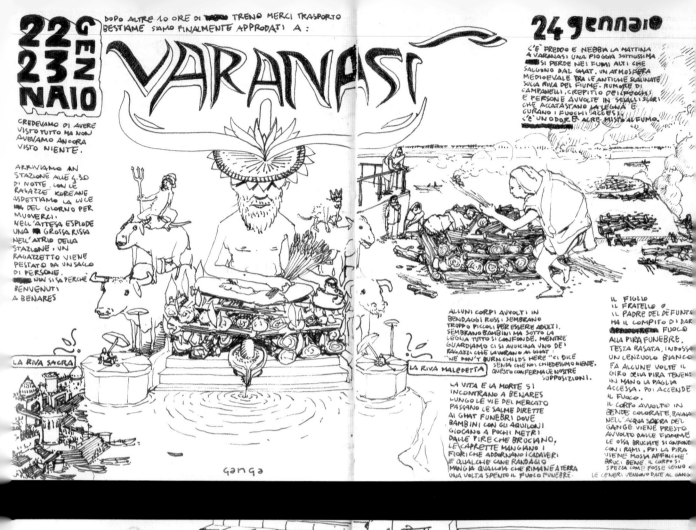

22 GEN 23 NAIO

DOPO ALTRE 10 ORE DI ~~TRENO~~ TRENO MERCI TRASPORTO BESTIAME SIAMO FINALMENTE APPRODATI A:

VARANASI

CREDEVAMO DI AVERE VISTO TUTTO MA NON AVEVAMO ANCORA VISTO NIENTE.

ARRIVIAMO AN STAZIONE ALLE 4.30 DI NOTTE. CON LE RAGAZZE KOREANE ASPETTIAMO LA LUCE DEL GIORNO PER MUOVERCI. NELL'ATTESA ESPLODE UNA GROSSA RISSA NELL'ATRIO DELLA STAZIONE. UN RAGAZZETTO VIENE PESTATO DA UN SACCO DI PERSONE. NON SI SA PERCHE. BENVENUTI A BENARES

LA RIVA SACRA

GANGA

24 gennaio

C'E FREDDO E NEBBIA LA MATTINA A VARANASI UNA PIOGGIA SOTTILISSIMA SI PERDE NEI FUMI ALTI CHE SALGONO DAL GHAT. UN'ATMOSFERA MEDIOEVALE TRA LE ANTICHE SCALINATE SULLA RIVA DEL FIUME. RUMORE DI CAMPANELLI, CREPITIO DEI FUOCHI, E PERSONE AVVOLTE IN SCIALLI SCURI CHE ACCATASTANO LA LEGNA E CURANO I FUOCHI ACCESI. C'E UN ODORE ACRE MISTO AL FUMO.

ALCUNI CORPI AVVOLTI IN BENDAGGI ROSSI SEMBRANO TROPPO PICCOLI PER ESSERE ADULTI. SEMBRANO BAMBINI MA SOTTO LA LEGNA TUTTO SI CONFONDE. MENTRE GUARDIAMO CI SI AVVICINA UNO DE' RAGAZZI CHE LAVORANO AL GHAT "WE DON'T BURN CHILDS HERE" CI DICE SENZA CHE NOI CHIEDESSIMO NIENTE. QUESTO CONFERMA LE NOSTRE SUPPOSIZIONI.

LA RIVA MALEDETTA

LA VITA E LA MORTE SI INCONTRANO A BENARES LUNGO LE VIE DEL MERCATO PASSANO LE SALME DIRETTE AI GHAT FUNEBRI DOVE BAMBINI CON GLI AQUILONI GIOCANO A POCHI METRI DALLE PIRE CHE BRUCIANO, LE CAPRETTE MANGIANO I FIORI CHE ADORNANO I CADAVERI E QUALCHE CANE RANDAGIO MANGIA QUALCOSA CHE RIMANE A TERRA UNA VOLTA SPENTO IL FUOCO FUNEBRE.

IL FIGLIO IL FRATELLO O IL PADRE DEL DEFUNTO HA IL COMPITO DI DARE ~~~~ FUOCO ALLA PIRA FUNEBRE. TESTA RASATA, INDOSSA UN LENZUOLO BIANCO FA ALCUNE VOLTE IL GIRO DELLA PIRA TENENDO IN MANO LA PAGLIA ACCESA. POI ACCENDE IL FUOCO. IL CORPO AVVOLTO IN BENDE COLORATE, BAGNATO NELL'ACQUA SACRA DEL GANGE VIENE PRESTO AVVOLTO DALLE FIAMME LE OSSA BRUCIATE SI CONFONDONO CON I RAMI, POI LA PIRA VIENE MOSSA AFFINCHE BRUCI BENE. IL CORPO SI SPEZZA COME FOSSE LEGNO. LE CENERI VENGONO DATE AL GANGE

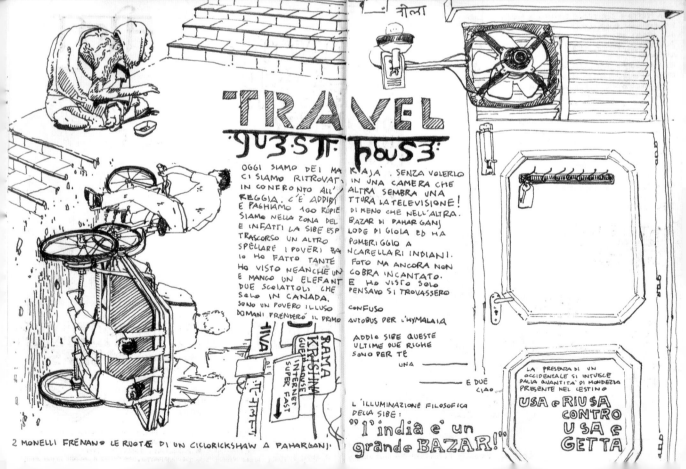

TRAVEL GUEST HOUSE

OGGI SIAMO DEI MA... CI SIAMO RITROVATI IN CONFRONTO ALL' REGGIA. C'E ADDI... E PAGHIAMO 100 RUPIE SIAMO NELLA ZONA DEL E INFATTI LA SIBE ESP TRASCORSO UN ALTRO SPELLARE I POVERI BA IO HO FATTO TANTE HO VISTO NEANCHE UN E MANGO UN ELEFANT DUE SCOIATTOLI CHE SOLO IN CANADA. SONO UN POVERO ILLUSO DOMANI PRENDERO' IL PRIMO

R JA . SENZA VOLERLO IN UNA CAMERA CHE ALTRA SEMBRA UNA TTURA LA TELEVISIONE! DI MENO CHE NELL'ALTRA. BAZAR DI PAHARGANJ LODE DI GIOIA ED HA POMERIGGIO A NCARELLARI INDIANI. FOTO MA ANCORA NON COBRA INCANTATO E HO VISTO SOLO PENSAVO SI TROVASSERO

CONFUSO AUTOBUS PER L'HYMALAIA

ADDIO SIBE QUESTE ULTIME DUE RIGHE SONO PER TE

UNA ___

___ E DUE ___ CIAO

L'ILLUMINAZIONE FILOSOFICA DELLA SIBE: "l'india è un grande BAZAR!"

RAMA KRISHNA GUEST HOUSE INTERNET SUPER FAST

LA PRESENZA DI UN OCCIDENTALE SI INTUISCE DALLA QUANTITA DI MONDEZZA PRESENTE NEL CESTINO

USA E RIUSA CONTRO USA E GETTA

2 MONELLI FRENANO LE RUOTE DI UN CICLORICKSHAW A PAHARGANJ

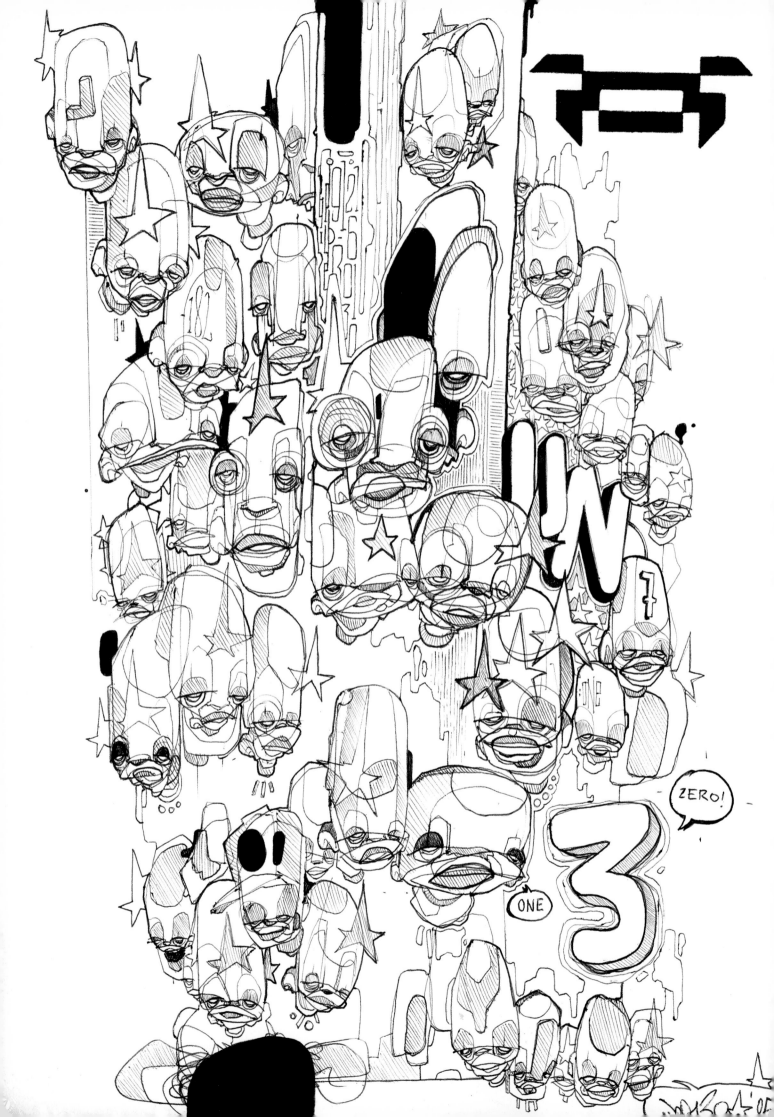

Bo130

Bo130 is a key figure in the street art scene, particularly in his native Italy, but his ephemeral street art campaigns with posters, stickers and murals can be found in many cities around the world. He has also mounted gallery exhibitions and created sculptural installations in more unusual places, including an abandoned swimming pool.

Graphic novel authors such as Manara and Moebius were important influences when he was growing up. On a visit to the United States he became captivated by graffiti, especially the character art of Mode2. The work of Robert Rauschenberg, Keith Haring and Andy Goldsworthy furthered his interest in art. His general interest in all forms of art, along with music, travel and meeting people, inspires the artwork he creates today.

'I use sketches to gather ideas or to describe things but mostly to release stress,' he says. 'I feel particularly good when I draw freely with a biro on a white piece of paper!' His final paintings or digital works are the result of the 'layering of dirty shapes': 'When I work on canvases or walls, after very quick loose sketches, I start to lay down the first lines and shapes. I then go on putting down different layers of drawings, colours, a line etc. until a little voice in my head says "That's it!"'

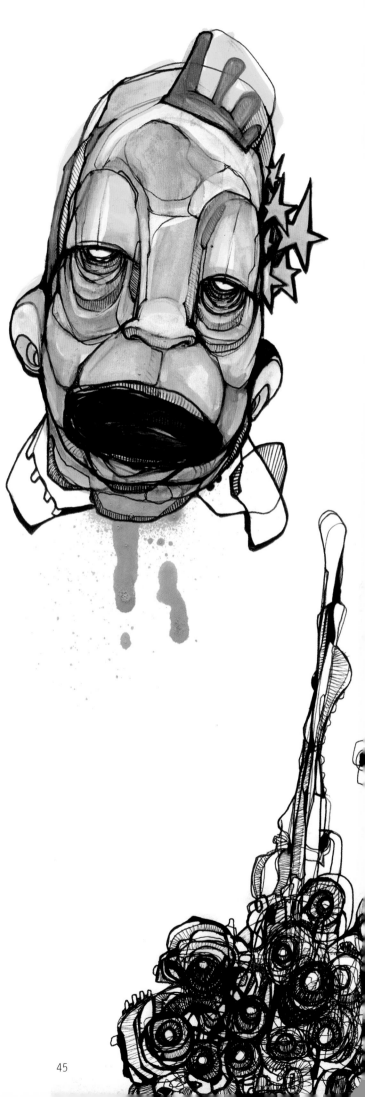

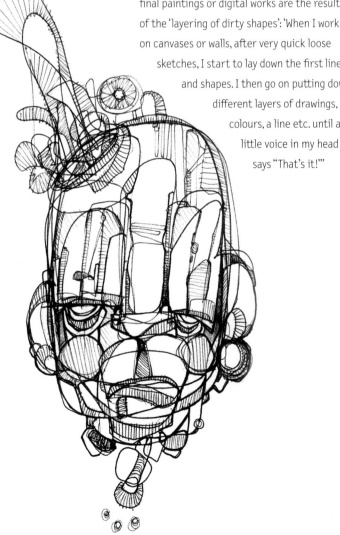

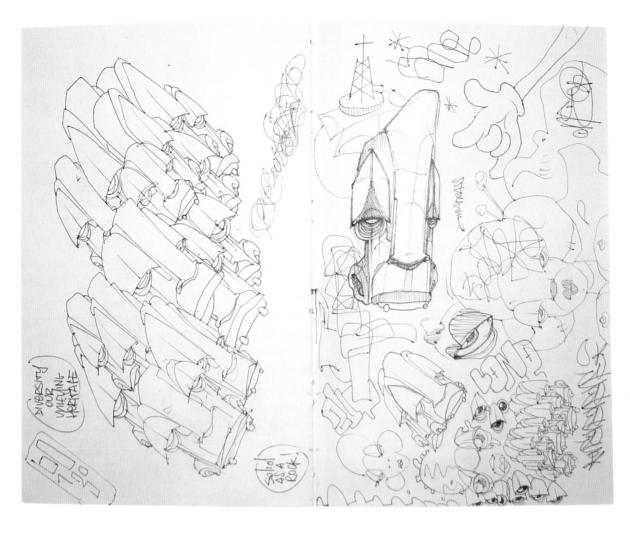

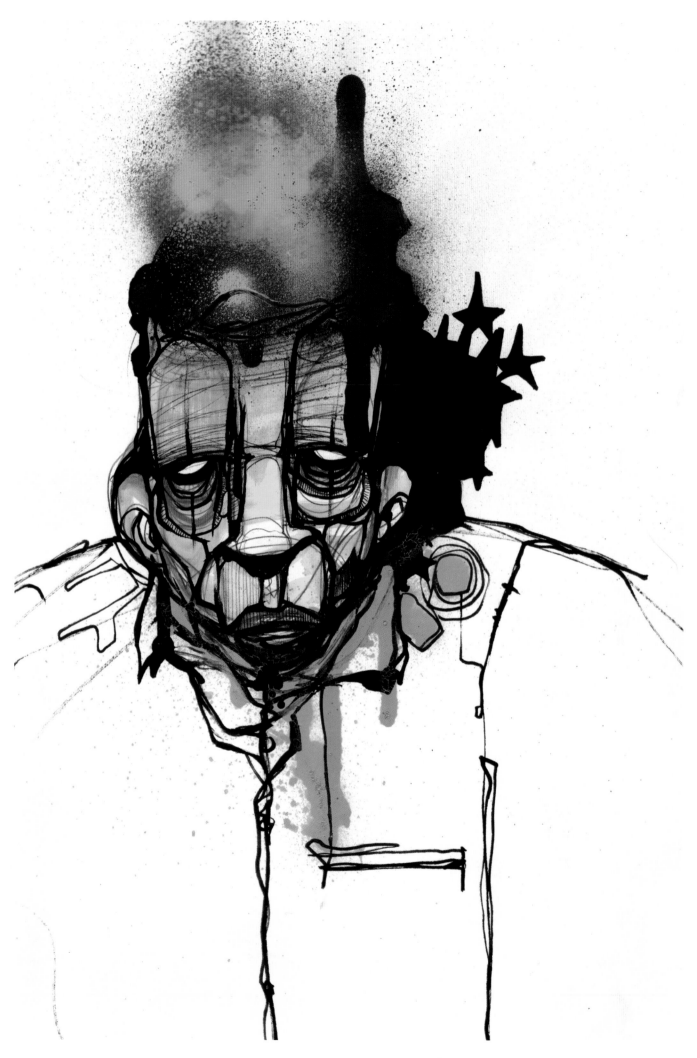

47 B0130

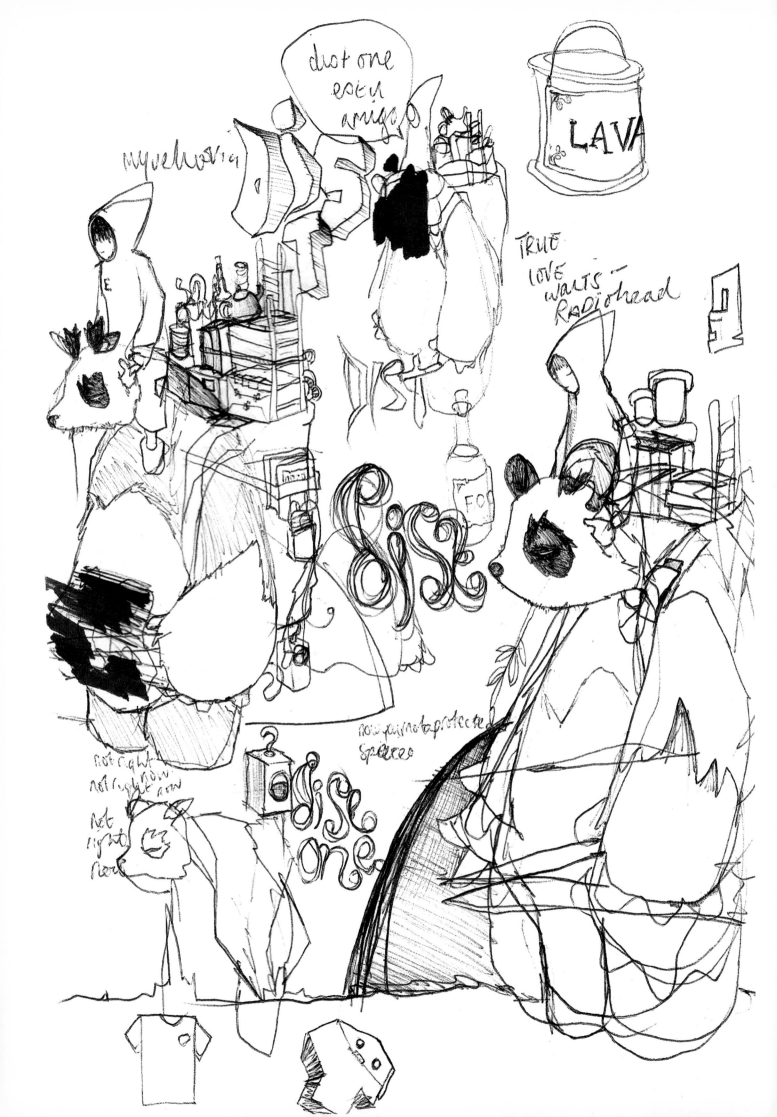

David Earl Dixon

--

British artist David Earl Dixon
lives in Colchester, where he runs a
skateboard company and works as
a freelance artist and illustrator.
Curious characters, fantasy worlds,
and the interaction between humans
and animals permeate his artworks.
Under the pseudonym Dist.One he
also brings his world of characters
to the street.

 'Sketching helps exorcize the
demons!' he says. 'No, in truth it's just
a good space to let ideas flow as freely
as possible. In fact most of the time
it's this stuff that to me looks the
best. It has that creative spontaneity,
that unsure yet somehow confident
set of strokes or lines, which is often
impossible to recreate, or pursue. It's
a momentary thing...the first furtive
ramblings of ideas and thoughts.'

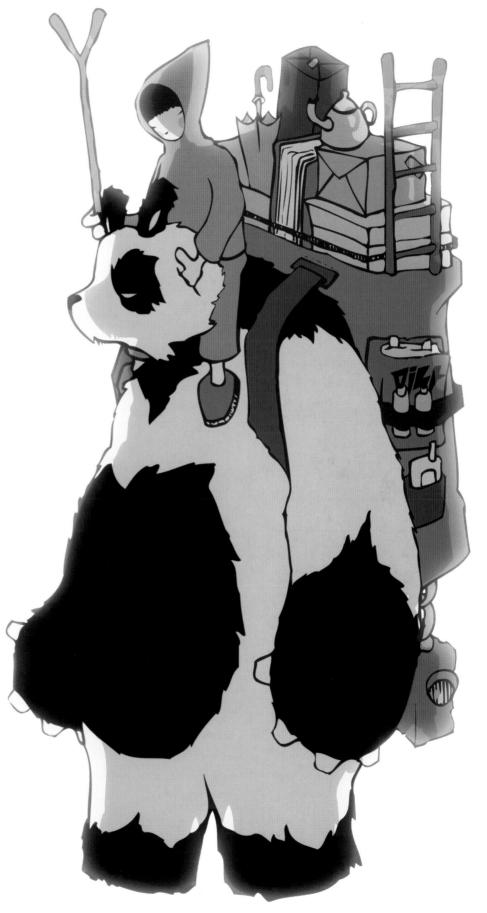

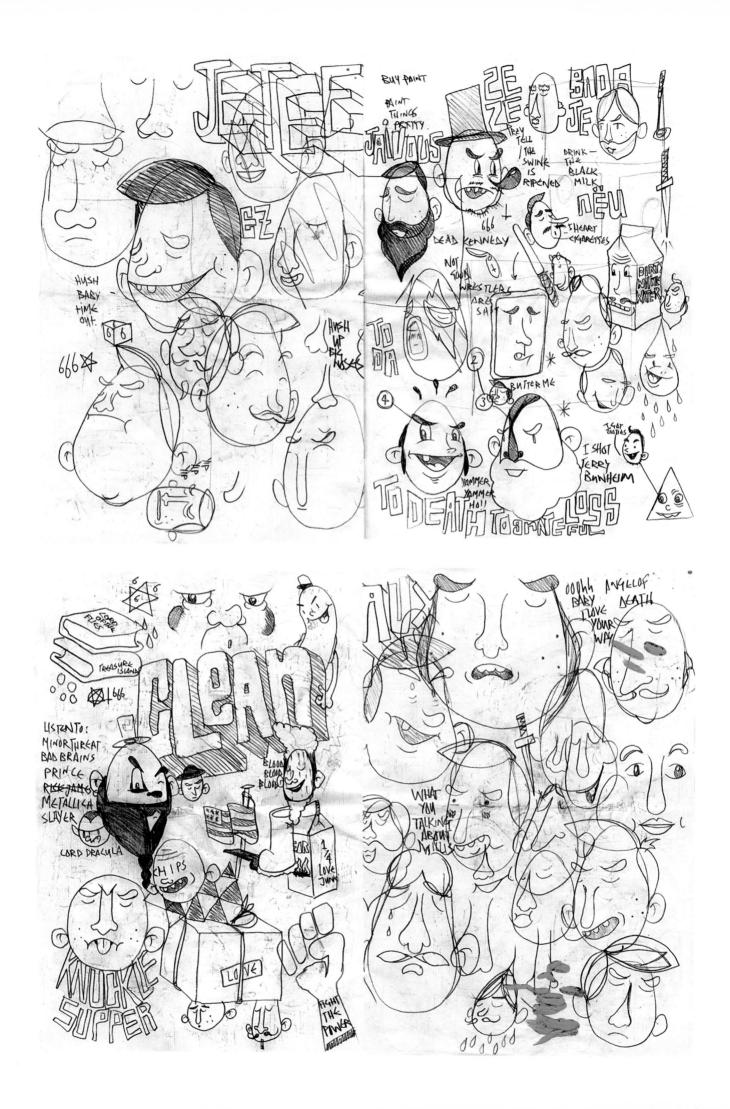

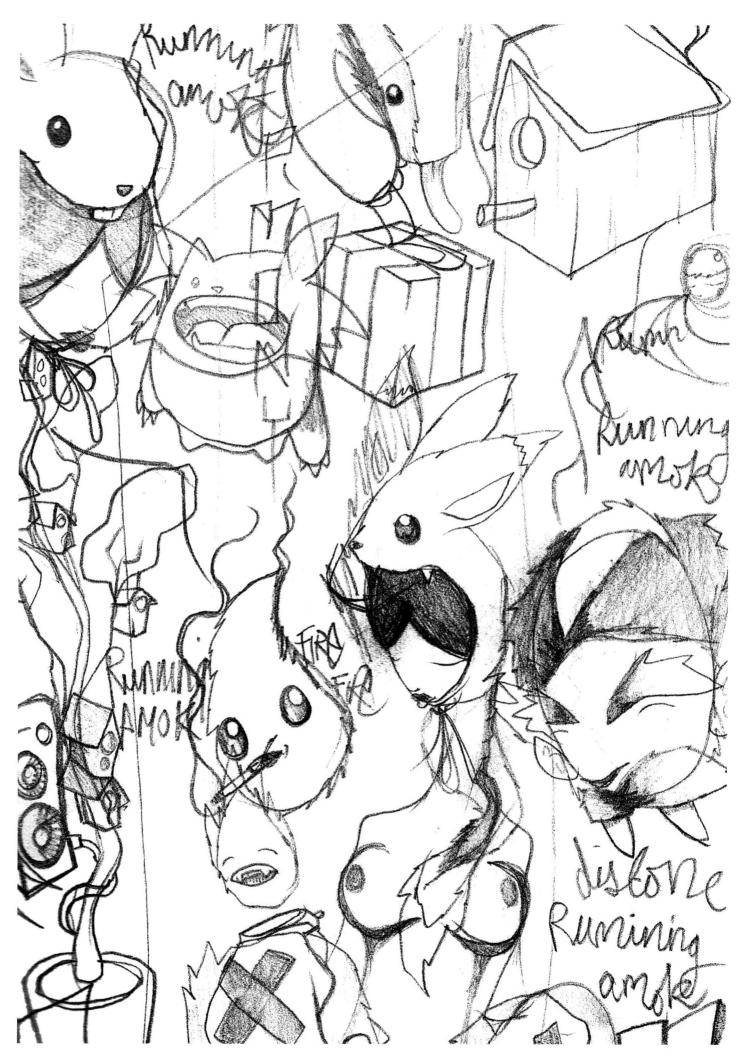

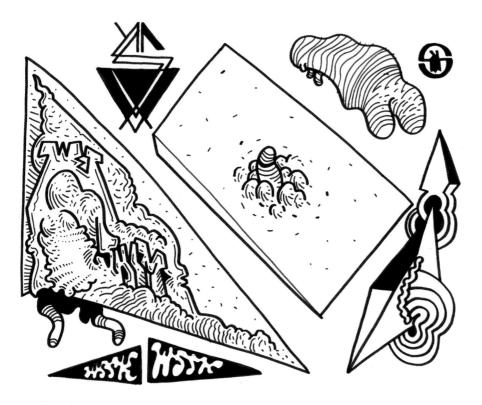

Eco

Eco is an artist and illustrator based in the Cotswolds, in the south-west of England. He is also a graffiti writer of long standing and a respected member of the Wet Shame (WSSK) and TCF crews. His sketchbooks are full of experimental line drawings, many of which have resulted from breaking down letterforms and exploring shapes. Some of these sketches are developed in his artwork; when he paints a wall he refers to his drawing to get the overall balance and then generally freestyles.

Graffiti writing is central to the way Eco draws. Often when he sketches it is with the endless and infinite brief of writing his name ECO/EKO/EKOE: 'The brief set down many years ago by graffiti innovators – this is my baseline and from there I only have my own preconceptions of what a letter is to stop me going anywhere I like...weight, form and line, anything that isn't a letter has its beginning with me as a letter, is abstracted till it becomes something else, a pattern, a nonentity, a character.'

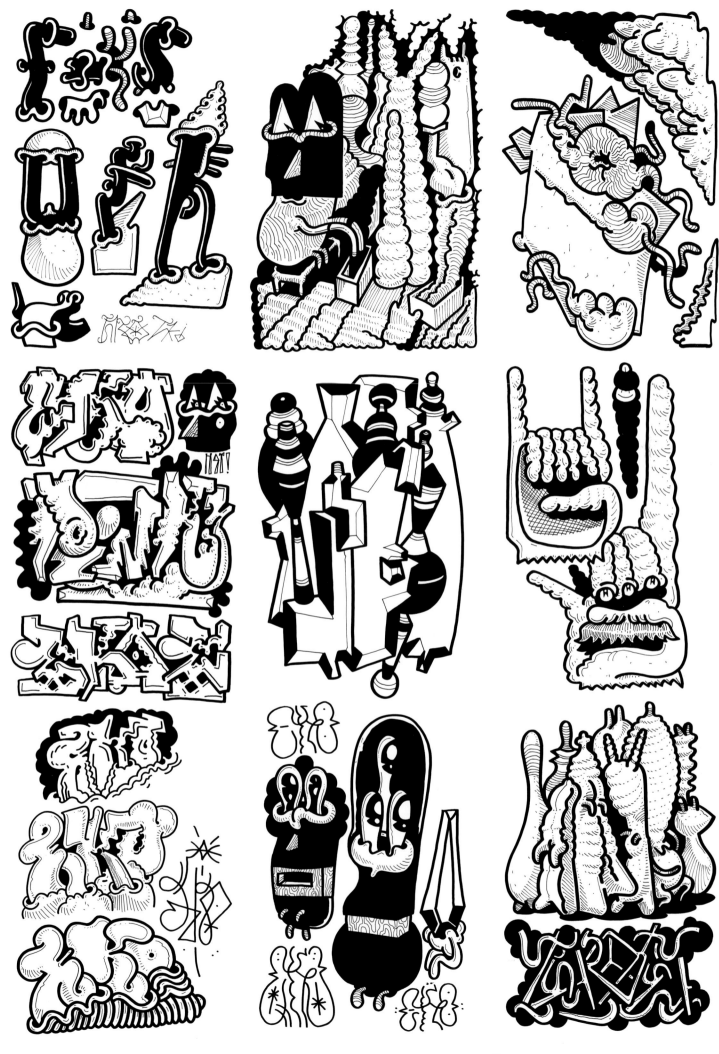

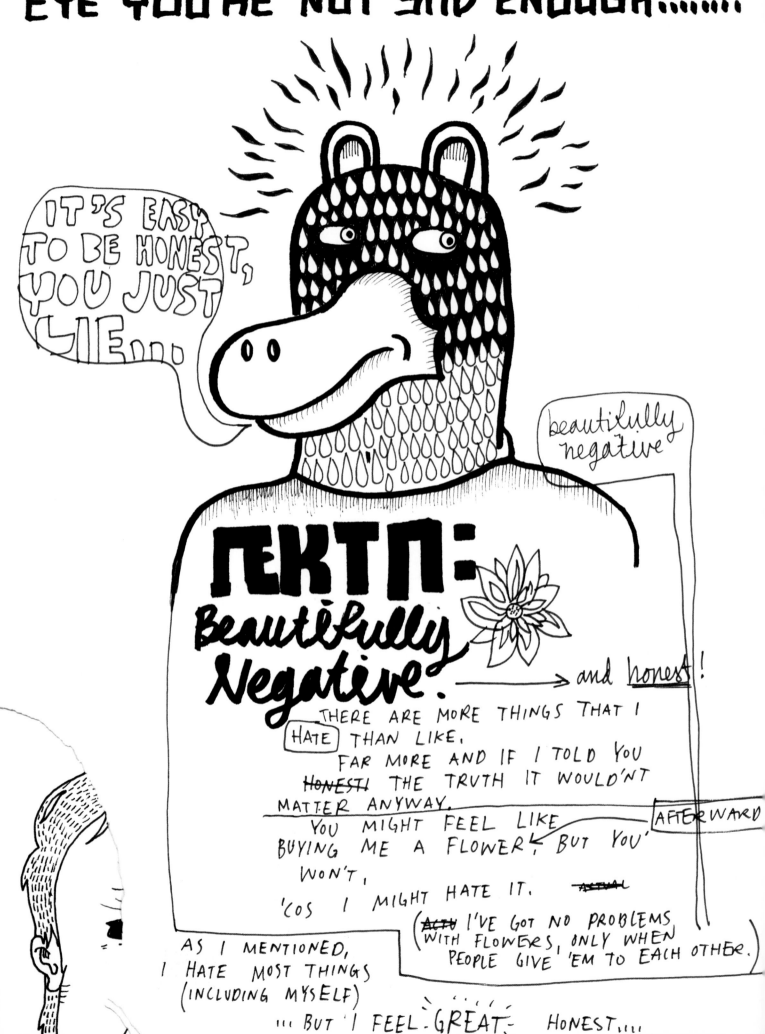

Ekta

--

As well as being a full-time artist, Ekta is one of seven people who run the ORO gallery in Gothenburg, Sweden. His sketchbooks are sometimes source material for his self-published 'zines, paintings and murals, but often they are simply personal spaces. His drawings are bold and confident; he's not one for sketching things out tentatively. In his own words: 'I don't like knowing too much about what I'm drawing till I've drawn it. Sometimes I get ideas that I will try to draw – 90 per cent of the time I fall out of love with these drawings as soon as I've done them. I see every drawing as a finished piece.'

Ekta's sense of humour is evident in his strange narratives and juxtaposition of characters, symbols and patterns. Sometimes text can act as a catalyst for his visual ideas, taking words and sentences out of context and throwing things about.

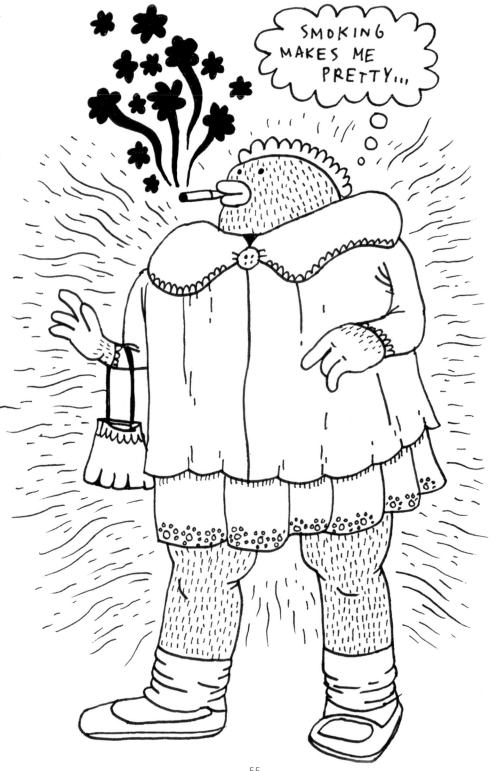

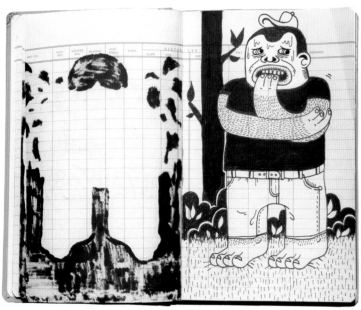

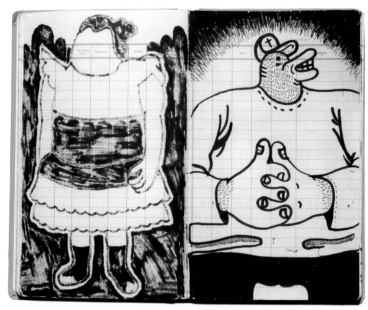

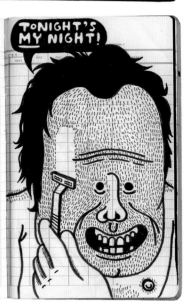

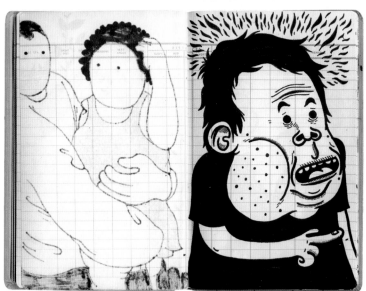

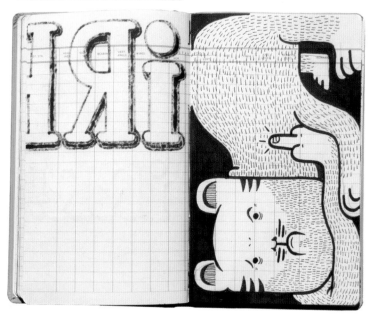

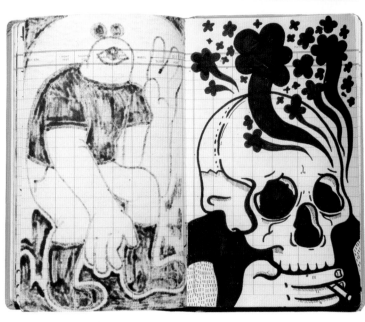

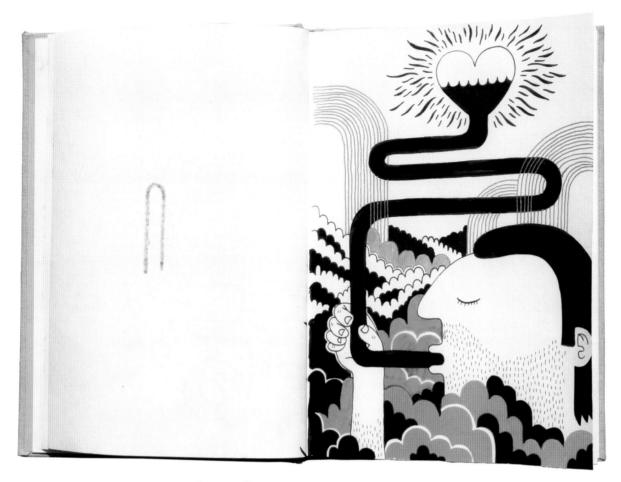

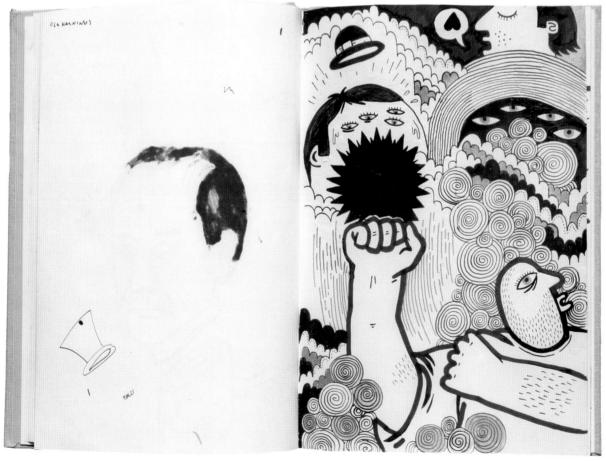

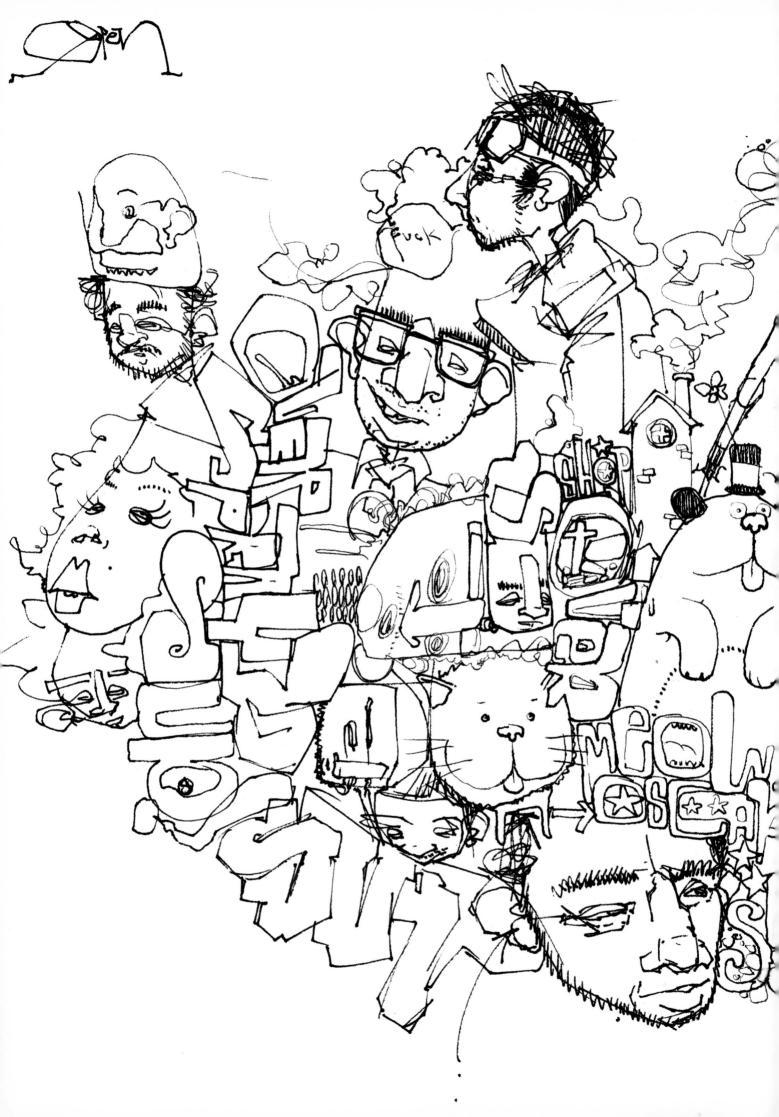

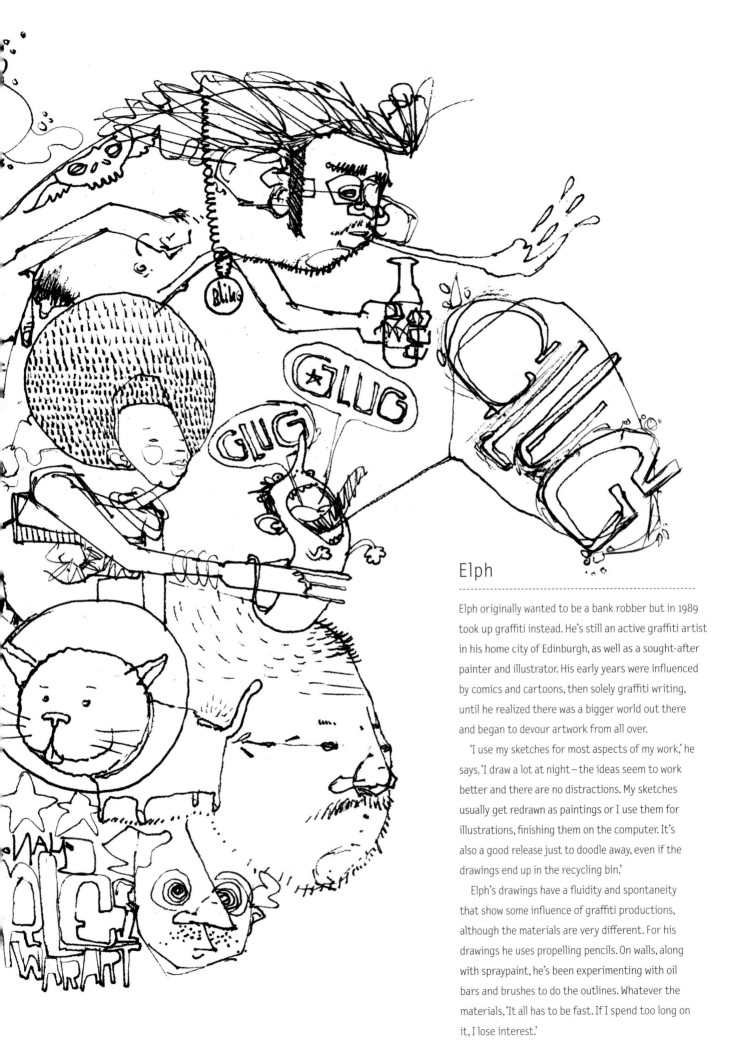

Elph

Elph originally wanted to be a bank robber but in 1989 took up graffiti instead. He's still an active graffiti artist in his home city of Edinburgh, as well as a sought-after painter and illustrator. His early years were influenced by comics and cartoons, then solely graffiti writing, until he realized there was a bigger world out there and began to devour artwork from all over.

'I use my sketches for most aspects of my work,' he says. 'I draw a lot at night — the ideas seem to work better and there are no distractions. My sketches usually get redrawn as paintings or I use them for illustrations, finishing them on the computer. It's also a good release just to doodle away, even if the drawings end up in the recycling bin.'

Elph's drawings have a fluidity and spontaneity that show some influence of graffiti productions, although the materials are very different. For his drawings he uses propelling pencils. On walls, along with spraypaint, he's been experimenting with oil bars and brushes to do the outlines. Whatever the materials, 'It all has to be fast. If I spend too long on it, I lose interest.'

59

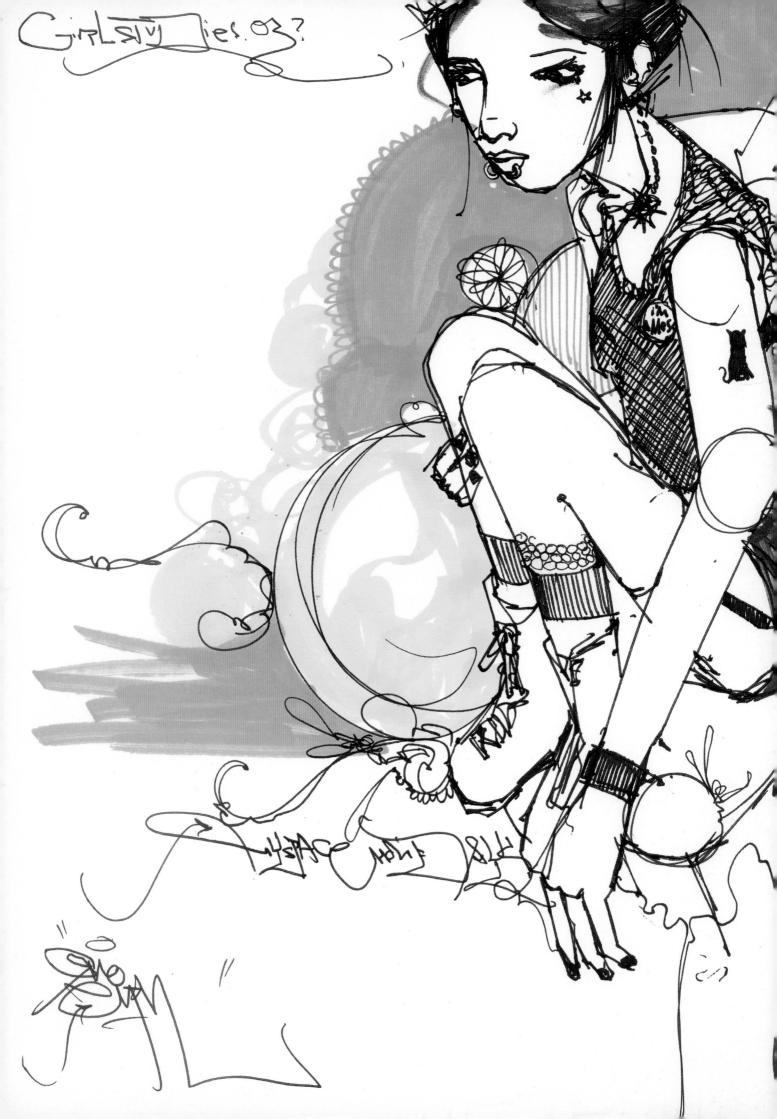

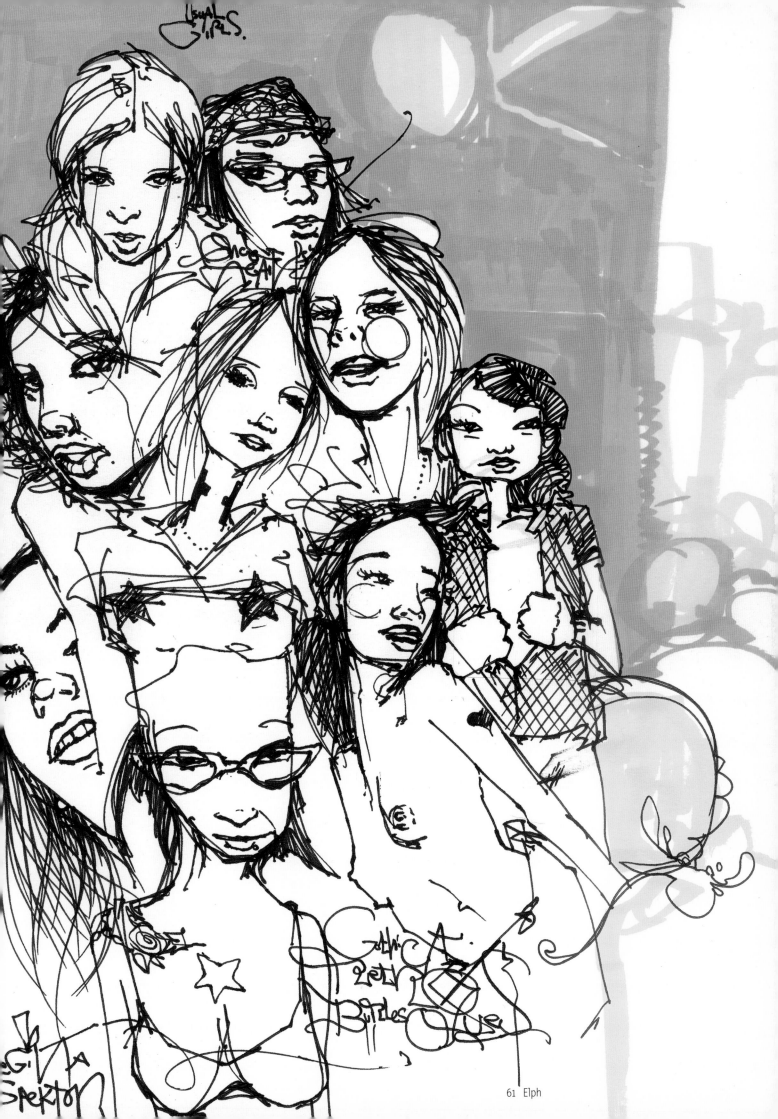

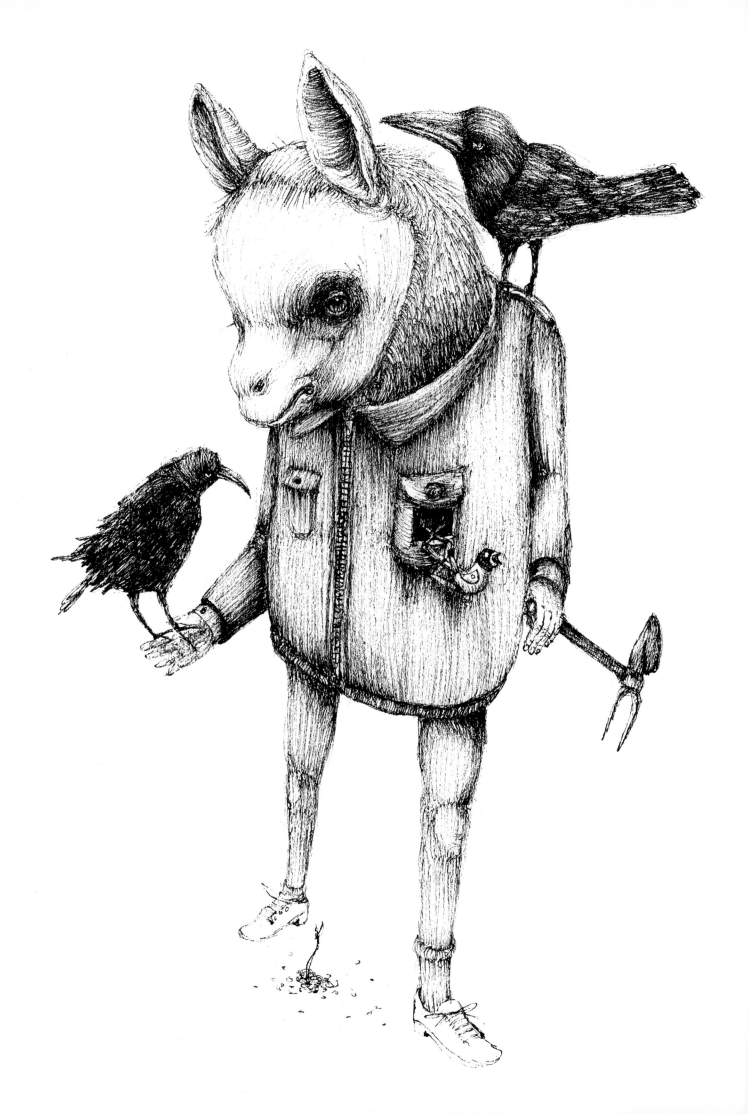

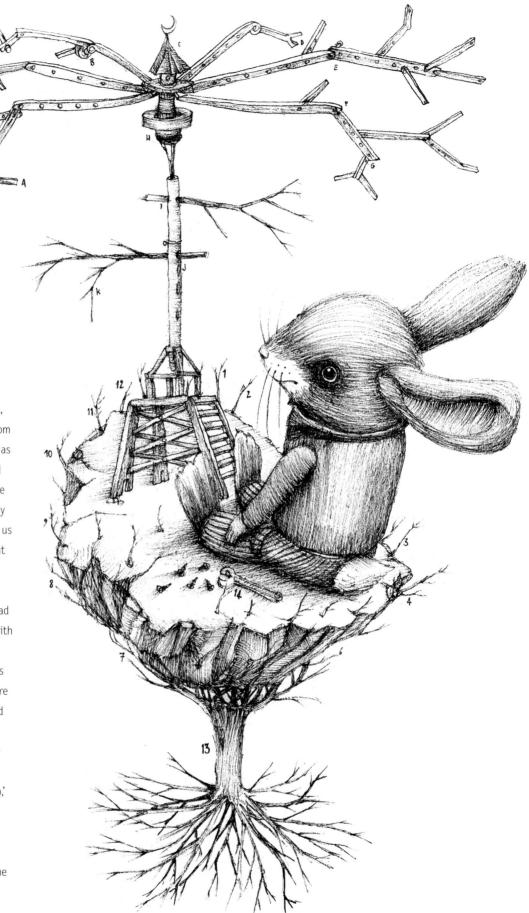

Ericailcane

Ericailcane, which roughly translates as 'Eric the Dog', lives and works in Bologna, Italy. His work embraces many media, from delicate etchings to vast murals, as well as otherworldly short films using animated models and mixed media. His friends joke that his work belongs to another century but, while his draughtsmanship reminds us of a bygone age, his ideas often comment on modern life.

Drawing is central to Ericailcane's output and he almost always carries a pad of paper and an Indian ink pen around with him. 'Drawing is a way of talking without opening my mouth,' he explains. Often his aim is to capture a particular atmosphere using inspirations from the world around him – experiences such as travelling, people, things and animals: 'I try to draw what I see and what I'm feeling.'

'I don't know how my work will develop,' he says. 'Perhaps, I don't want to know seeing as it's a search, an attempt to discover something perpetually. As soon as you know where you want to get to, the game's over.'

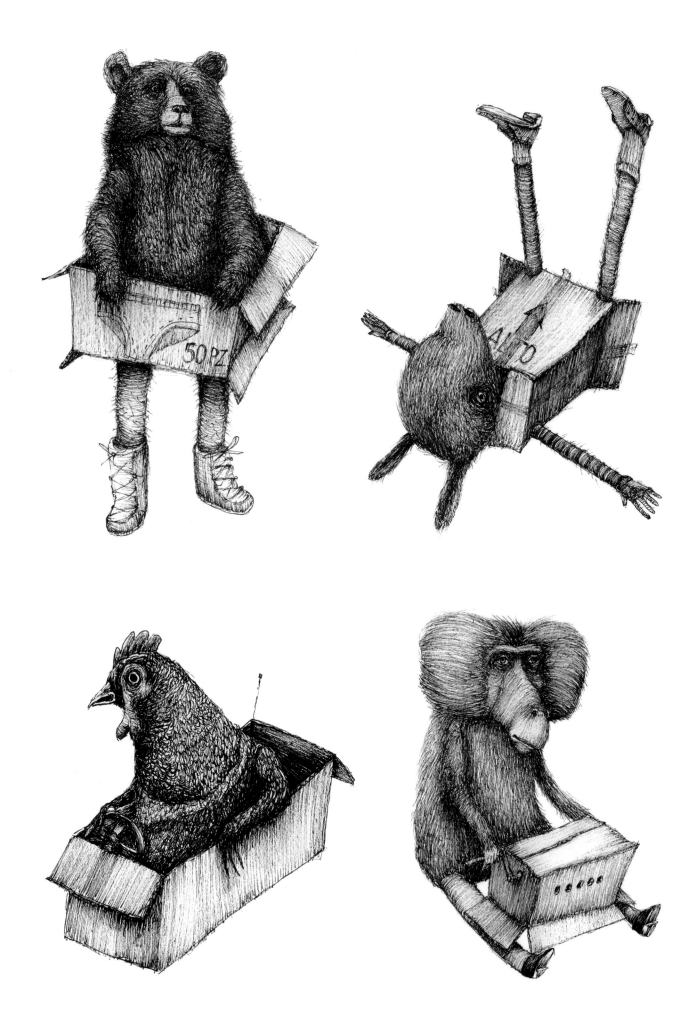

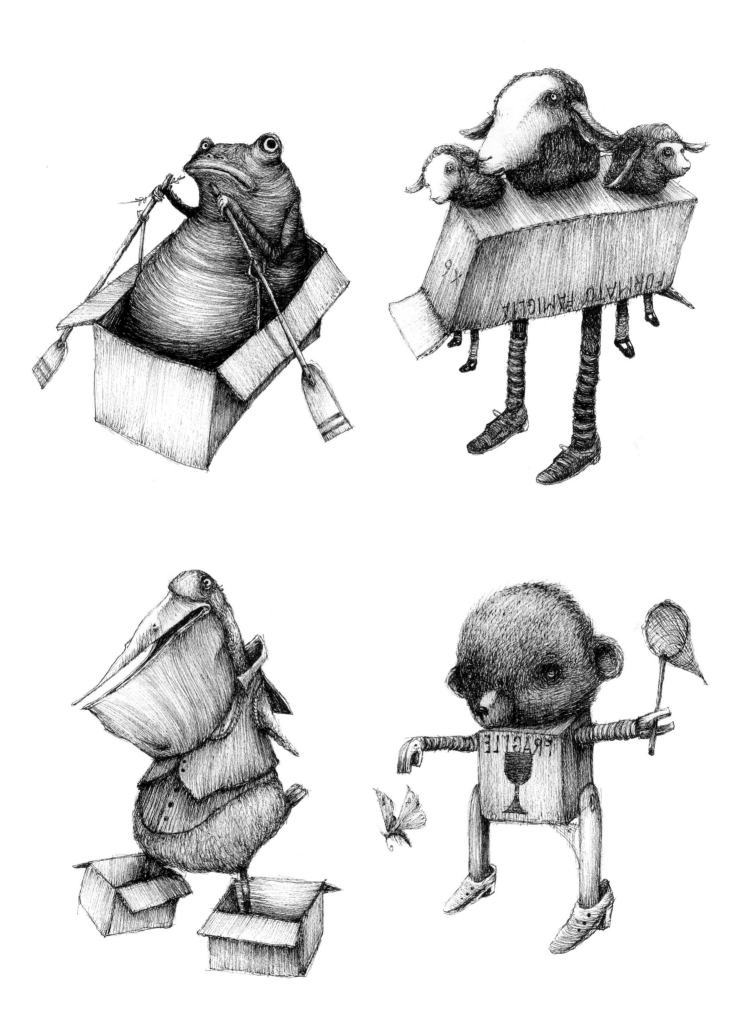

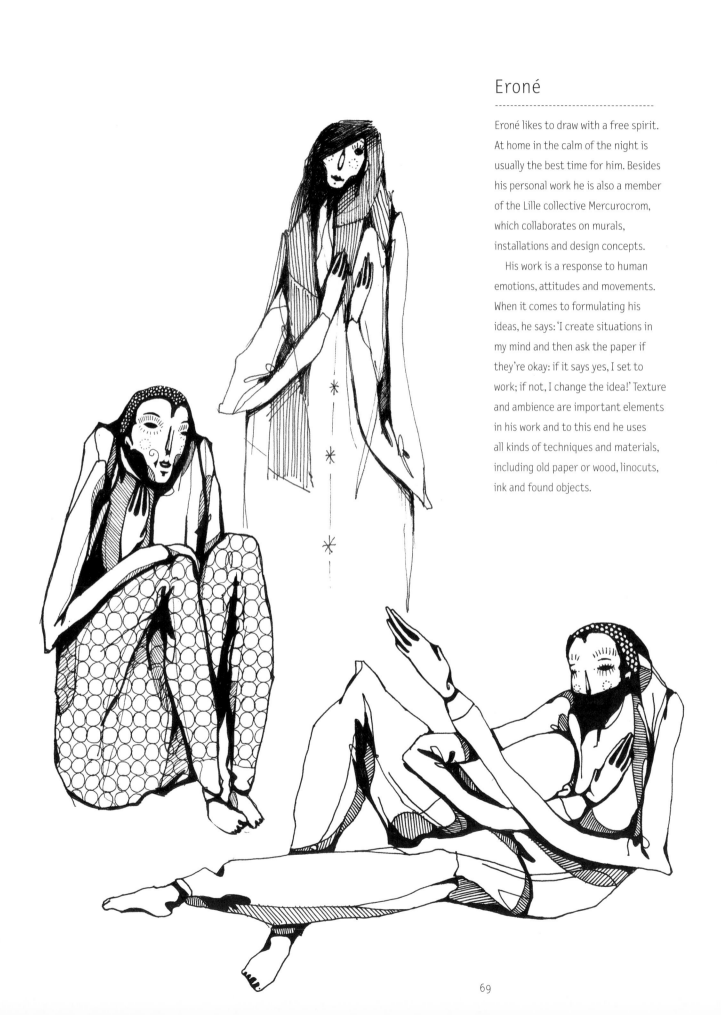

Eroné

Eroné likes to draw with a free spirit. At home in the calm of the night is usually the best time for him. Besides his personal work he is also a member of the Lille collective Mercurocrom, which collaborates on murals, installations and design concepts.

His work is a response to human emotions, attitudes and movements. When it comes to formulating his ideas, he says: 'I create situations in my mind and then ask the paper if they're okay: if it says yes, I set to work; if not, I change the idea!' Texture and ambience are important elements in his work and to this end he uses all kinds of techniques and materials, including old paper or wood, linocuts, ink and found objects.

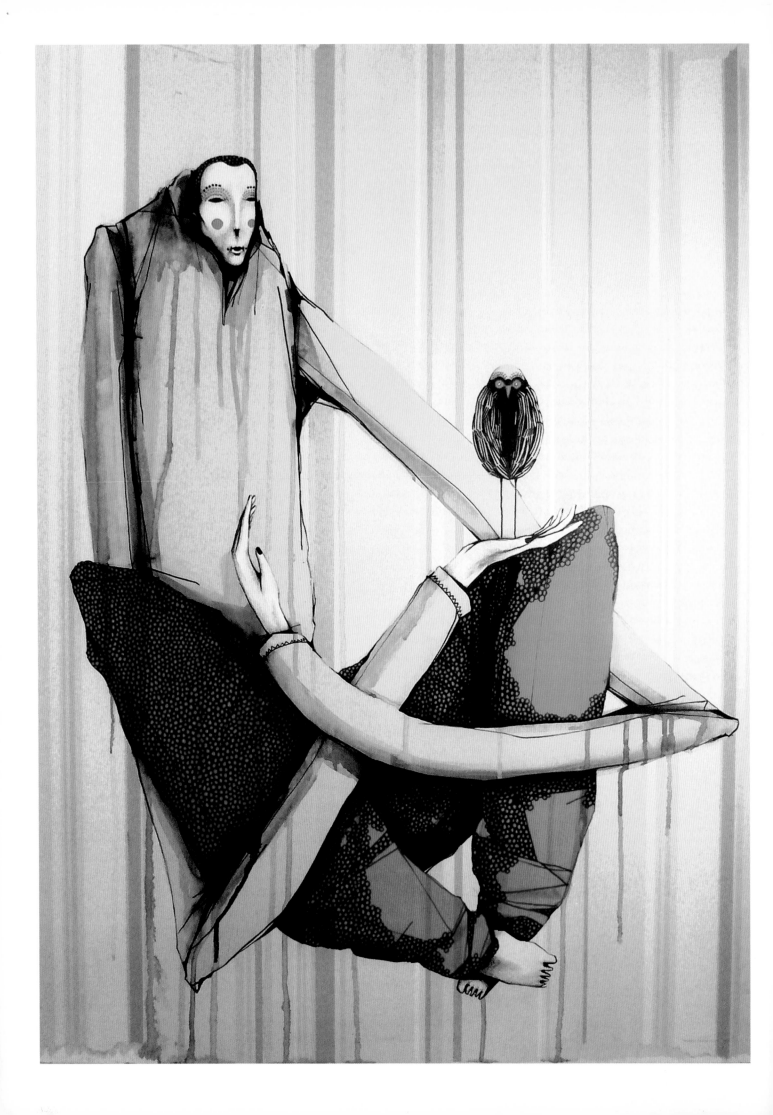

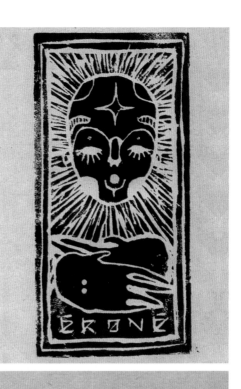
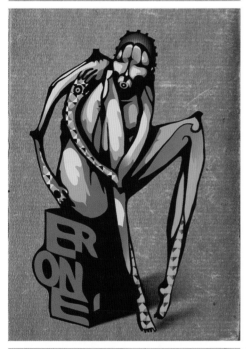

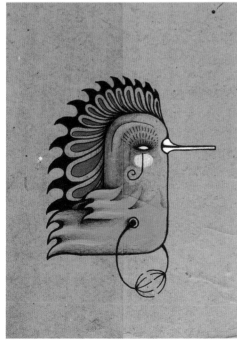
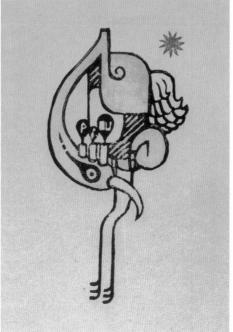
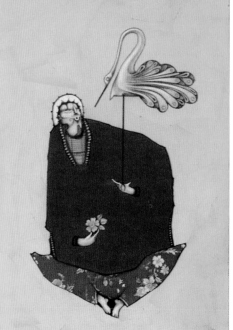

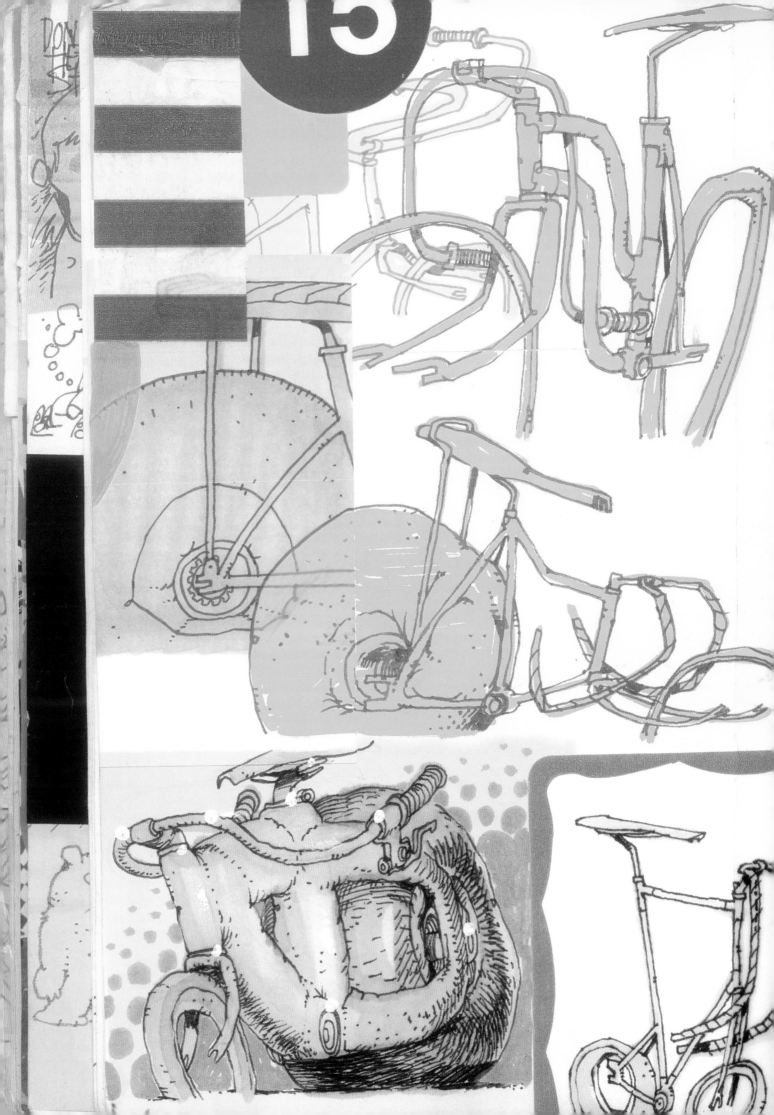

Erosie

Erosie is an illustrator from Eindhoven and comes from a graffiti and street art background. Whether it's a mural, a painting or a sticker campaign, his work is likely to be humorous, ironic and thoughtful. Behind his many guises, he is a prolific sketchbook user: 'My drawings always start off completely rough. I only want to focus on the general feel, attitude or shape when I sketch. I leave all the details for the second run – going over the sketch, on the computer, on a wall or in a sketchbook, to create the final drawing. It's that graffiti vibe I guess, where there are no second chances for doing a line right.'

The drawings shown here are taken from a larger project, which included placing stickers on the frames of abandoned bicycles to draw the public's attention to them, as well as making bicycle drawings, graffiti and sculptures: 'I try to make my drawings personal, both visually and conceptually. The *Eroded City Cycles* project, for instance, comes from the simple joy of drawing bikes, but also wanting to melt it with graffiti-tagging, or link it three-dimensionally to public space by applying stickers to abandoned bicycles. It comes from drawing, but actually is used much more dimensionally.'

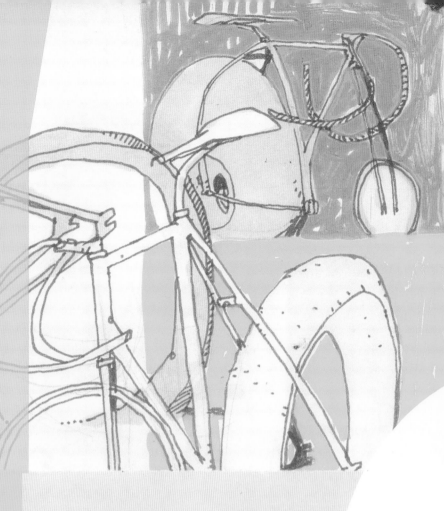

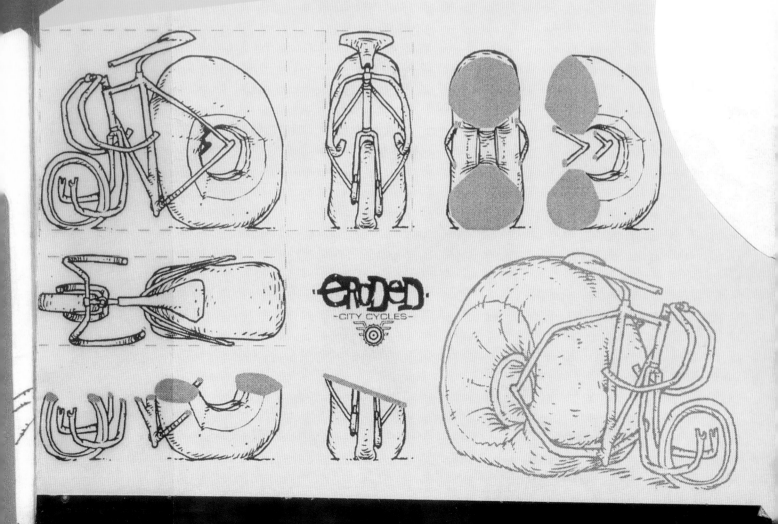

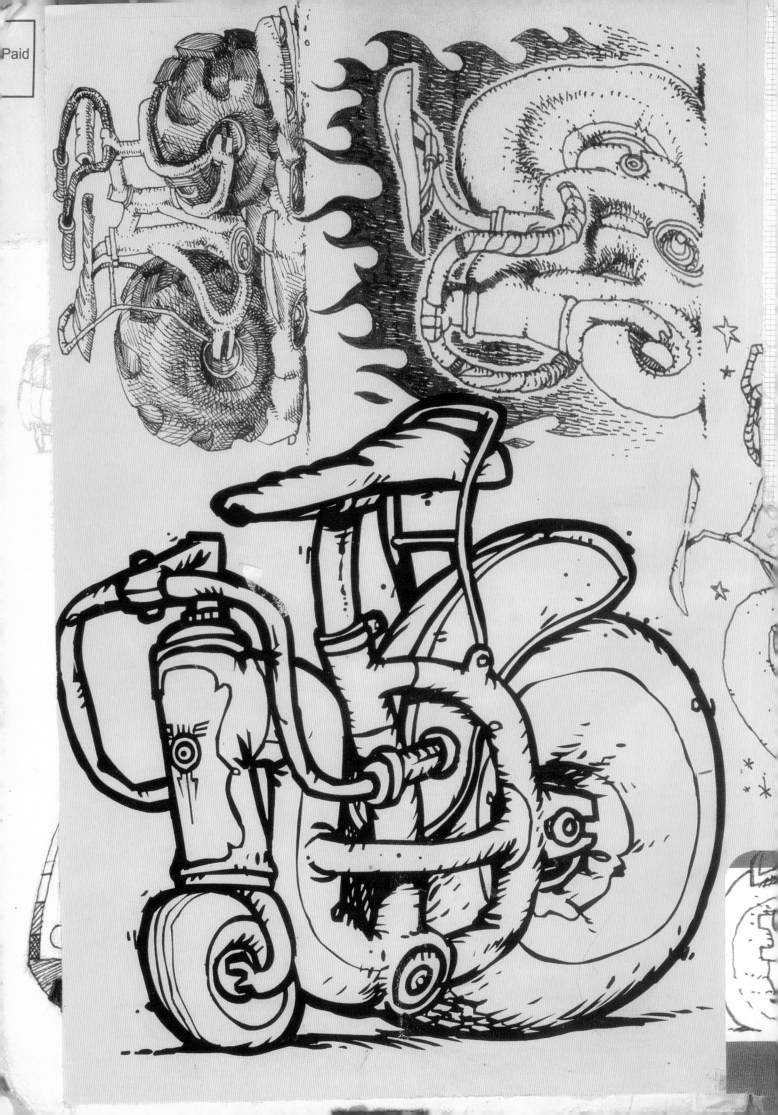

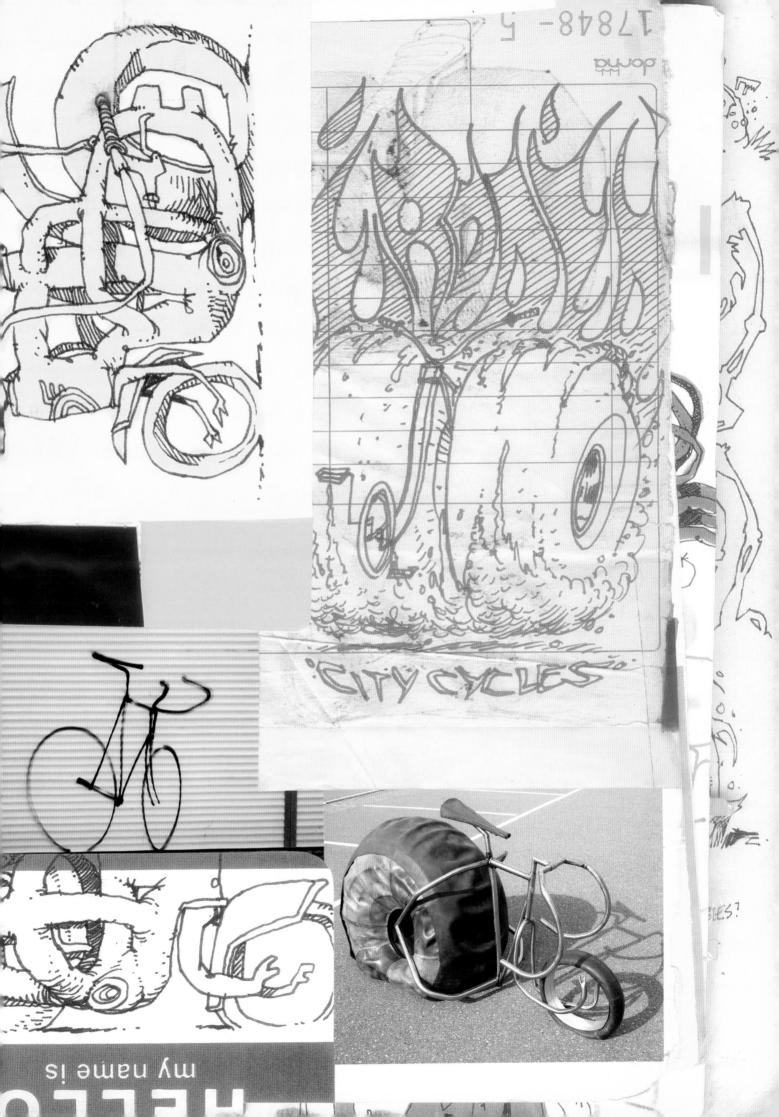

CITY CYCLES

17848-5

HELLO my name is

Roma 17.07.06

Hitnes

Hitnes lives in Rome where he works
as a freelance illustrator and graphic
designer. In his career he has worked as
a cartoonist for a satirical newspaper, a
storyboard artist, a movie set designer
and a printmaker. Since 1996 he has also
painted graffiti, with many commissions
for private and public clients in Italy,
across Europe and in Australia.

In his paintings, illustrations and
graffiti works the animal kingdom has a
starring role. Things that currently light
his fire are lobsters, fish, cats, etching,
seagulls, walls, mountains, cubes and
the mighty platypus! While his sketches
are partly observational, he brings
character and narrative to the lives of the
creatures he draws. His line work is playful,
decorative and economic, or in his own
words 'fine as a leaf, smooth as a squid,
heavy as darkness, still as a stone....'

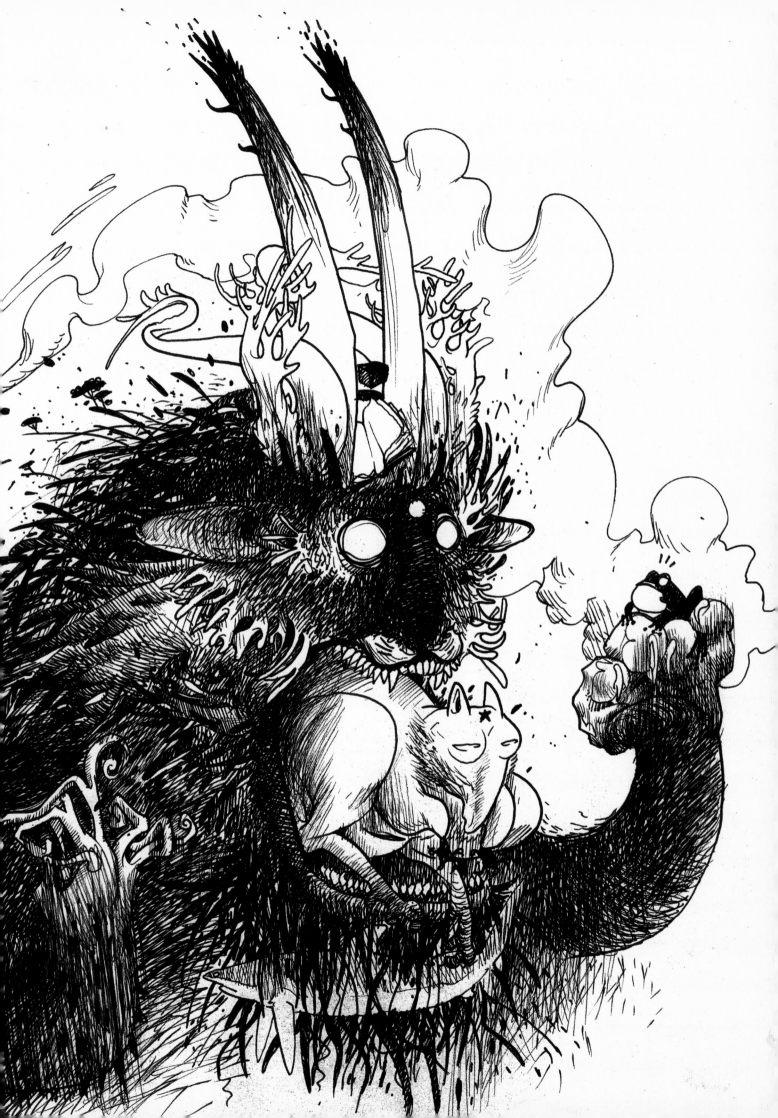

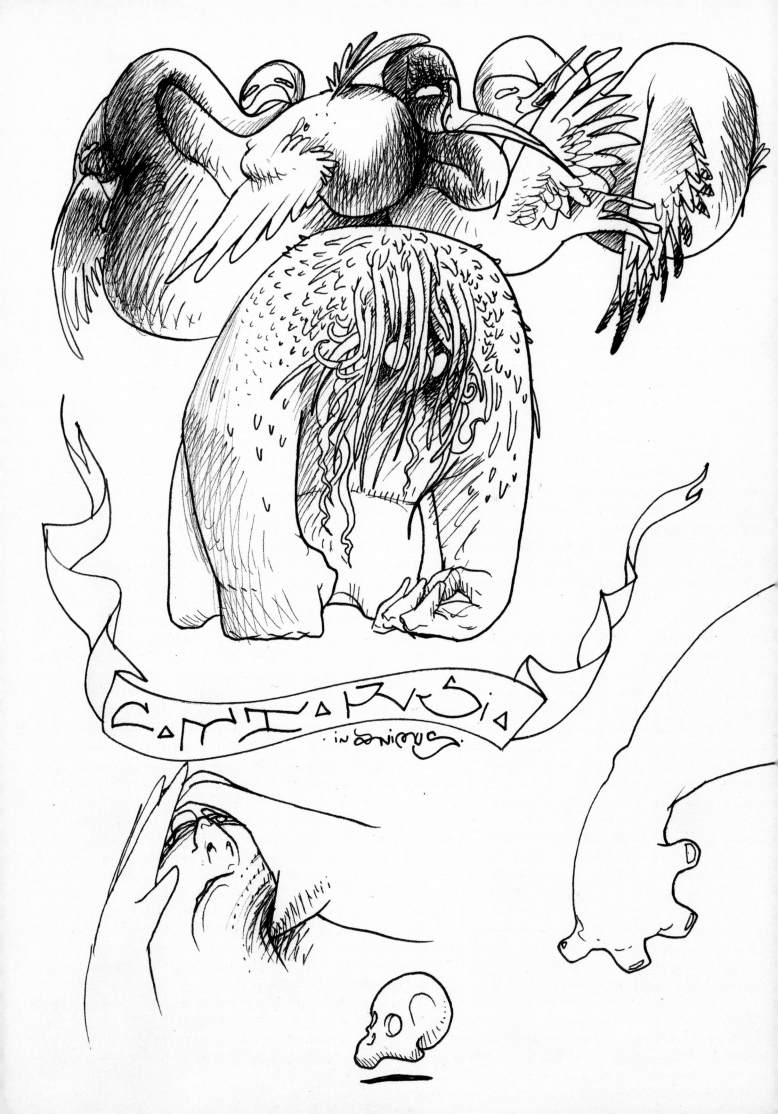

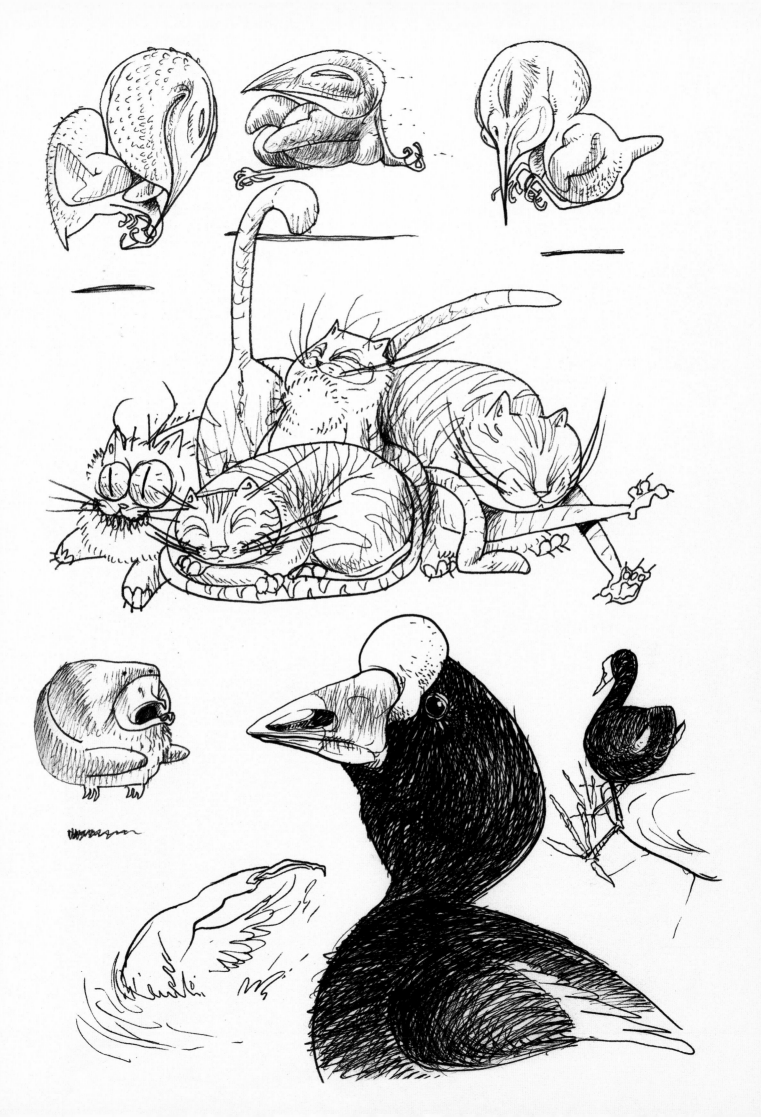

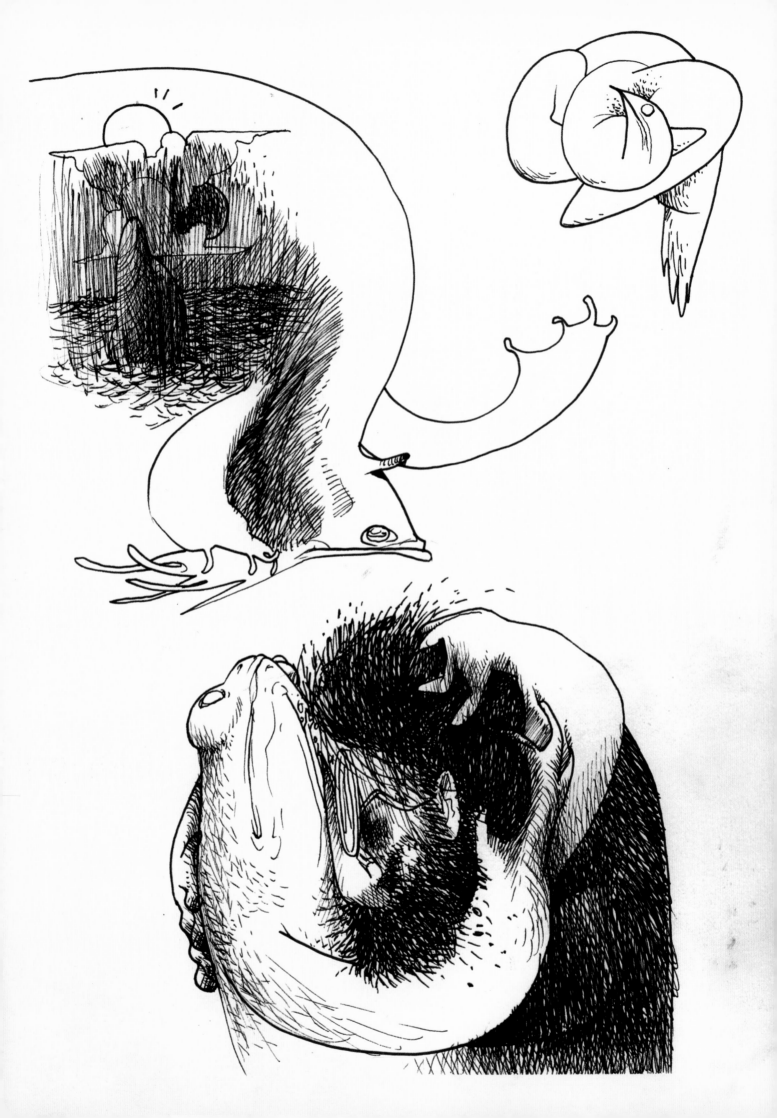

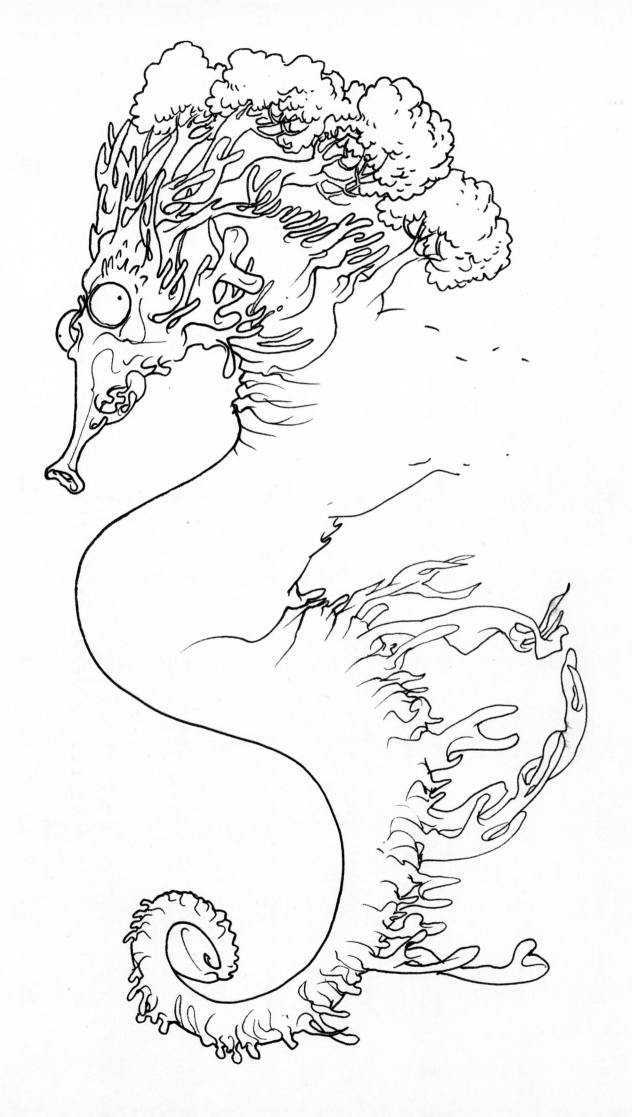

Wayne Horse

--

Animator, filmmaker and graffiti artist
Wayne Horse started off painting 'Cutie'
characters on the street, but the cute
appearance of these characters was
deceptive: they kept getting into trouble
with hard drugs and gangs, and the
German artist has since been trying to
distance himself from their bad behaviour.
He lives in Amsterdam but is originally
from Bremen.

His sketchbooks are filled with quirky
cartoons, personal notes and calligraphy:
'Most of the time I don't do my sketches
for a purpose. It's more like a ritual – I
take some time, every once in a while, to
sit down and sketch. I try to do sketches
mindlessly, but you can't avoid reflecting
on surroundings and expressing opinions,
whether you want to or not.' All his work
reveals a sense of humour, an awareness
of the absurd side of popular culture.

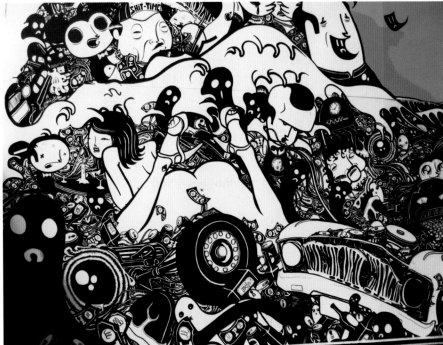

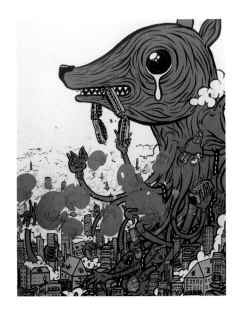

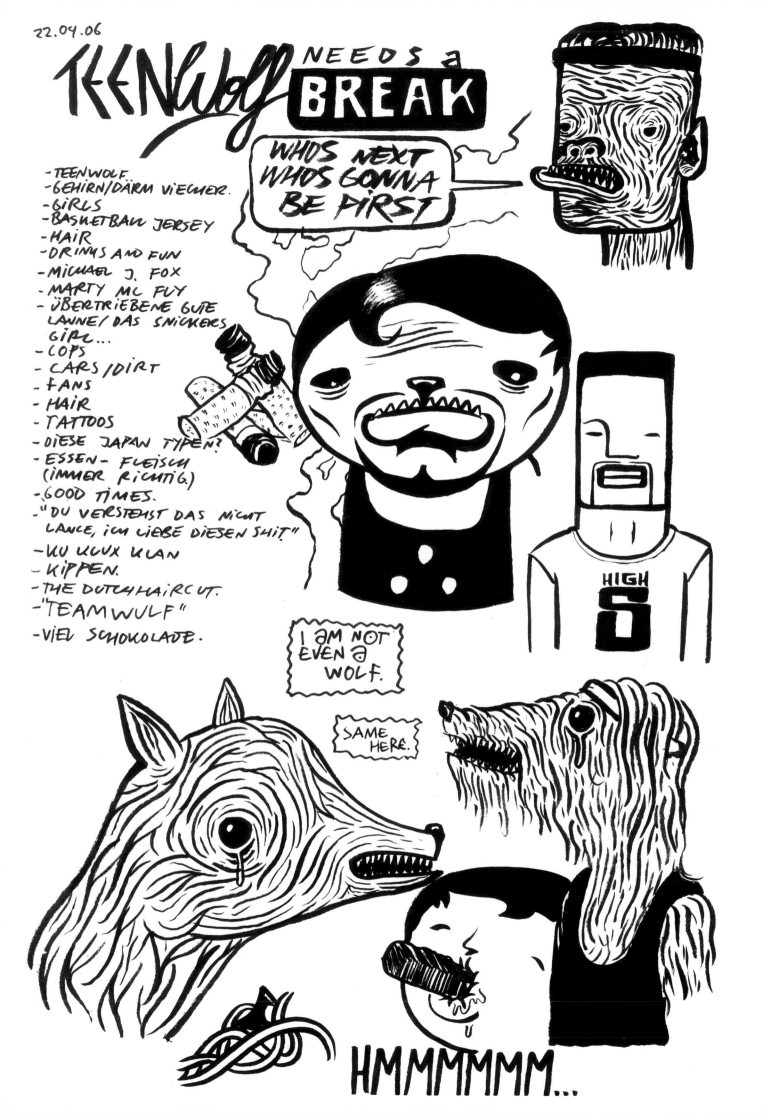

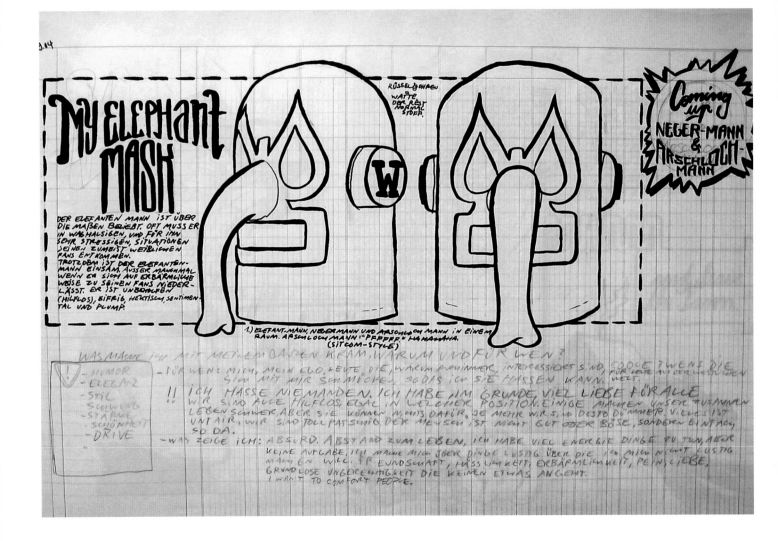

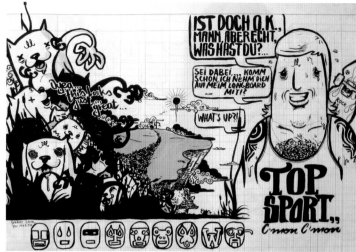

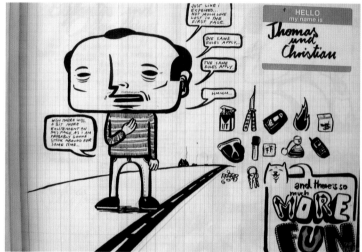

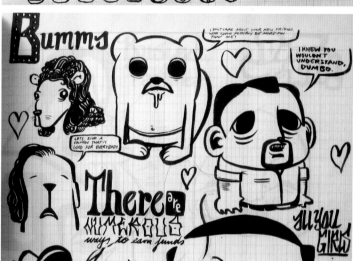

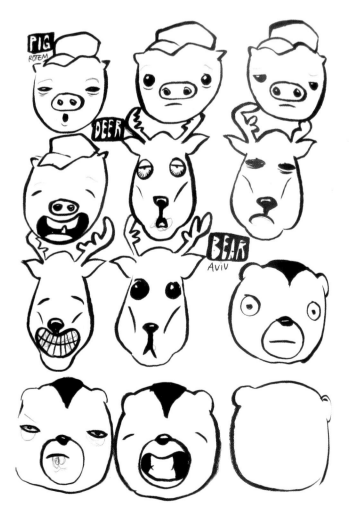

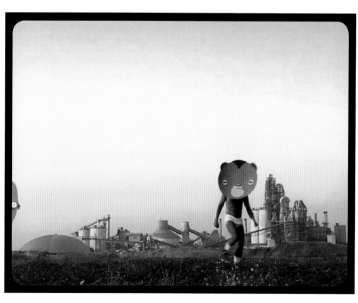

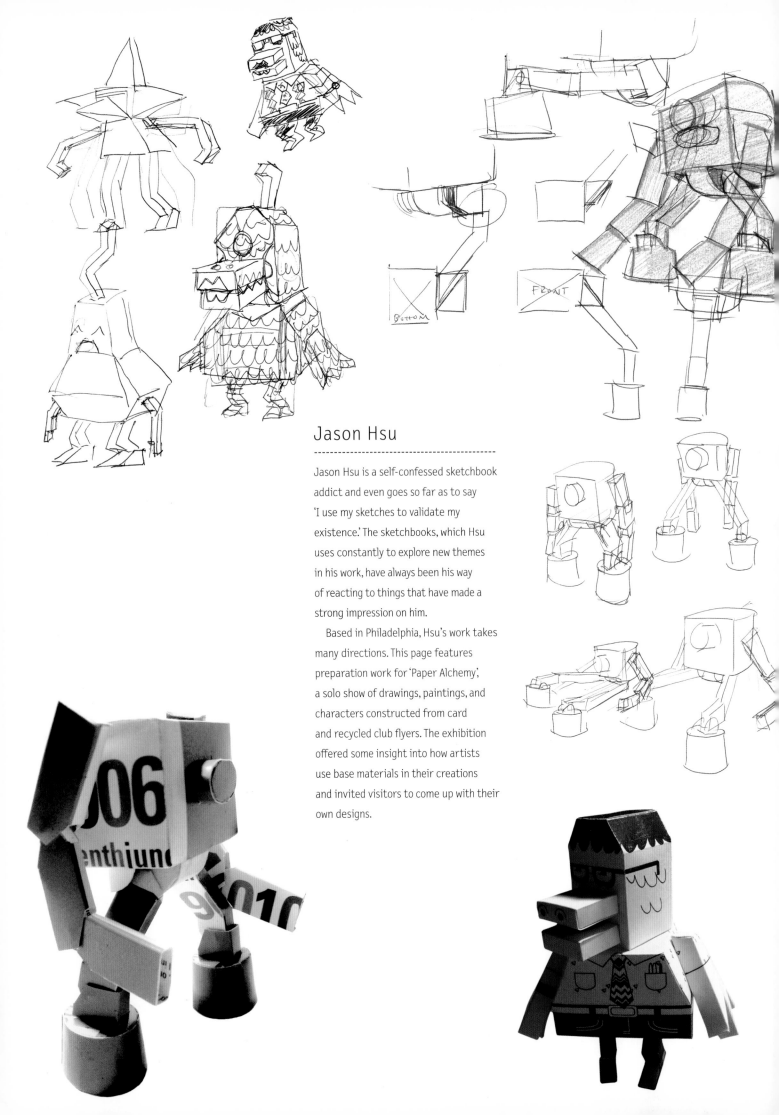

Jason Hsu

Jason Hsu is a self-confessed sketchbook
addict and even goes so far as to say
'I use my sketches to validate my
existence.' The sketchbooks, which Hsu
uses constantly to explore new themes
in his work, have always been his way
of reacting to things that have made a
strong impression on him.

 Based in Philadelphia, Hsu's work takes
many directions. This page features
preparation work for 'Paper Alchemy',
a solo show of drawings, paintings, and
characters constructed from card
and recycled club flyers. The exhibition
offered some insight into how artists
use base materials in their creations
and invited visitors to come up with their
own designs.

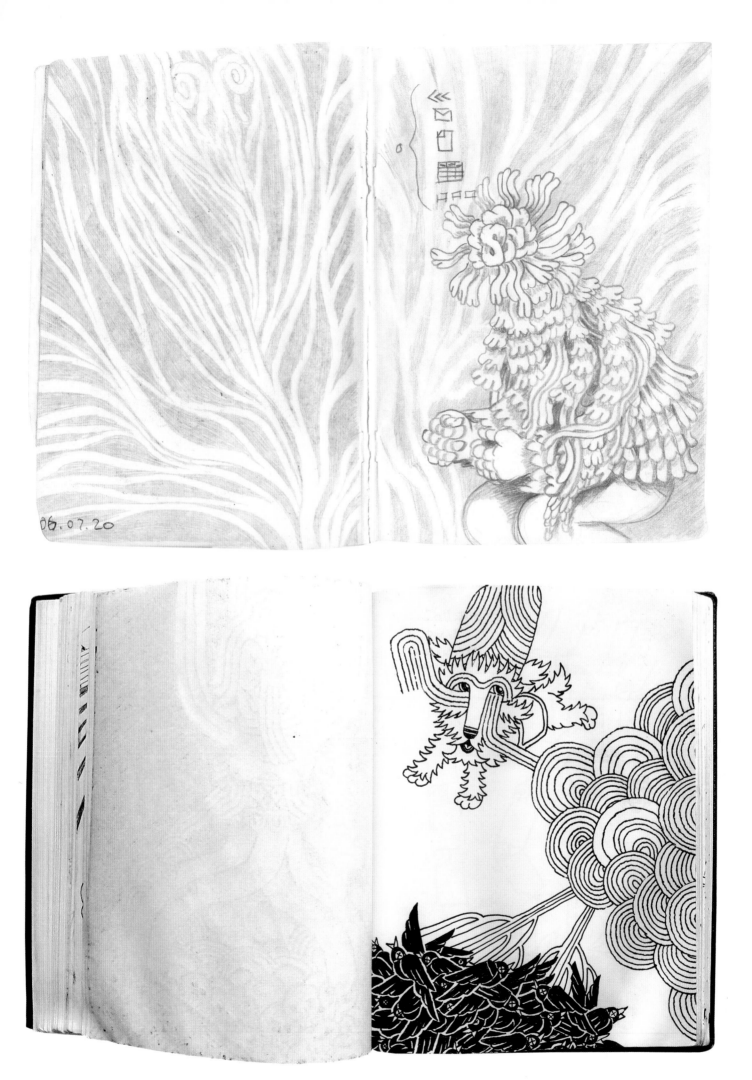

06.07.20

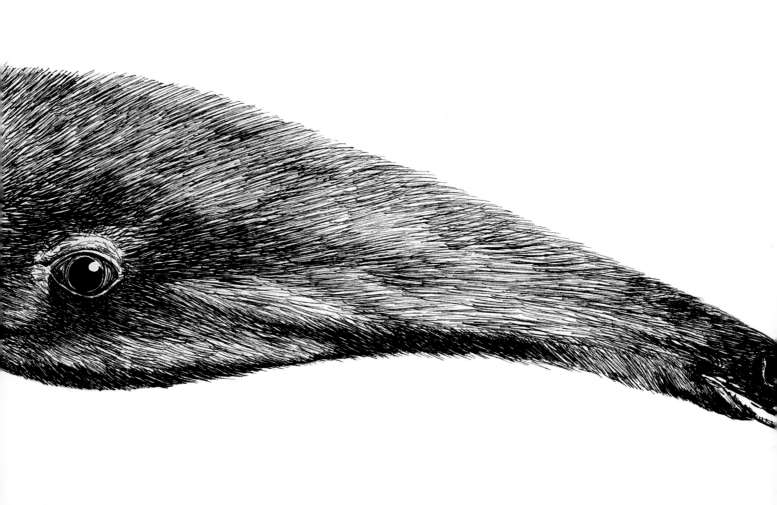

Joska

--

Joska is a talented German artist
living and working in Berlin. Street
art, including hand-painted posters,
stickers and paintings, is an
important outlet for her work, and
she enjoys seeing people's reactions
when they discover her playful
creatures in the urban environment.

In her drawings and paintings
much of her inspiration comes from
animals, people and nature in general.
Joska's sketchbooks are full of
observational drawings and her own
small world of evolving characters
such as her 'hazelnutmousebears'. Her
drawings are full of humour and a
lightness of touch that always bring a
smile to the viewer. As a young artist
she says she is still developing: 'I'm
at the beginning of "my evolution".
You can only improve through making
your own experiences – "learning by
doing" as it were.'

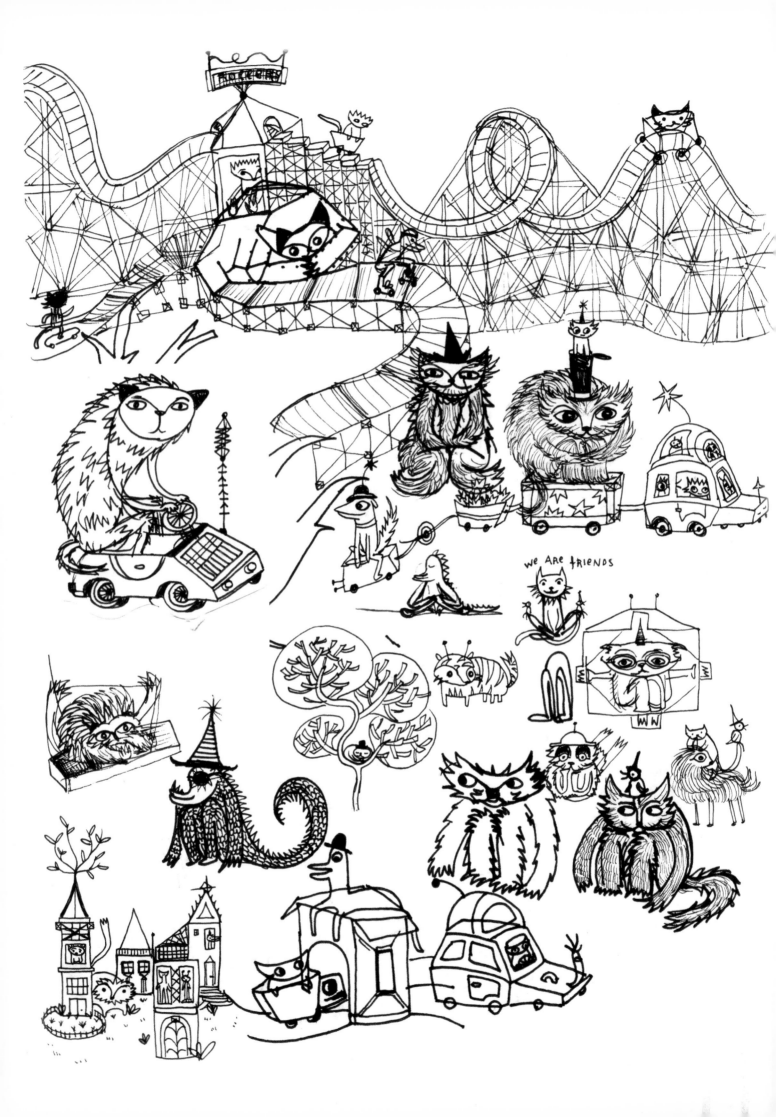

we are friends

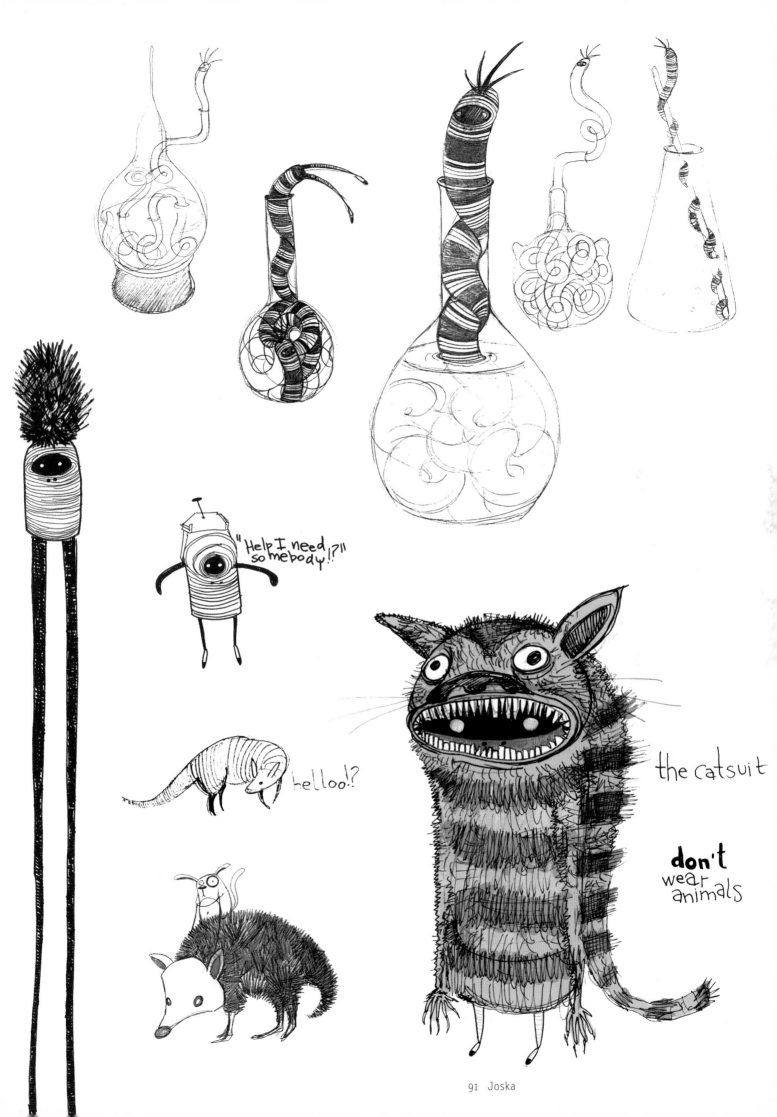

"Help I need somebody!?"

helloo!?

the catsuit

don't wear animals

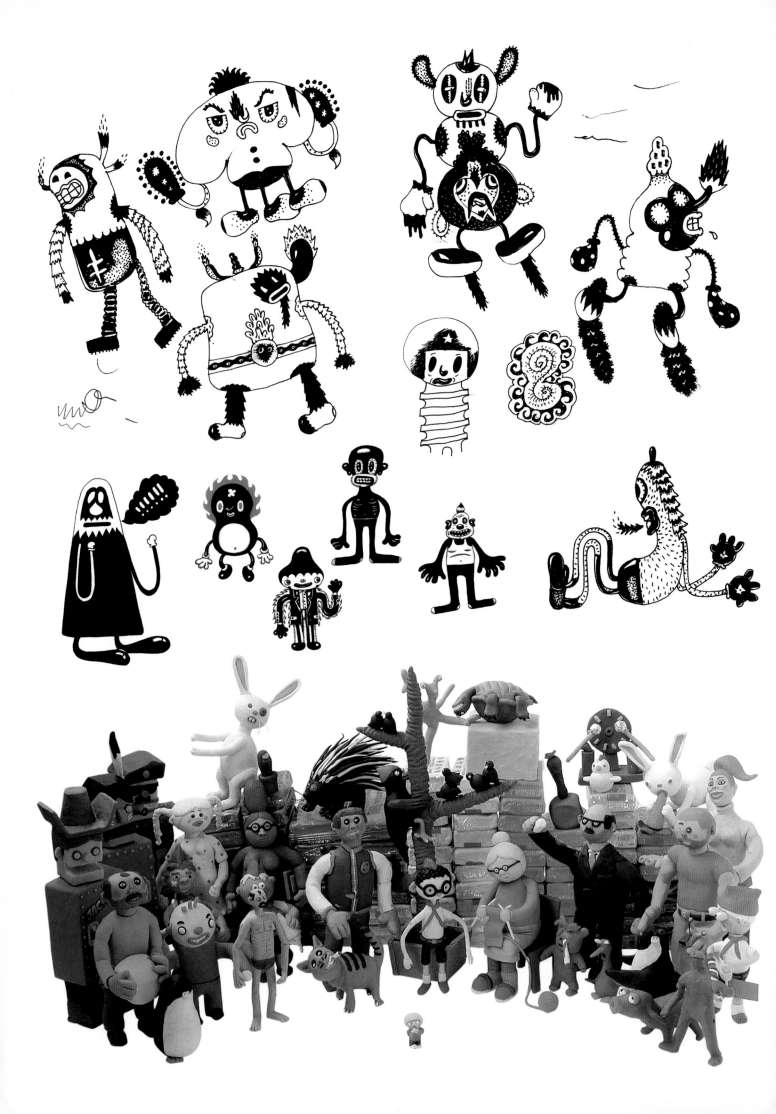

Edik Katykhin

Moscow-based Edik Katykhin is a man of many talents: he is a writer and illustrator of children's books, a clay sculpture artist and an animator. Drawing is at the heart of everything he does and so he uses his sketchbook whenever new ideas occur to him. Inspiration may strike him at any time, when he's with friends, watching a film or a cartoon, listening to music or just as he turns over a new page of his sketchbook.

Since Katykhin is principally a model maker, he finds that even his drawings imitate plasticine work. He values his sketches for their 'aliveness', reflecting a definite mood, emotion and energy. Like handwriting, they are characteristic and meaningful. When scanned and Photoshopped, they lose some of their former vividness and individuality, he feels. However, working with plasticine enables him to attain an even higher level of liveliness and emotional impact – the models even bear the fingerprints of the person who has moulded them.

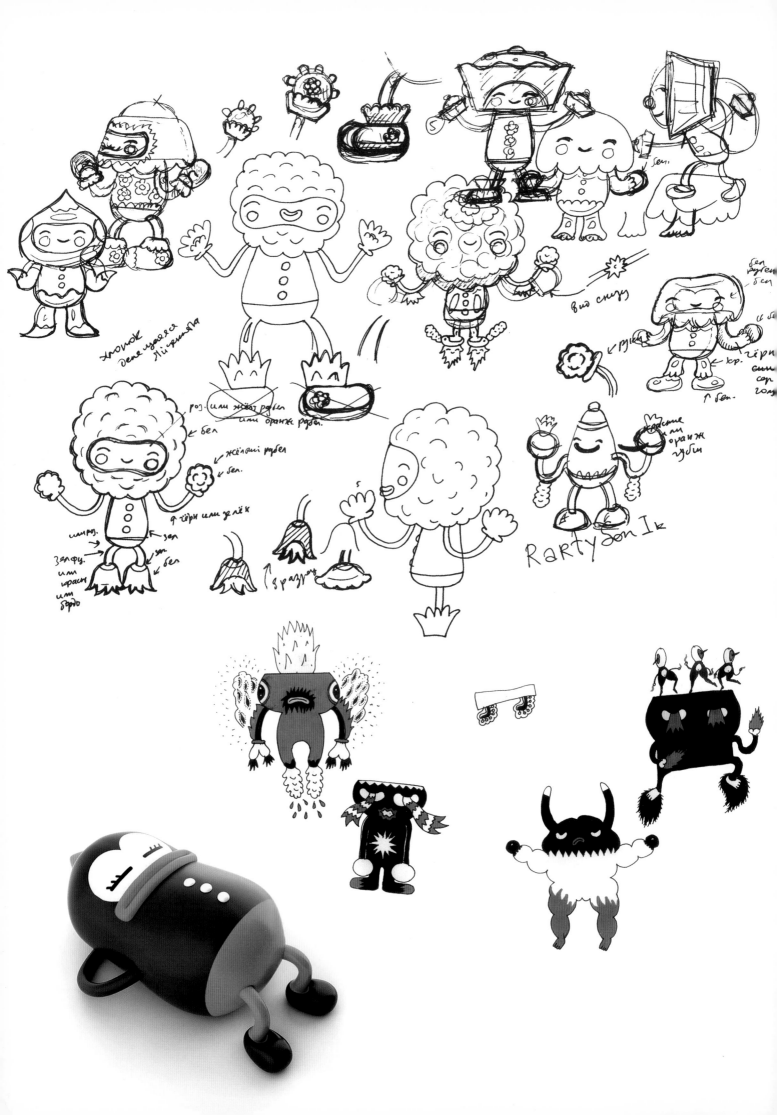

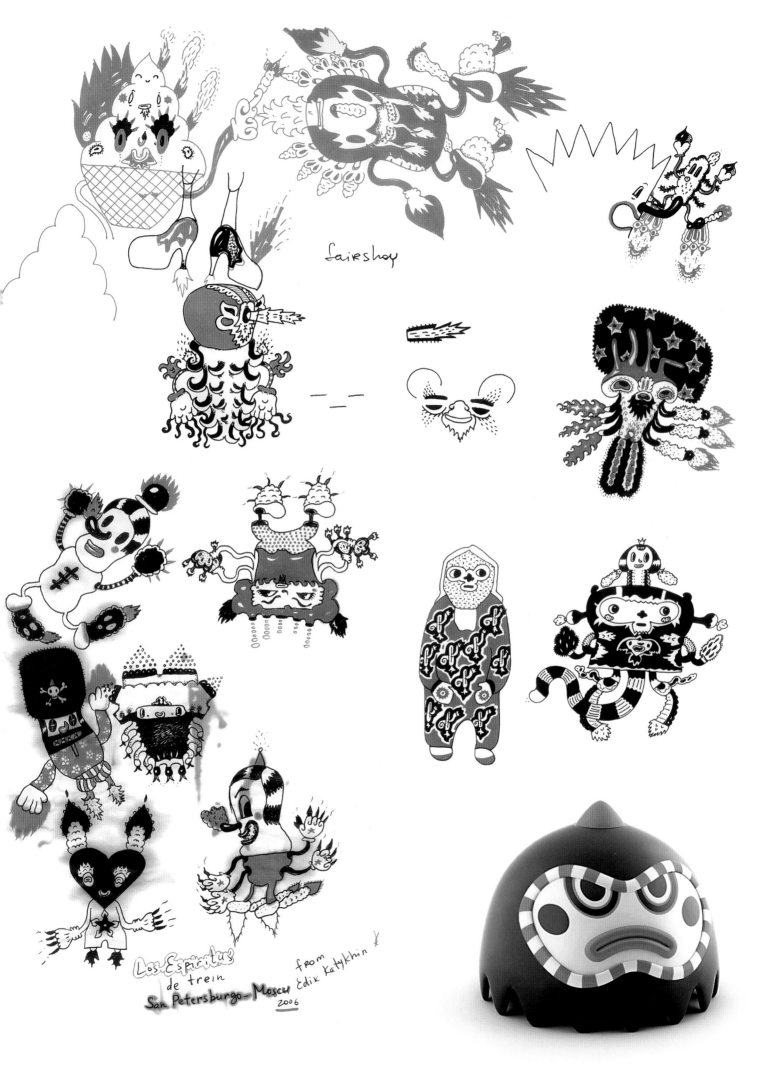

fairshoy

Los Espíritus
de trein
San Petersburgo–Moscu
2006

from
Edik Katykhin

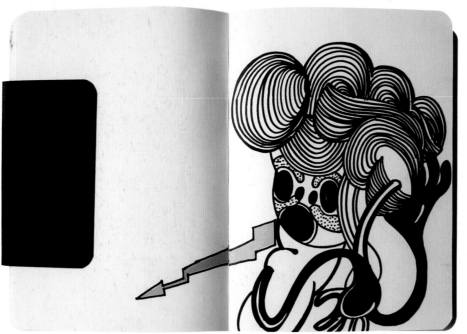

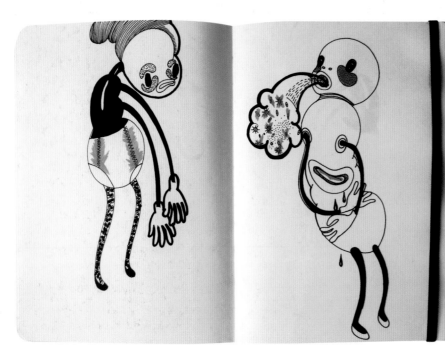

Tanya Kochergina

Tanya Kochergina (aka Doclone) is a recent graduate from the graphic design faculty of the Moscow State University of Printing Arts. She works as a designer and art director for the Russian magazine *Afisha*, as well as independently as an artist.

Much of her inspiration comes from Max Fleischer's classic black-and-white animated cartoons, such as *Betty Boop*, and Disney's earliest works. In her sketchbooks she is into big fat markers, using black as her favourite colour, and occasionally adding silver and gold splashes: 'I like it when my pictures look a little bit medieval, when they are moderately eclectic by nature.'

As an artist Kochergina paints murals and illustrates, but in her eyes a sketchbook is a separate area of art: 'It's an intimate space, a kind of diary meant for your own observations. So it has no urge to grow into something bigger. It doesn't ask for extended interpretations. I like this very special feeling that a continuous, elastic, round outline implies.'

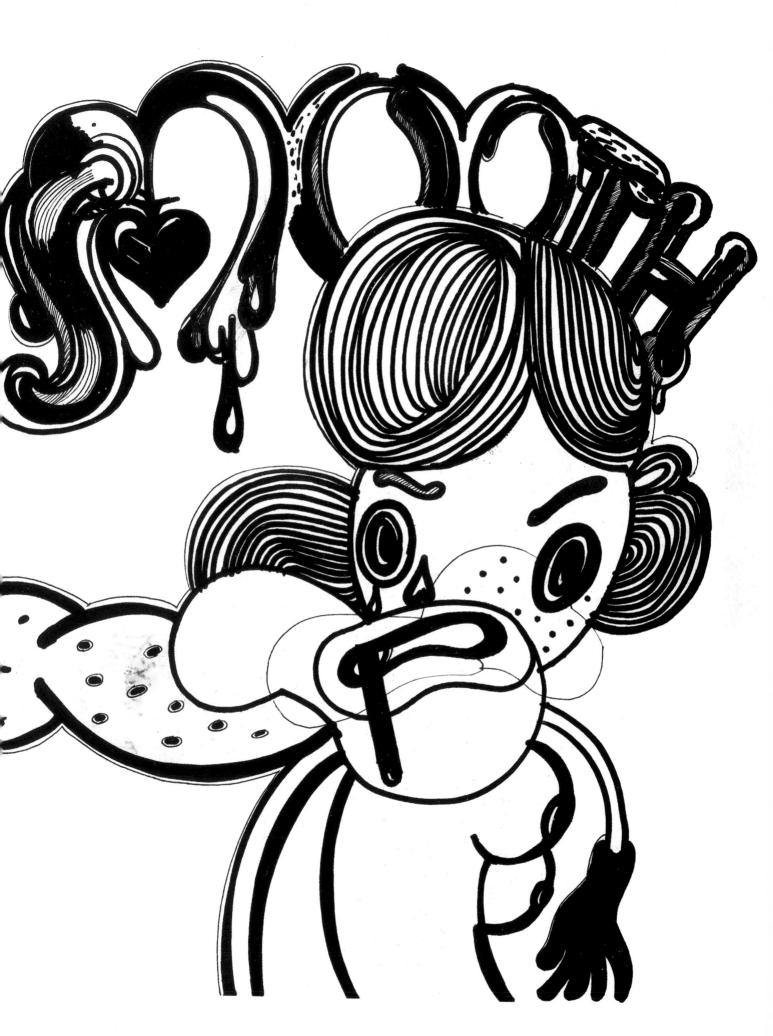

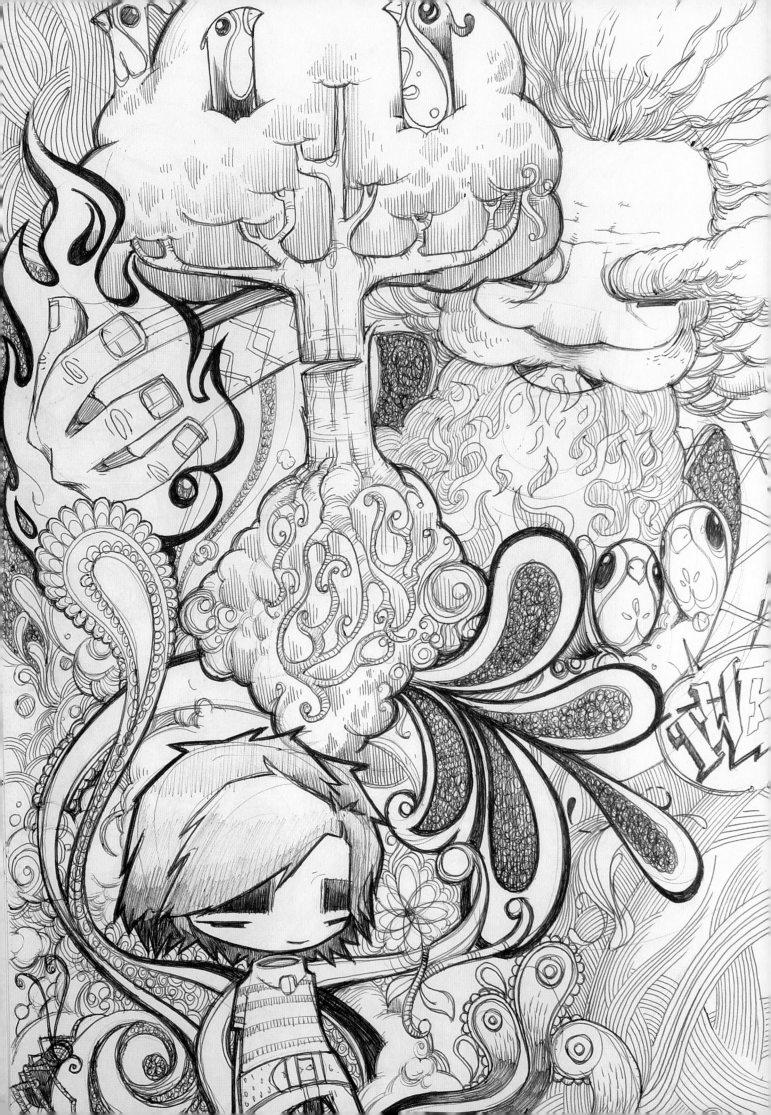

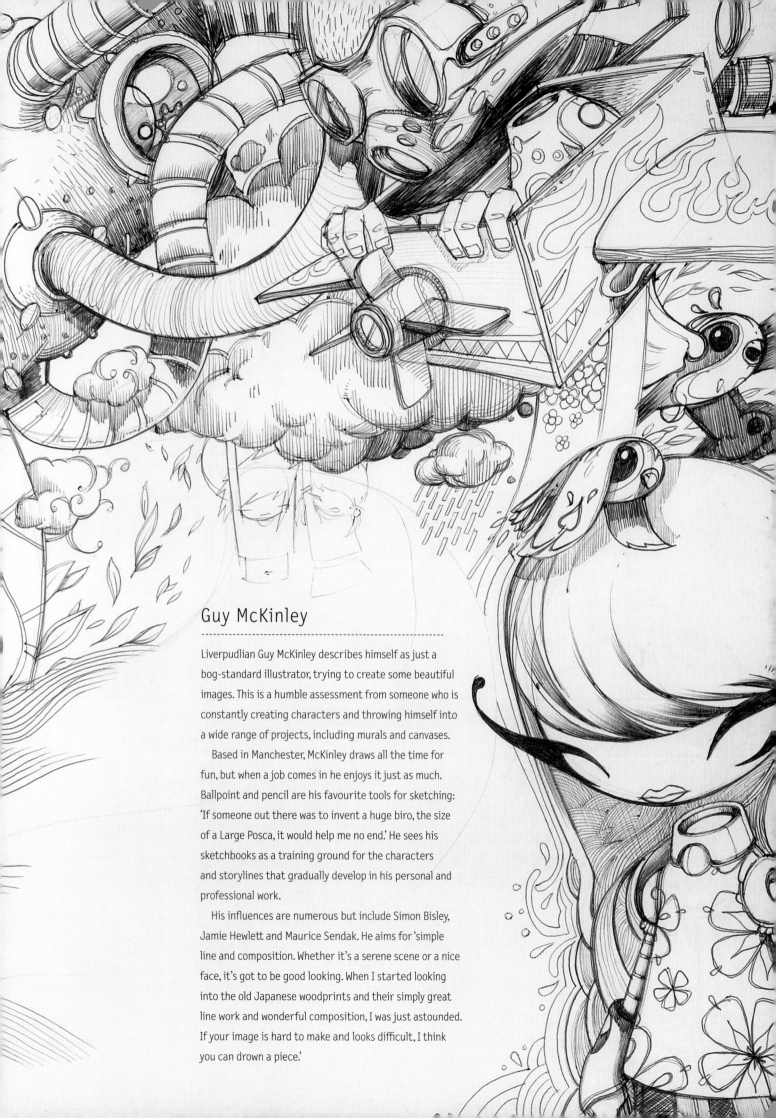

Guy McKinley

Liverpudlian Guy McKinley describes himself as just a
bog-standard illustrator, trying to create some beautiful
images. This is a humble assessment from someone who is
constantly creating characters and throwing himself into
a wide range of projects, including murals and canvases.

Based in Manchester, McKinley draws all the time for
fun, but when a job comes in he enjoys it just as much.
Ballpoint and pencil are his favourite tools for sketching:
'If someone out there was to invent a huge biro, the size
of a Large Posca, it would help me no end.' He sees his
sketchbooks as a training ground for the characters
and storylines that gradually develop in his personal and
professional work.

His influences are numerous but include Simon Bisley,
Jamie Hewlett and Maurice Sendak. He aims for 'simple
line and composition. Whether it's a serene scene or a nice
face, it's got to be good looking. When I started looking
into the old Japanese woodprints and their simply great
line work and wonderful composition, I was just astounded.
If your image is hard to make and looks difficult, I think
you can drown a piece.'

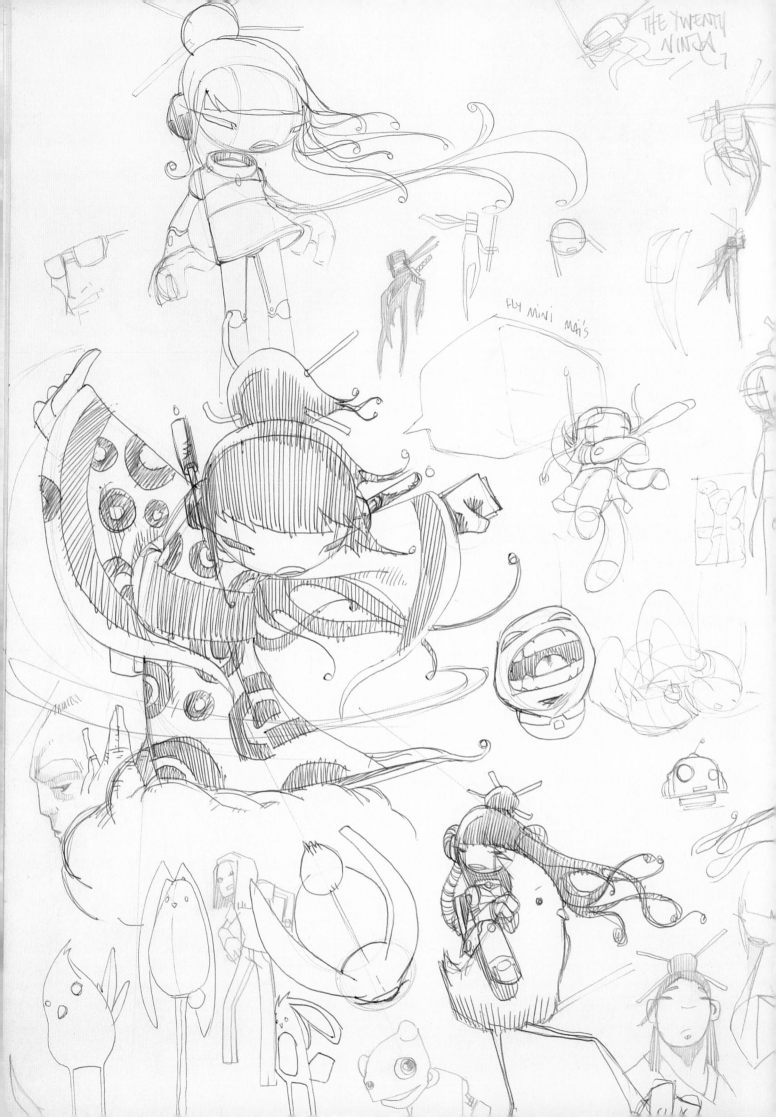

THE TWENTY
NINJA

FLY MINI MAIS

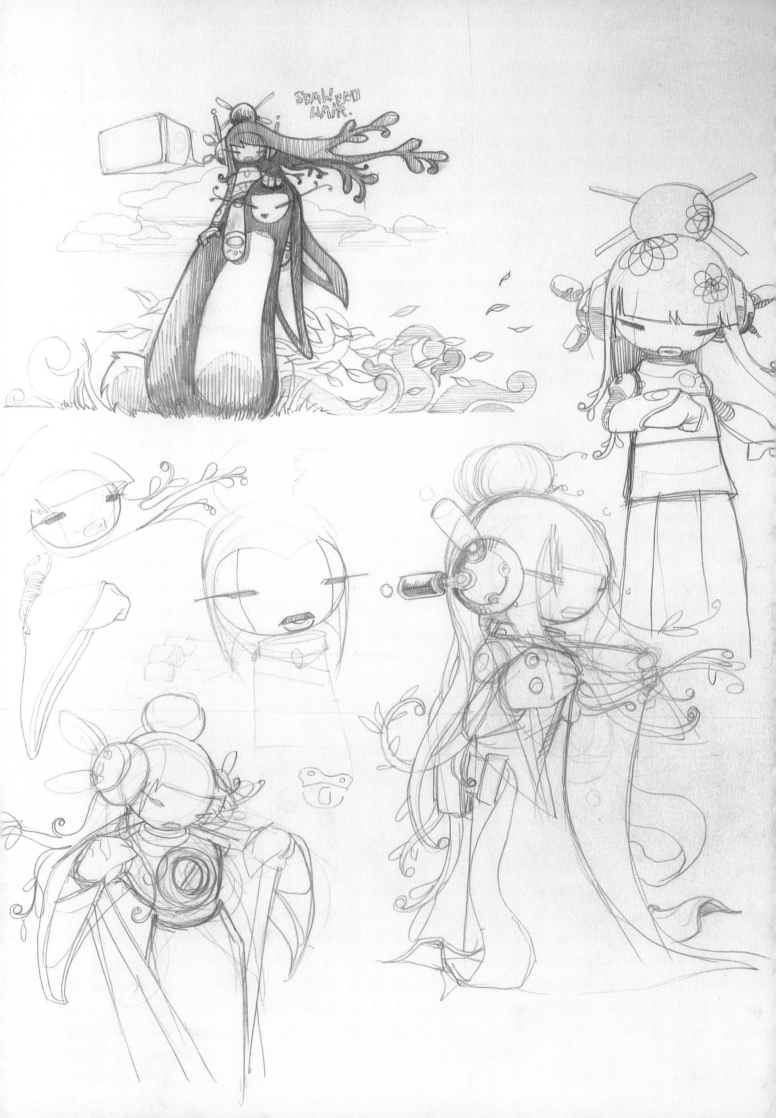

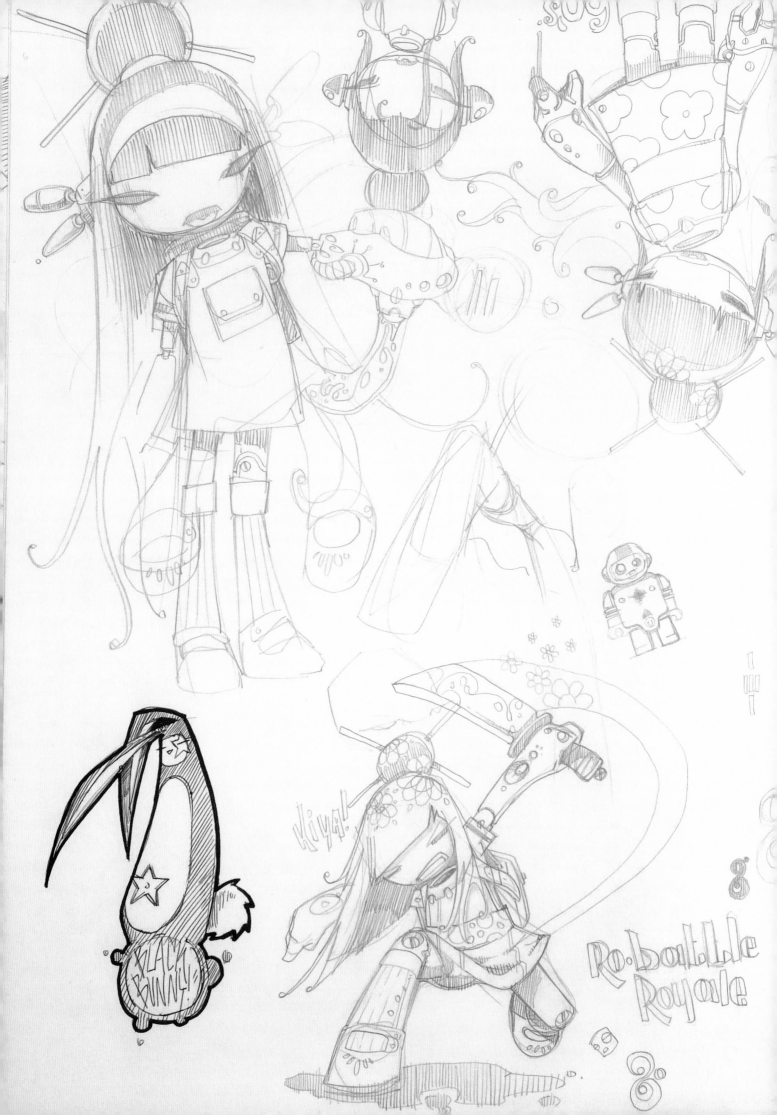

Kiya!

BLACK BUNNY

Ro.battLle Royale

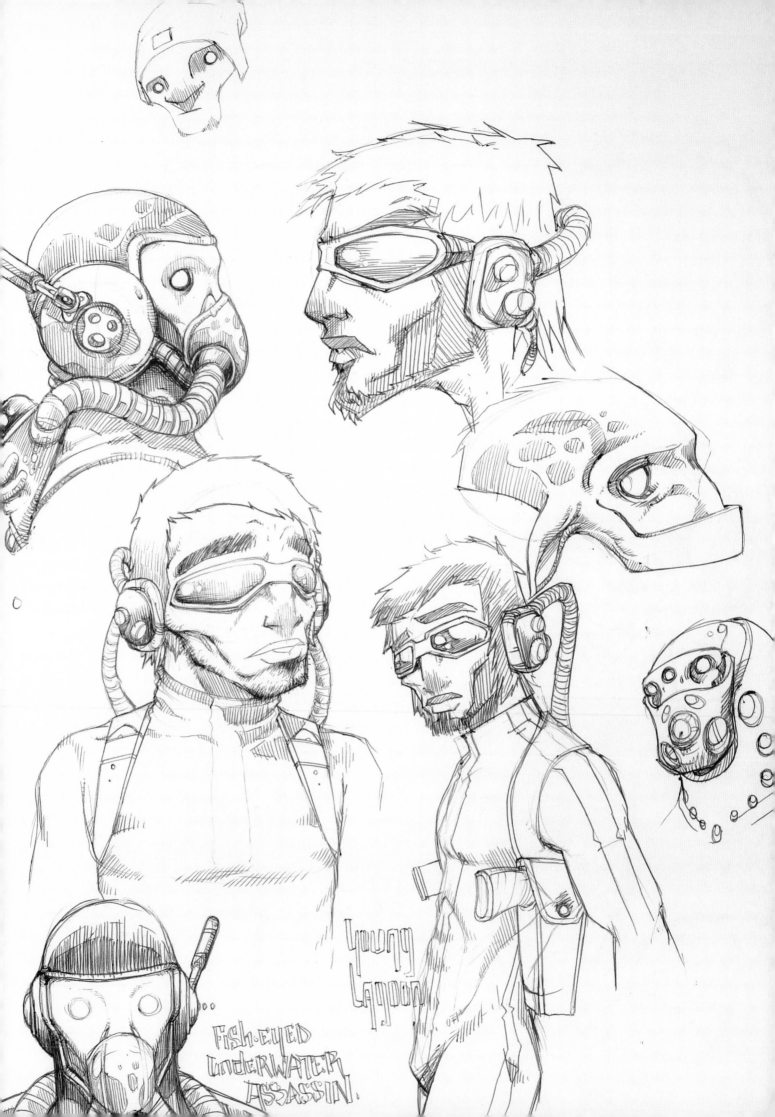

FISH·EYED
UNDERWATER
ASSASSIN.

Young
Lagoon

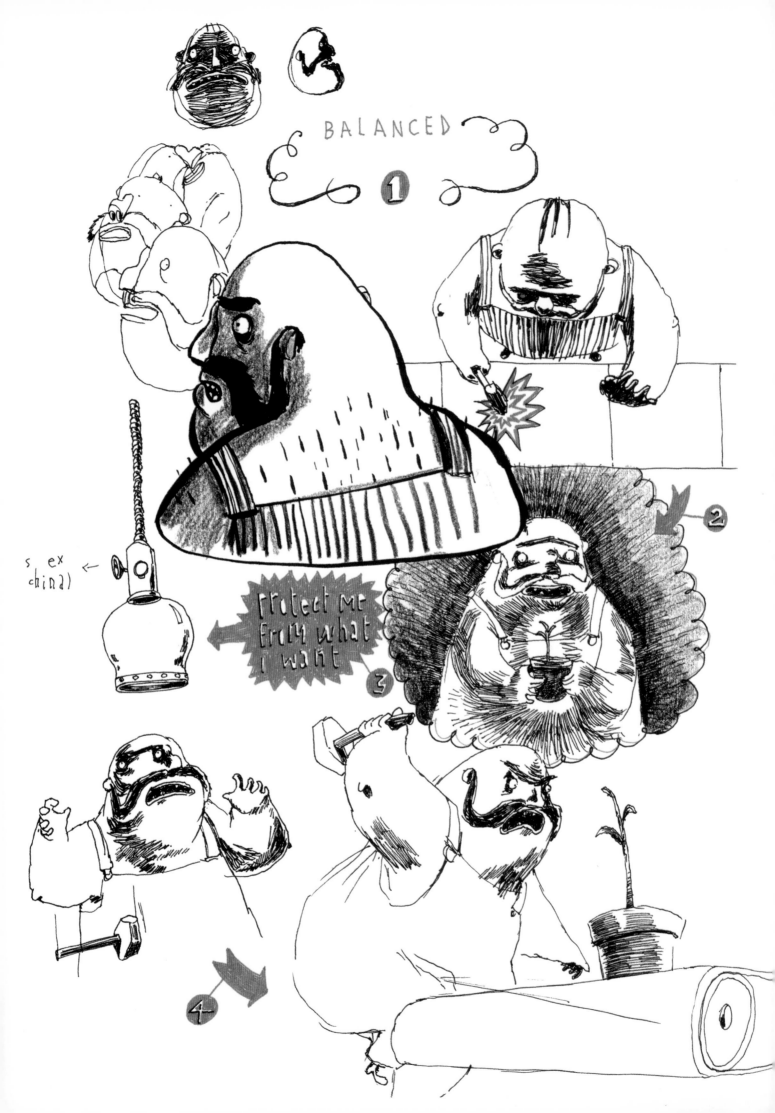

Melvin

Melvin was born in a little Belgian village near the Dutch borderline. He moved from the prairie to the city in 2003 and is the only guy in Antwerp who goes shopping in a tractor. By day he works as a freelance illustrator, but by night he collaborates with a collective called 'de klup' which could be compared to Fight Club with pencils. Four friends meet each week in various underground locations to draw together. Sometimes their work is displayed at gigs and art shows, but primarily the group's aim is to enjoy drawing. 'Because we're mixing four different styles in one and the same drawing, things become more spontaneous. It's communicating with lines…. The result is often surrealistic, funny, absurd, childish.'

As an illustrator Melvin draws for a living, but even when he gets bored he draws. His ideas often come from the trashiest sources – TV shows like *Wheel of Fortune*, cooking programmes and soft porn! – and he lists Dolly Parton, Samantha Fox and, of course, David Hasselhoff among his main artistic influences. He is currently working on a book project, from which the sketches here are taken.

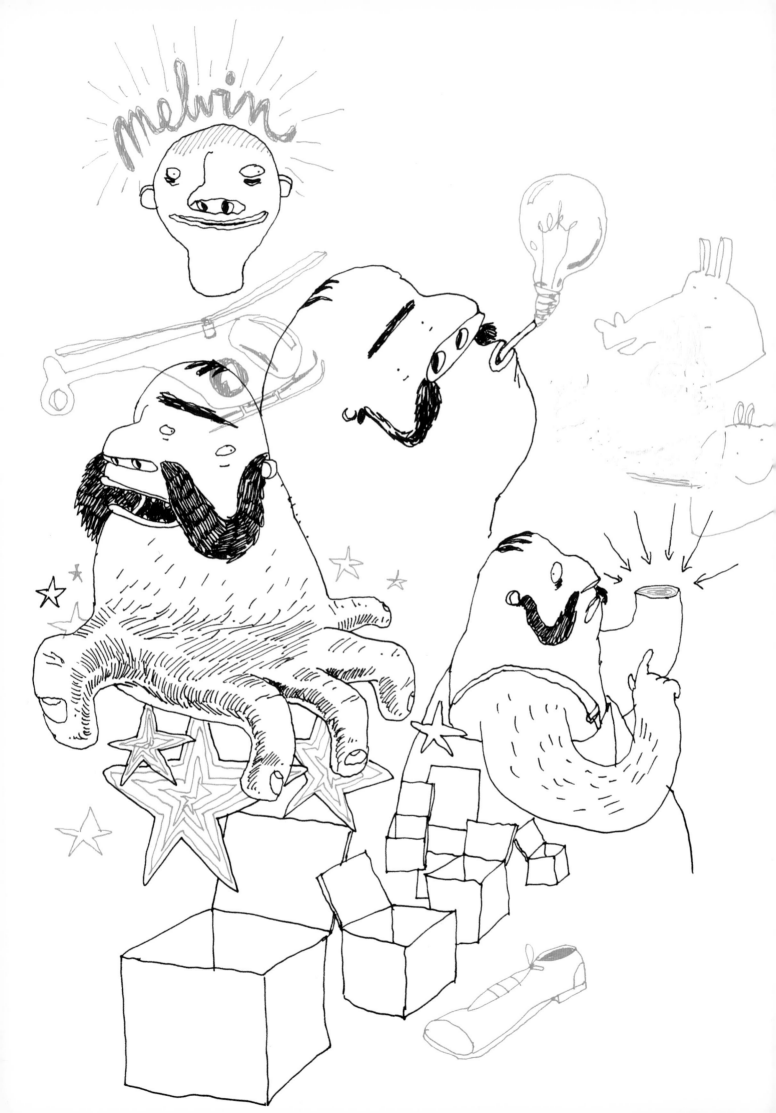

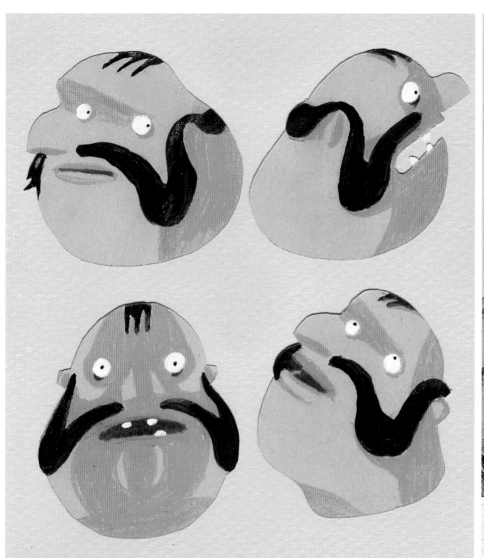

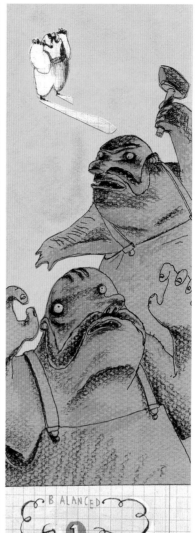

DEUS EX
machina
1984

Microbo

Microbo lives and works with her partner
Bo130 in Milan. Her moniker comes from the
microbes and doodles that are a recurring
theme in her art; the microbiological world
represents the beginning of life when
everything was pure nature. She brings her
imaginary universe to life by interchanging
and integrating graphics, painting,
photography, video, animation and design.

'I have always been addicted to patterns,
dots and lines,' says Microbo. 'When I was in
my teens I was crazy about Keith Haring, and
some years later I was blown away by the art
of Chris Ofili.' For this reason pattern plays a
big role in her drawings. Sketches are a central
part of her working method — as preliminary
drawings for her canvases and murals, as well
as in her poster and sticker designs. She likens
the drawing process to music, using basic
'notes' and playing with them to create new
characters and forms.

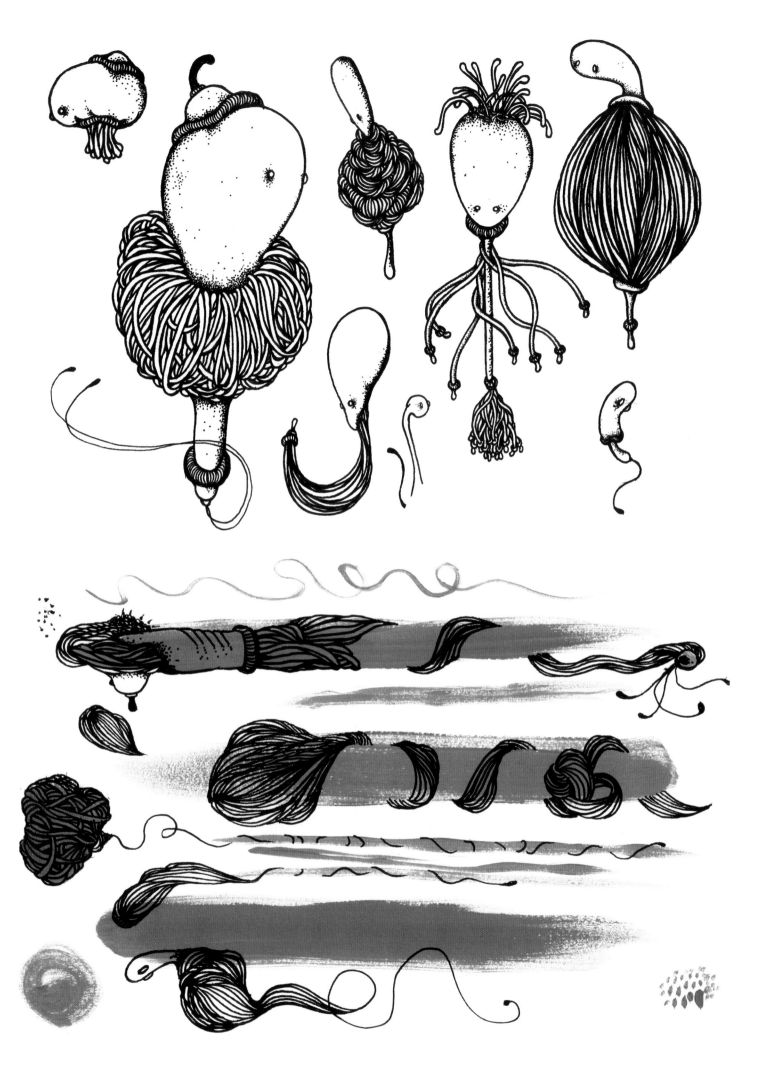

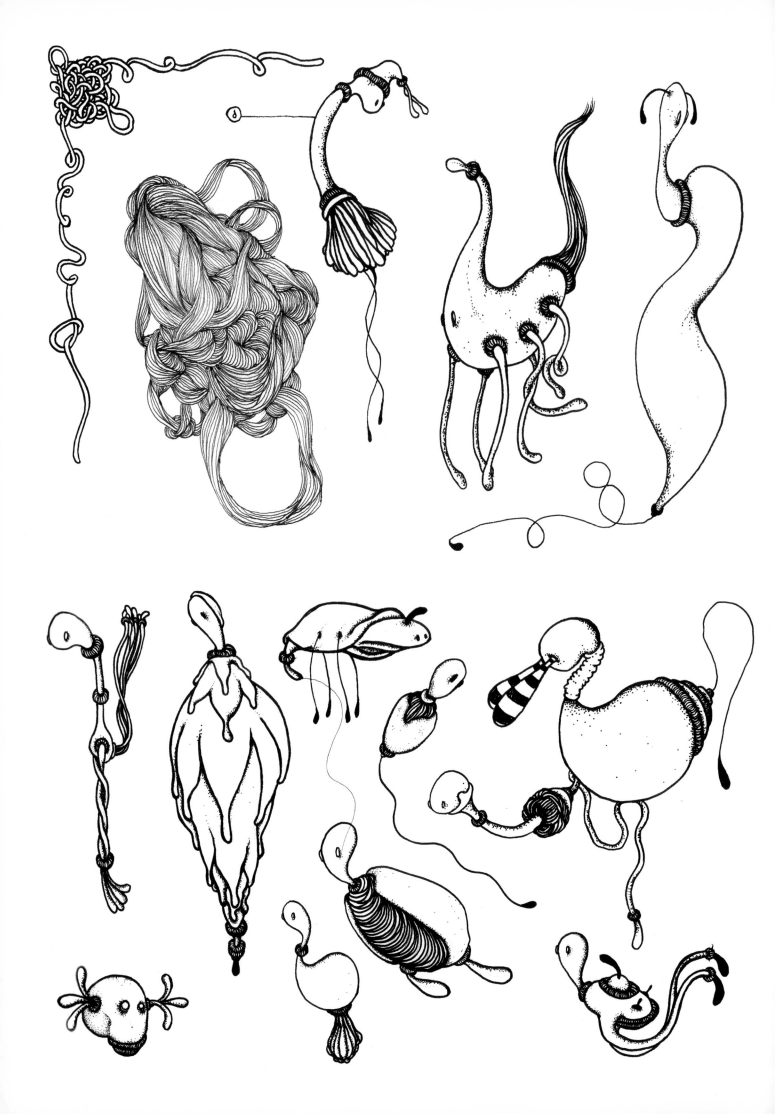

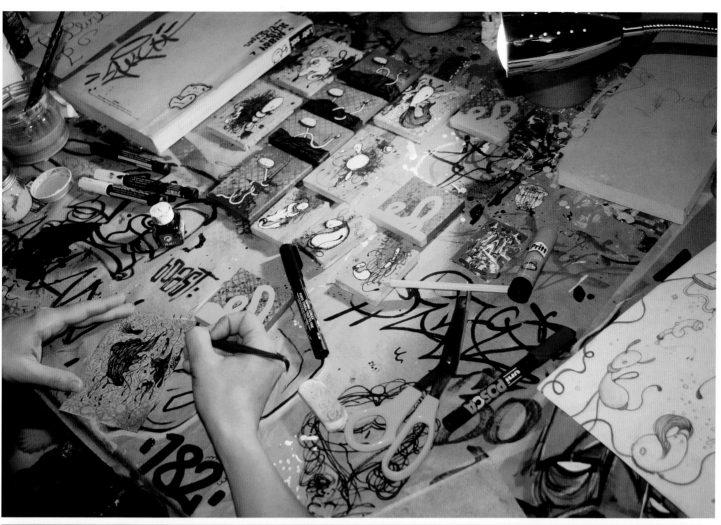

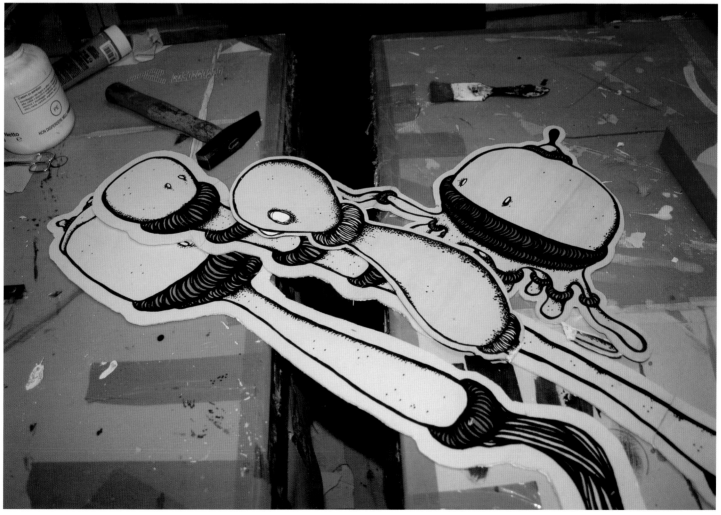

Miss Lotion

Miss Lotion (aka Louise) was born with a pen strapped to her left hand. Sketches are part of everyday life for the Danish-born artist from Copenhagen, who draws for recreation and simply can't help herself. Her art tends to be personal, based on her own reflections of her experiences and surroundings, particular situations, conversations etc. Nature and mythology are also a great influence.

She sketches on anything she has at hand, be it napkins, printer paper or beer mats, usually with a 0.2 black felt-tip pen. Her drawings form the beginnings of her illustrative ideas, some of which progress to paintings on canvas, murals, T-shirts and many other applications. Collaborations with other artists are a great inspiration and motivation for her. In recent years she has worked on and instigated many group projects such as collaborative drawings, books and exhibitions with like-minded artists such as Ekta and 45rpm.

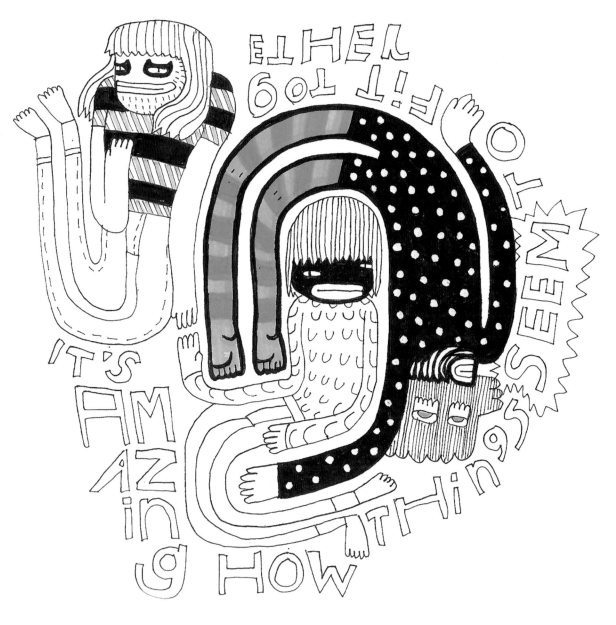

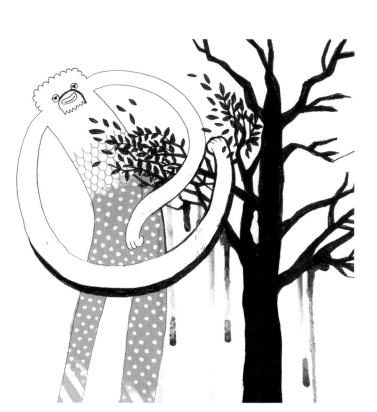

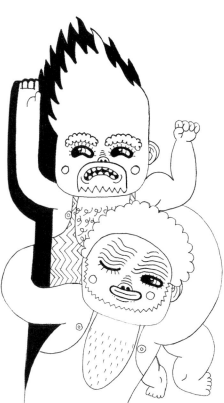

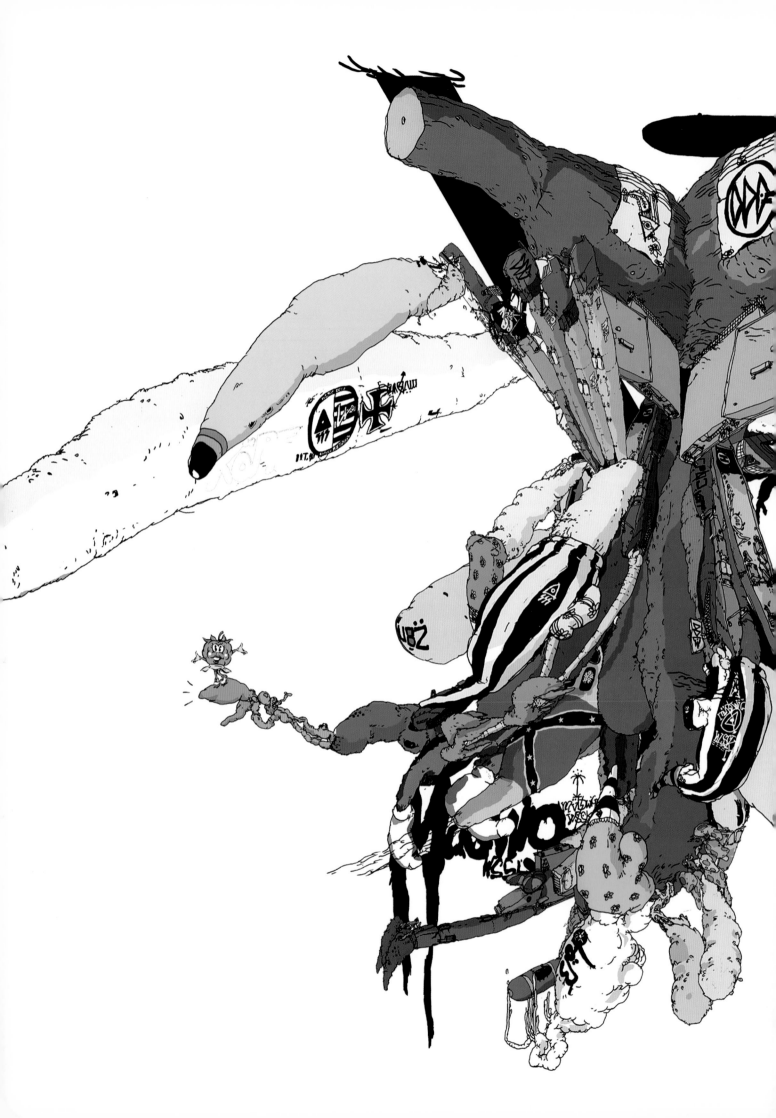

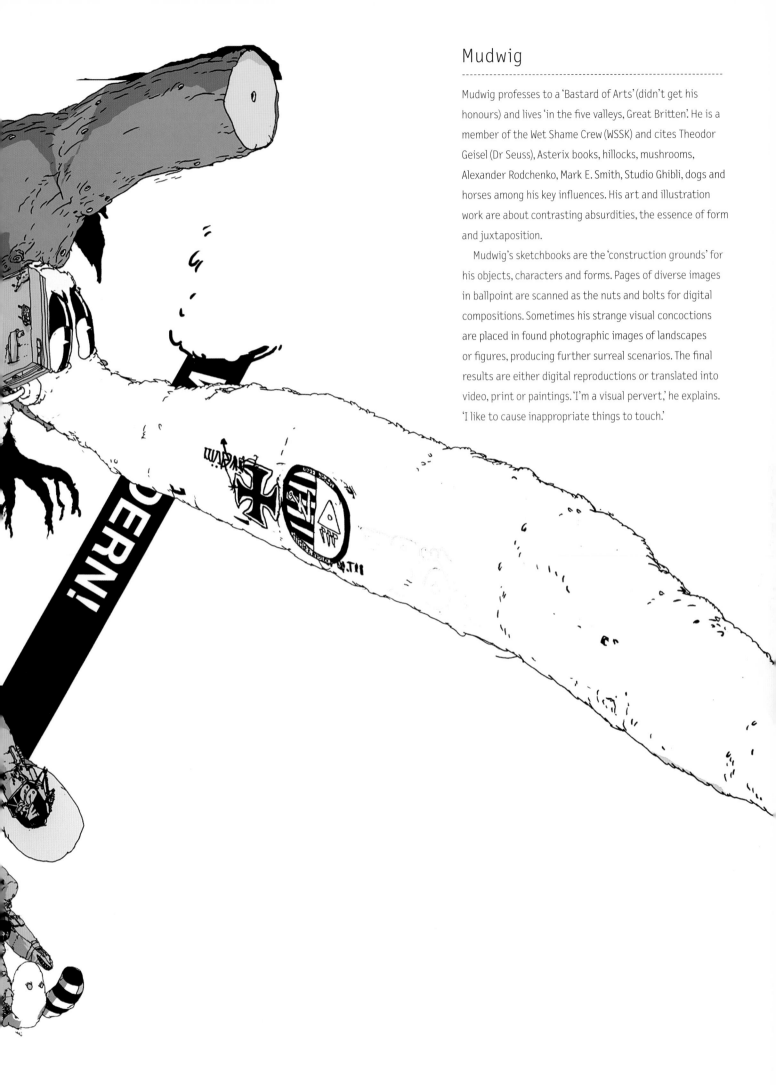

Mudwig

Mudwig professes to a 'Bastard of Arts' (didn't get his honours) and lives 'in the five valleys, Great Britten'. He is a member of the Wet Shame Crew (WSSK) and cites Theodor Geisel (Dr Seuss), Asterix books, hillocks, mushrooms, Alexander Rodchenko, Mark E. Smith, Studio Ghibli, dogs and horses among his key influences. His art and illustration work are about contrasting absurdities, the essence of form and juxtaposition.

Mudwig's sketchbooks are the 'construction grounds' for his objects, characters and forms. Pages of diverse images in ballpoint are scanned as the nuts and bolts for digital compositions. Sometimes his strange visual concoctions are placed in found photographic images of landscapes or figures, producing further surreal scenarios. The final results are either digital reproductions or translated into video, print or paintings. 'I'm a visual pervert,' he explains. 'I like to cause inappropriate things to touch.'

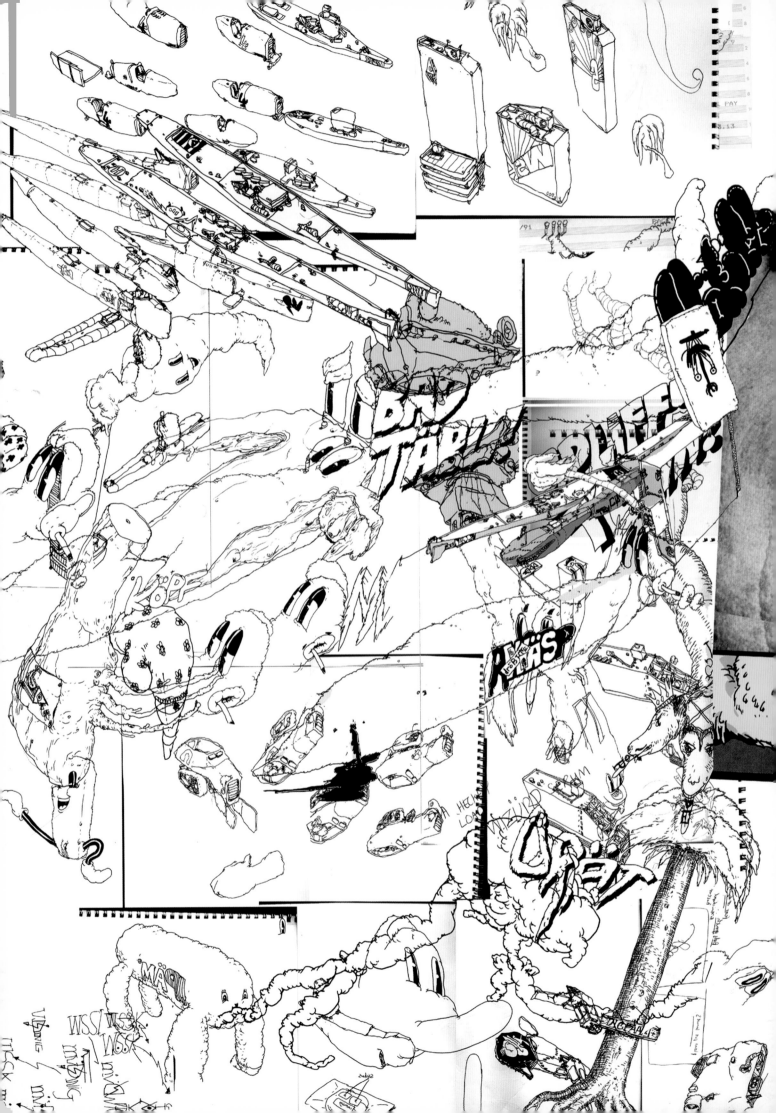

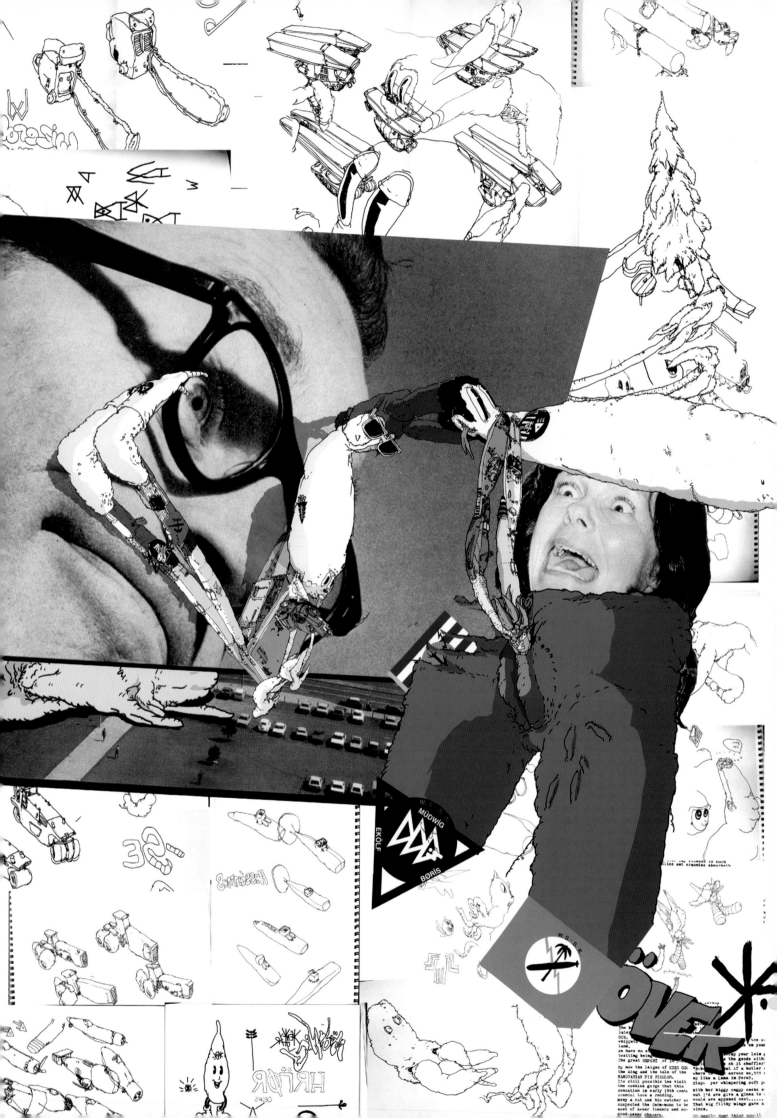

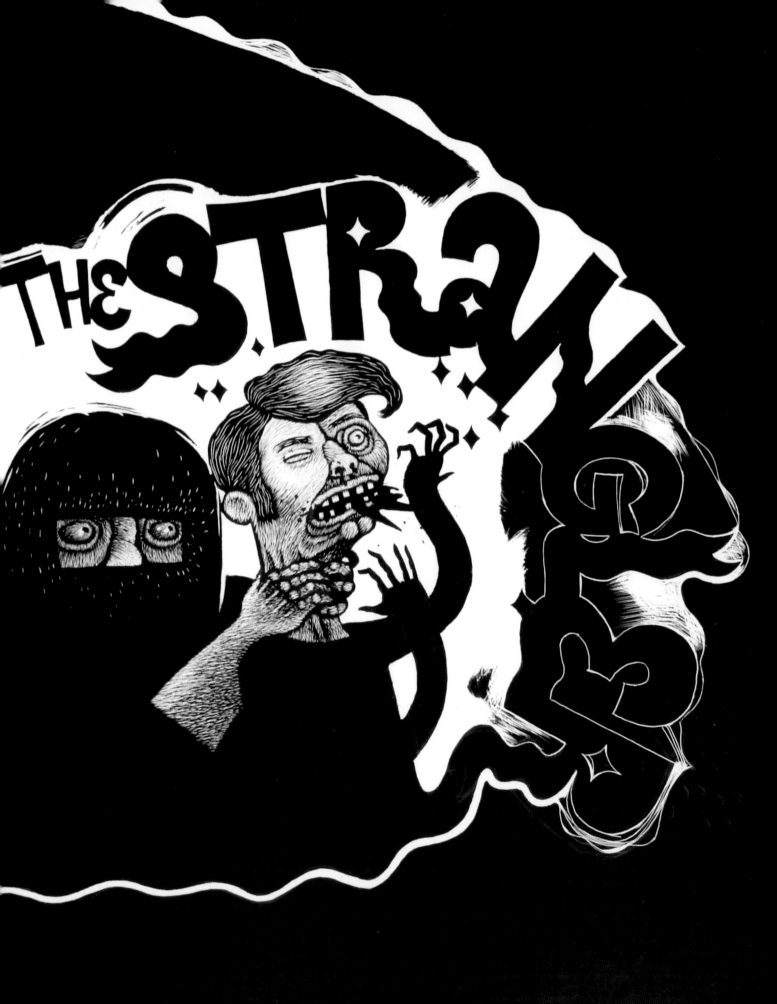

Neb

Sometimes known as 'The Strangler', Neb
describes himself as an artist and a
preacher, seeing for those who cannot
see. With a background in graffiti, the
Belgian artist works in many media, from
ink on paper to spraypaint on walls. His
current work explores stark contrasts
of light and shade, sometimes just using
black, white and red, with typography as
a key element. A sketchbook, he feels, is
very personal; the research inside it is like
the torn-up pieces of a map, hopefully one
that leads to treasure.

Ideas and themes come as 'visual flashes,
like windows into my own thoughts. They're
like coffee, black and bitter but sweet.' There
is, he says, Neb the person, but curiously
'there's something else as well, something
in the air. It's what I call my sixth sense – a
sense that connects all the other ones. The
recipe is hidden among the lines. My fuel is
absinthe, diluted in black coffee with sugar;
I couldn't imagine without it.'

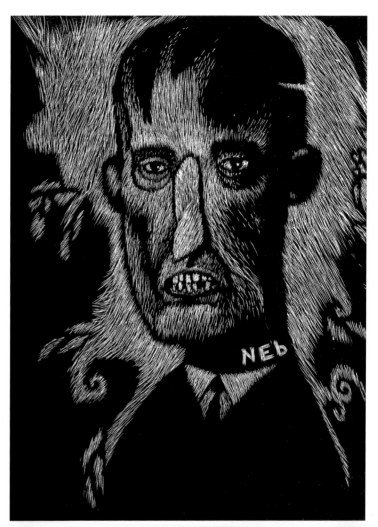

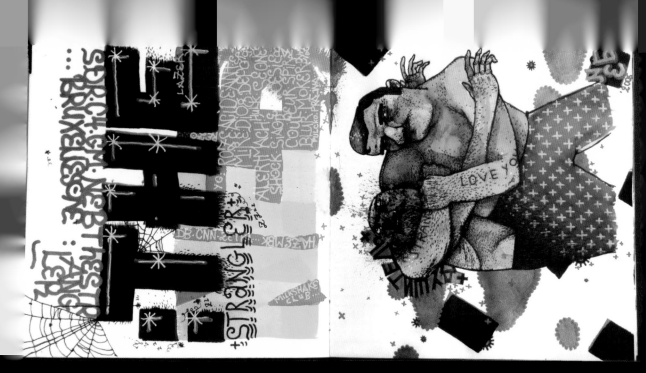

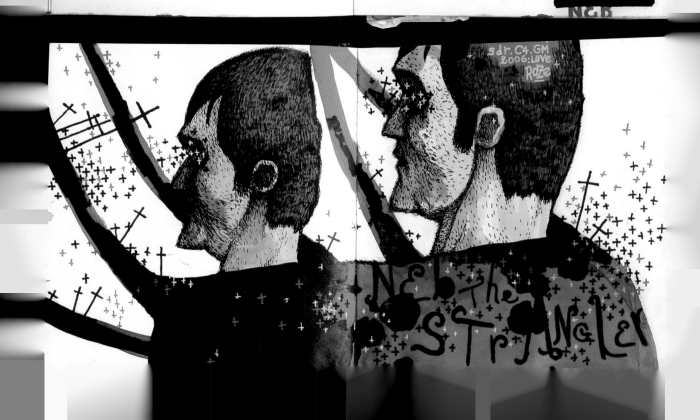

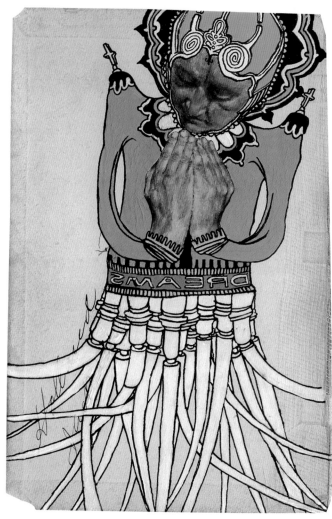

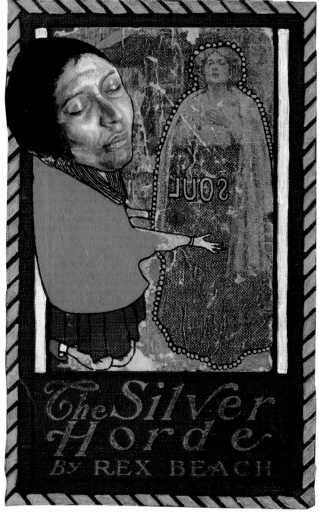

Other

Canadian painter and printmaker Other currently lives in Berlin and is well-known for his freight train graffiti. Many of his oil pastel drawings are in transit across the North American train network. His sketchbooks generally contain more writing than drawing, but he uses them to draft out ideas.

Other likes working with found materials such as the book covers shown here. Like the rusting freight trains he paints, he is inspired by the scrapes, colours and ageing process at work on the discarded objects he uses. He also scours the garbage for art materials like pens, paint and paper so that every process has been achieved through recycling.

'It takes a lot of exploring to find something that I can actually paint on,' he says. 'It needs stains, time and a history. I just want to add to the surface and make my work blend in.'

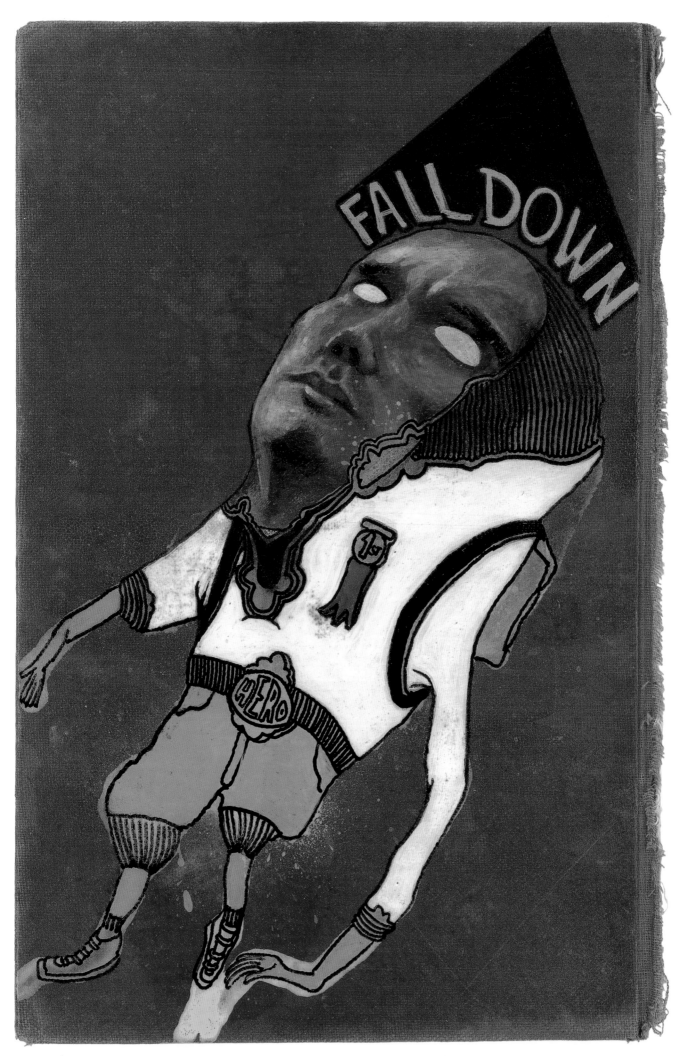

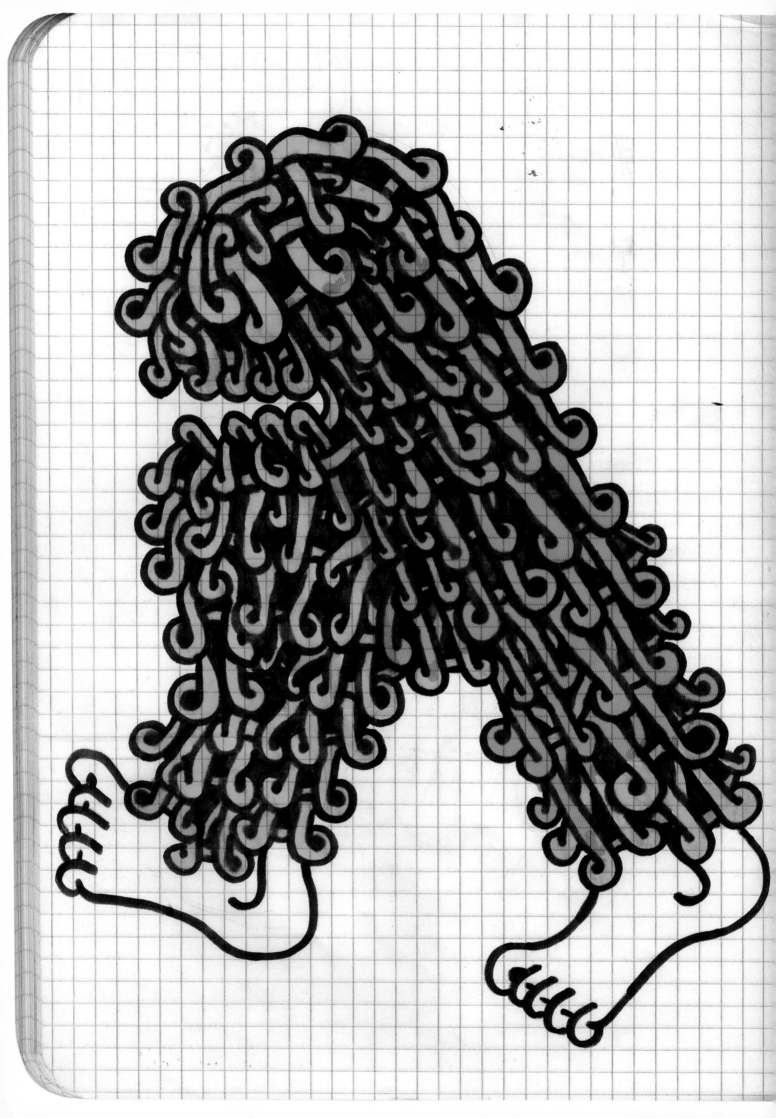

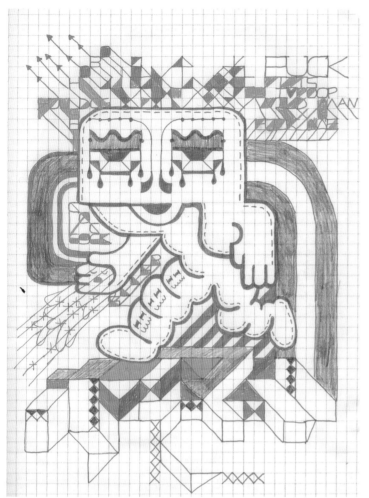

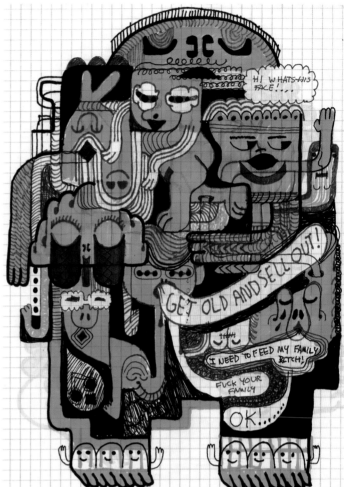

A. J. Purdy

A. J. Purdy is a graphic design graduate from the East Coast of the United States. His sketches reveal an attraction to absurdism and abstract narrative. His curious books are full of strange cartoony worlds or creatures that sometimes comment on human ideas. 'I always try to think up things that run contrary to the normal daily circle of thoughts which end up depleting people,' he says.

His sketchbooks are the raw materials for both art and design projects such as 'zines, screen prints and graphic design commissions where he tends towards hand-drawn illustrations. 'In general people are becoming more aware of the "inhumanness" of things created on computers,' he observes. 'The computer is a tool. I use it every day but it's not the be-all-and-end-all. When I create graphics it's a combination of drawing and computer rendering.... Drawing in the moment is very important to me – that's where the best lines come from. Though in the back of my mind I'm still thinking like a designer in composition and form, placing things specifically where I want them.'

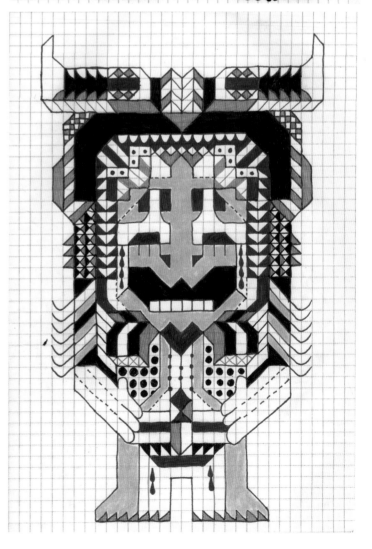

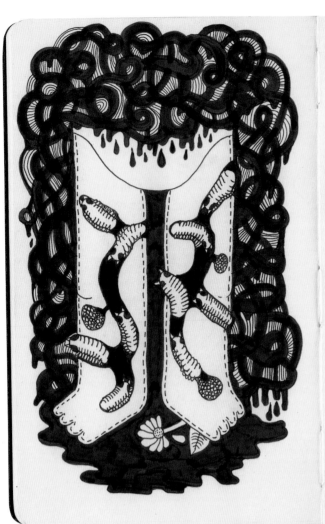

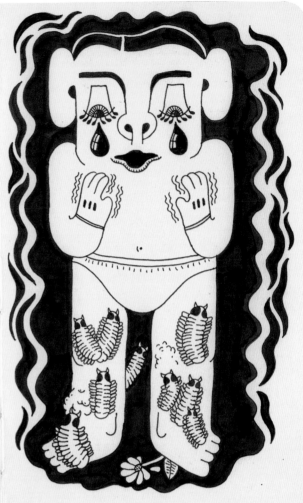

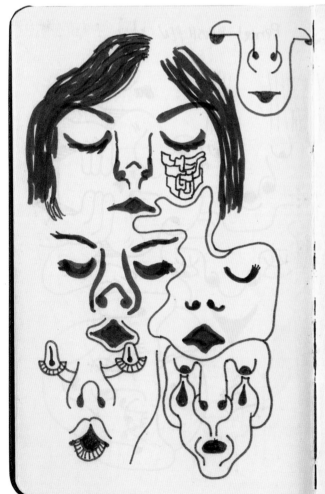

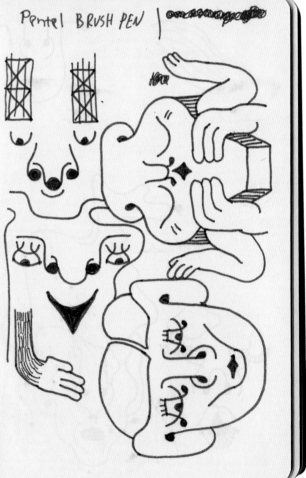

Pentel BRUSH PEN |

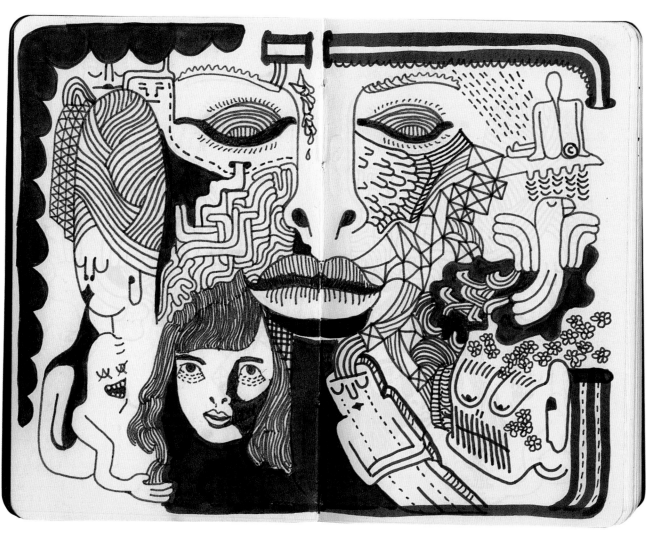

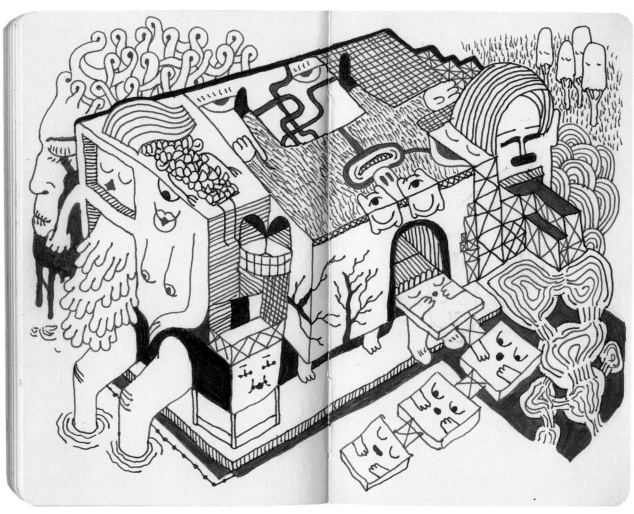

129 A. J. Purdy

Luke Ramsey

Luke Ramsey and his partner Angela have an artist residency on Pender Island, Canada, where they invite artists into their home free of charge. They partly fund the scheme by publishing books and 'zines.

With a background steeped in comic books and cartoons, Luke has been drawing in sketchbooks since he was a child. In 2003 he moved to Taiwan and was heavily influenced by the abundance of cartoons and comics in Asian pop culture. His style is a reflection of what it was like to draw as a child, full of fun and with infinite possibilities.

'I usually like to explore a theme of love and happiness,' he says. 'I illustrate from a personal place to remind myself of why I am alive. I also like to play with the idea of ugliness and cuteness holding hands with each other.... A lot of my influences come from a possibility, and that possibility is that I can visually create anything I want with a pen and paper. I seldom sketch out my idea before applying the paint. I just let the paint stroke take me where it wants to.'

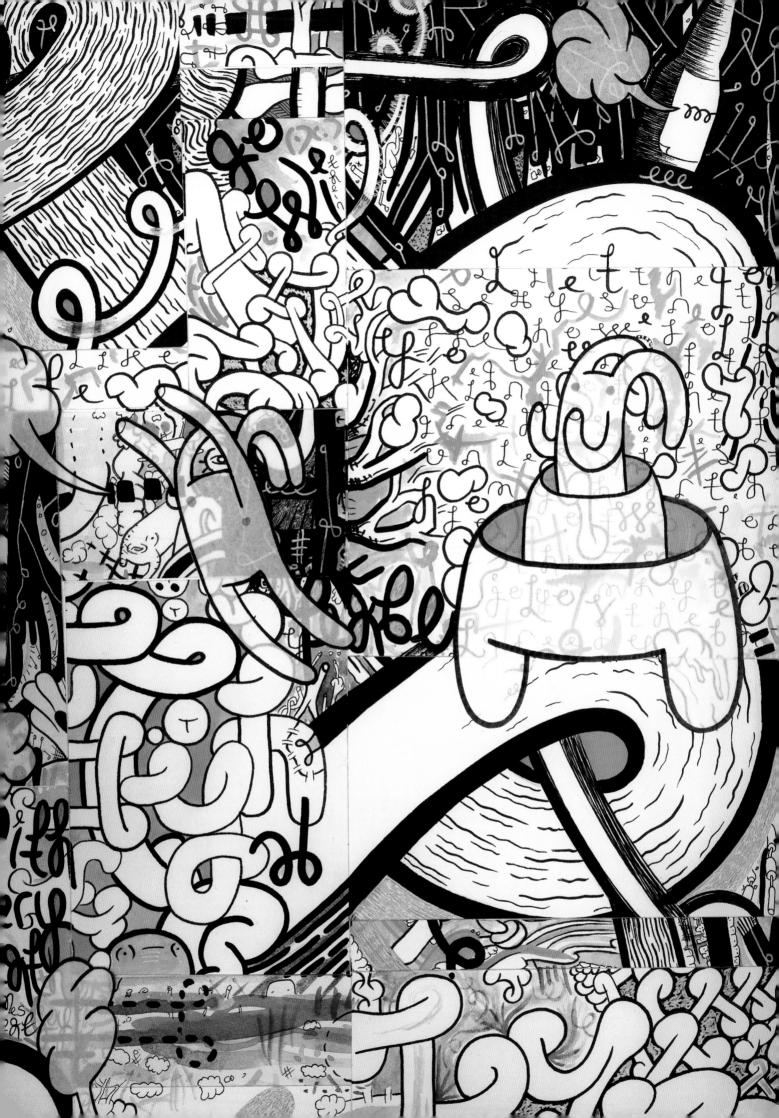

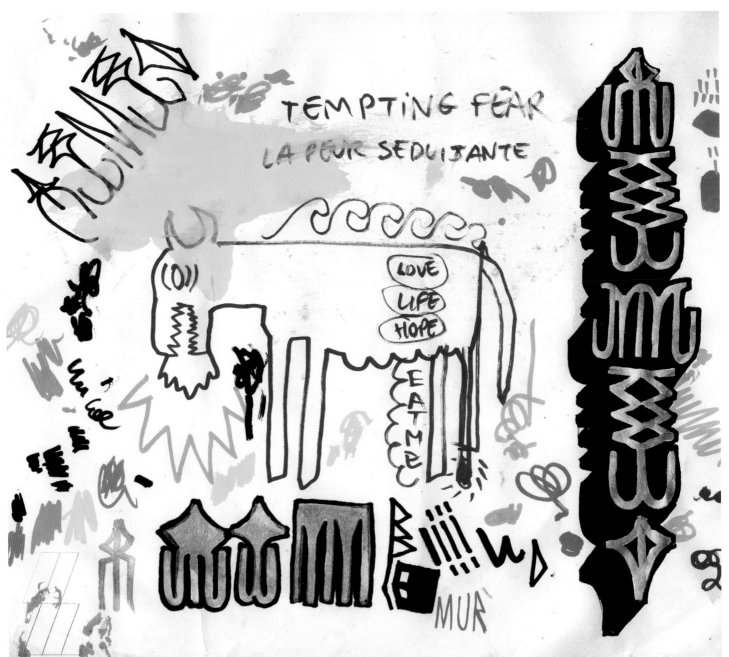

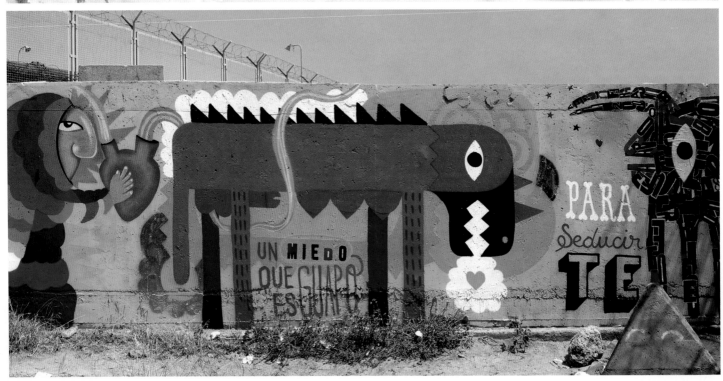

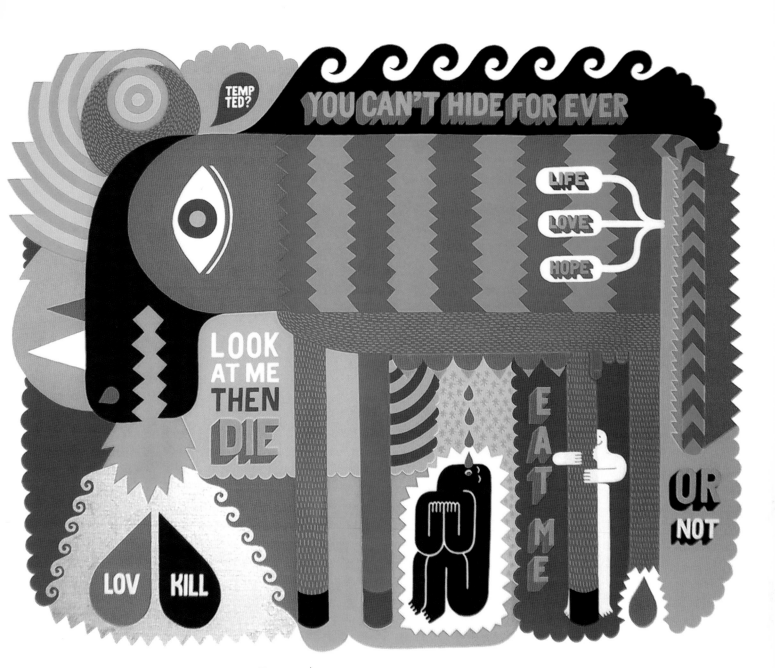

Remed

Remed is a French artist who divides his time between Lille and Madrid. He loves painting on canvas and doing graffiti, often in collaboration with artists such as 3ttman (Madrid), A. J. Purdy and Fefe (Brazil). His influences include graffiti culture, which he fell into in 1999, and 20th-century painters such as Modigliani, Picasso, Matisse, Léger and Basquiat.

His sketches form a library of thoughts and shapes. He usually mixes several sketches and keeps an element of freestyle when he paints, which enables him to adapt his art to reflect the context of the painting – the texture of the wall, for example, or his feelings at that moment.

Remed's ideas develop as words, icons, colours or shapes that begin to form a dialogue as they gradually build up on the page. His personal life, the people he meets, events and his environment are all elements he brings into his work. By sharing his own feelings, he hopes to spark feelings in others.

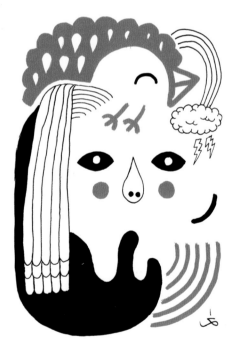
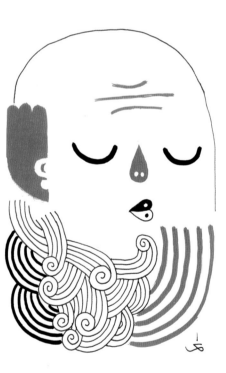

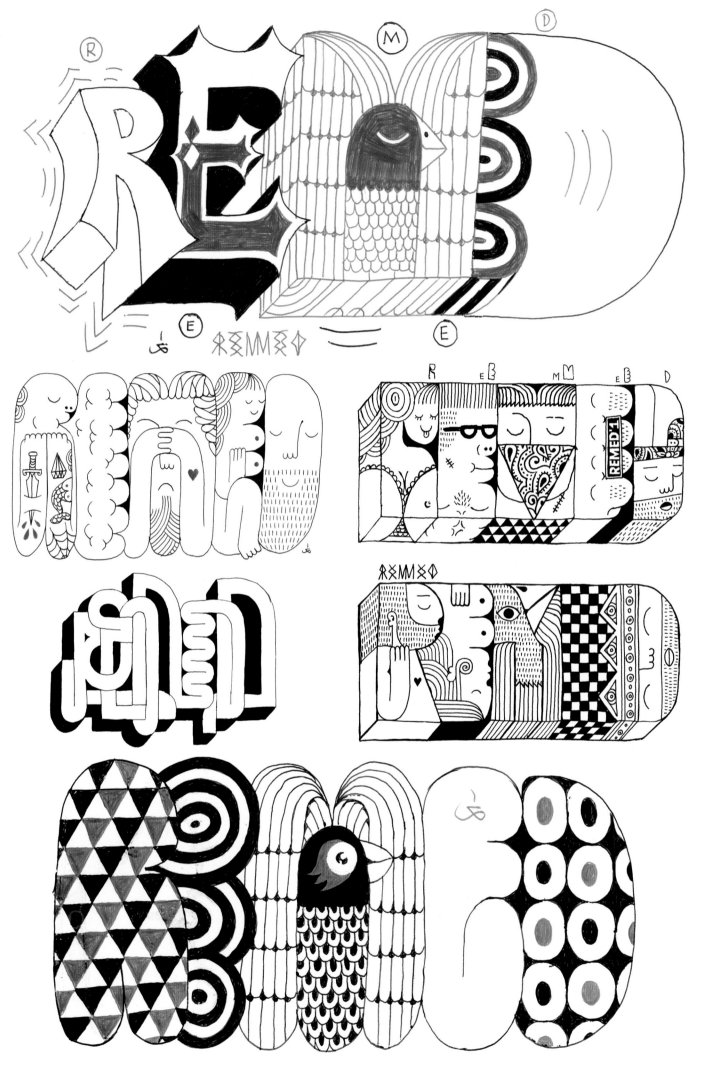

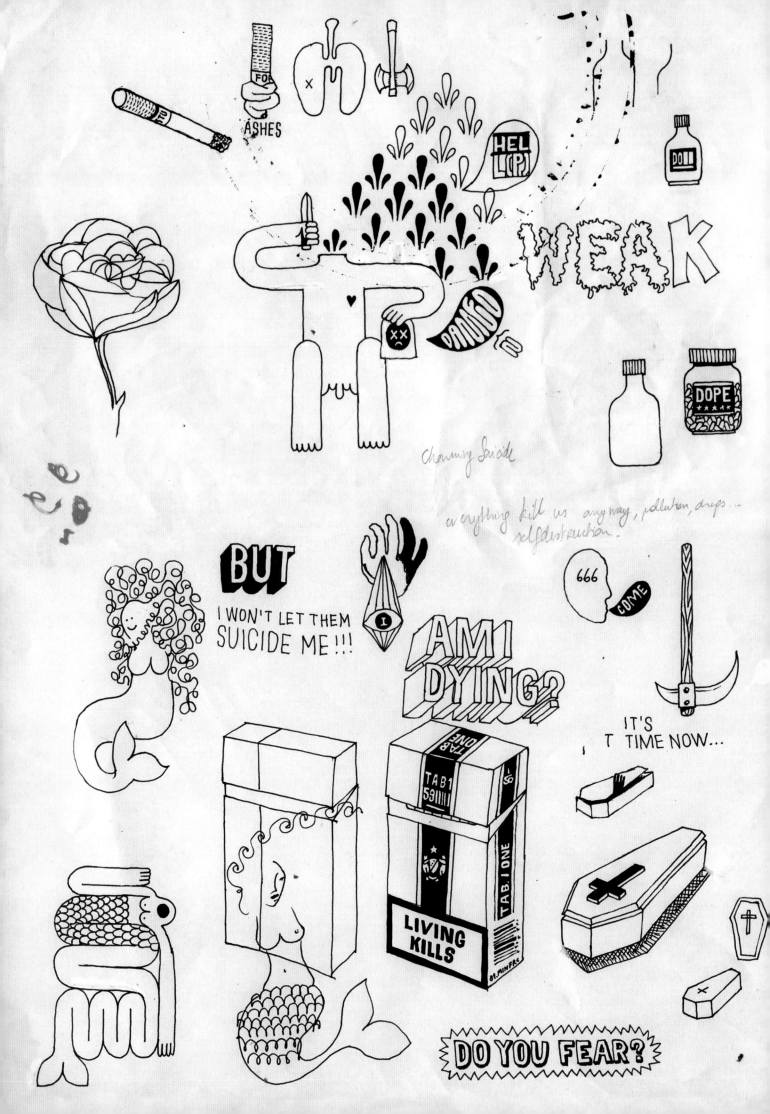

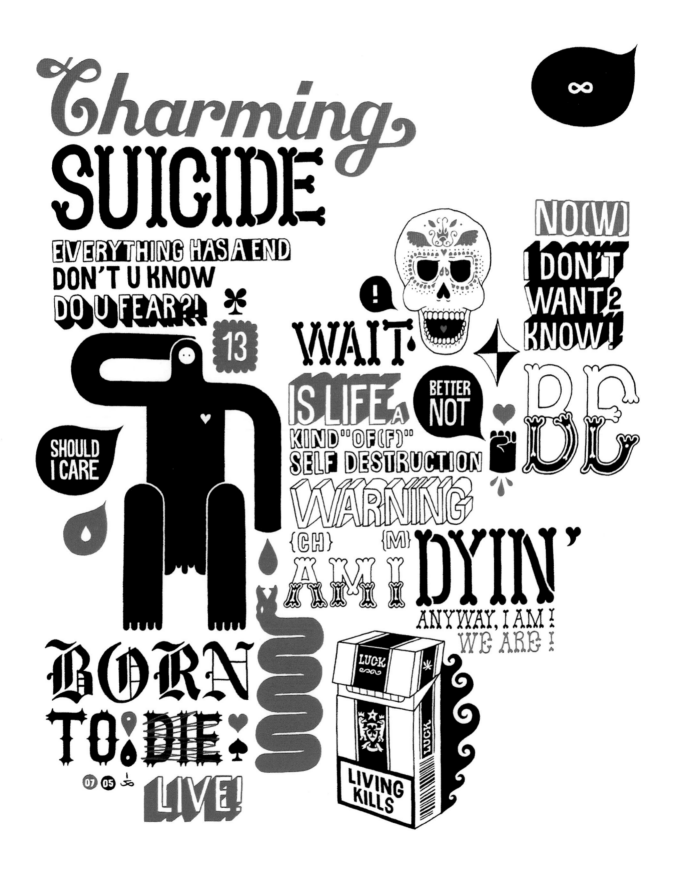

Andy Rementer

Andy Rementer comes from New Jersey but
has recently been based in the Italian town of
Treviso. In his profession as a cartoonist and
graphic designer he puts an emphasis on the
handmade and collaborates with artists around
the world on drawing-orientated 'zines. Going
back to the roots of graphic design, much of his
output is hand-drawn, whether it's a commercial
or self-initiated poster, a website or a logo.
Through drawing he puts his own personality
directly into his work.

 Andy's sketchbooks are his free space to
develop his graphic and artistic voice with
words, statements, shapes, characters and
cartoons. 'My ideas come from the constant
flow of what's going on in my brain and onto
the paper,' he explains. 'There's an infinite
amount of inspiration to be found in everyday
life, observing and being around other people
all the time.' Summing up his approach to
drawing, Andy adds: 'I have a desperate need
to draw all the time – it's kind of pathetic,
but I enjoy it. I try to keep things quick and
loose for the most part, and let my hand speak
for my brain. I also sometimes use drawing as
a defence mechanism.'

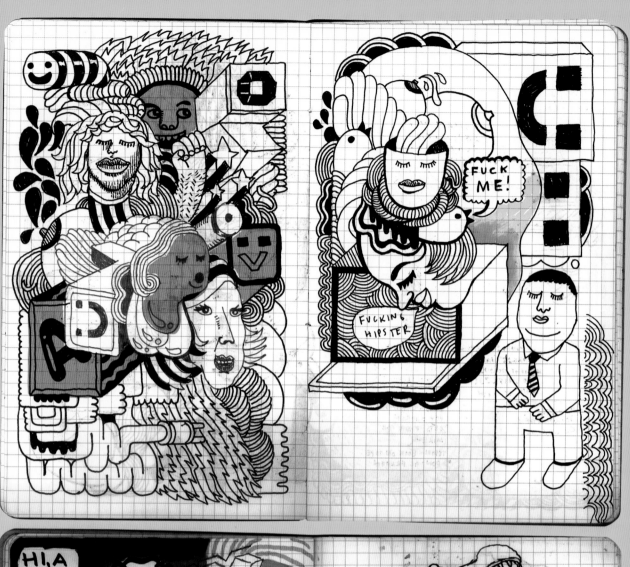
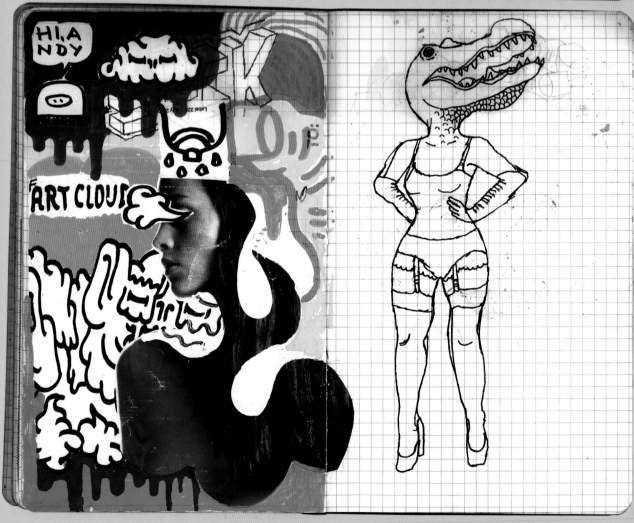

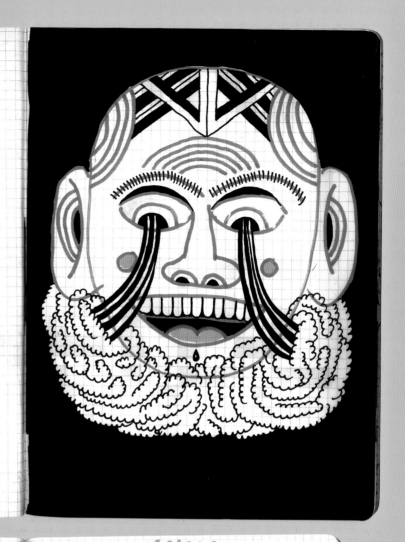

ARMAGEDDON
BUT I JUST ?
BOUGHT
NEW SHOES!

RIDE THAT SHIT

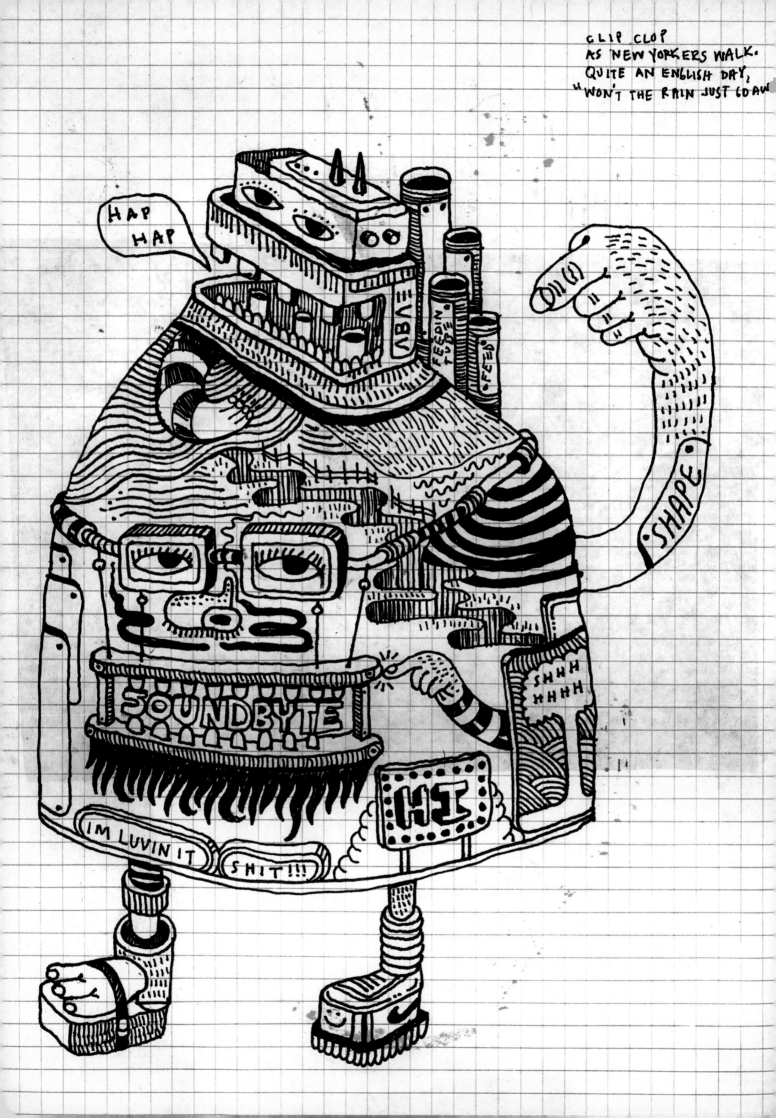

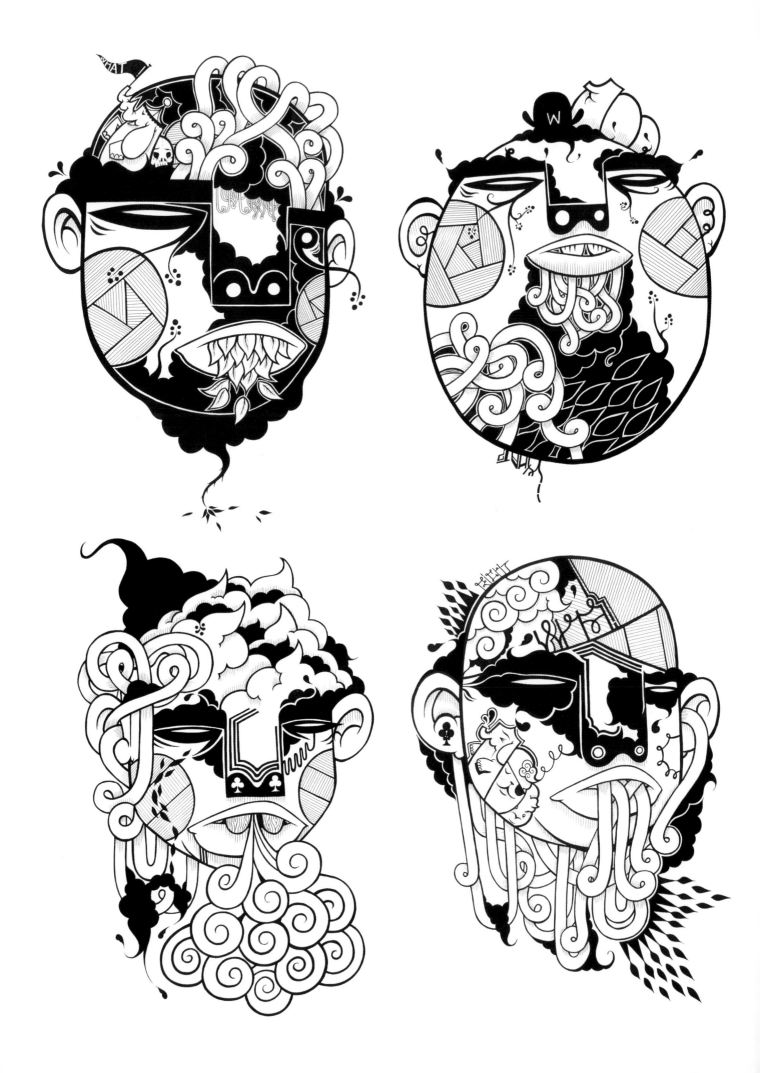

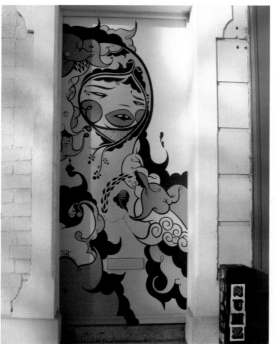
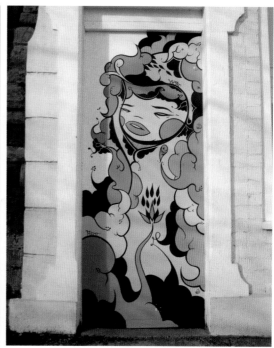

Richt

As an artist, Richt is a relative spring chicken, having painted his first canvas in 2004 and his first mural in 2005. He grew up in North Devon and currently lives in Bristol, where graffiti and the local scene were an important influence and a kick-start to his artistic career.

Drawing is habitual for Richt, who is a member of the What collective; he draws every day, usually in the nocturnal hours. His ideas usually come from lucky mistakes in his sketchbook, which he then expands on. Once he has drawn something he likes, he tends to draw it over and over until it's been exhausted, exploring different elements for the enjoyment of drawing. Sometimes aspects of his sketches appear on a wall or canvas, but in an unplanned way. Although Richt's work initially focused on his characters, slowly they have become abstracted into organic forms and patterns.

Recently one of Richt's characters, an onion called Alan, was turned into a model and entered into a TV competition. The television company refused to return the model, sparking a protest campaign to 'Free Alan'.

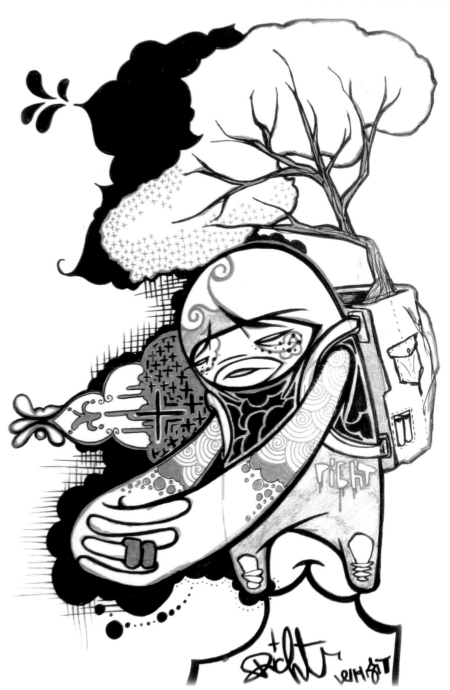

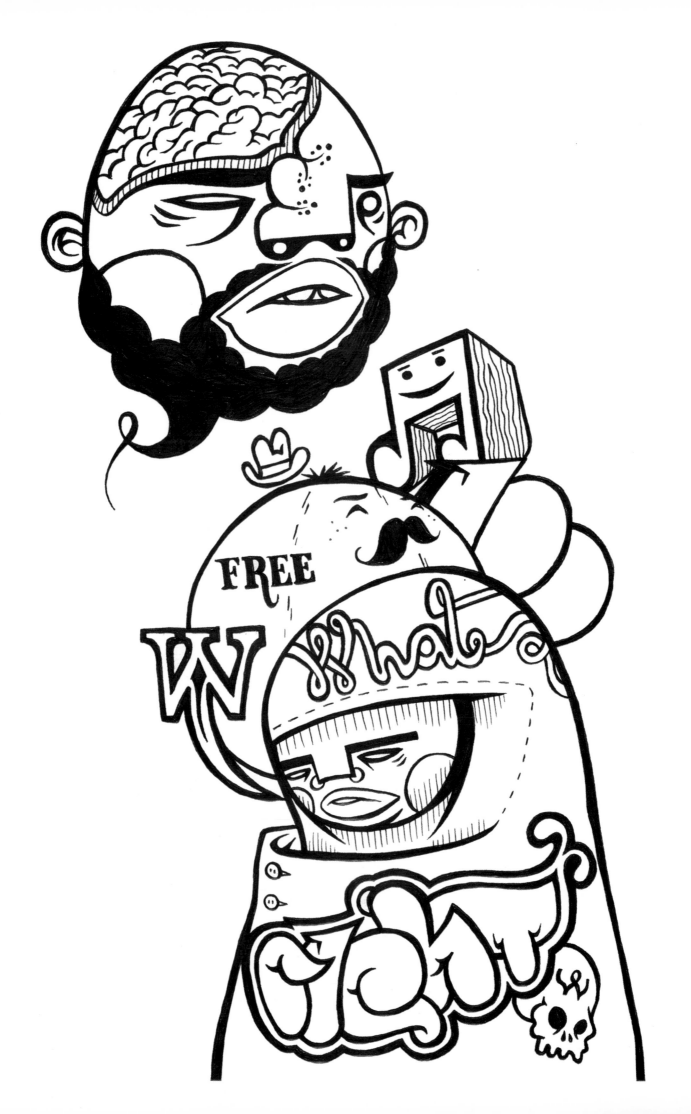

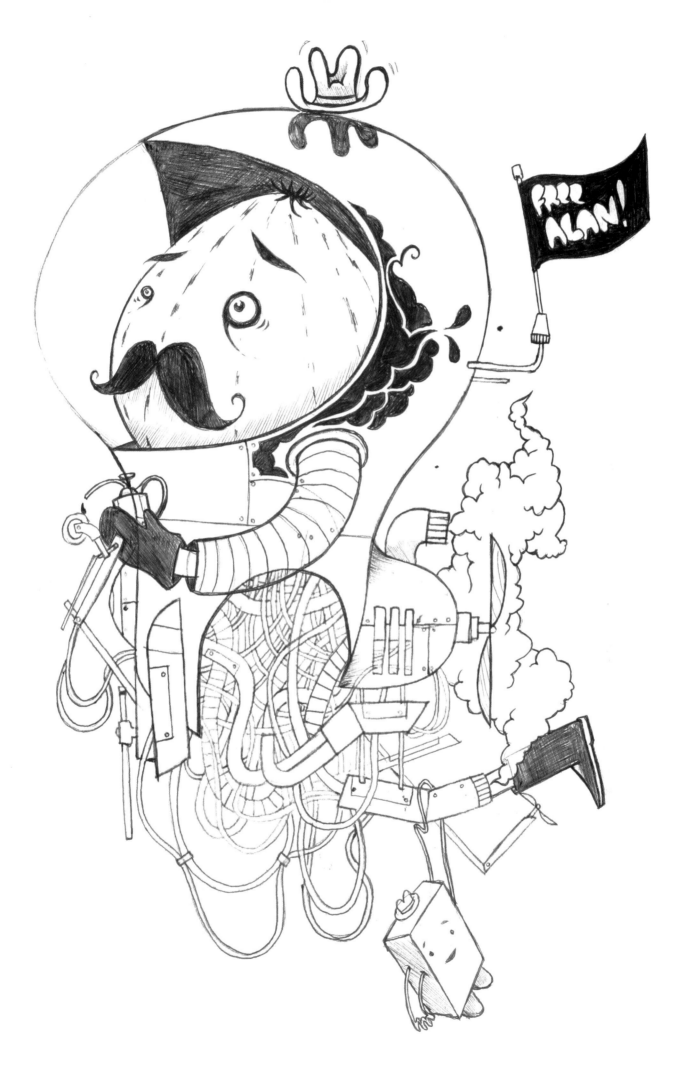

Sam

Drawing pervades Sam Vanallemeersch's life. For commercial jobs the Belgian illustrator from Antwerp uses sketches to work out ideas, but when it comes to his own work he sees his sketches as drawings in their own right. Technique is not a big issue for Sam, who believes that drawing is about content, not style.

His personal drawings, some of which are shown here, are often free associations of ideas and observations built up over one page. Describing the development of his images, he says: 'I never think about what I make, I just do it. I just draw and something happens, and when something happens on the paper (something I probably didn't think about beforehand) I react to it with something else, and so forth. My ideas develop in that way.'

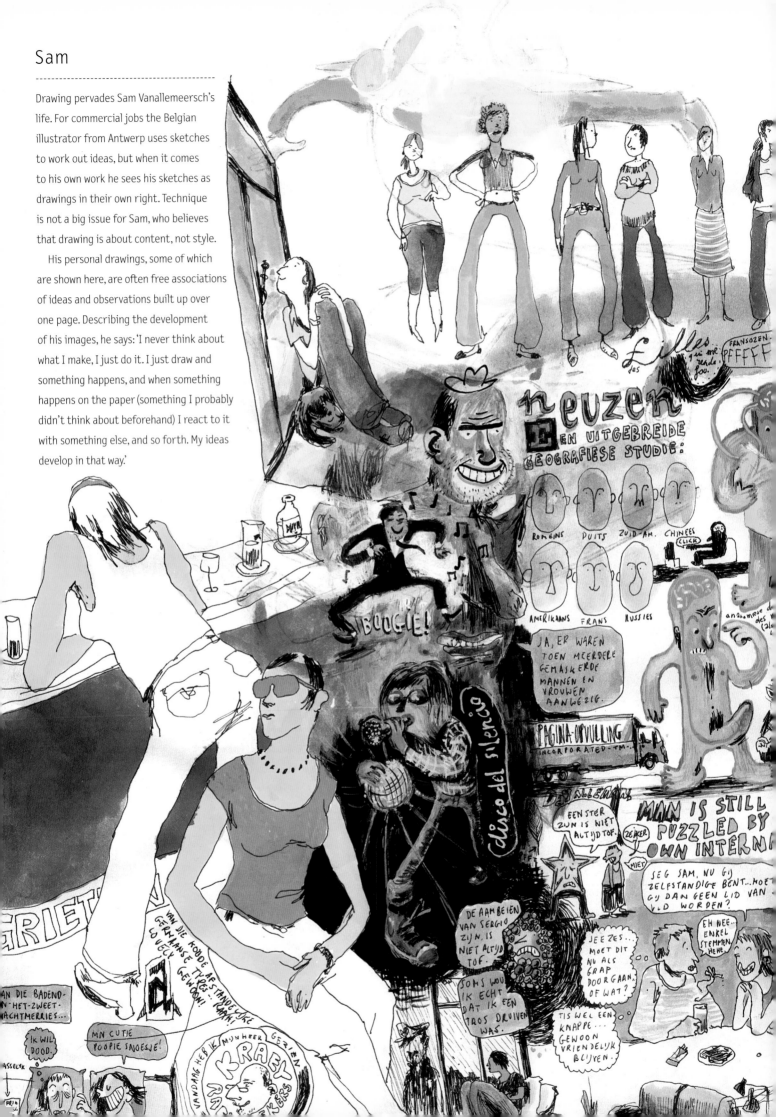

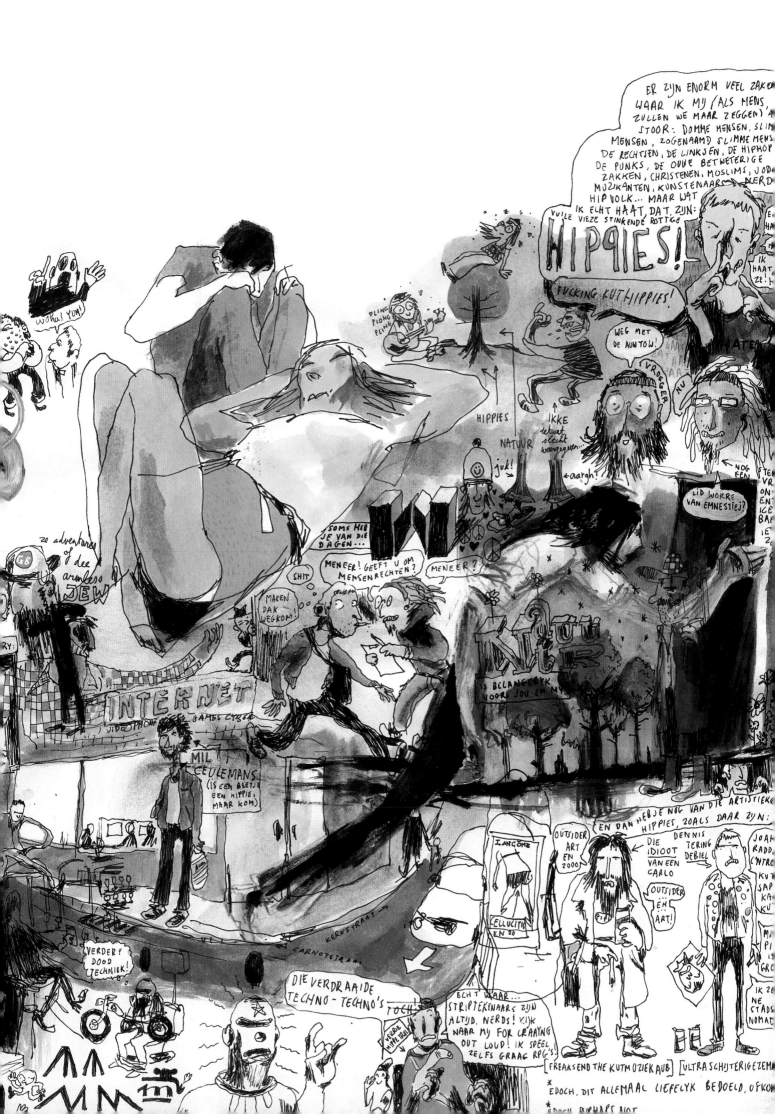

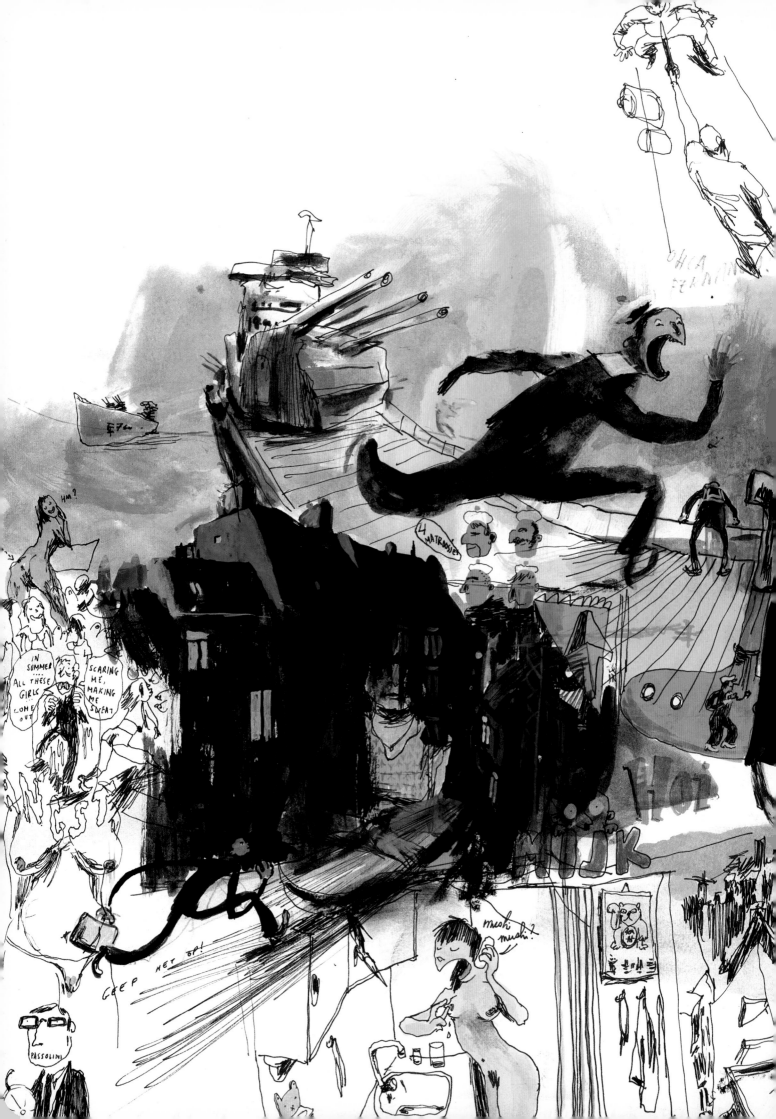

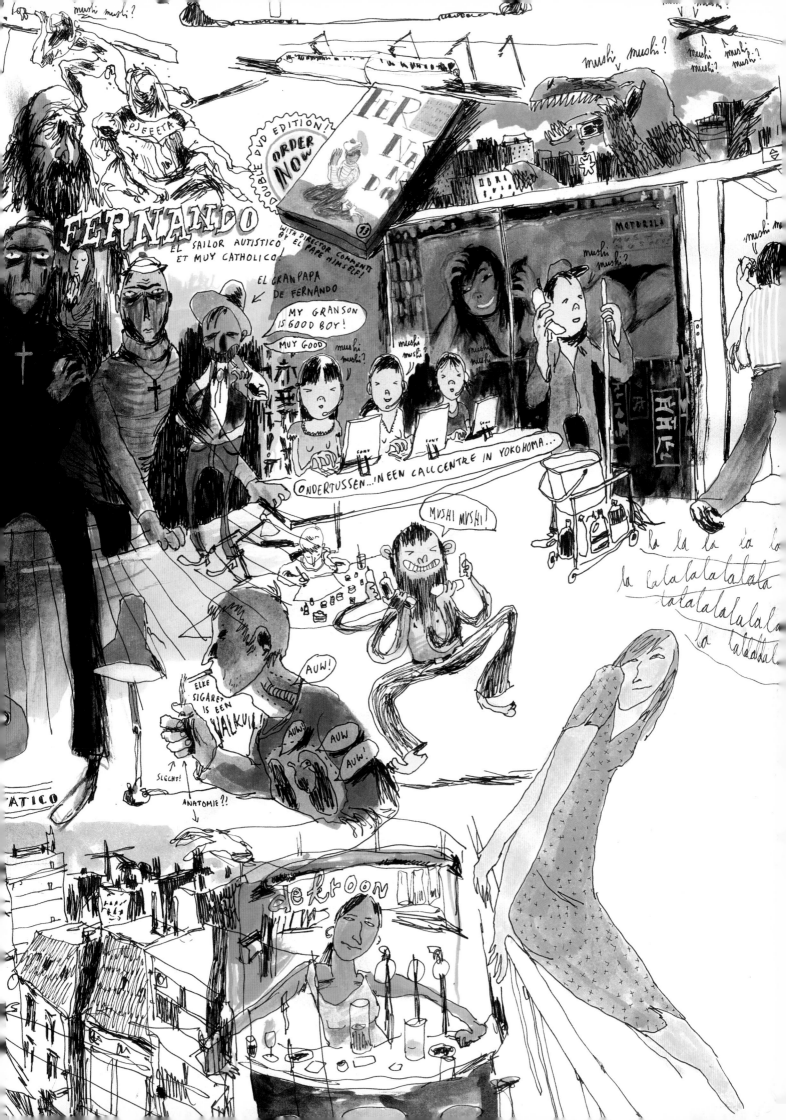

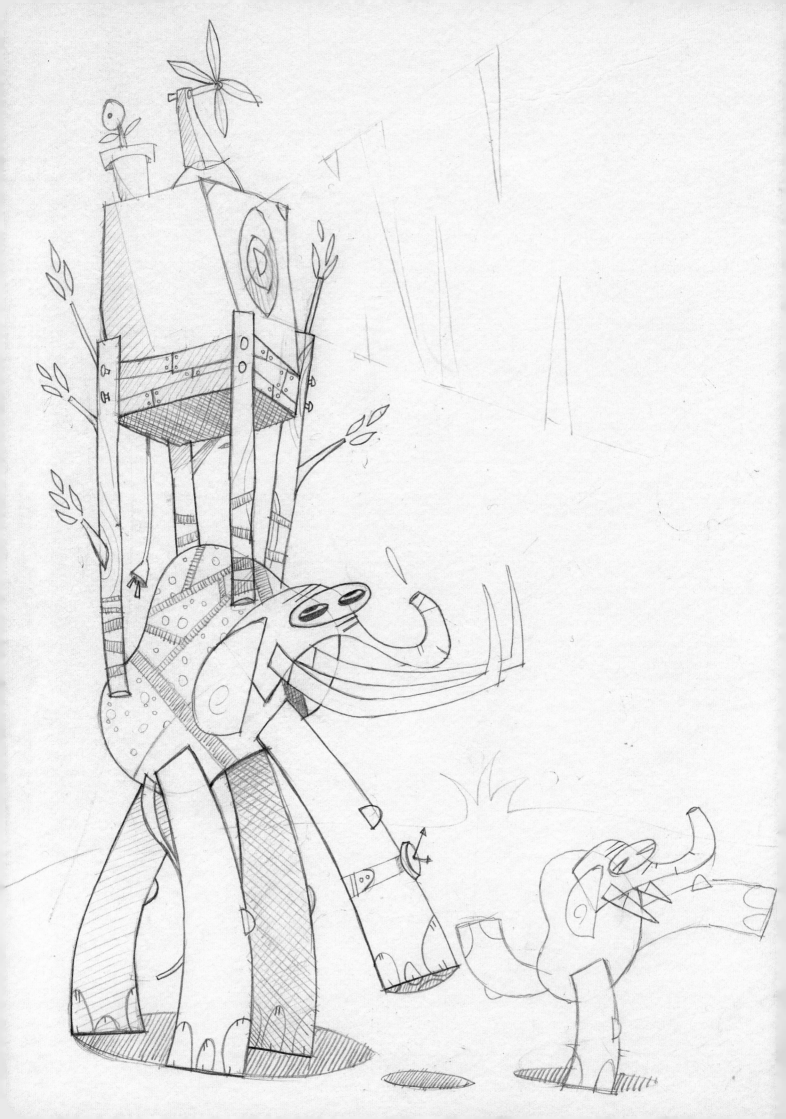

Showchicken

Nick Sheehy studied bronze sculpture in Australia where he made sculptural machines to destroy other art. Today he lives in London and under the name Showchicken is involved in numerous artistic projects. Heavy-metal album covers, dodgy sci-fi art and bad architecture are cited as some of the influences on his world, which is populated by strange creatures and badly constructed vehicles.

Showchicken's sketchbook is a meditation; his images don't necessarily have a particular purpose, but gradually a visual universe starts to fit together. 'I think that's half the fun – creating the world by drawing snapshots from that world,' he explains. 'I have no idea where the ideas come from. They usually arrive in their own time…. I like weirdness, different levels of weirdness, monsters, travelling, things falling apart, dysfunctional animals and strange machines with no use. I'd like to get this world in a book somehow, with some kind of wordless narrative.'

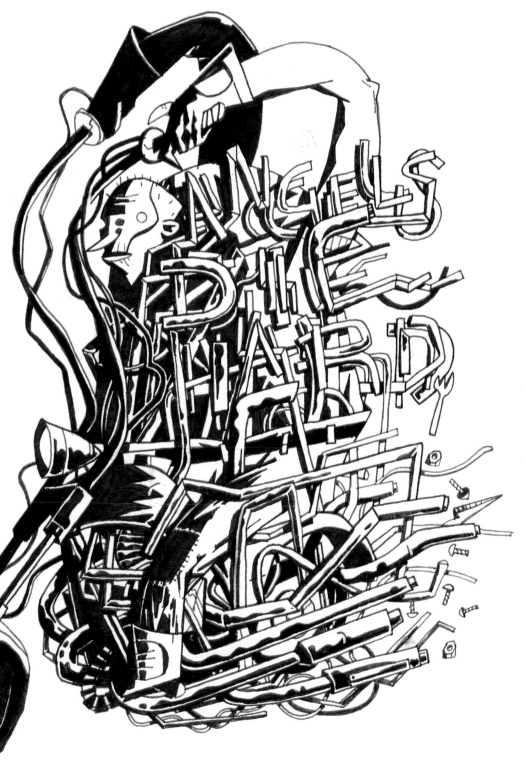

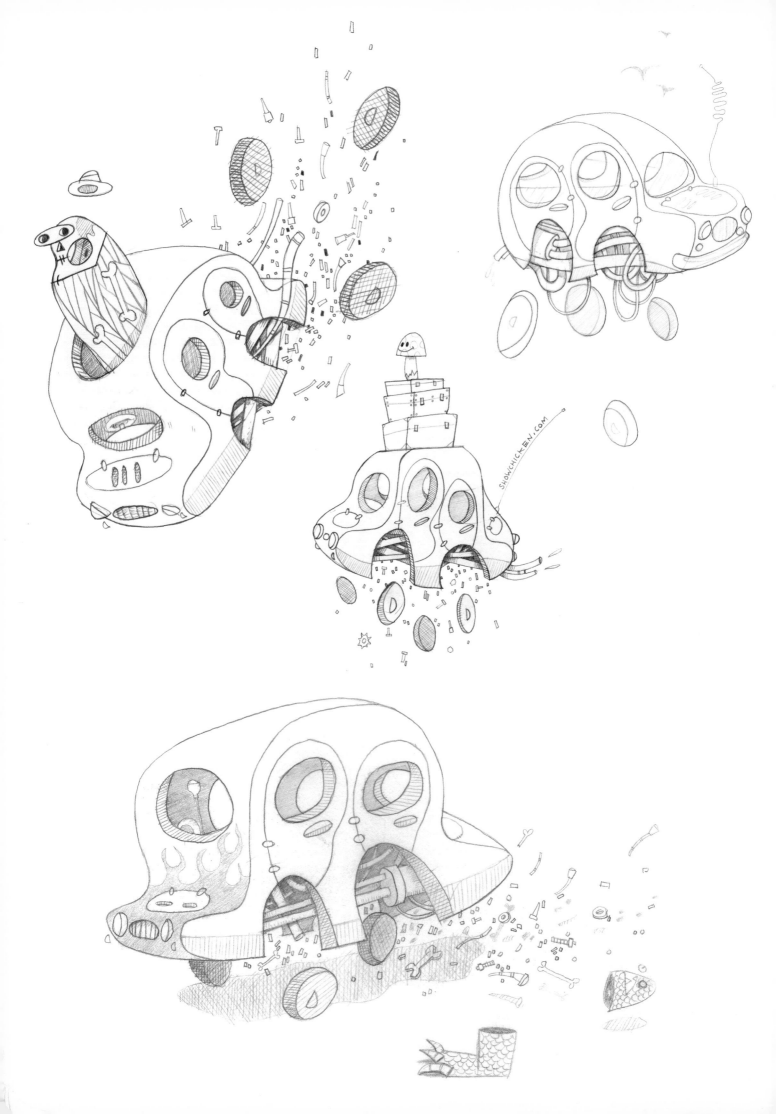

SHOWCHICKEN.COM

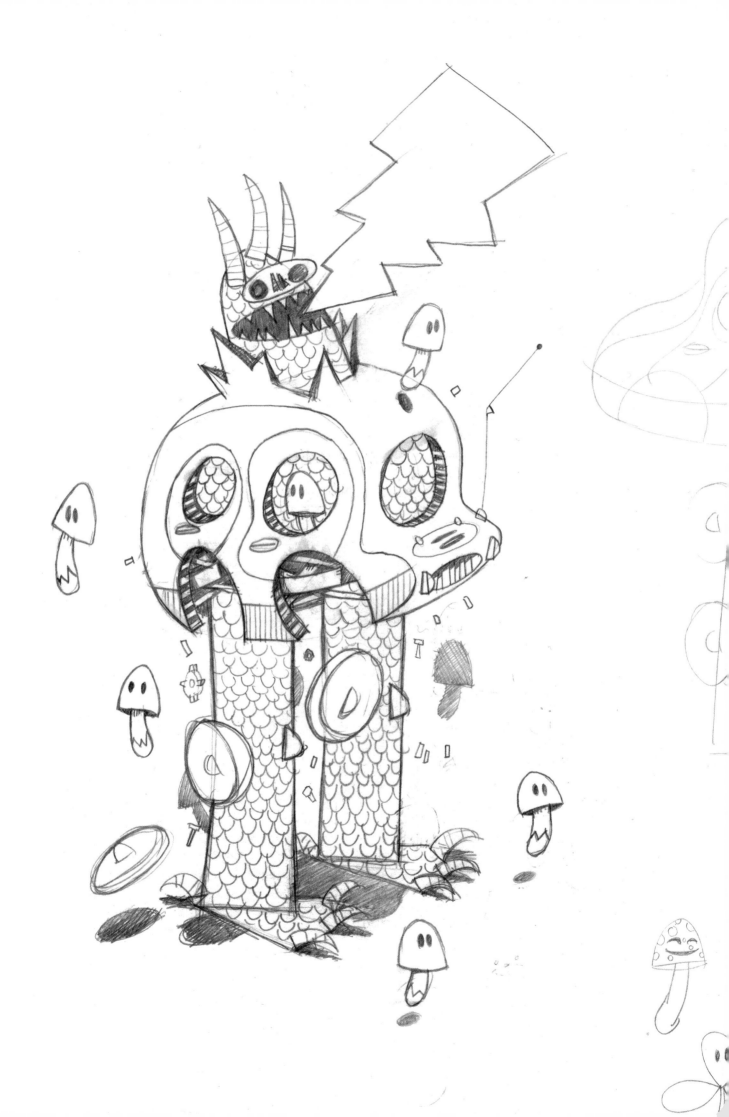

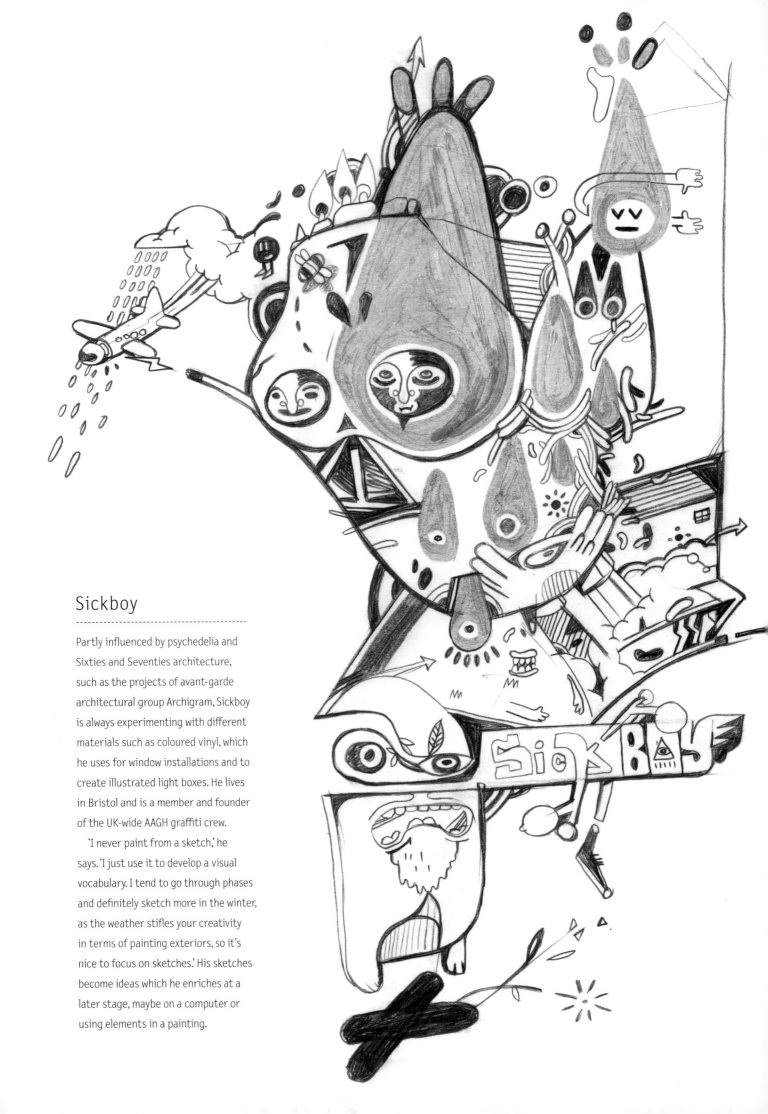

Sickboy

Partly influenced by psychedelia and
Sixties and Seventies architecture,
such as the projects of avant-garde
architectural group Archigram, Sickboy
is always experimenting with different
materials such as coloured vinyl, which
he uses for window installations and to
create illustrated light boxes. He lives
in Bristol and is a member and founder
of the UK-wide AAGH graffiti crew.

'I never paint from a sketch,' he
says. 'I just use it to develop a visual
vocabulary. I tend to go through phases
and definitely sketch more in the winter,
as the weather stifles your creativity
in terms of painting exteriors, so it's
nice to focus on sketches.' His sketches
become ideas which he enriches at a
later stage, maybe on a computer or
using elements in a painting.

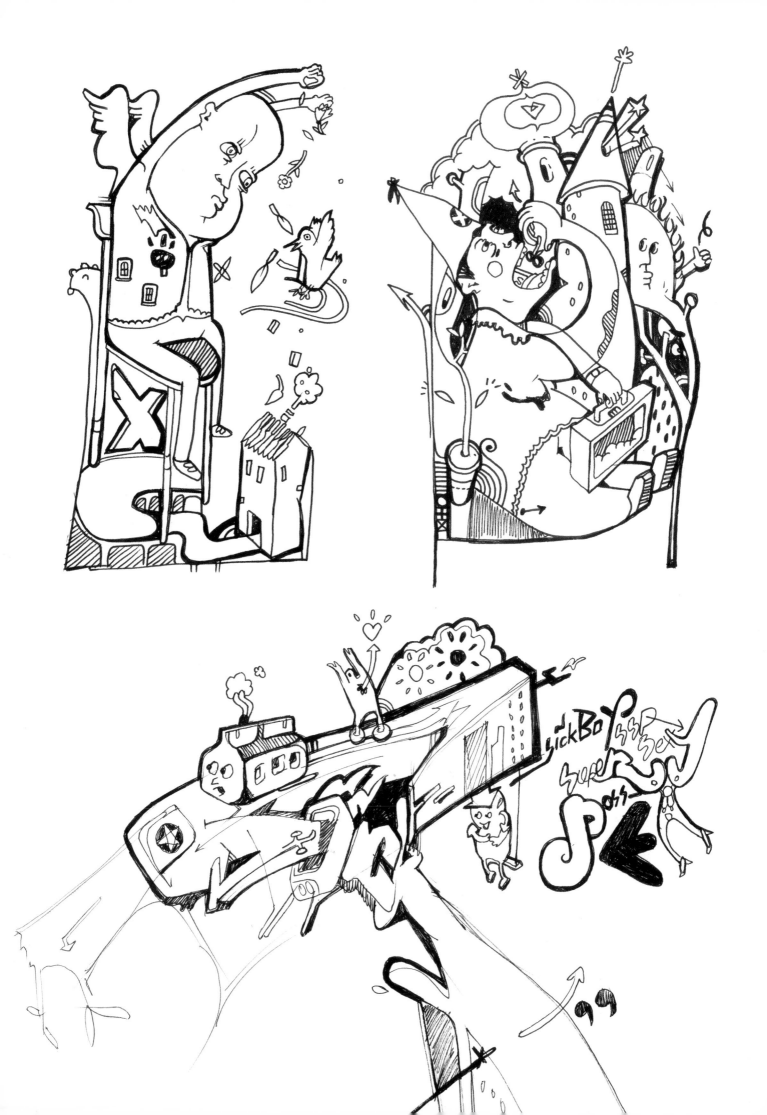

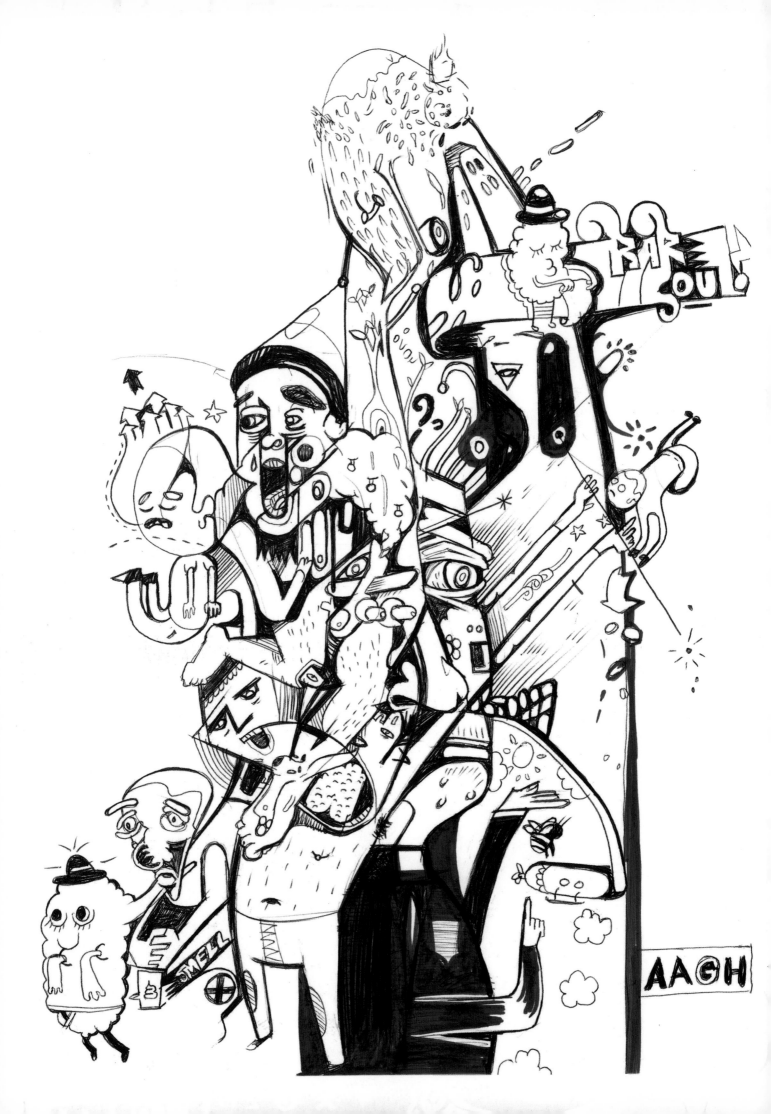

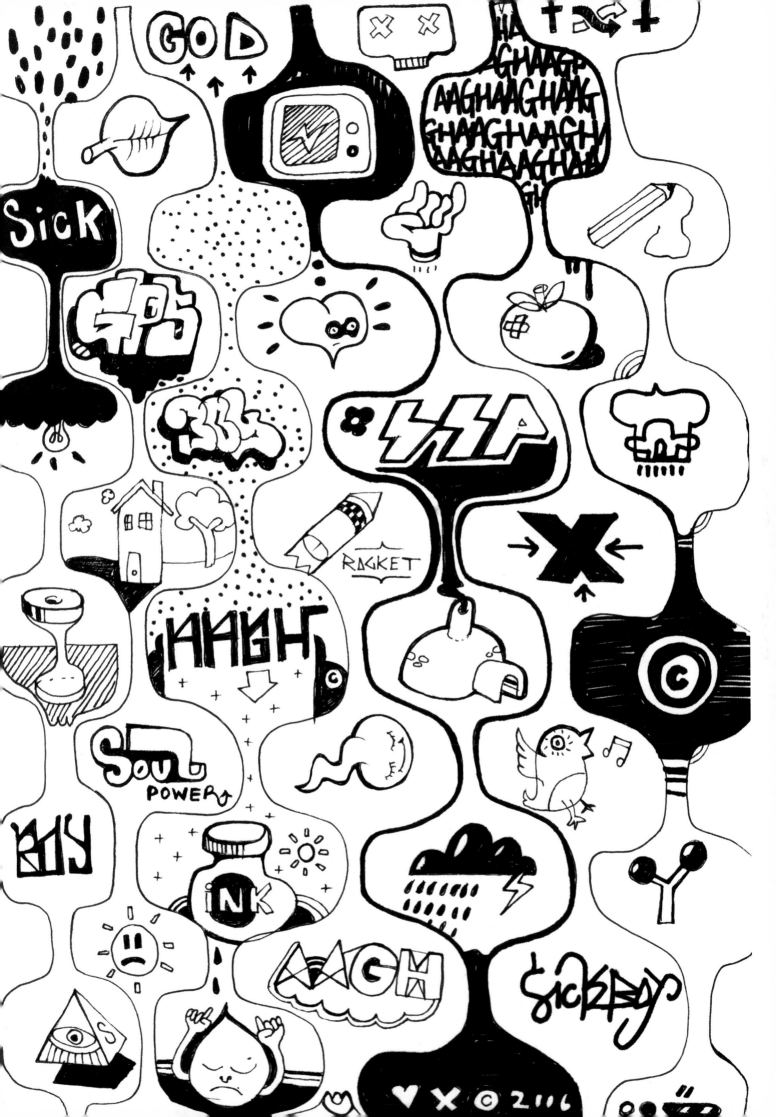

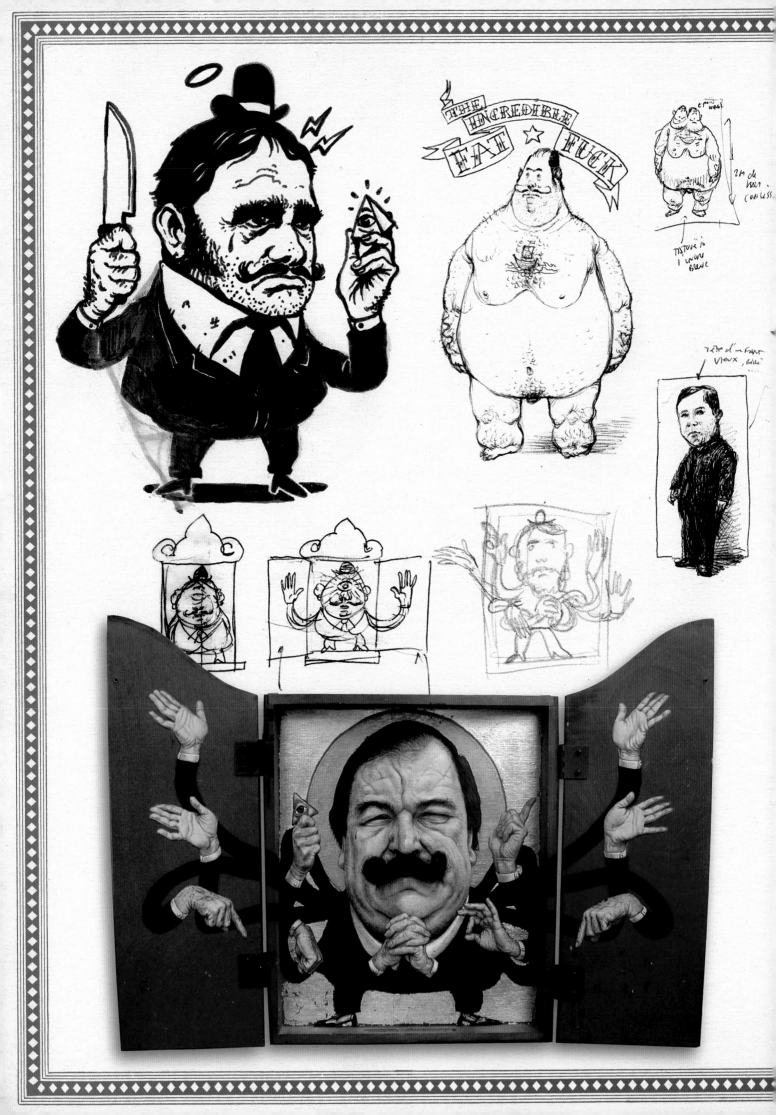

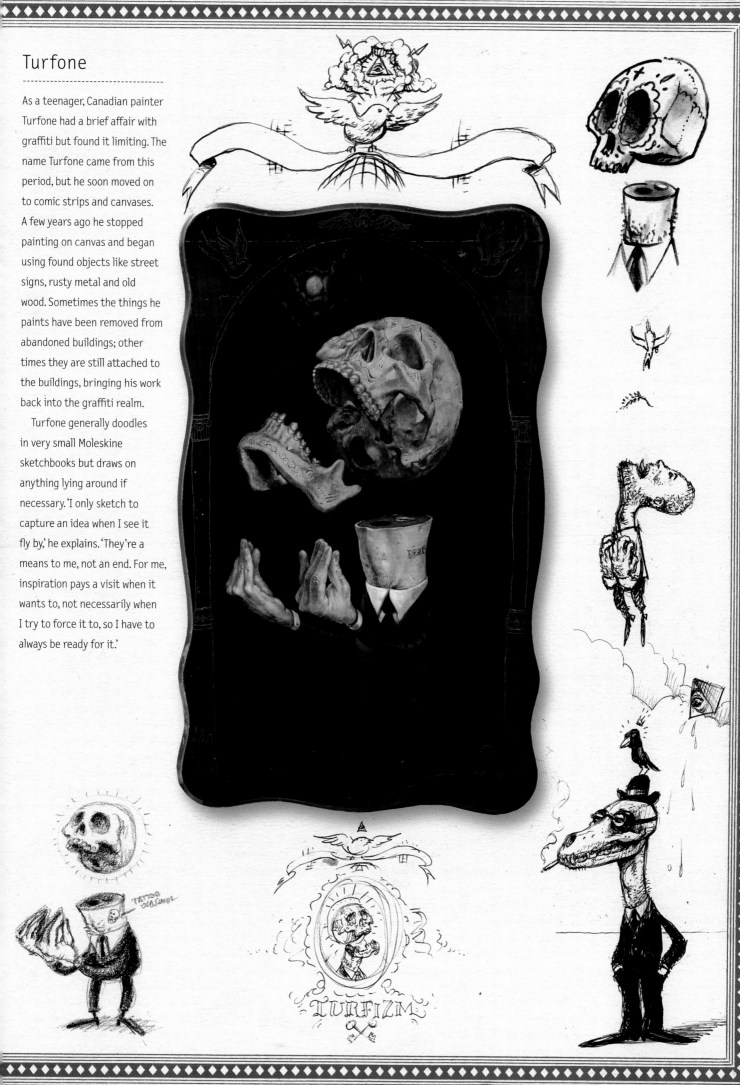

Turfone

As a teenager, Canadian painter Turfone had a brief affair with graffiti but found it limiting. The name Turfone came from this period, but he soon moved on to comic strips and canvases. A few years ago he stopped painting on canvas and began using found objects like street signs, rusty metal and old wood. Sometimes the things he paints have been removed from abandoned buildings; other times they are still attached to the buildings, bringing his work back into the graffiti realm.

Turfone generally doodles in very small Moleskine sketchbooks but draws on anything lying around if necessary. 'I only sketch to capture an idea when I see it fly by,' he explains. 'They're a means to me, not an end. For me, inspiration pays a visit when it wants to, not necessarily when I try to force it to, so I have to always be ready for it.'

TURFIZM

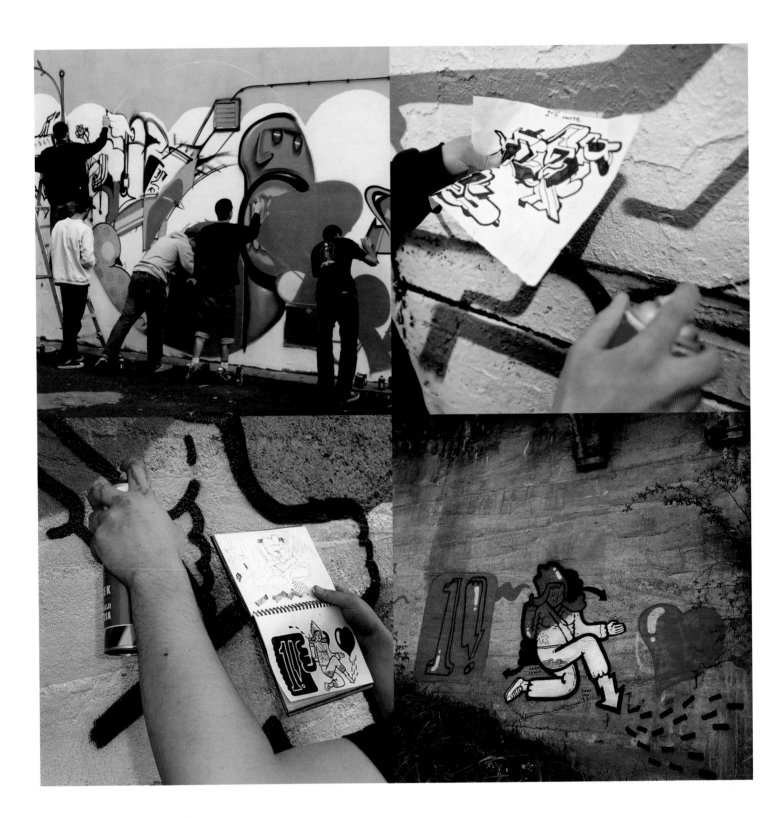

Outside

In the late-1970s and early-1980s era of classic 'New York' graffiti, writers used sketchbooks known as 'blackbooks' to draft letters and 'masterpieces'. The blackbook and the 'writers' bench', a spot where artists would meet to plan pieces on walls or trains and swap stories, are all part of the folklore of graffiti and remain ingrained in its culture. While the writers' bench is more of a metaphor these days, artists still meet at graffiti jams, and blackbooks continue to be used for sketching out pieces and collecting signature tags or sketches from other artists.

Classic graffiti culture is steeped in bravado and exploits such as scaling walls and crossing train tracks to 'get up'. The idea of writers getting together to look at each other's drawings and photographs seems rather tame in comparison. Nonetheless, sketchbooks and photo albums can be incriminating for writers producing illegal graffiti and so they are often kept hidden away.

During the late 1990s the 'classic' graffiti art movement and the street art scene entered a revitalized era, with artists becoming more experimental in their imagery, use of different media and approaches to public space. Street artists began to use posters and stickers to colonize new spaces, interacting with the city using the language of propaganda and advertising. Graffiti writers looked beyond the formulaic styles in a break away from clichéd images. Although rooted in graffiti art tradition, a new wave of artists such as San Francisco-based Barry McGee, the Brazilian twins Os Gemeos and British artist Banksy began to develop their own visual languages for the street.

The rejuvenation of graffiti has resulted in a huge increase in urban-influenced graphic design and fashion, which reference stencils, street art posters and styles of graffiti painting. For example, the use of paint drips and sprayed edges as visual devices can be seen everywhere from TV commercials to advertising. With graffiti in the spotlight, the challenge for graffiti artists has been to stay independent and innovative and not fall prey to soulless commercialization.

The artists in this chapter reflect the way graffiti art has become more personal and experimental. Most of these sketchbooks and drawings differ vastly from the blackbooks of the 1980s, yet the principle of sketching out work is still the same. It is at an individual level that artists have been gradually changing the possibilities of graffiti. For instance, British artists Dreph and Paris grew up with hip-hop graffiti, and their sketchbooks from the 1980s onwards record their development and evolution of personal styles. Each artist takes his own path, gathering influences from all kinds of sources. Dreph cites early UK graffiti writers The Chrome Angels and British comics such as 2000AD and Tank Girl, whereas Paris mentions the subtlety of Italian and Swiss logo design. Much as a graphic designer is aware of typographic and stylistic trends each year, over time graffiti artists build up a similar knowledge of graffiti styles while developing their own eclectic tastes and individual twists. In a culture that frowns on 'biting', slang for copying, a graffiti writer's currency is his or her originality.

Some graffiti has a more political edge, like the work of Barcelona-based Zosen. Many of his pieces have been made in reaction to social injustices, politics and personal causes such as squatters' rights or animal liberation. The street also calls out to artists who might not consider it their main stage. Juan Carlos Noria, a Canadian based in Barcelona, is a traditional painter under the name Dixon but uses the moniker Royal for his more illustrative style. He uses handmade posters as a therapy to vent his frustrations towards First World societies, the daily grind and the media.

Mainstream graffiti culture has not completely uprooted itself from its New York origins, but it has become more imaginative in its imagery. Gone are the days when wild-style lettering and sneaker-wearing B-boys were essential to every piece. Outside the mainstream, artists have been taking inspirations from wildly different sources. Kafre looks back to Romanesque and early Gothic art, and the work of the medieval alchemist Paracelsus (1493–1541). In contrast, artists such as Turbo and Zbiok (Poland) have been returning to the New York source, taking influence from the initial energy and style of early-1980s hip-hop graffiti.

As no two artists have exactly the same fascinations or approach, the relationship between the sketchbook drawing and the final piece depends on the individual processes of each artist; and naturally there are extremes in the complexity and attention that artists afford to their sketches and drawings. Escif (Spain) is one artist who works very loosely. His simple sketches anticipate a prodigious skill with spraypaint, translating them into full-colour, highly polished pieces on a wall. Another spraypaint maestro, British graffiti artist Xenz, often doesn't use a formal sketch. Instead he gets inspiration for his improvised landscapes from loose brushstrokes and splashes of paint. Many other graffiti writers take no reference with them to a wall, preferring

to be impromptu. Fellow Brit Ponk uses his sketchbooks more as a place to practise his style, rather than referring to them directly. In either case an idea mapped out prior to execution is only a guide. As soon as a spraycan or brush is in your hands, everything can change.

In contrast, artists such as Laguna (Spain) and Hello Monsters (Belgium) produce highly detailed drawings either as references for paintings or as finished pieces of art in their own right. They do improvise, but when it comes to big projects they like to put in some serious preparation work. Hello Monsters are a group of four artists who paint walls together but also enjoy drawing collectively, working on their drawn pieces as a team: 'It is important to leave room for instant inspirations and we influence each other during the work. That way, we also complement each other. We couldn't do it separately, one after the other. It is a whole process. And even if it takes hours and nights, we go for it.'

The communal aspect is a unique feature of graffiti art. Most graffiti painters work either exclusively or occasionally on shared productions. Discussing a mural with friends is half the fun. Figuring out how colours and compositions will come together and egging each other on to add or change something while you're painting is a totally different experience from sketching at home. The adrenaline of producing work in this way and the experience gained from learning what stands out in a composition are then fed back into a person's drawings.

The techniques and approaches to painting outside can also influence the way you draw. Bristol-based artist Paris agrees: 'As far as composition goes, yes, the way you place lettering on a building is very important and leaving space is a must. Not many people seem to know that. The speed of spraypaint makes you think fast, think on your feet. It's good to have that looseness. And that's important in drawing, being fluid and free styling.' For French artist Iemza, abandoned structures and urban architecture are as much the subject of his work as they are the surfaces on which he paints. His drawings on paper are a reflection of this cyclical process, taking inspiration from the structure of urban spaces and their networks and at the same time painting on abandoned walls and buildings. The results on paper and on walls are ghostly deconstructions of figures and structures melting together as one. Iemza's work exemplifies in a literal way the two-way street that connects sketches and drawings to a 'piece' painted outside.

While people may draw for different reasons, graffiti brings it to the streets – whether it's political, artistic or vandalistic. As Emma Dexter, Curator of Contemporary Art at Tate Modern, points out in her introduction to *Vitamin D: New Perspectives in Drawing*, 'In the urban context graffiti acts as a form of drawing within an expanded field.' Graffiti is an explicit act of mark-making, but at other levels we all leave traces on our environment in the footsteps we take, the trails we make and our global environmental imprint, as Dexter reiterates: 'Drawing is part of our interrelation to our physical environment, recording in and on it, the presence of the human.'

Graffiti artists literally make traces on the landscape with paint and other materials, while reflecting our environment and human experiences, but the impact of graffiti can be seen in both positive and negative ways. The UK has an unlikely cultural export in London-based stencil graffiti artist Banksy. His books are bestsellers, his paintings highly collectable, and his street works often carefully conserved. At the same time his work pokes fun at institutions, makes political comment and still hits many illegal spots. There is a fuzzy logic applied in our appreciation of artists in the graffiti spectrum. We applaud the ones we like and condemn the ones we don't.

Graffiti and current trends present a double-edged sword: media interest can create opportunities and legal work for graffiti artists, but these artists are still expected to 'keep it real'. Artists are categorized by subjective labels, from hardcore graffiti bomber to occasional sticker artist. People who have never done any graffiti at all are redefined as 'urban artists'. To compartmentalize a generation of artists in terms of how much graffiti they may or may not have done seems like a missed opportunity to be open to art, wherever it may come from.

Despite the pitfalls of fashion, the streets remain interesting and unexpected places to discover new art. As these sketches and drawings illustrate, what is found on the street is only the tip of the iceberg. Behind some of today's incredible murals are years spent developing a personal artistic vision through drawing.

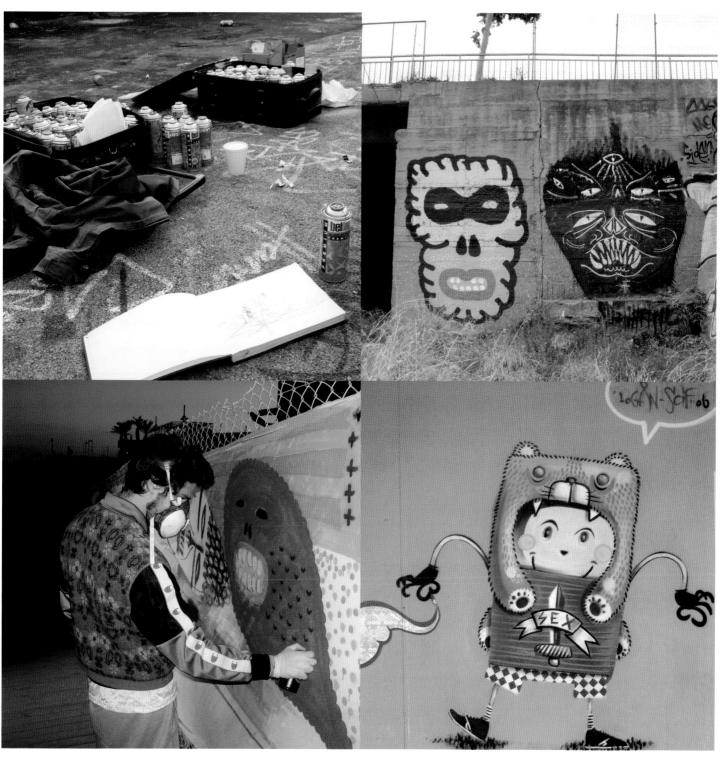

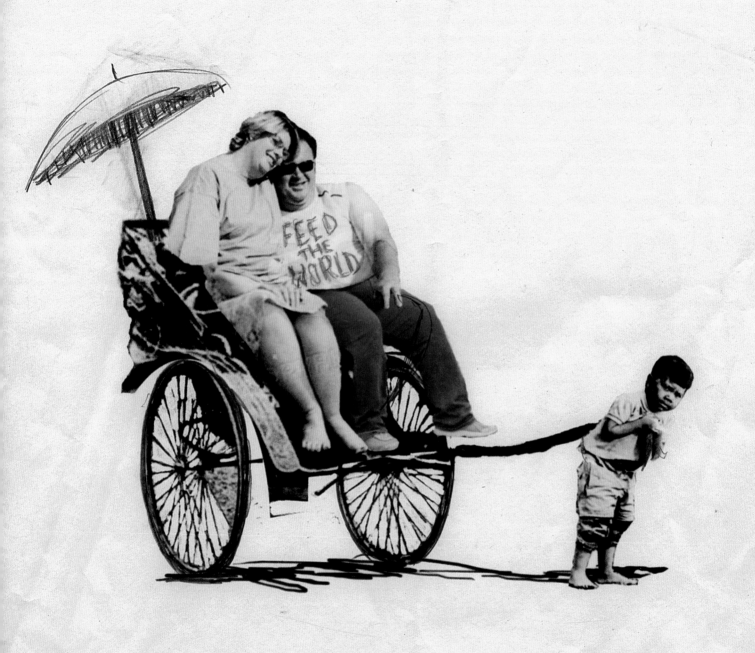

or

Banksy

--

'The artist Paul Klee said "drawing is like taking a line for a walk", but for me it's always been more like drowning a photocopier in the canal.

'I never use sketchbooks in the way you imagine a "real" artist does – perched in a terrace cafe with a pencil capturing the essence of their muse. I tried that once when I was on holiday with a girl, but her nose came out so big in the drawing that she never let me touch her again.

'I pretty much use sketchbooks to note down great ideas of somebody else's I've just had. A good sketchbook means you don't actually need to bother with having a memory yourself. You can get away with a fair bit of substance abuse if you always carry a notepad and a sharp pencil around with you.'

is possible with
mediation, as the

srael
he "peace
no more.
of repeat-
ase like an in-
CNN will revive
soon. Like Monty
rrot, it has ceased

dying a long time
gh you would no
rom much of the v
subject. Israel's tire
ve brilliantly rewrit
A myth has been sp

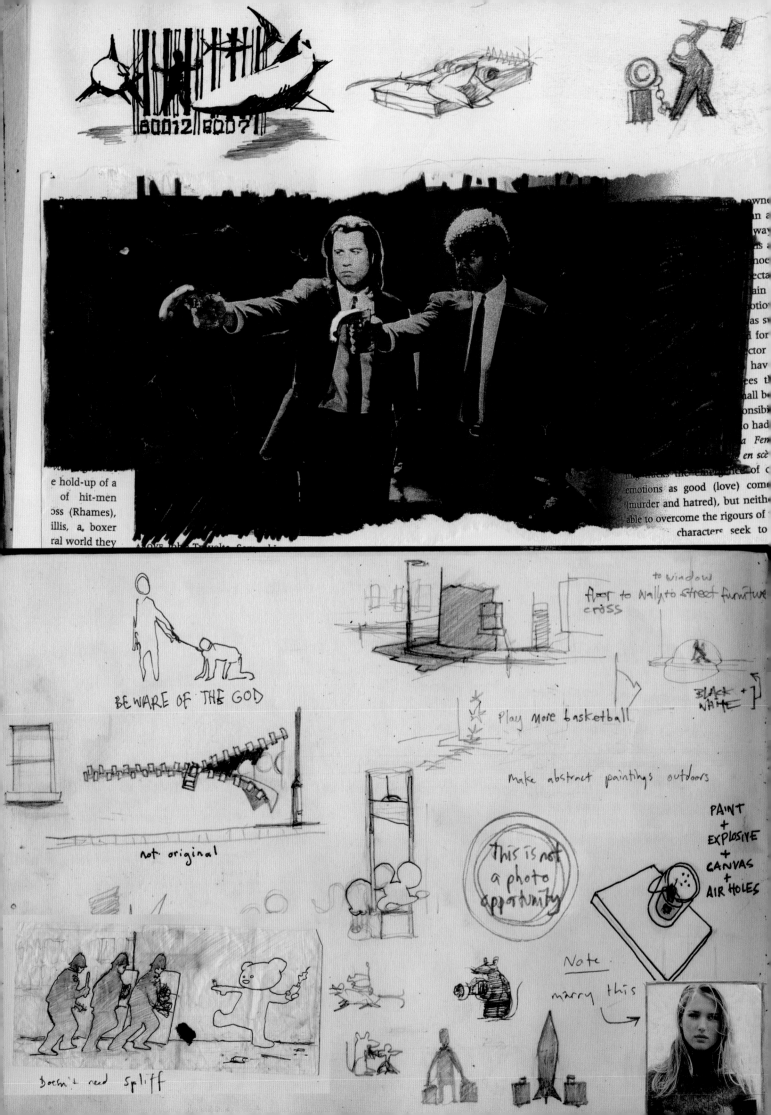

BOO12 BOO7

e hold-up of a
of hit-men
oss (Rhames),
illis, a. boxer
ral world they

owne
an a
way
as a
noe
ecta
ain
otio
as sw
d for
ctor
hav
ees th
all be
onsib
o had
a Fem
en scè
tracks the emergence of c
emotions as good (love) come
(murder and hatred), but neithe
able to overcome the rigours of
characters seek to

BEWARE OF THE GOD

to window
floor to wall to street furniture
cross

BLACK + WHITE

Play More basketball

Make abstract paintings outdoors

not original

this is not a photo opportunity

PAINT
+
EXPLOSIVE
+
CANVAS
+
AIR HOLES

Note
marry this

Doesn't need spliff

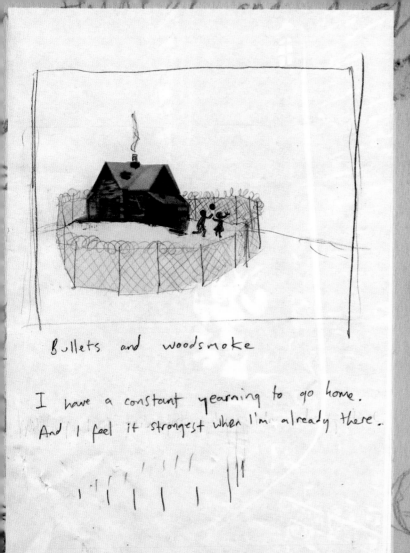

Bullets and woodsmoke

I have a constant yearning to go home.
And I feel it strongest when I'm already there.

Truer colour

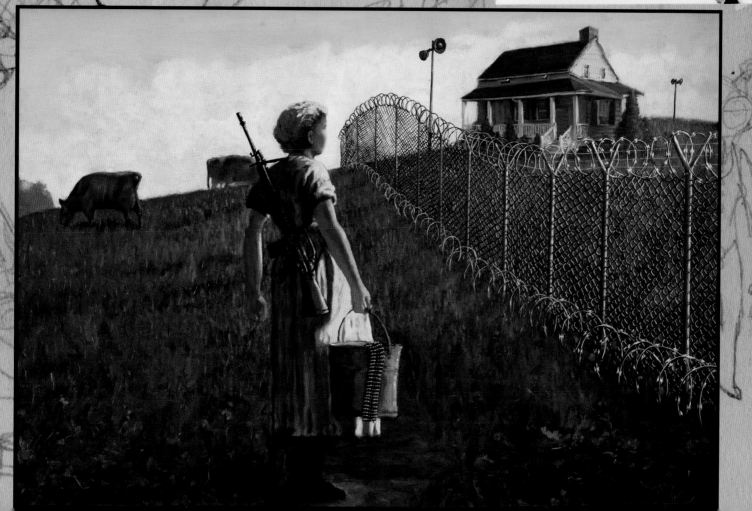

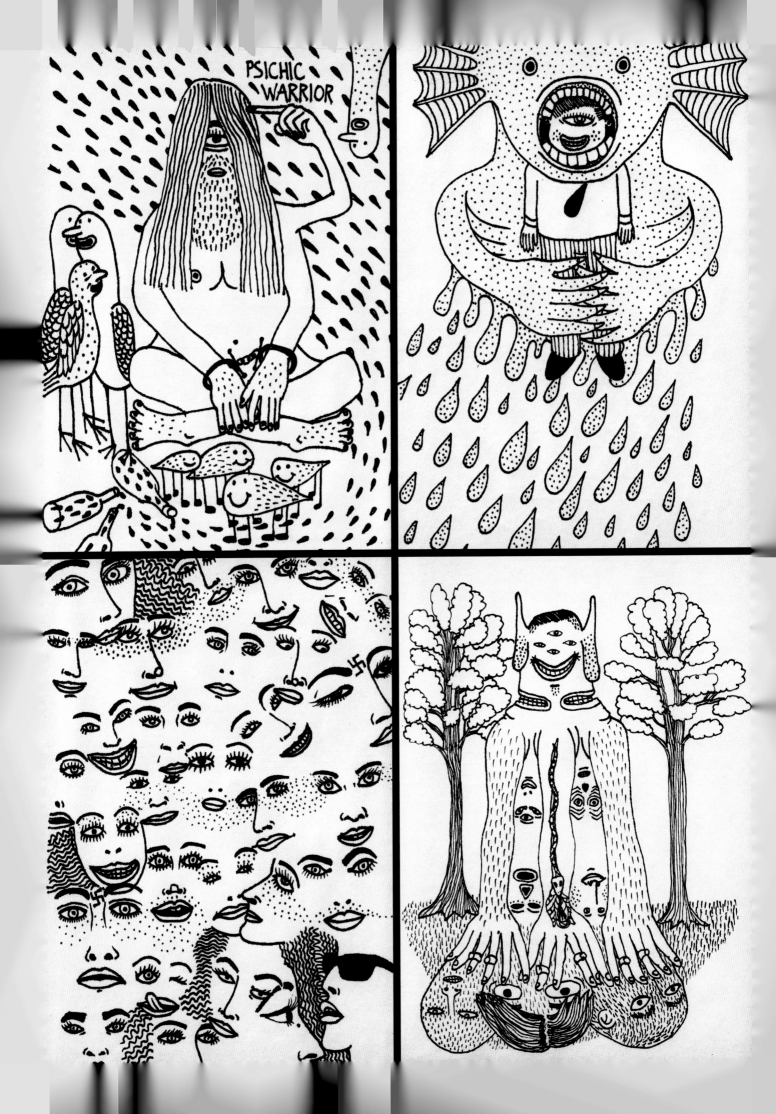

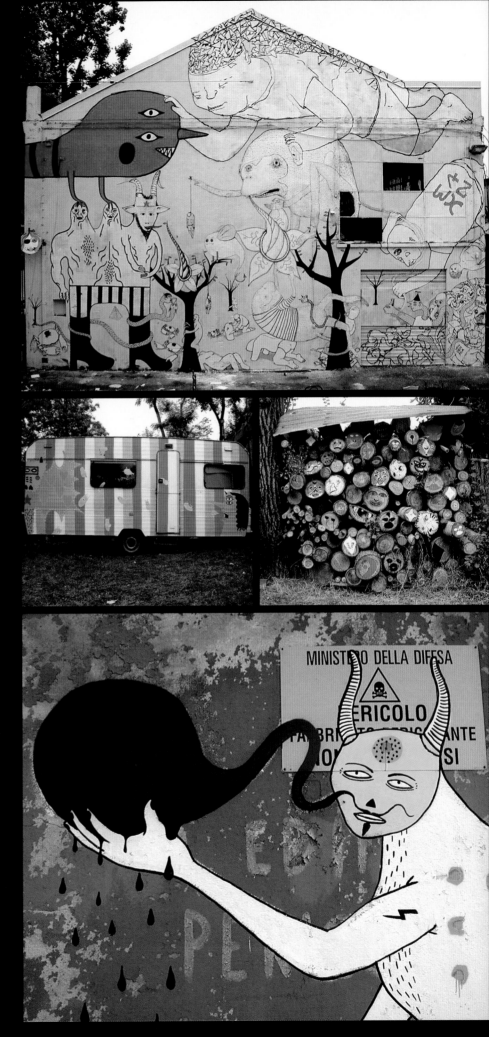

Dem

Dem lives in the Po Valley, northern Italy, in an industrial area that is often blanketed by factory fog. He started painting 'classic' graffiti in 1990, but by 2000 he no longer found archetypal graffiti writing satisfying and began to paint more figuratively instead. In his work he often depicts monsters or animals to reflect the distortion of human beings by society. Through these fantastical characters he feels more able to express himself using a language that is open to everyone.

All kinds of subjects fascinate him, from Homer's *Odyssey*, religious symbols, voodoo, demons and the Devil to ancient civilizations, African and prehistoric art, and contemporary artists such as Hundertwasser. 'A piece of paper and a biro will do for me and I enter into "my world",' he explains. 'With walls they tell me what to draw. I look at them and see the spaces that I must fill. I start with a shape and then develop it according to my mood or that particular moment. Each mural is specifically created for the space, and each place gives me different emotions that I then transform into drawings.'

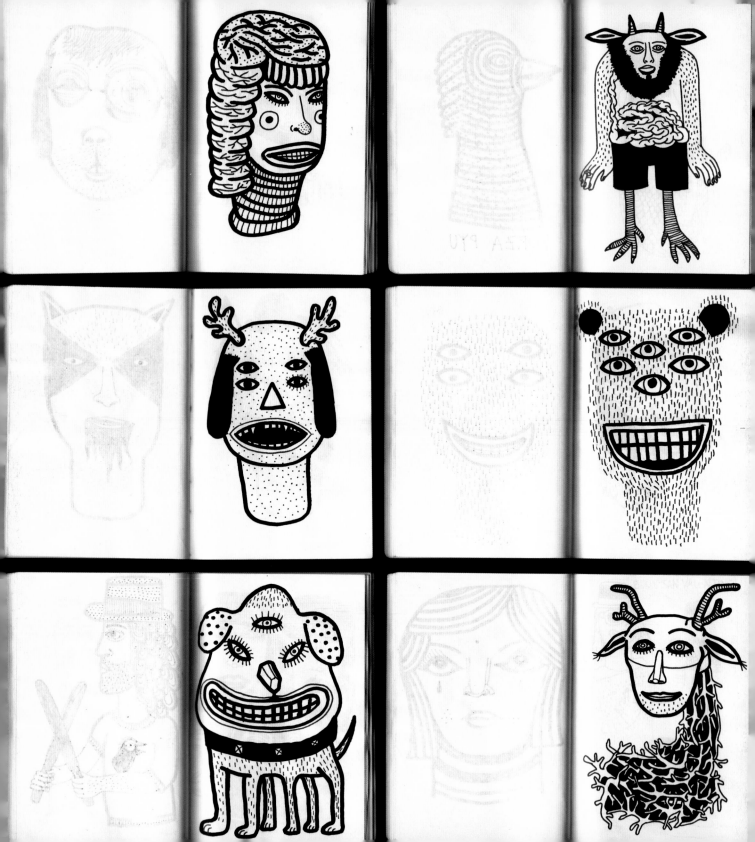

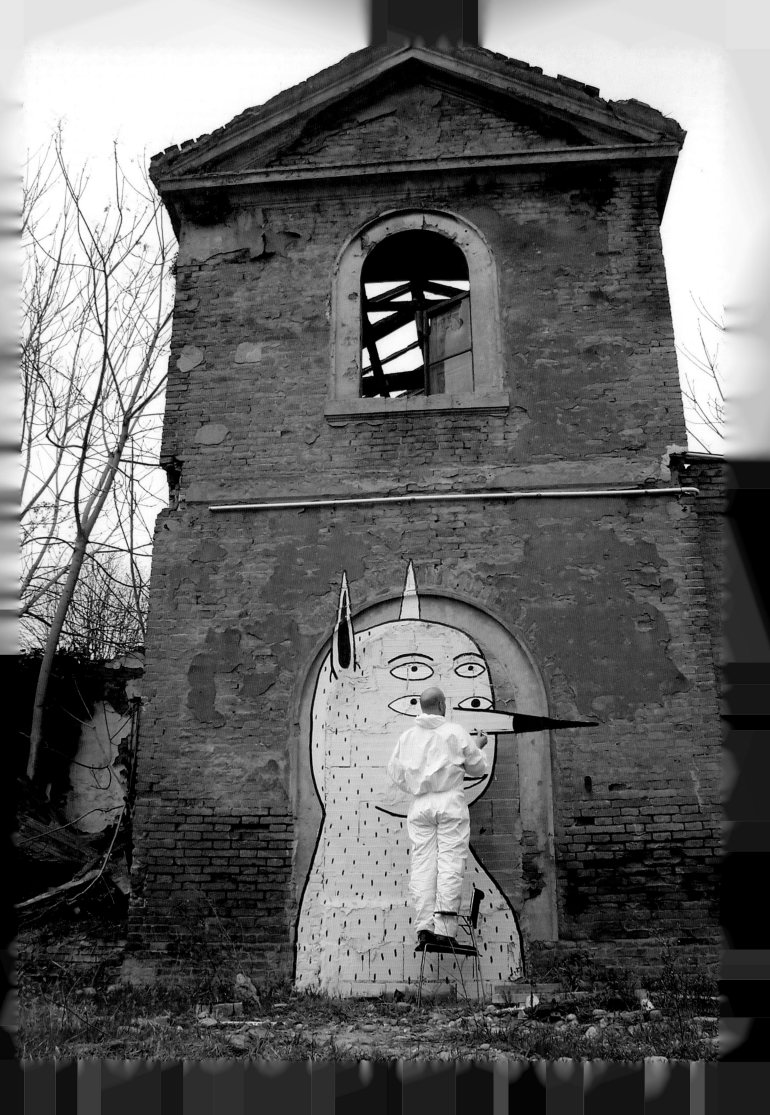

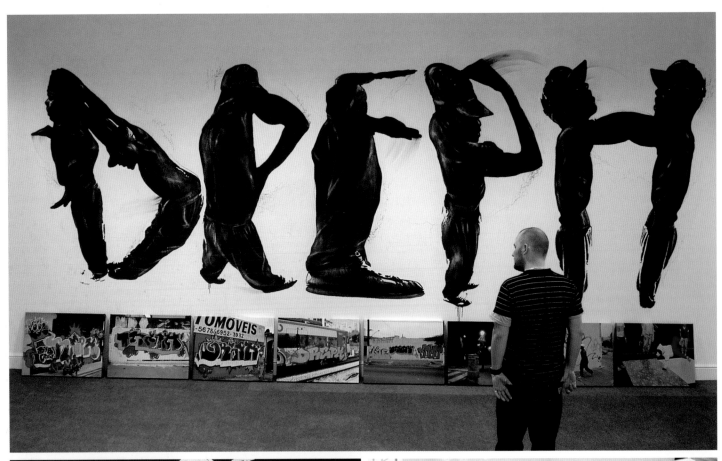

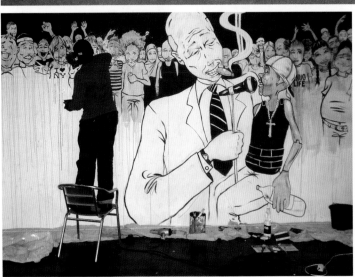

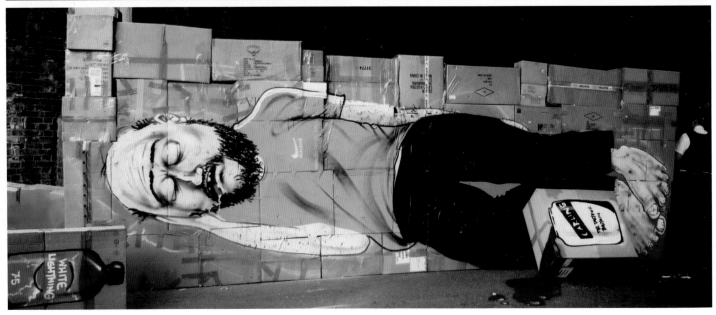

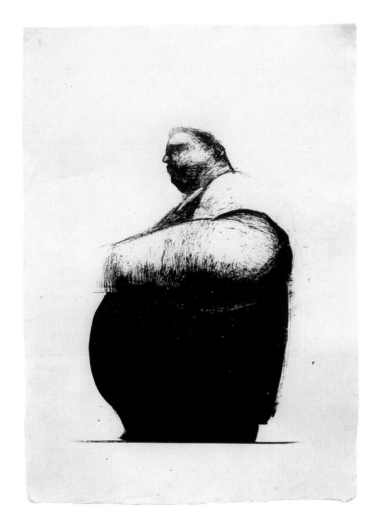

Dreph

Neequaye Dreph was initially inspired by the New York subway
art of the late 1970s and 1980s, which he felt was a new art
form challenging the status quo, but he didn't start painting
on the streets of the UK until 1985. Today, his work has
matured into expressive figurative paintings and installations.
Influenced by modern British living, Dreph fuses graffiti, fine
art and photography in his diverse and thought-provoking
work. In a recent installation, at the mouth of a tunnel in
Manchester city centre, he painted a large-scale reclining
figure onto a 'wall' of cardboard boxes to draw attention
to the homelessness within the city. He has painted in the
streets of São Paulo, Rio de Janeiro, Nairobi, Cape Town,
Mexico City and throughout Europe.

 Describing his sketches as 'visual Post-it Notes', Dreph says:
'They are a way to work through ideas. I observe people and
ask myself "why?" a lot. I have always used sketchbooks, but
I have never used them in the way "blackbooks" have been
traditionally used by writers – mostly it's quick sketches
as opposed to elaborate, laboured drawings. I'm interested
in how people behave in public. My ideas come from
conversations, popular culture and things I witness in daily
life or on my travels abroad.'

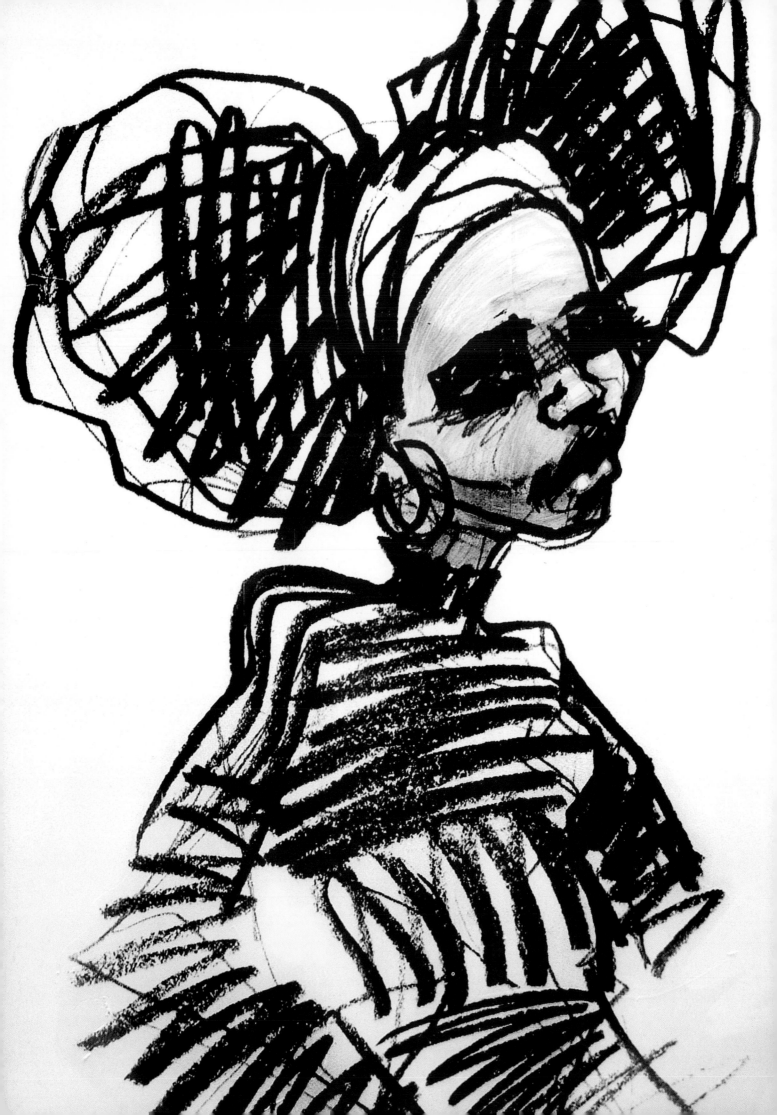

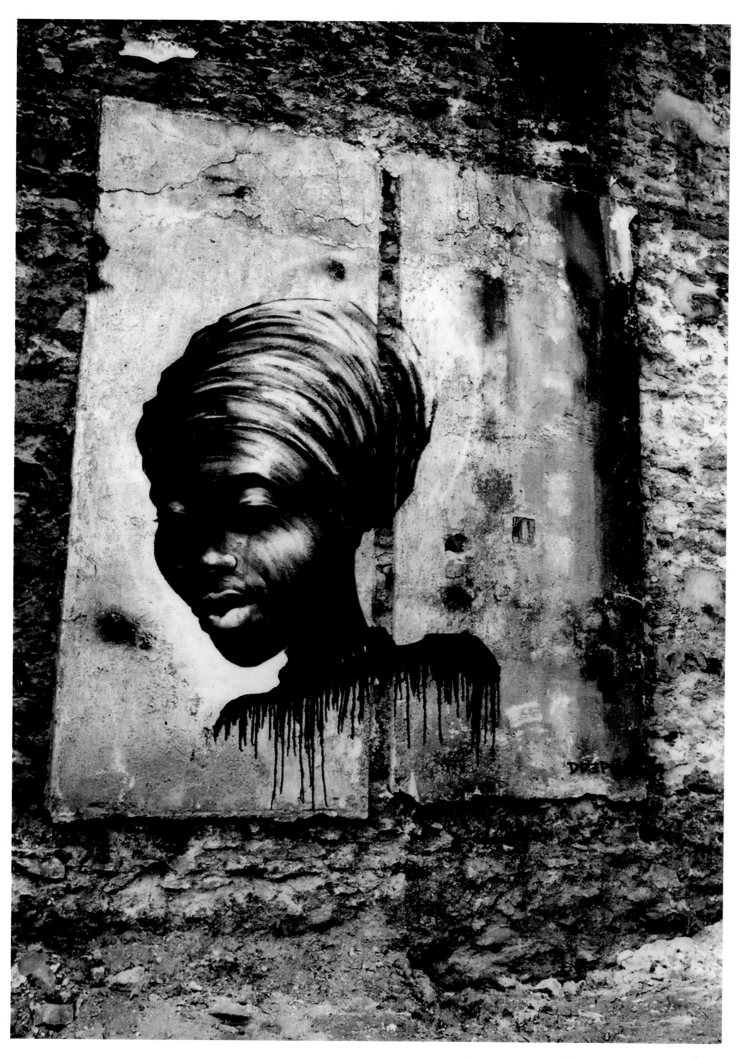

179 Dreph

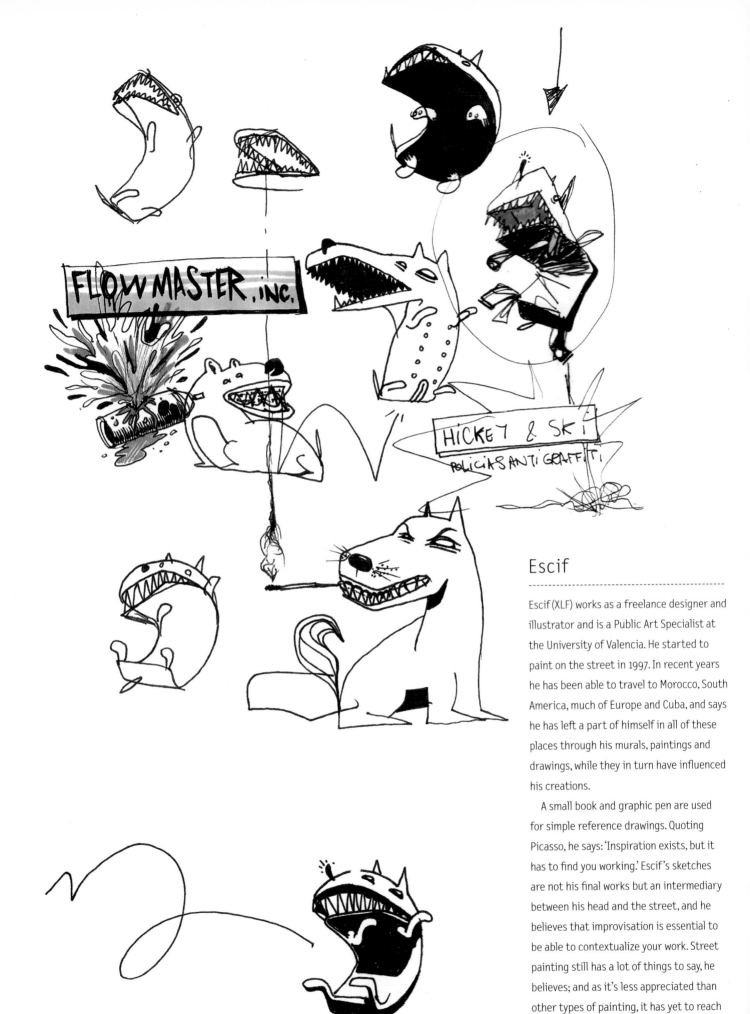

Escif

Escif (XLF) works as a freelance designer and illustrator and is a Public Art Specialist at the University of Valencia. He started to paint on the street in 1997. In recent years he has been able to travel to Morocco, South America, much of Europe and Cuba, and says he has left a part of himself in all of these places through his murals, paintings and drawings, while they in turn have influenced his creations.

A small book and graphic pen are used for simple reference drawings. Quoting Picasso, he says: 'Inspiration exists, but it has to find you working.' Escif's sketches are not his final works but an intermediary between his head and the street, and he believes that improvisation is essential to be able to contextualize your work. Street painting still has a lot of things to say, he believes; and as it's less appreciated than other types of painting, it has yet to reach its full potential.

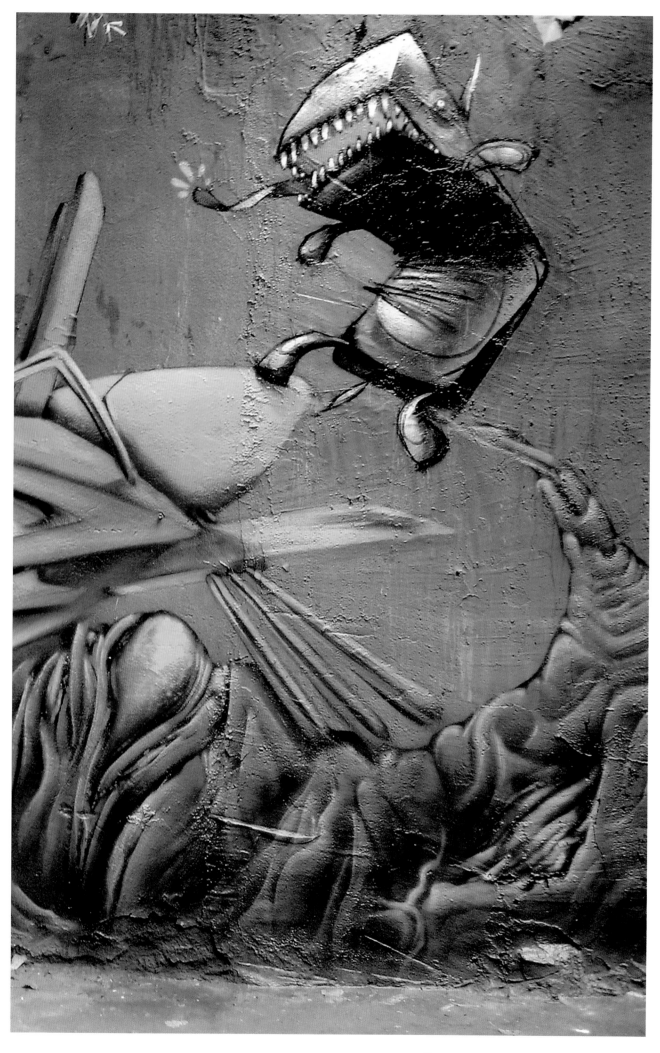

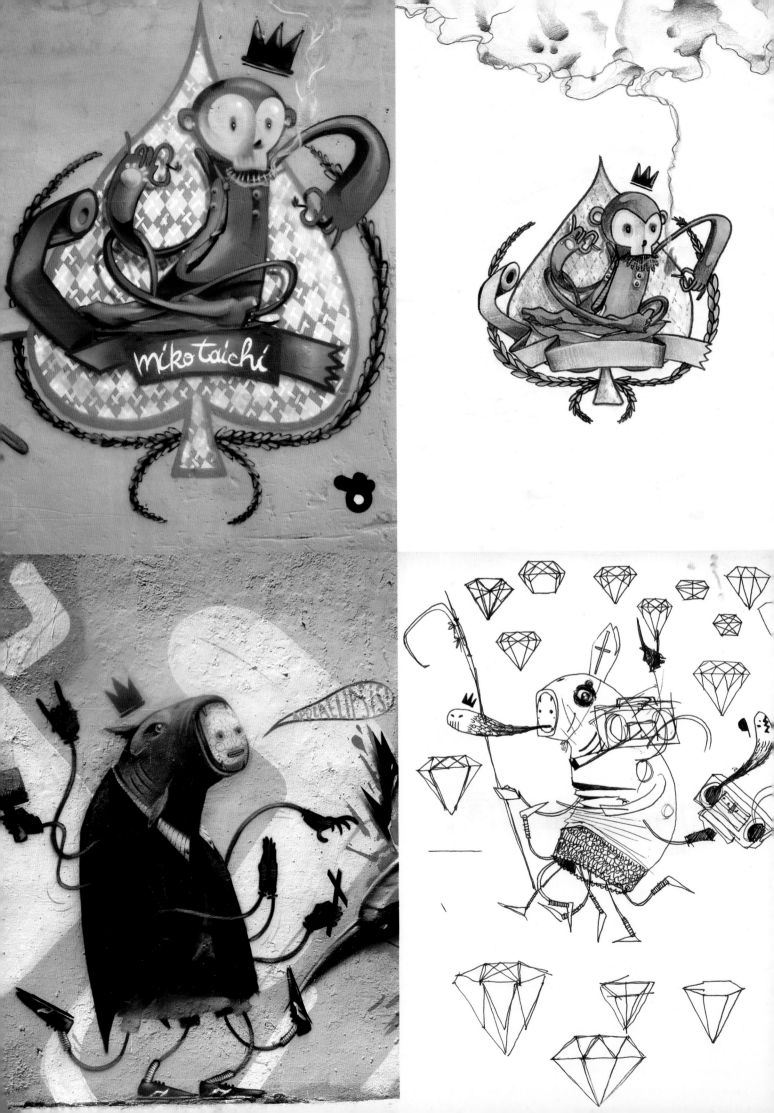

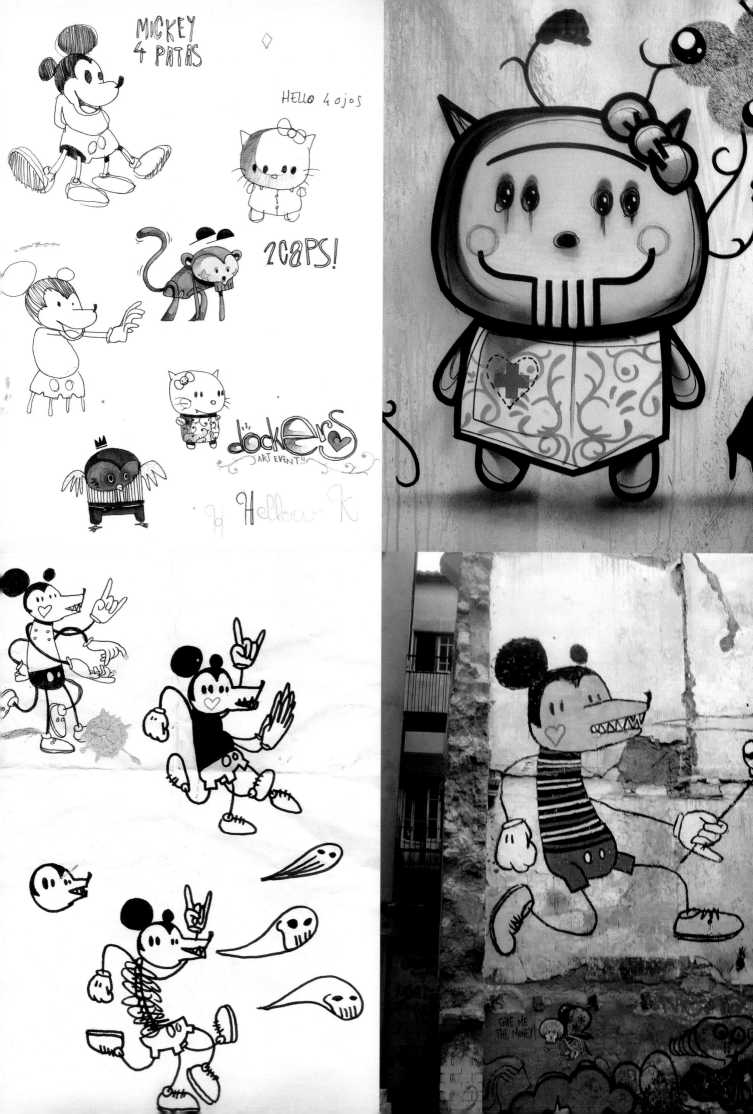

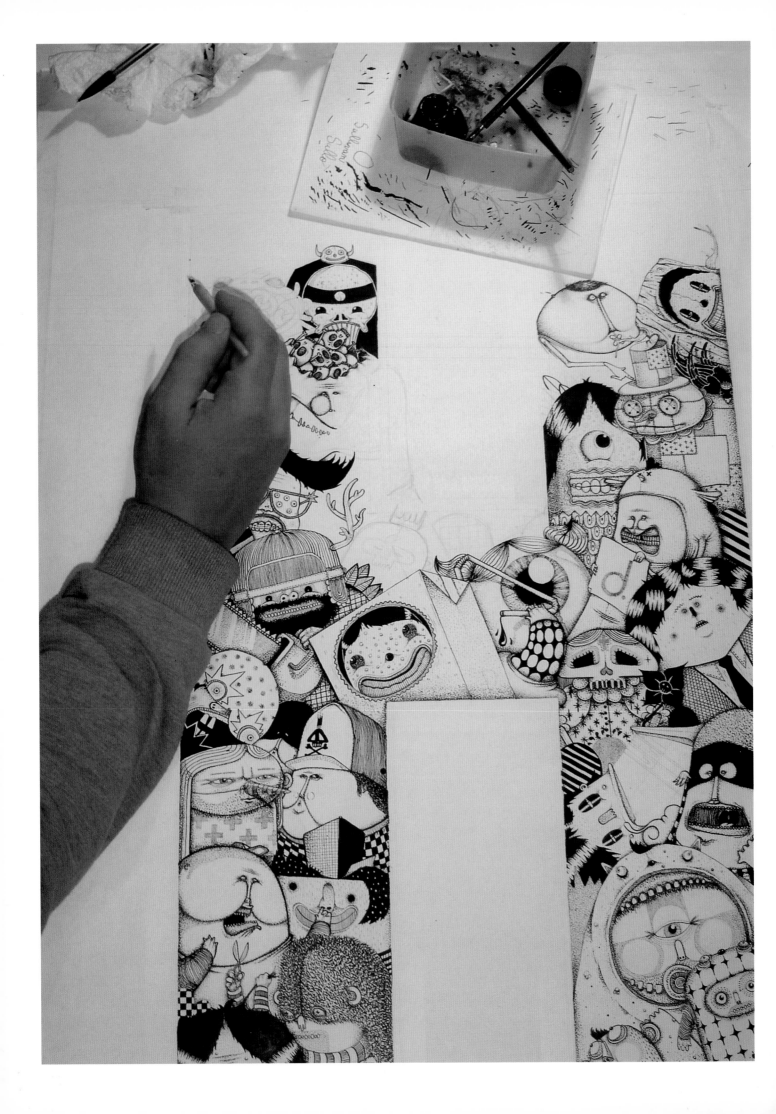

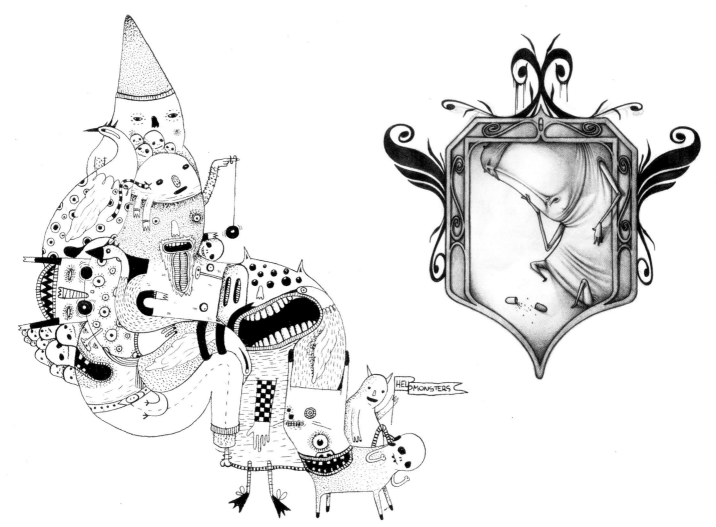

Hello Monsters

--

Hello Monsters is the collective energy of Blast, Desro, Ewing33 and Tatone. The four artists come from similar backgrounds—all attended fine art schools in different cities around Belgium and have been involved in graffiti. Their highly detailed pen drawings and graffiti works are full of character and invention.

Sketching is part of their preparation for pieces or design projects, but it's also an essential and communal activity for them: 'Drawing is just natural for us. It is a visceral activity, even a need. We have always drawn to put our thoughts down. A drawing isn't just a preparation; it can also be considered as a piece of art. We know each other quite well and we work on the pieces simultaneously.'

Their monster characters have not been directly influenced by anything in particular, although there are hints of the Garbage Pail Kids, Hieronymus Bosch and Pieter Brueghel the Elder. They are not meant to be scary but kitsch, in the spirit of *Ghostbusters* or *Star Wars*. Dense images are full of characters that can be psychopathic, schizophrenic and humorous, and they brim with details that come from the interactions between the artists, including monsters eating each other!

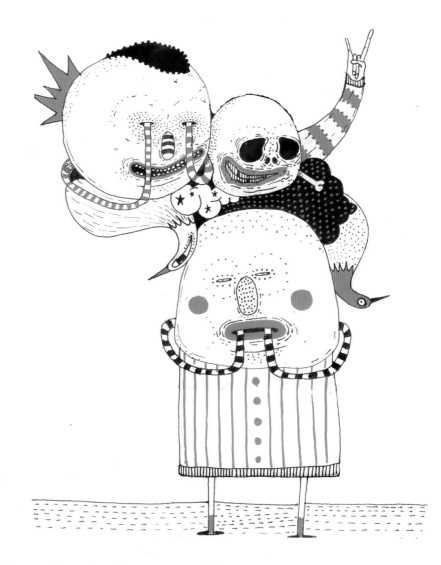

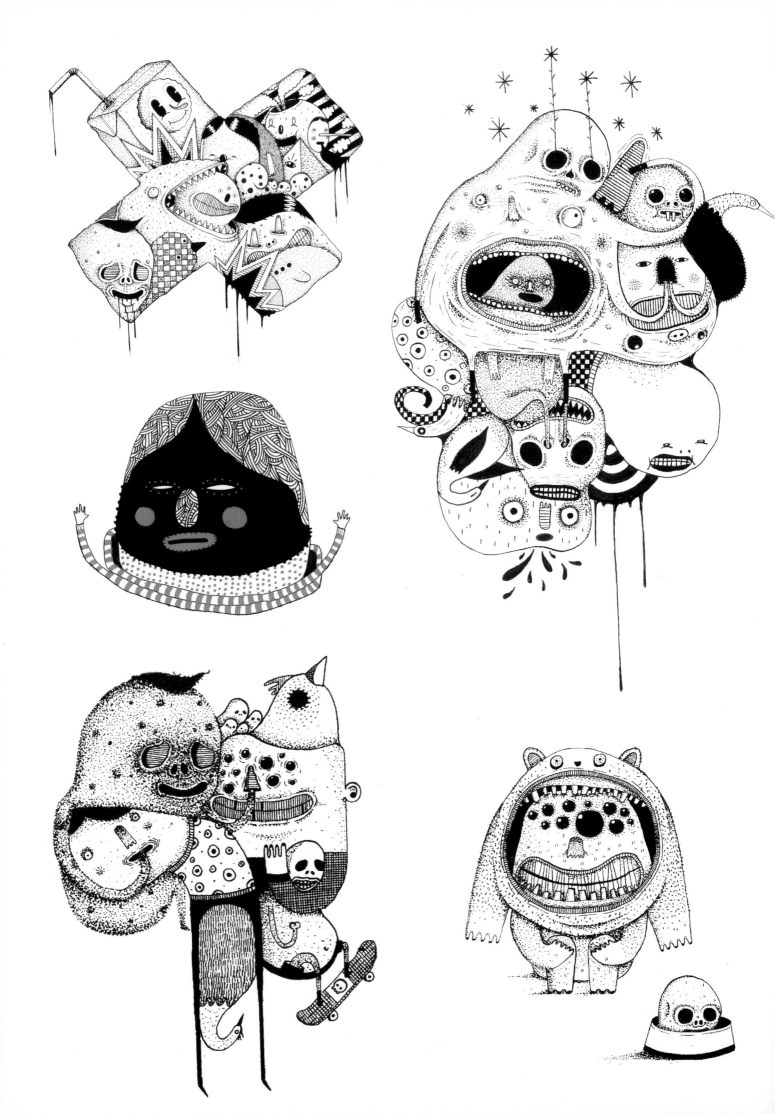

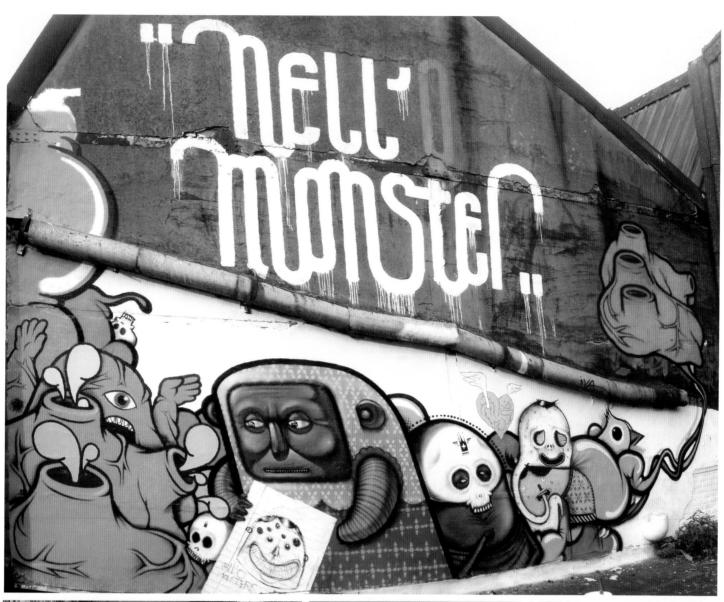

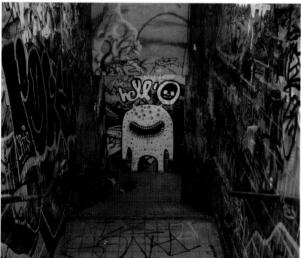

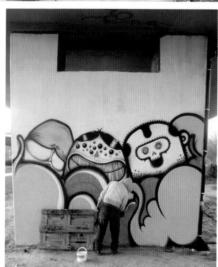

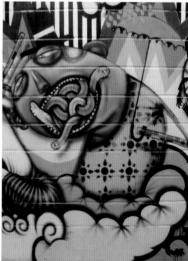

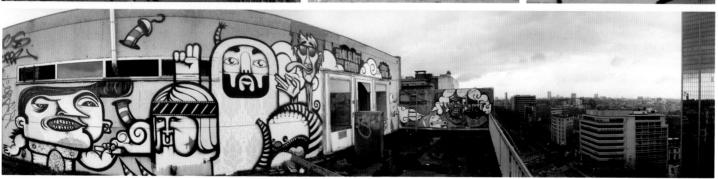

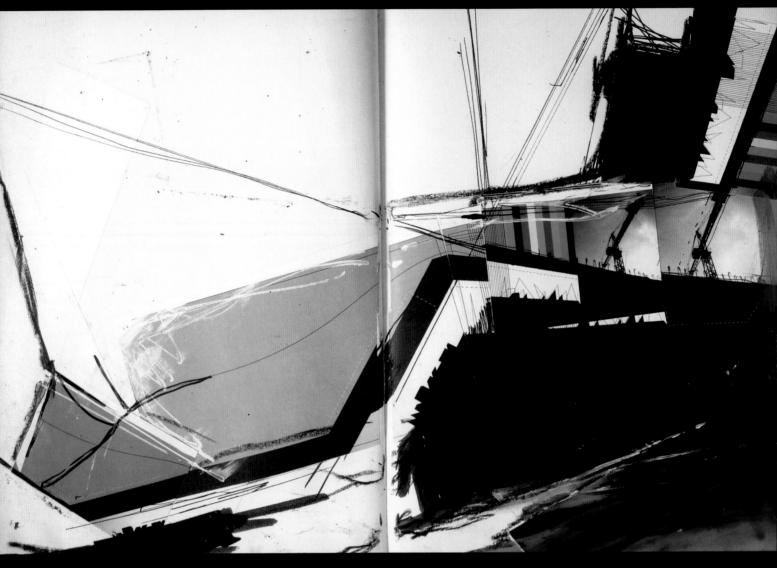

Iemza

Iemza grew up in Reims and came into contact with urban art through skateboarding. Soon he began painting graffiti with friends. Over the years the process evolved: his first graffiti was very technical, rich in colour and based on lettering; gradually he began to look more at the structure of buildings, the textures and deconstructed nature of abandoned spaces, which led him to reduce his colours and to deconstruct his own work, to be 'dirty, dark and without tricks'.

His sketchbooks are filled with a spider web of overlaid lines, perspectives and figures. He approaches them in a similar way to a wall, taking the space and size into consideration. On paper he builds up his own structure and texture; on walls he uses what he finds. Sometimes he integrates salvaged materials into his sketches, such as found paper, thread mixed with photographs, ink and drawings. Abandoned places stimulate his imagination: in his drawings he distorts architectural perspectives to disturb and make the city come alive, a characteristic that is mirrored in his figurative work in which he deforms and twists the human form to explore fragility, inner demons and weaknesses.

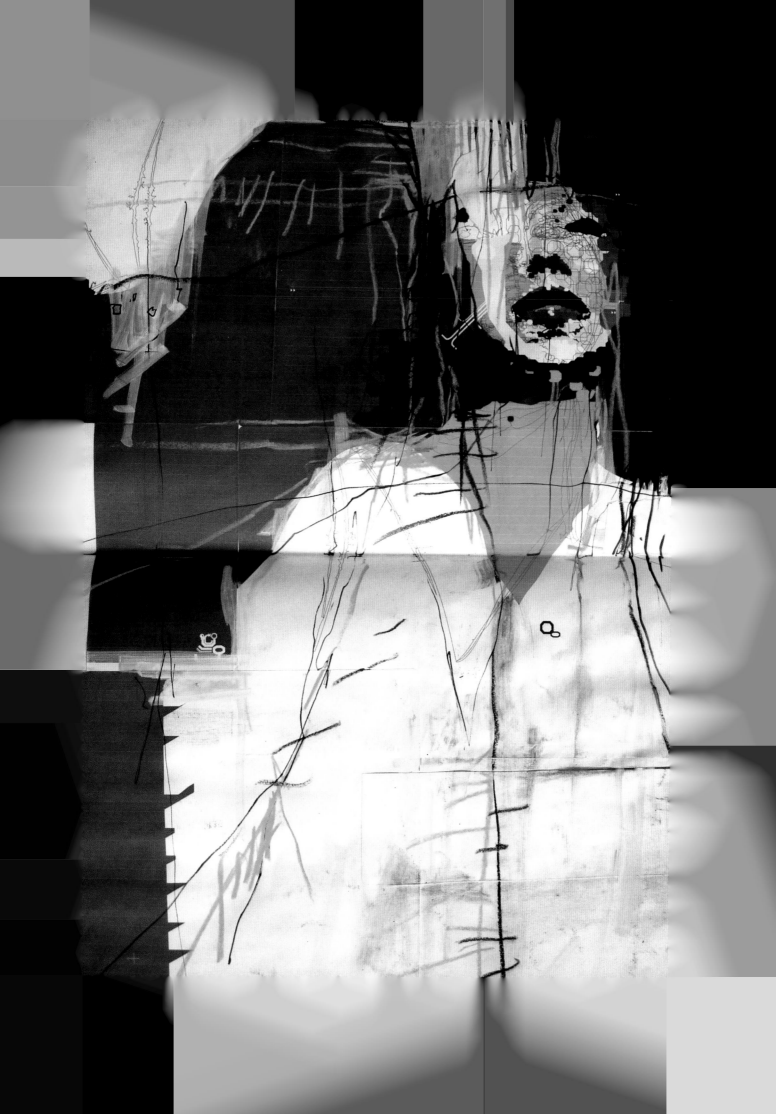

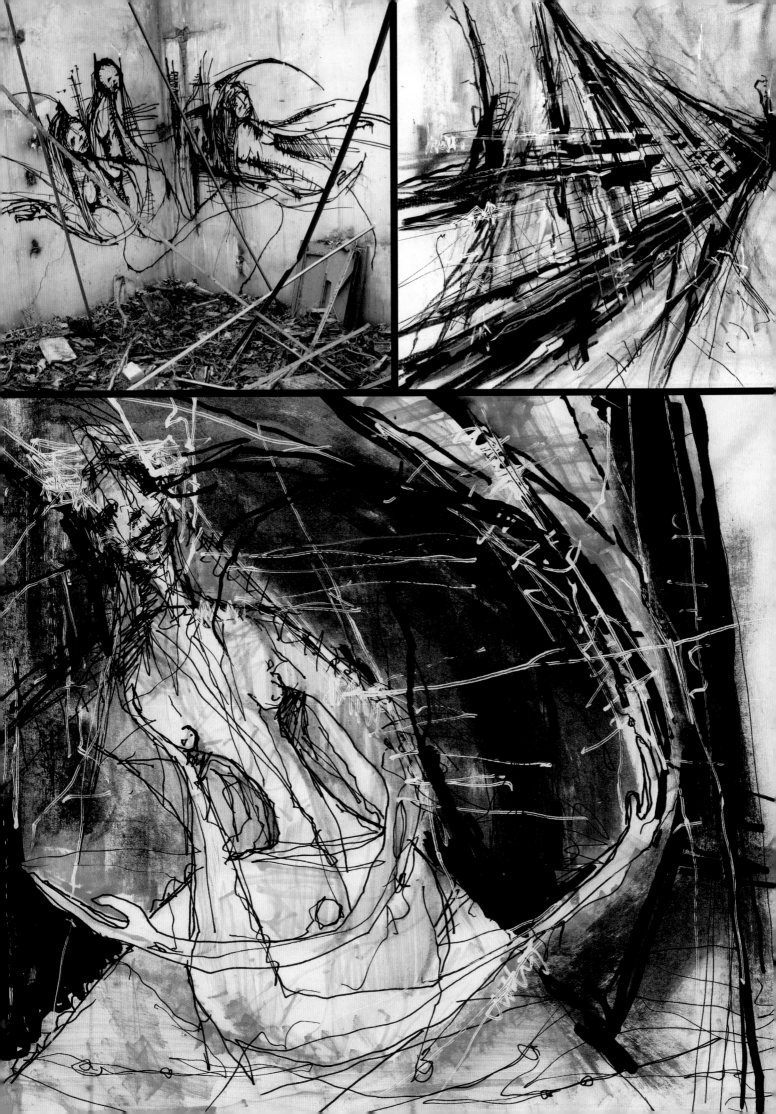

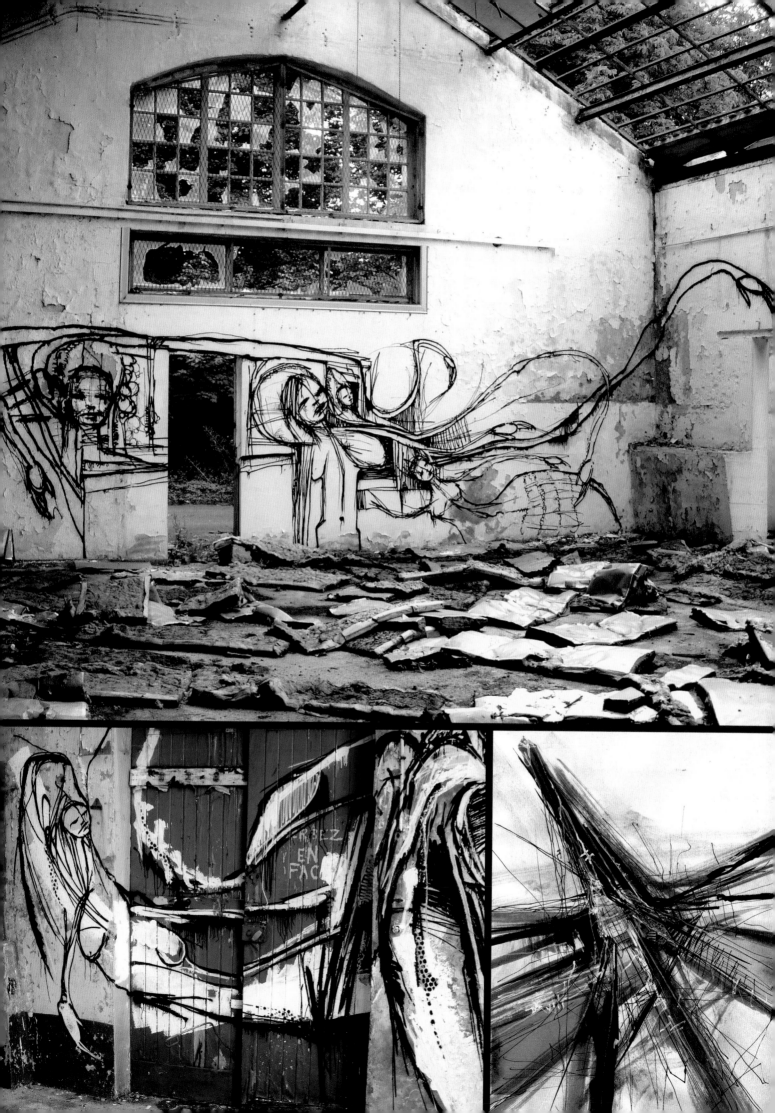

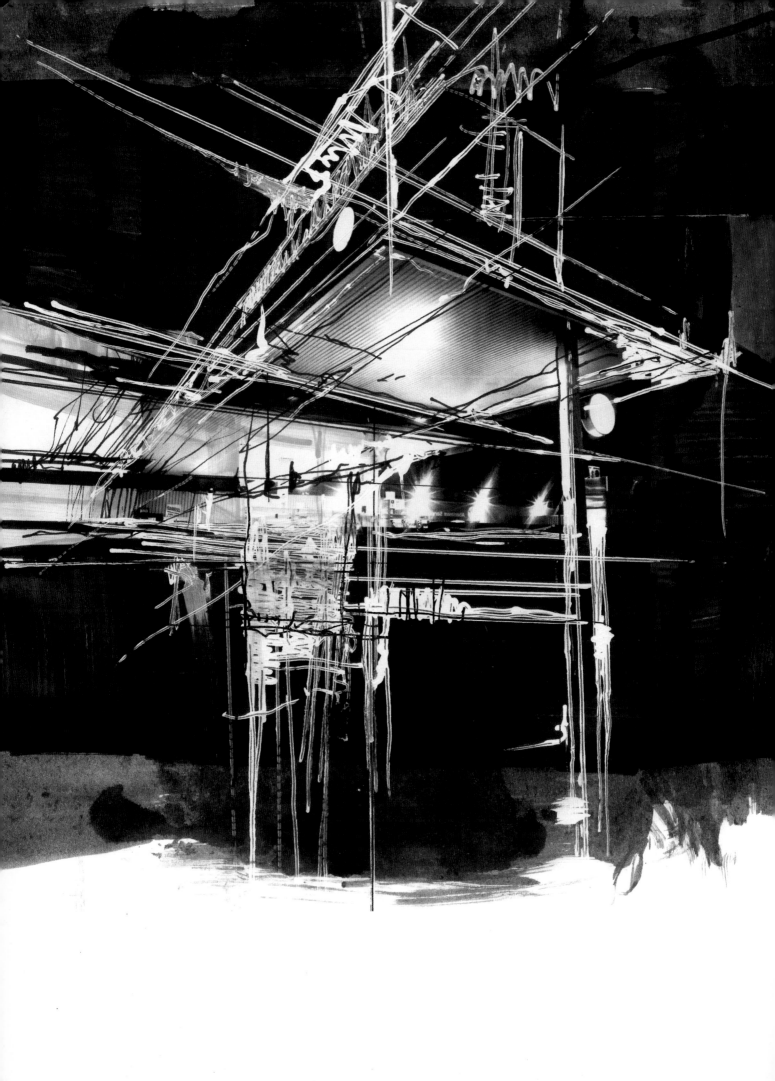

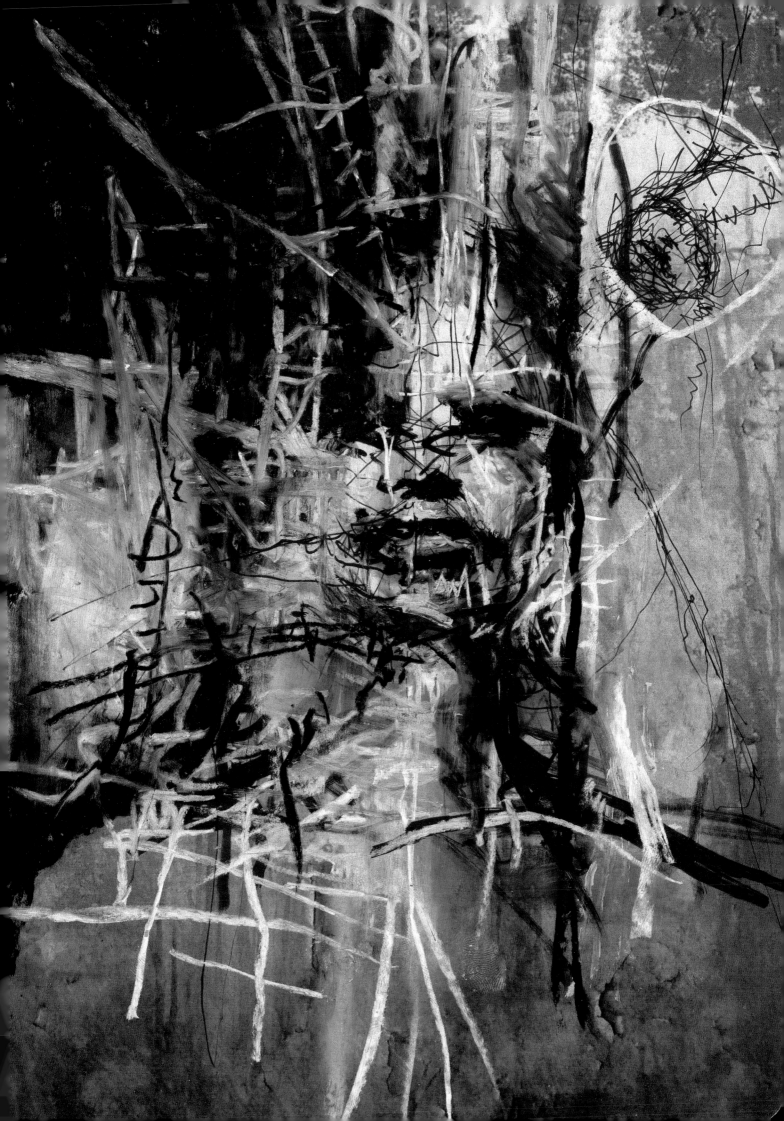

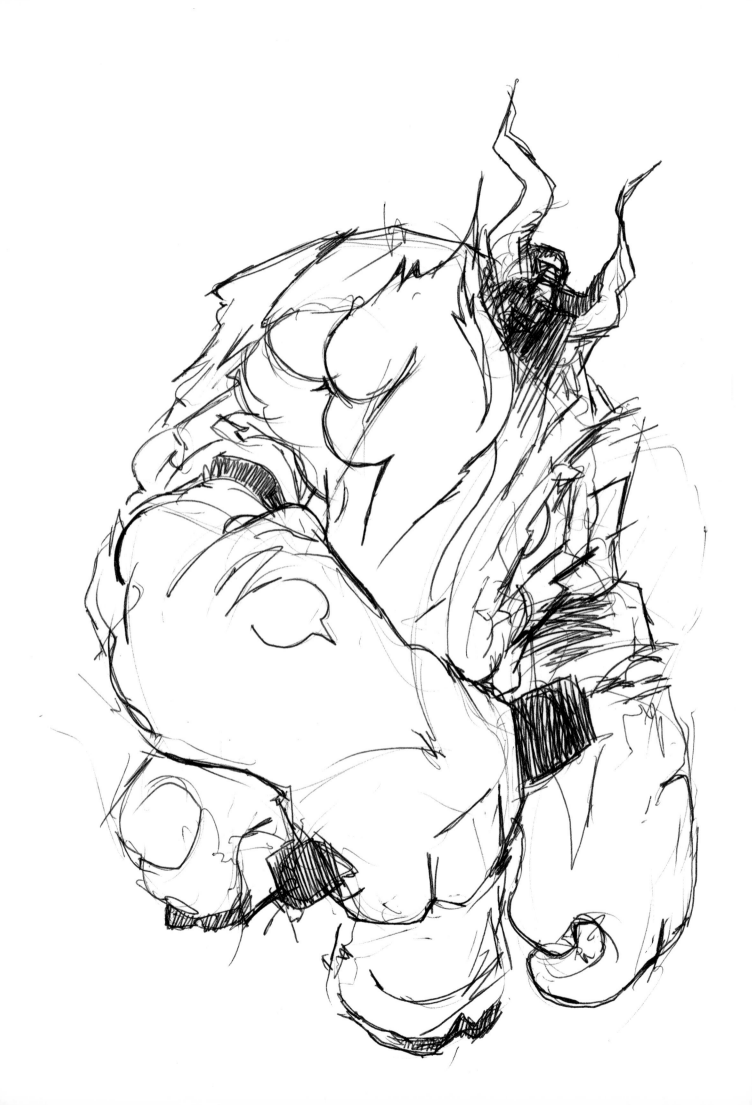

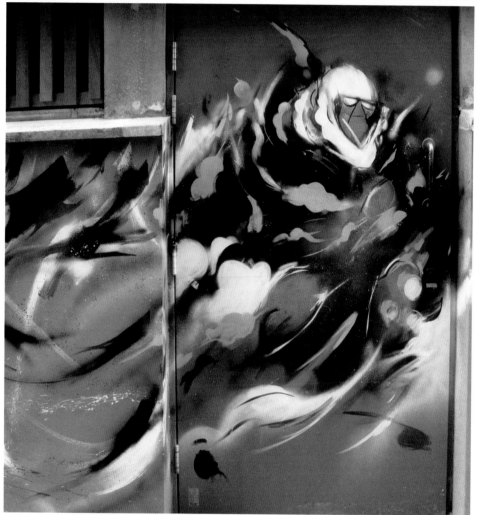

Duncan Jago

Slightly disgruntled-looking bio-mechanoids populate landscapes reminiscent of abstract Japanese woodblock prints. It's a strangely beautiful world conjured up by Bristol-based Duncan Jago, who describes himself as a starving artist and wildlife enthusiast. He modestly fails to mention that, as a member of the Scrawl collective, his work has been hugely influential and attracts a cult following. His own influences include graffiti artists like Futura 2000, Japanese art and the original *Star Wars* trilogy. Even as a child living in a small village, the hip-hop phenomenon managed to somehow reach him, and seeing Dondi's spraypainted renditions of Vaughn Bodé characters was the starting point. Today nature is his biggest inspiration.

In the late 1990s he famously developed his style while doodling away the boredom of an office job. Those doodles gradually blossomed into a freelance career. These days he still draws nearly every day – usually late at night, the later the better. Although generally not an illegal graffiti painter, large-scale brush painting on walls or canvas is an important part of his work. Sketches are a reference for his paintings, but they usually end up being quite different. With both his drawings and paintings he keeps things loose, building up structure through layers of exploratory lines.

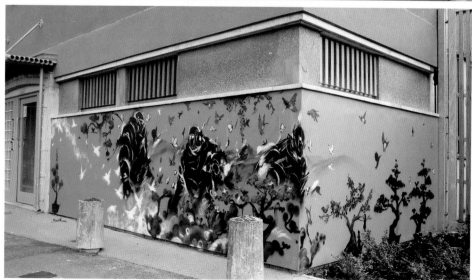

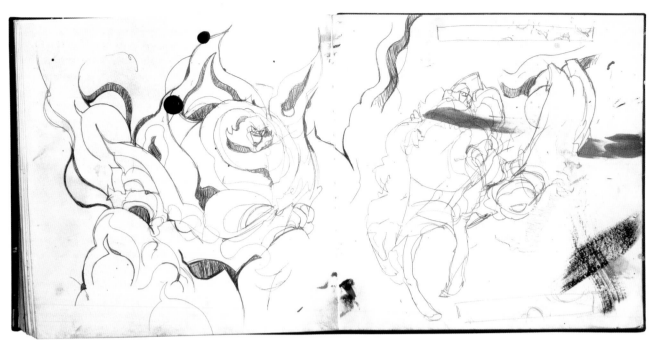

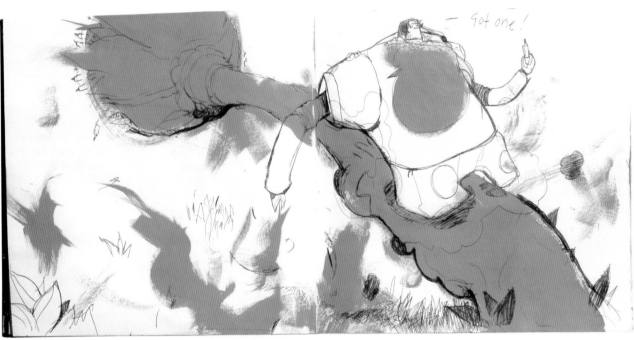

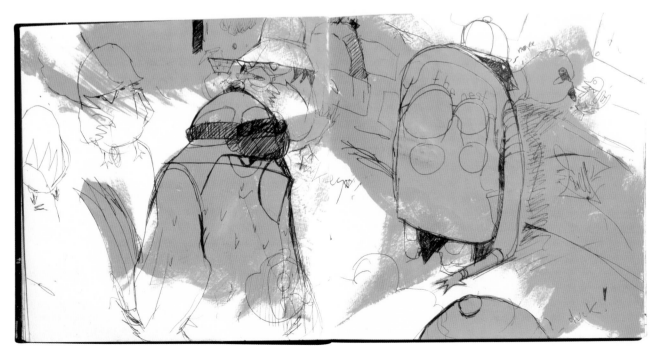

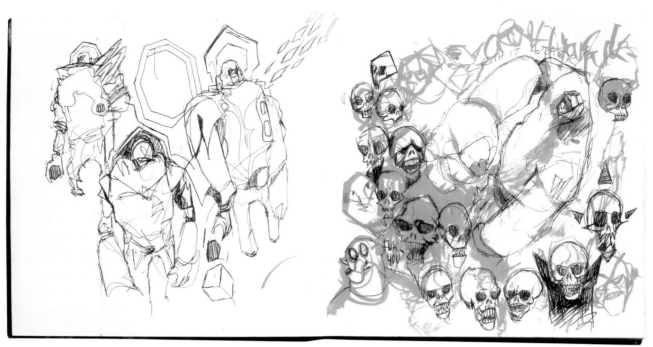

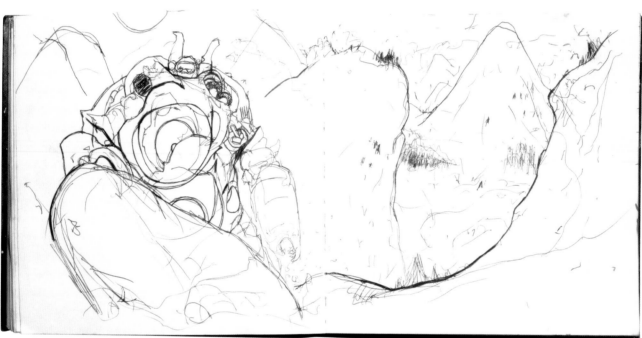

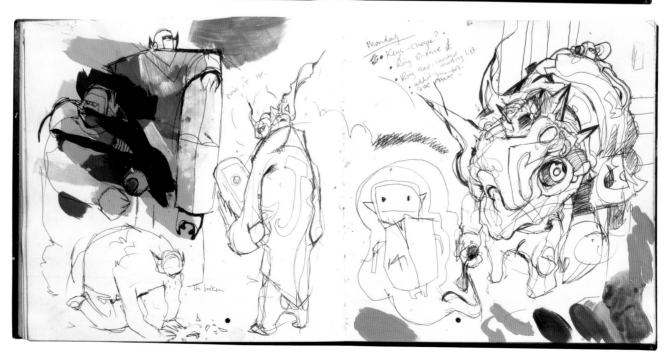

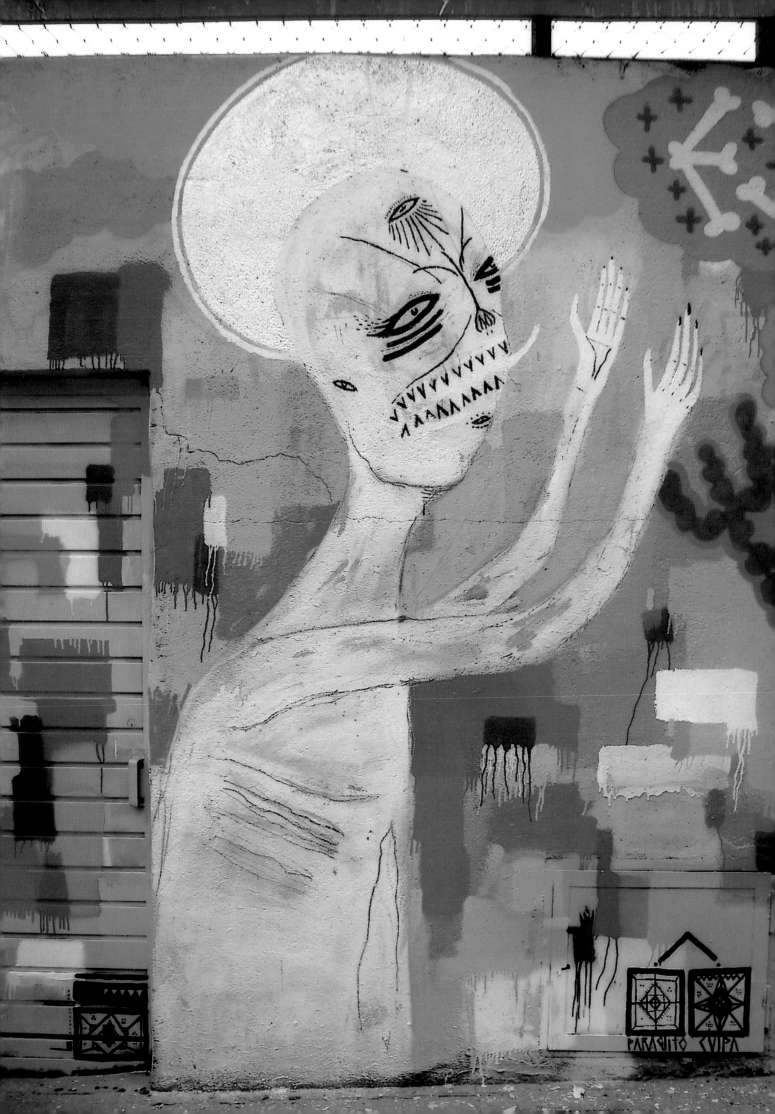

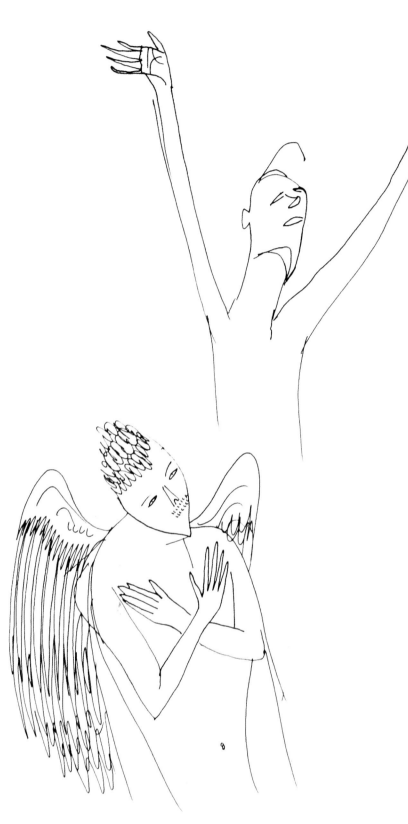

Kafre

--

Kafre (aka León Ka) is a painter and philosophy
graduate from Barcelona whose interest in
history and philosophical theory is strongly
represented in his work. Among his influences
are the engravings of Paracelsus, scientific
illustrations and Romanesque and early
Gothic art. Generally his drawings are symbolic
representations of theoretical concepts,
although he also enjoys drawing freely without
any forethought or deliberation.

 For drawings he uses pen and black ink; on
walls, sharp tools to scratch and scrape; and on
canvas, oil paints and brushes. Describing his
methods, he says: 'Technique in mural painting
has been one of my constant obsessions, a
sort of savagery in action. I differentiate and
change my style of representation depending
on where I'm working. On walls, it's on a large
scale and ritualistic; on canvas, it's symbolic.'

 A consistent and difficult theme throughout
his work is 'the insubstantial nature of
existence, evil and the total absence or
deconstruction of everything': 'It all comes
down to a series of personal themes that I use
to symbolize my obsessions. My work forces me
to approach everything organically because
the subject matter is so difficult to tackle.'

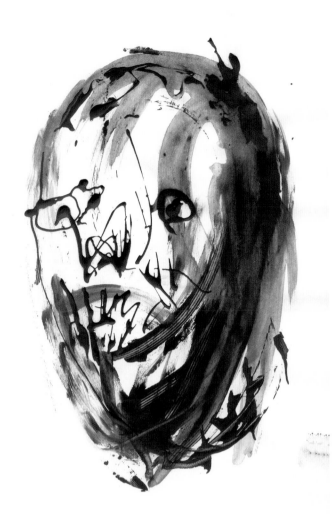

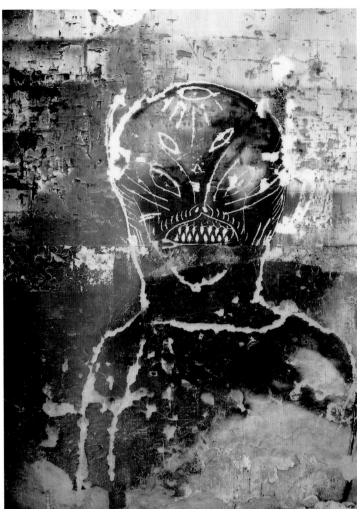

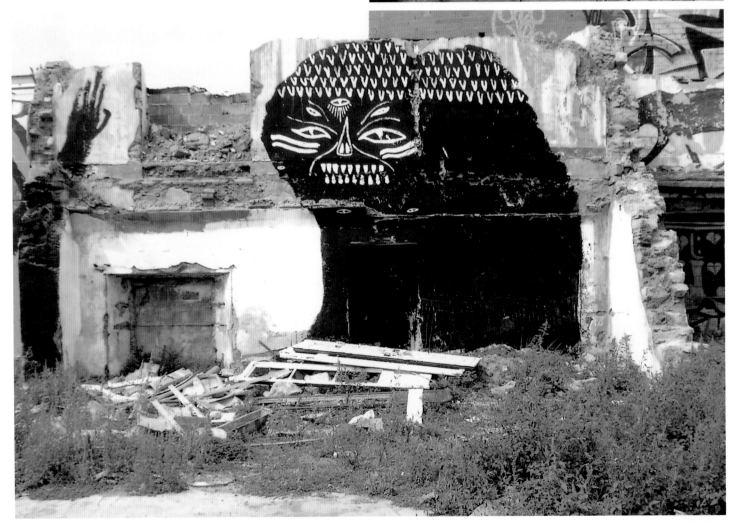

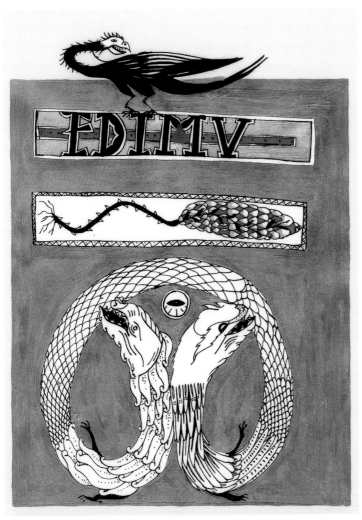

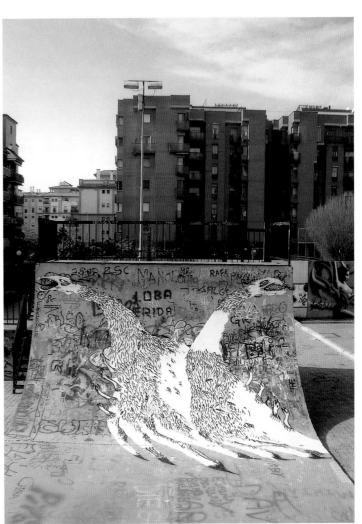

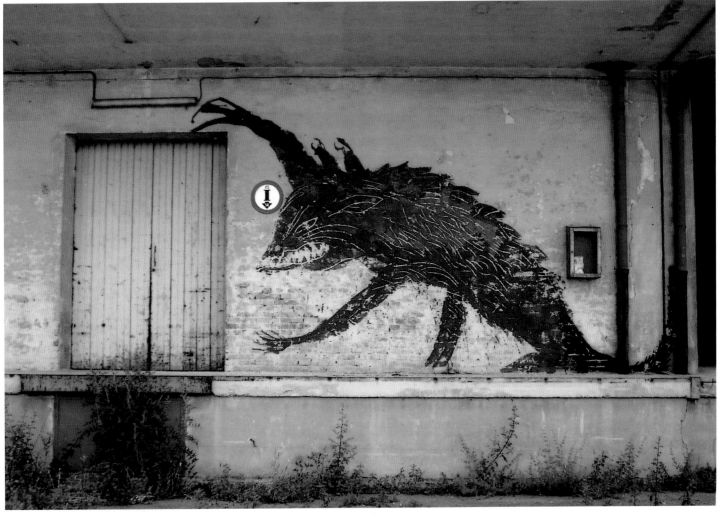

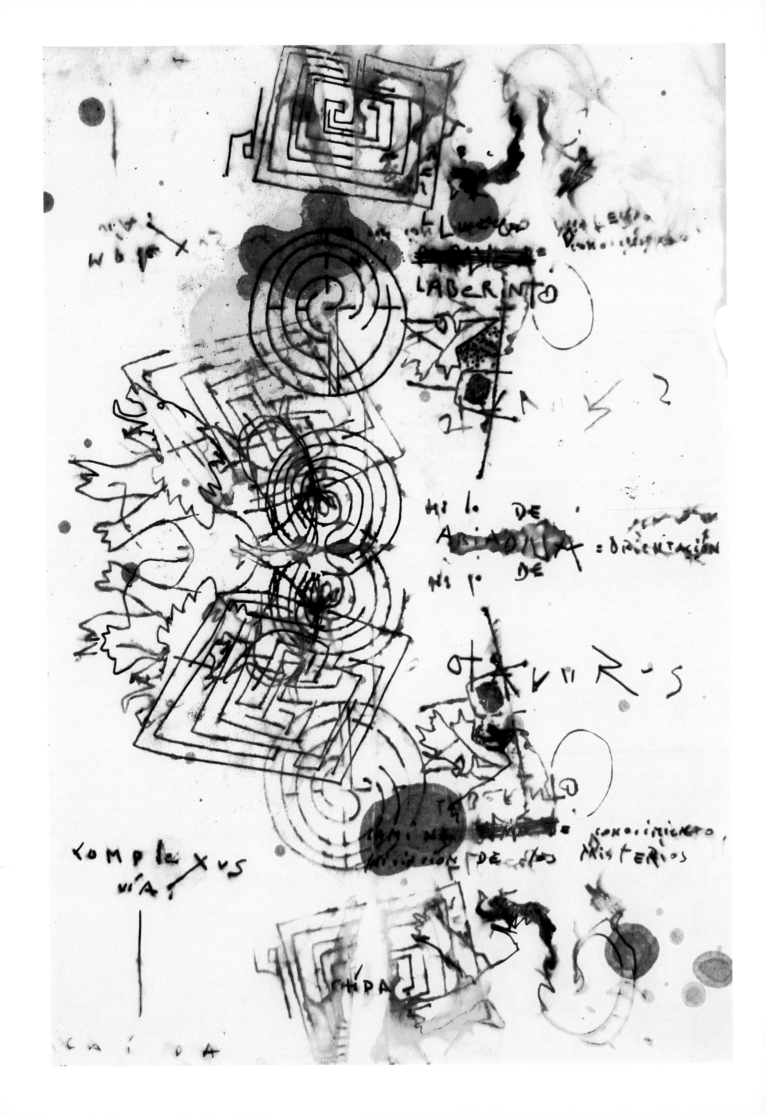

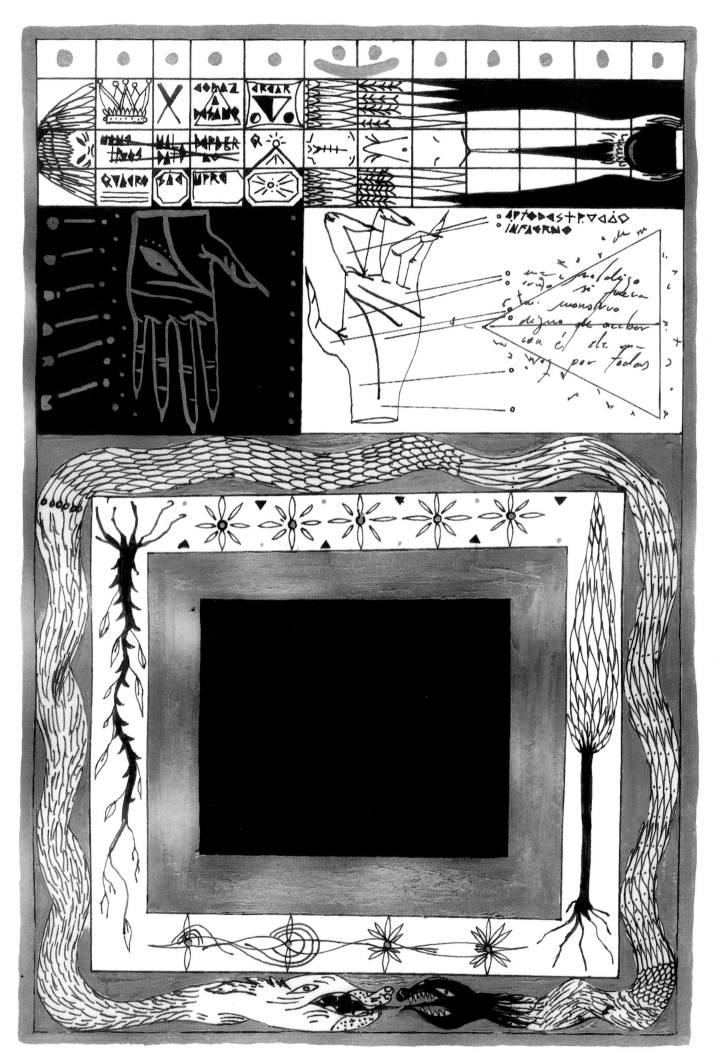

203 Kafre

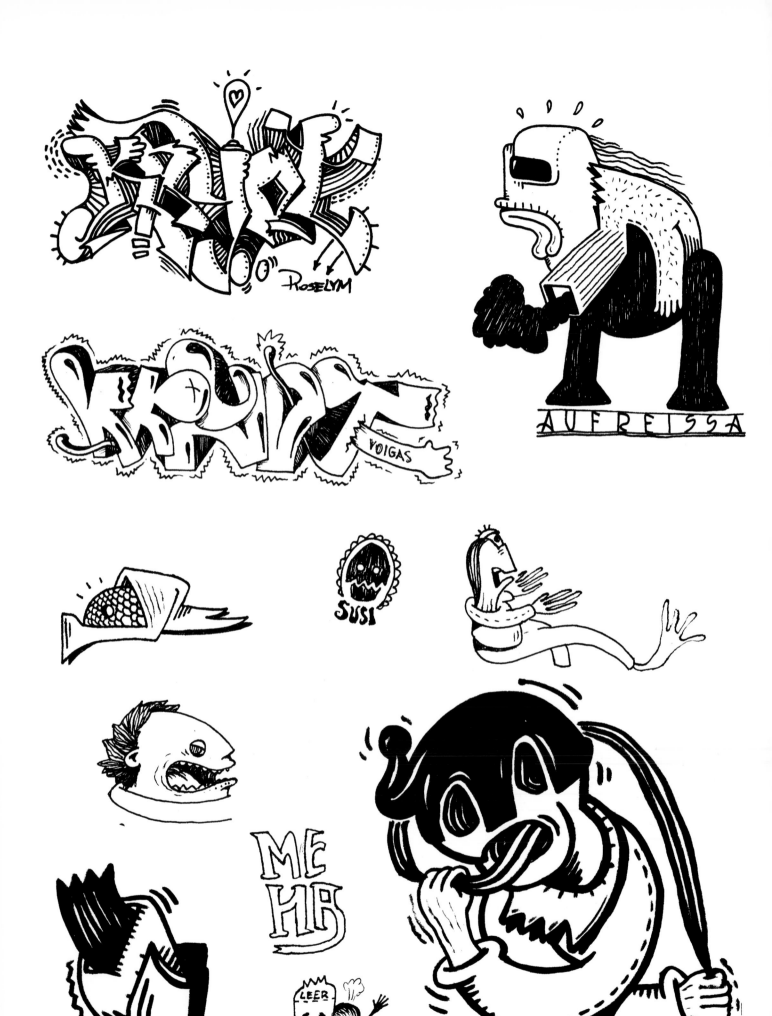

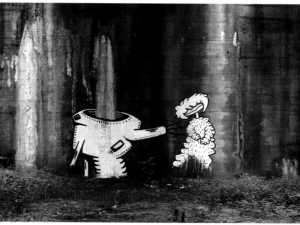

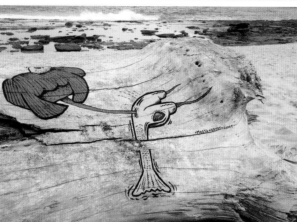

Kryot

Austrian graffiti writer Kryot has spent a
good deal of time in Venezuela and Brazil.
Austria, he says, is a good place to live but
not the best for painting, although working
with local artists in South America has
been influential. His sketches are a kind of
training and documentation of his personal
style. 'I don't see the image as something I
would like to transfer to another spot,' he
explains. 'So I never use any of my sketches
in my work outdoors or on canvas. My work
develops outside — the spot I paint feeds me
with ideas!'

Kryot's work has gradually evolved. He
started out more or less copying B-boy
characters from graff mags, moved on
to letter styles and full-colour blackbook
pages, and then to roughly sketched
naturalistic characters. He slowly left the
classic 'style-writing' behind, picking out the
essential lines and using them in a different,
simpler context.

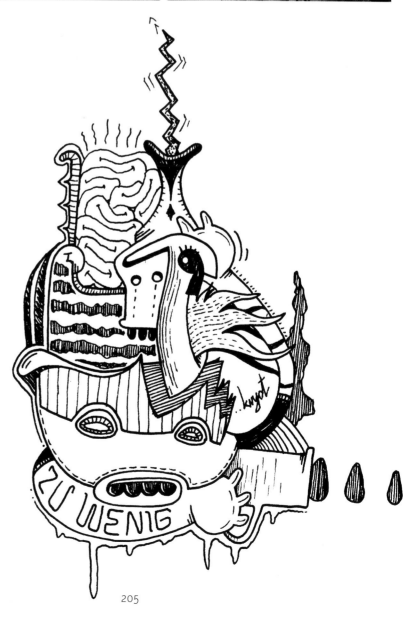

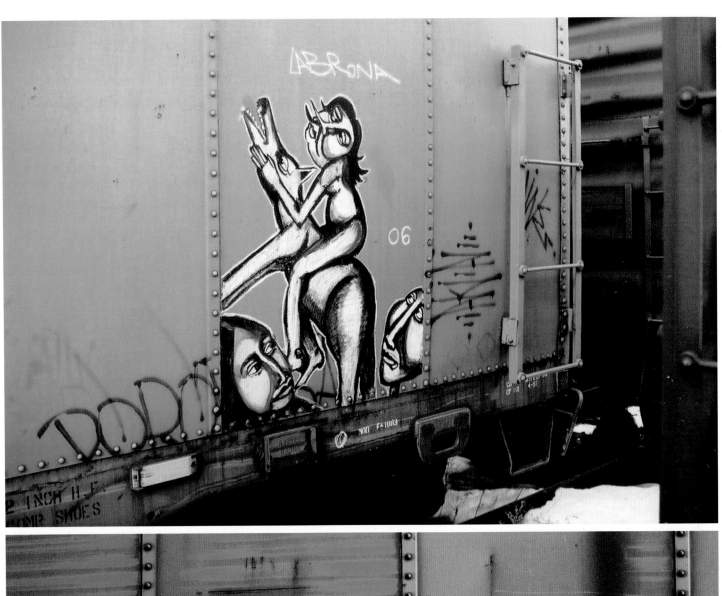

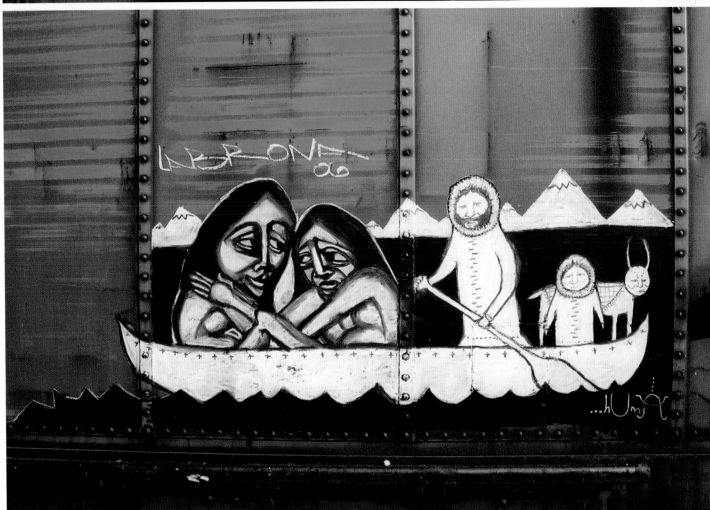

Labrona

Even in Montreal's deepest winter, rusting freight trains are Labrona's (aka Felix Berube) surface of choice. When painting a train, he never brings along any sketches; instead, a composition will come to mind on the walk to the train yard. Sometimes he brings a photo as a reference but he always draws rough lines first, which then evolve into the final oil stick drawing. His drawings on trains are a kind of sketch, he feels, and he refers to his photo album of freight train paintings like a sketchbook.

Growing up, his dad's own drawings were an early inspiration, as were 20th-century painters such as Picasso, Diego Rivera and Expressionists like Max Beckmann, who is a noticeable influence in his figurative work. He uses the human figure, especially the face, to convey emotions and ideas, but the state of the world, war and other scary issues provide a subtext to many of his paintings. 'I hope my work isn't as dreary as my concerns,' he says. 'I love colour and have been using it more to brighten things up.'

Classic themes reoccur in Labrona's work, including human behaviour and good-versus-evil power struggles: 'Painting is my language, so it's really hard to put into words. I let the work tell the story.'

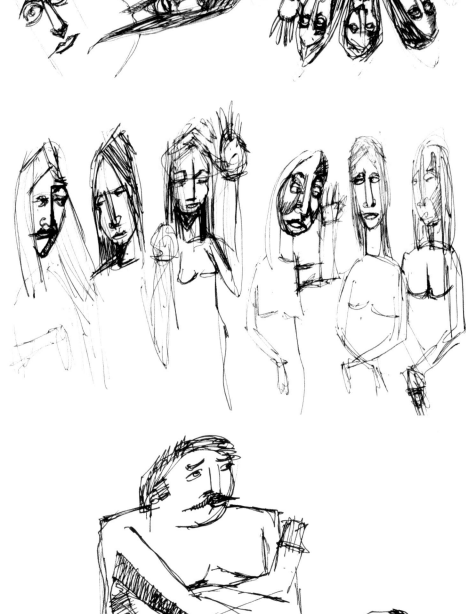

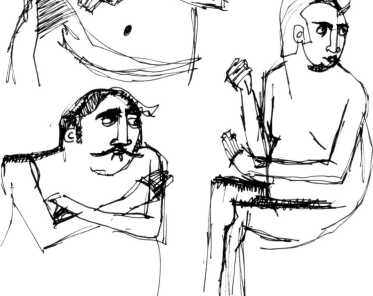

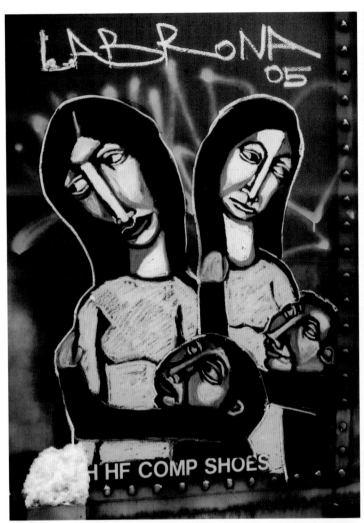

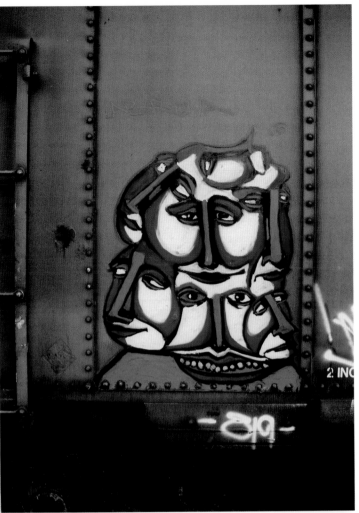

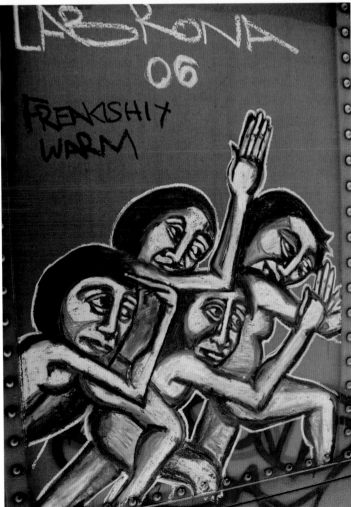

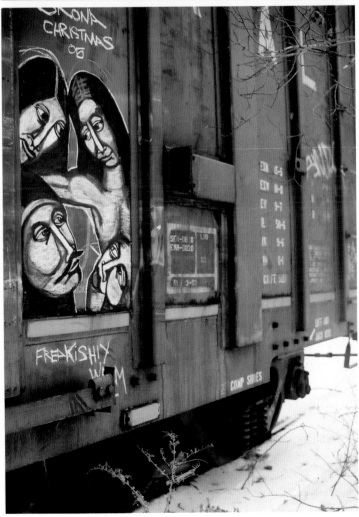

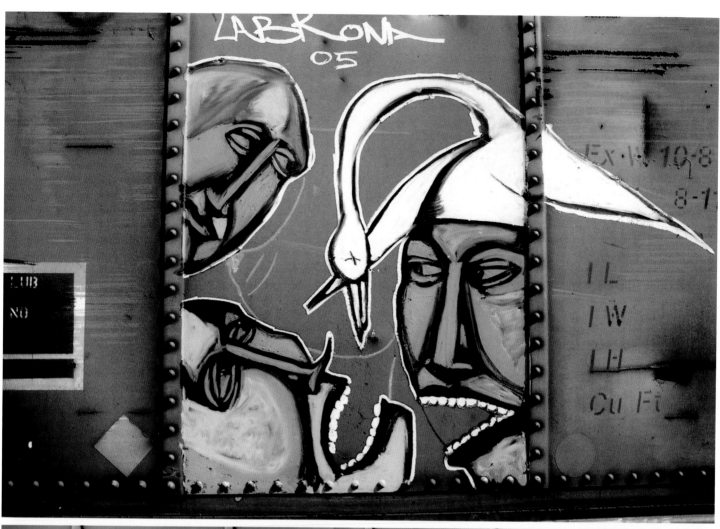

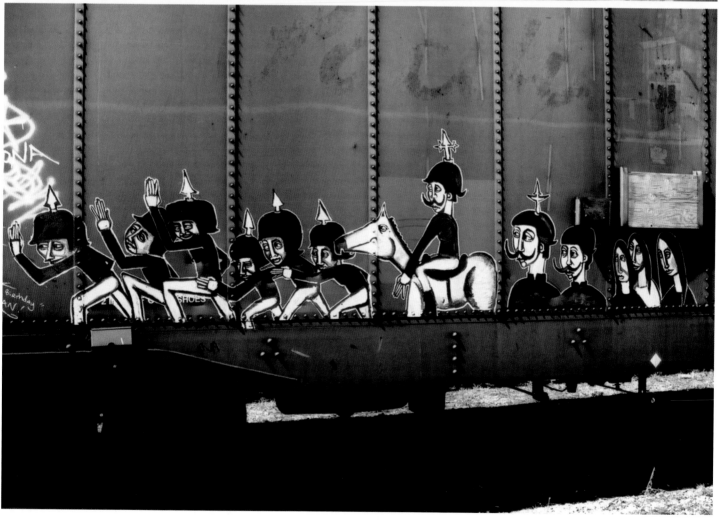

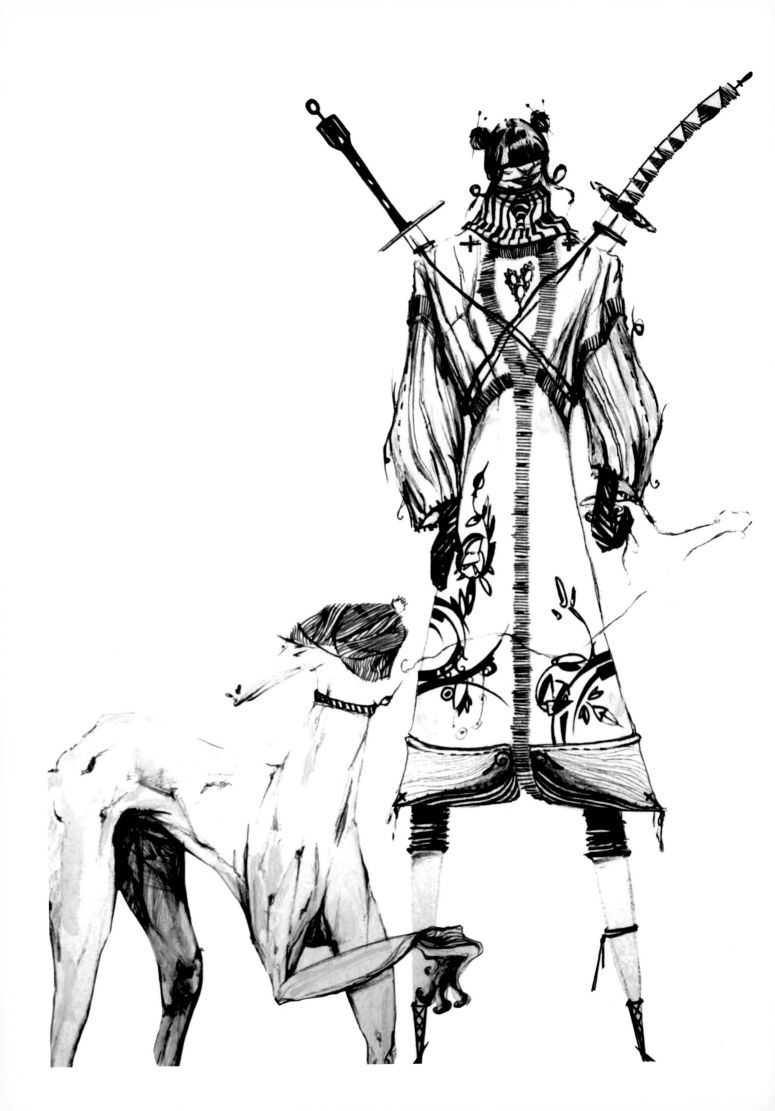

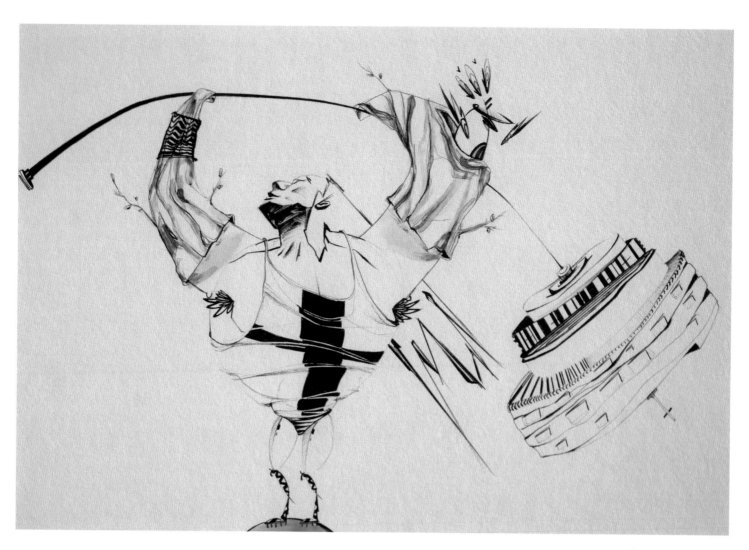

Laguna

--

Laguna (aka Antonio Lukas Juan) was born in
La Mancha, the region made famous by Miguel
de Cervantes in the novel *Don Quixote*. In his own
words he is a cameraman and a happy painter.
Laguna's main influences are movies and people
in his life, and his work is closely connected
to his daily experiences. Besides planning out
projects, he uses his drawings essentially to
communicate with others and to visualize his
own ideas. He always has two songs in his head
when he draws: 'Hexagon' by Aphex Twin and
'Somewhere Not Here' by Alpha.

 Although Laguna uses sketches for his
murals, there is always some element of
improvisation. The moment and circumstances
are all-important for him when he paints a wall.
Once he and his friends found a seashell near
a wall they were about to paint. The form of the
shell changed the way they all painted that day.
In this way, he says, 'life is a freestyle.'

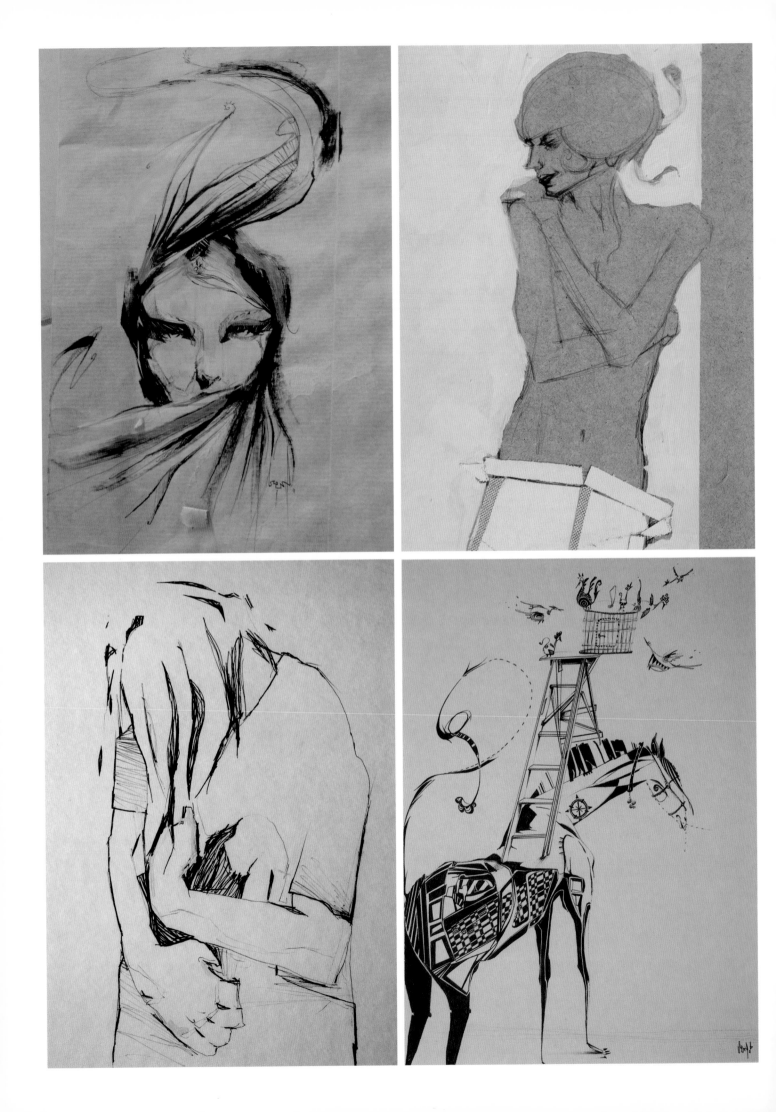

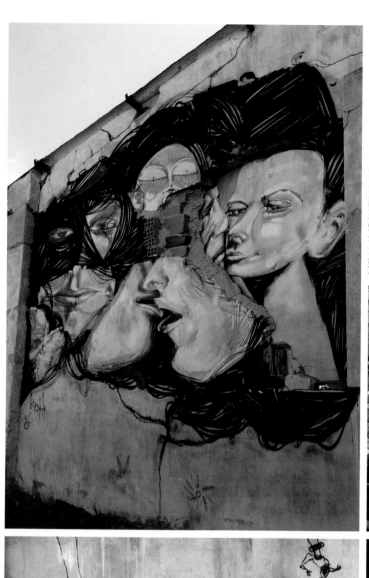

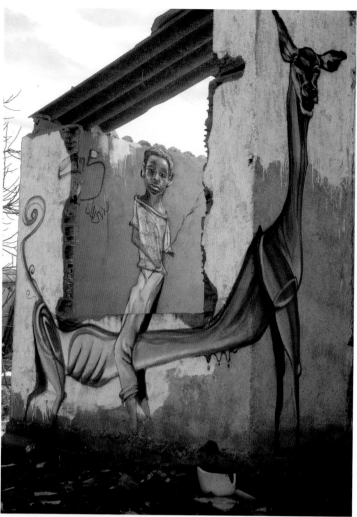

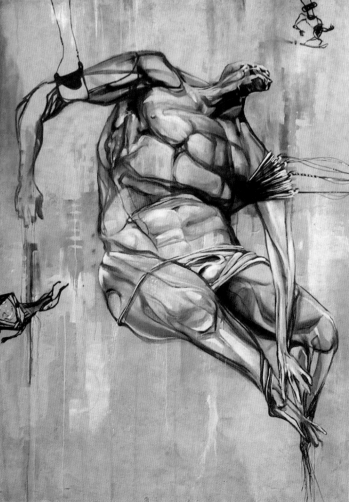

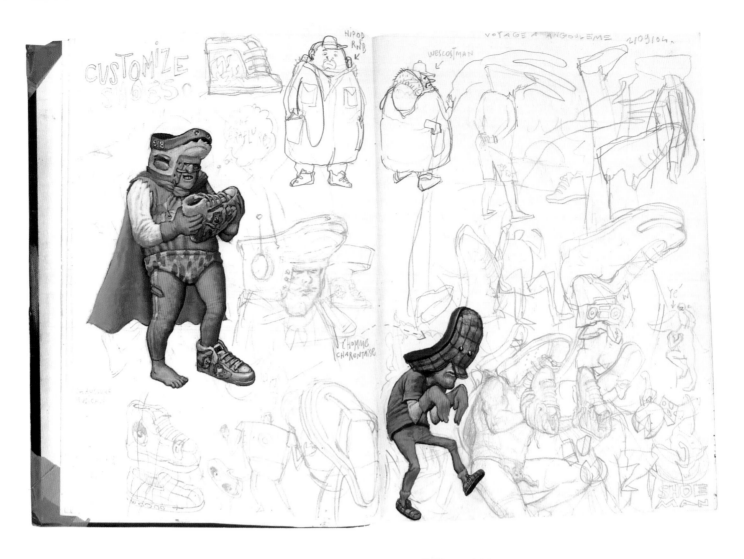

CUSTOMIZE SHOES

HIPOD RNB

WESCOSTMAN

VOYAGE A ANGOULEME 2/09/04.

L'HOMME CHARENTAISE

SHOE MAN

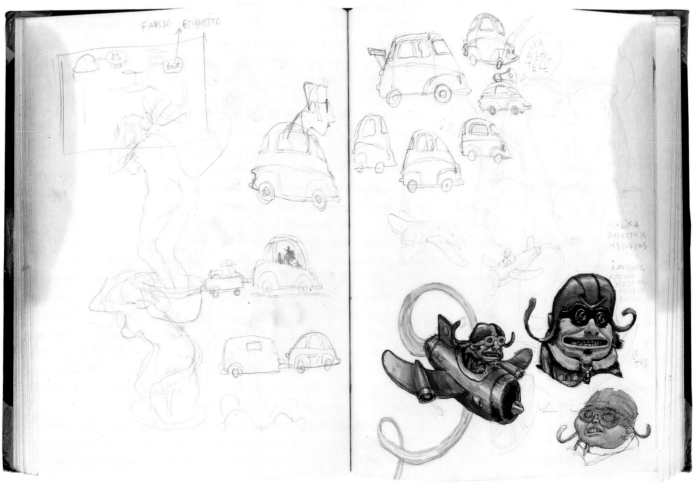

FAUSSE ÉTIQUETTE

VA A LA TÉLÉ

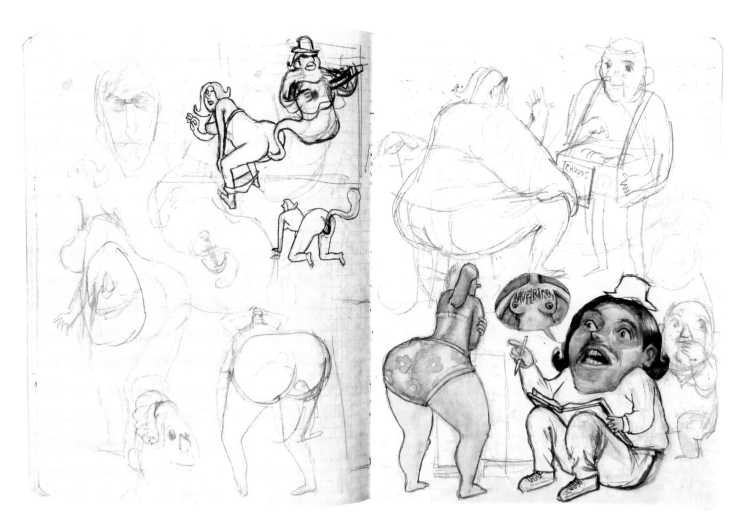

Mr Kern

Illustrator, painter and graffiti artist Mr Kern gives props to graffiti iconography, comic art and classical painting by great artists such as Velázquez, all of which are clear influences in his work. The Bordeaux-based artist uses his sketches in every aspect of his life, for personal relaxation as well as to plan projects.

His illustrations and paintings are always full of humour, but he also tries to inject some deeper meaning into his compositions — tackling subjects such as globalization, for example. In general he tries to paint a scene from a global point of view.

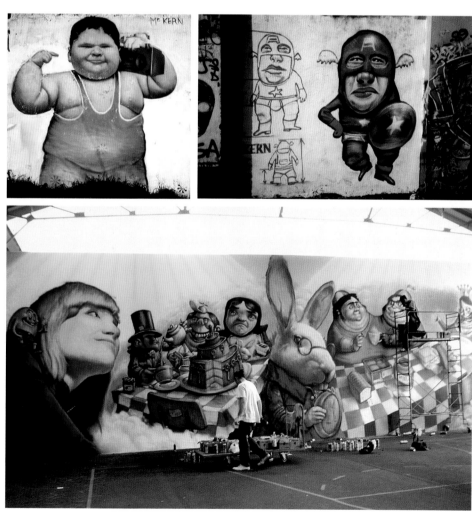

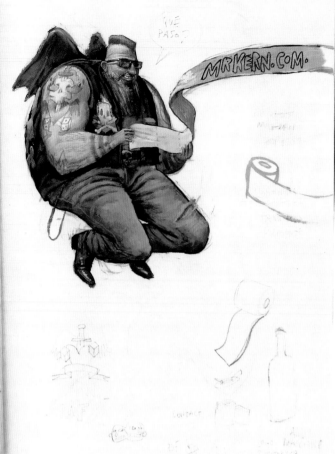

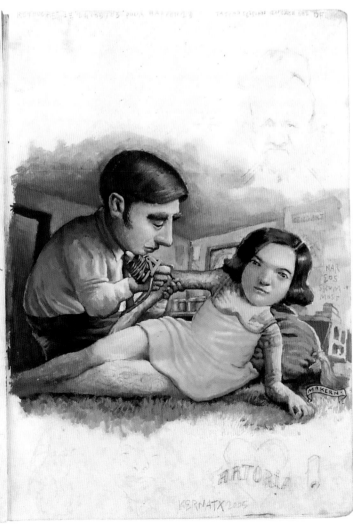

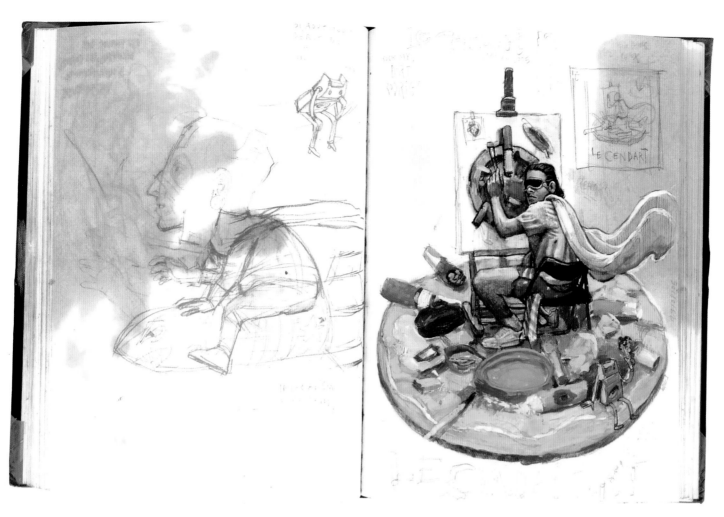

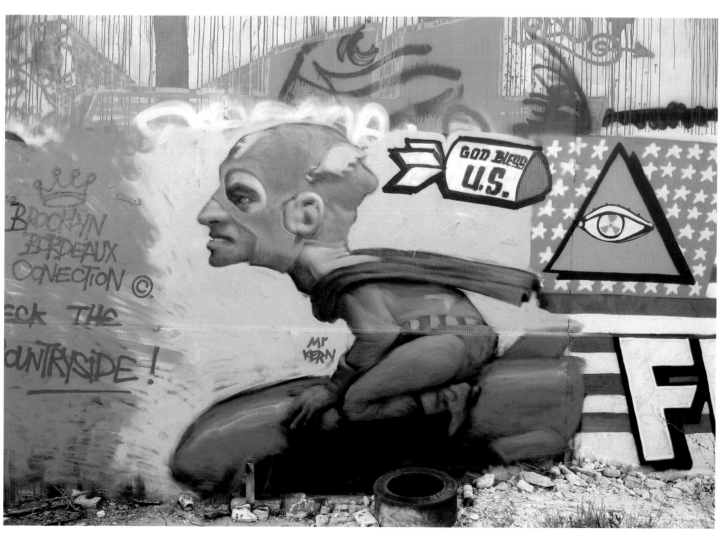

217 Mr Kern

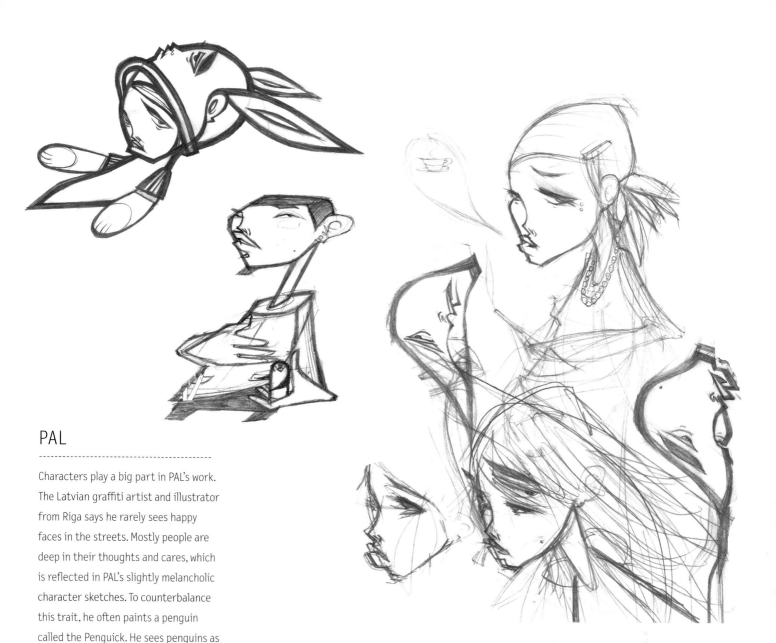

PAL

--

Characters play a big part in PAL's work.
The Latvian graffiti artist and illustrator
from Riga says he rarely sees happy
faces in the streets. Mostly people are
deep in their thoughts and cares, which
is reflected in PAL's slightly melancholic
character sketches. To counterbalance
this trait, he often paints a penguin
called the Penguick. He sees penguins as
warm-hearted and ridiculous creatures,
compensating for some of the coldness
in his human beings.

Sketchbooks are seldom used by PAL,
who prefers to cover countless sheets
of A4 paper with his pencil drawings.
When a sheet is filled with characters
he finds interrelations between them,
and a theme or subject starts to take
shape. Even if he edits a sketch on the
computer or uses it as a reference for a
painting, he feels it has a life of its own.
The original will always be unique; the
act of repainting or reworking brings
new emotions or feeling to the work.

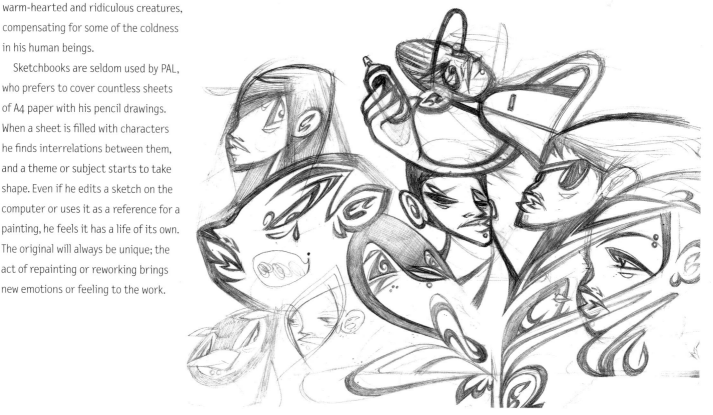

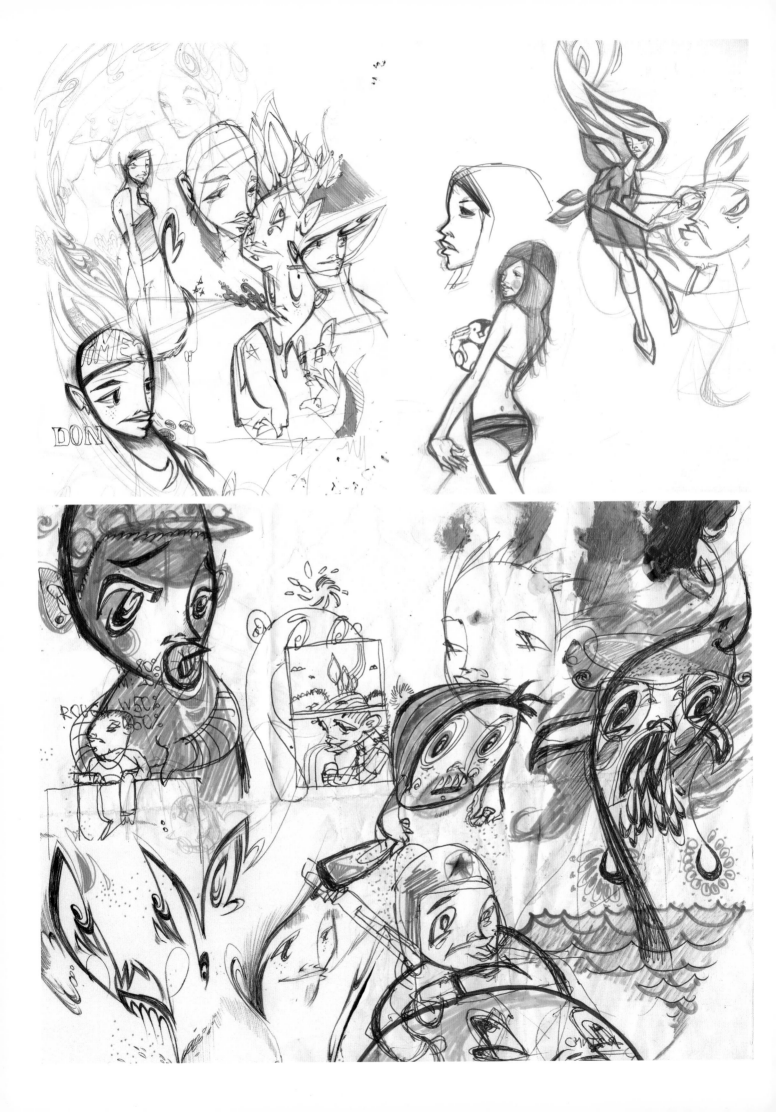

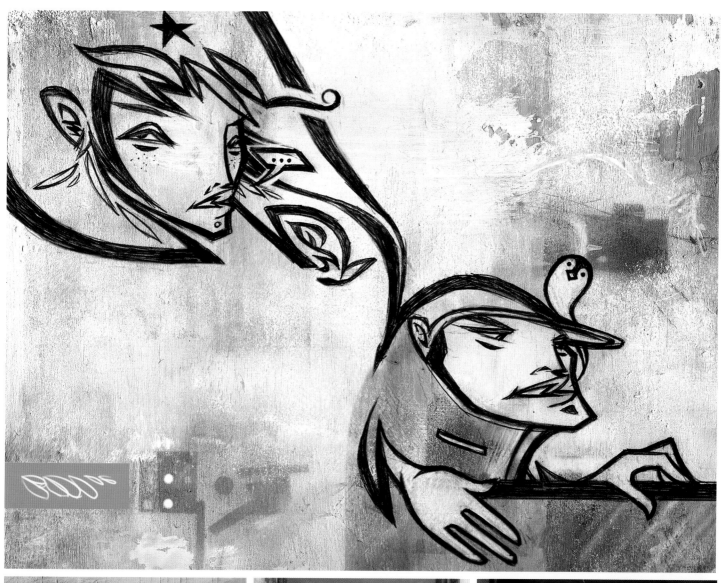

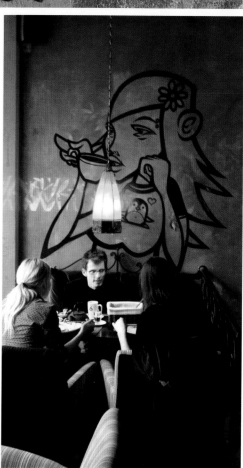

BLUE/INDIGO
YELLOW
PINK.

KEN PIYYR
UNUSED
COMPUTER
STYLE
GRAPHIC
DELUX
PHOTOGRAPHIQUE

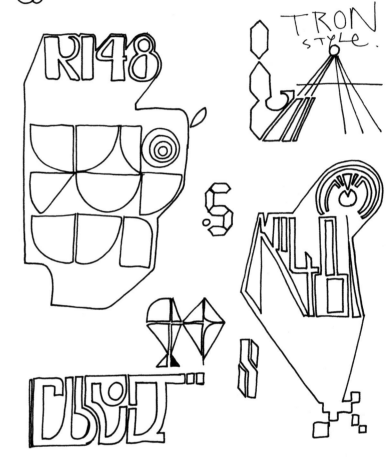

TRON
STYLE.

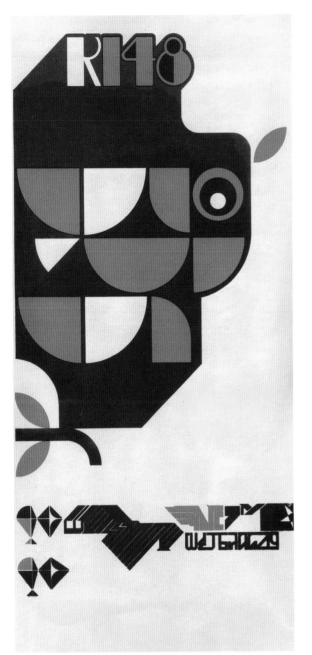

RI48

NEW _LUDWIG_ + ERKOE.

AALMANAC *.
ALCHEMY
AARD -
SECTIONS
FROM
A
DICTIONARY :

Randomatic.

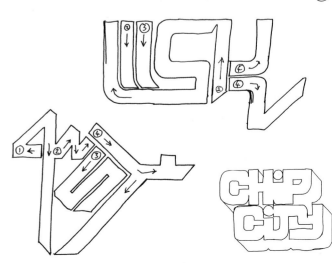

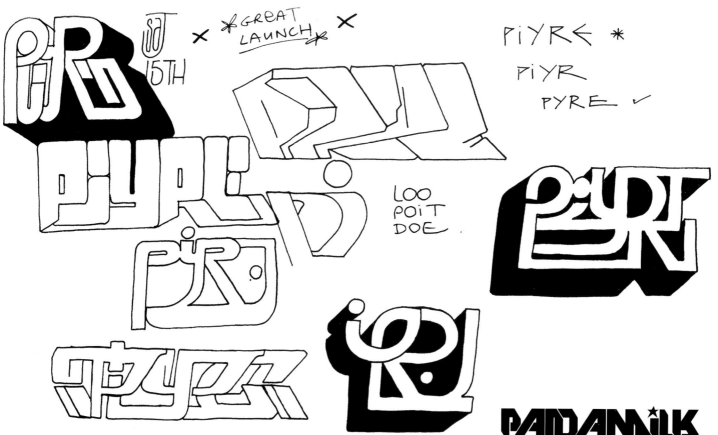

Paris

--

Born in Kingston upon Hull, but currently living in Bristol, Graham Dews has been using the name Paris for his graffiti art since 1990. As a child he would write stories and play with LEGO rather than draw. It was the connections between letters that fascinated him and initially drew him to graffiti. More recently Italian and Swiss logo design has been influencing his letterforms, which are central to his art and design work.

He draws at every available opportunity, mostly to get the pictures in his head onto paper. After that they become logos, pieces and patterns. Beyond experimenting with the letters PARIS, many of his type treatments revolve around completely fictional ideas, word games and narratives. 'Avant Graff' on this page is deconstructed from the well-known Avant Garde typeface.

Paris's work follows many different paths depending on whether he is working solo or on his many group projects. He is a member of the Bristol graffiti crew TCF and the experimental WSSK, and he also collaborates with his girlfriend Milk as 'PandaMilk'.

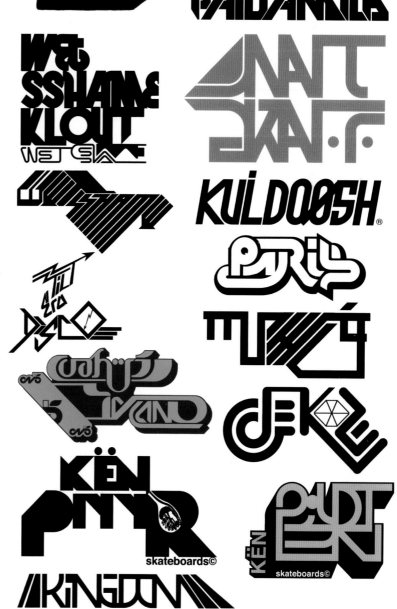

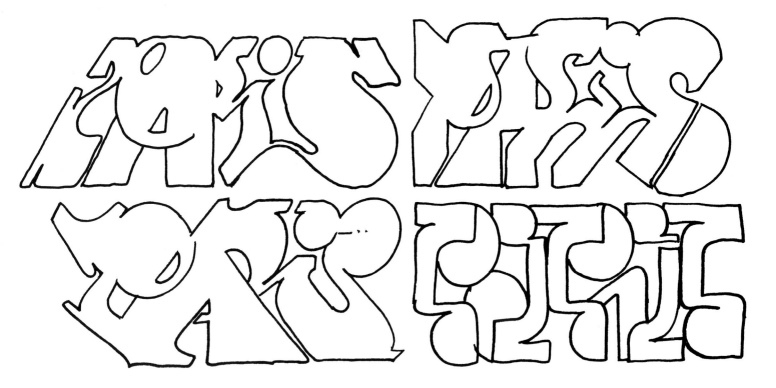

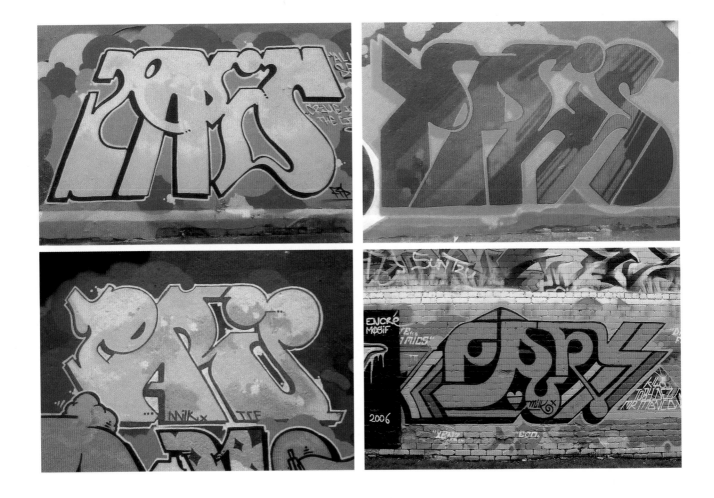

PAYROLL GROSS PAY REPORT

COMPANY 01 WHITE TREE GARAGE
BRANCH 01 WHITE TREE GARAGE

	BASIC HOURS	OVERTIME HOURS RATE 1	RATE 2	RATE 3	BASIC PAY	OVERTIME PAY RATE 1	RATE 2	RATE 3	HOLIDAY PAY	FIXED BONUS	TAXABLE SP. PAY	GROSS PAY
103 ALLCHORNE, J	40.00	6.50	0.00	0.00	139.20	33.93	0.00	0.00	0.00	0.00	0.00	31.75
104 ADAMS, D	40.00	4.00	0.00	0.00	139.20	20.88	0.00	0.00	0.00	0.00	0.00	173.
207 BENNETT, C	39.00	1.00	0.00	0.00	214.50	8.25	0.00	0.00	0.00	0.00	0.00	0.00
209 BOWDEN, A	39.00	1.00	0.00	0.00	214.50	8.25	0.00	0.00	0.00	0.00	0.00	130
213 BALSON, C												
214 BALL, C	10.00	0.00	0.00	0.00	42.79	0.00	0.00	0.00	0.00	0.00	0.00	349.85
223 BRACEY, A	39.00	0.00	0.00	0.00	173.08	0.00	0.00	0.00	0.00	0.00	0.00	109.08
225 BAINTON, A	40.00	1.00	0.00	0.00	214.50	8.25	0.00	0.00	0.00	0.00	0.00	
303 CANN, G	39.00	0.00	0.00	0.00	130.00	0.00	0.00	0.00	0.00	0.00	0.00	91.47
305 CROMPTON, S	31.00	1.00	0.00	0.00	240.77	0.00	0.00	0.00	49.?	0.00	0.00	320.16
306 CROSS, A	40.00	1.00	0.00	0.00	170.?0	8.25	0.00	0.00	0.00	0.00	0.00	310.00
308 CHANDLER, F	39.00	1.00	0.00	0.00	195.00	7.50	0.00	0.00	0.00	0.00	0.00	221.71
309 COOPEY, M	32.00	1.00	0.00	0.00	179.79	6.92	0.00	0.00	45.85	0.00	0.00	302.10
311 CLARK, S	32.00	0.00	0.00	0.00	160.00	0.00	0.00	0.00	0.00	0.00	0.00	4.25
317 COTTERELL, J					176.00	0.00	0.00	0.00	328.05	0.00	0.00	798.30
321 CARSTAIRS, W	40.00	4.00	0.00	0.00	117.??	11.50	0.00	0.00	0.00	0.00	0.00	33.28
401 DYER, P	40.00	0.00	0.00	0.00	35.00	0.00	0.00	0.00	35.00	0.00	0.00	169.78
	39.00	1.00	0.00	0.00	214.50	8.25	0.00	0.00	0.00	0.00	0.00	256.03

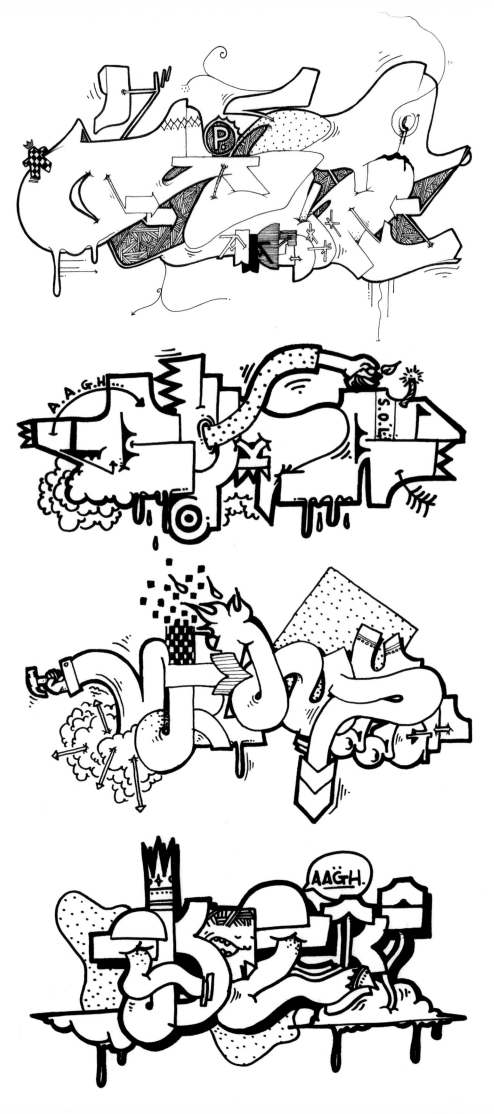

Ponk

Ponk (AAGH) is a Bristol-based artist who
takes the essentials of graffiti letterforms,
such as outlines, shading and highlights,
and adds his own fresh twist. By contorting,
extruding and embellishing shapes and
patterns he creates his own style, making
every piece look different from the last.
'I like my pieces and sketches to have
movement and energy — this is the most
important thing for me,' he says. 'Funky
with feeling and not so restricted by the
rules of graffiti.'

Often opting for a collaborative approach,
Ponk enjoys the camaraderie and creativity
of working together on a piece. He is part of
the UK-based AAGH (Ave A Go Heroes) along
with Nylon, Dr Dog, Sickboy, Dabl, Otick and
Yesov, as well as writing with the TCF crew, and
he regularly paints in Spain and Portugal with
artists such as Venus, XL crew and Klit/Leg
crew. Rather than designing a finished piece,
he uses sketches to build up a library of ideas
and details, which then come into play at a
later stage on the wall as he combines his
styles with those of other artists.

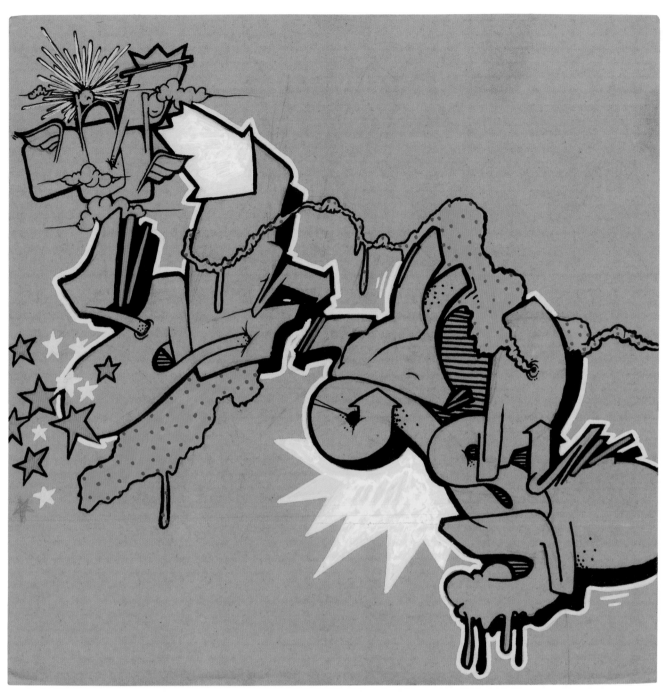

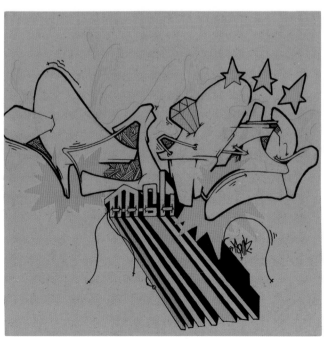

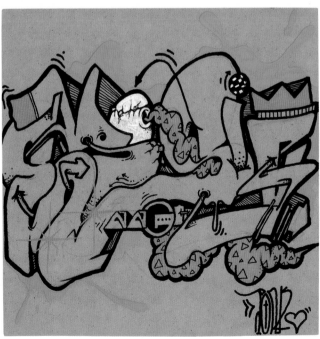

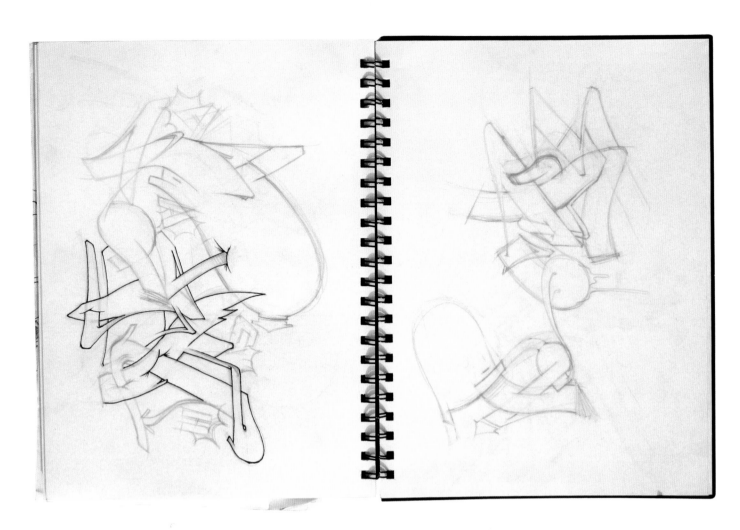

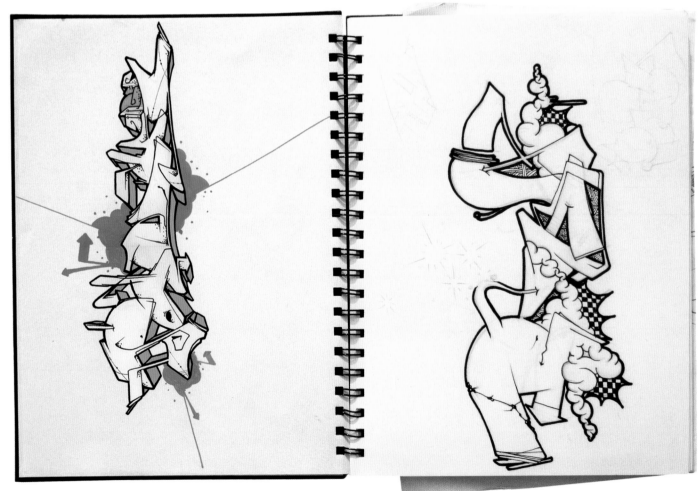

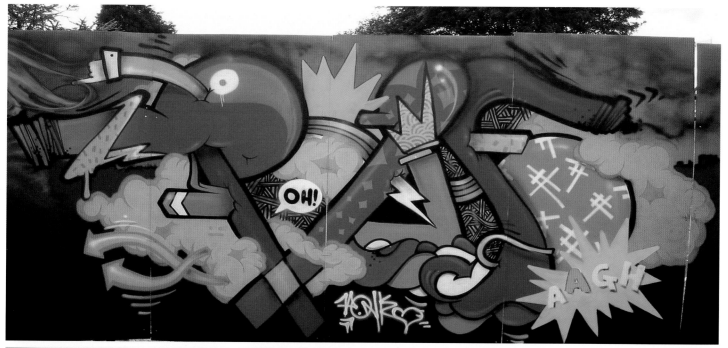

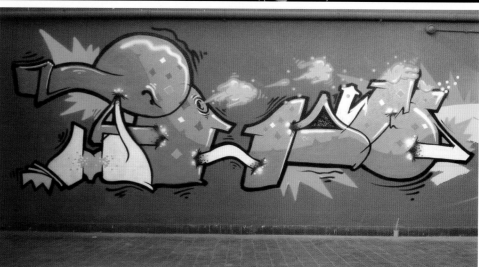

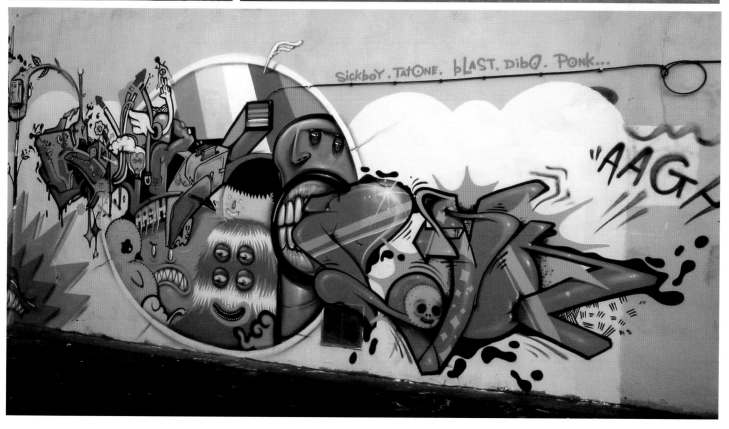

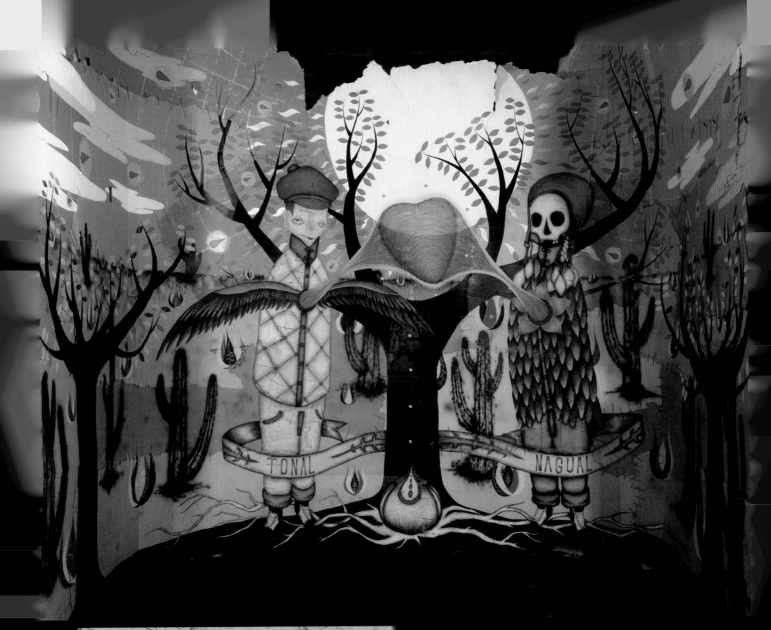

TONAL NAGUAL

Rekal

--

As an Italian artist living in Venice, Rekal's beginnings
lay with classic graffiti lettering. Over time he discovered
graffiti artists like Barry McGee who were going beyond
lettering, which pushed him to experiment in new fields.
Having grown up in a small mountain town, a visit to
New York with its vibrant street art scene was an
inspirational discovery. A trip to Mexico proved equally
important, bringing him closer to the extremes of
nature and its mystic relationship with ancient
civilizations. The clash between the spiritual view
of nature and a metropolis like New York was a deep
influence on his work.

Rekal often makes quick sketches in natural science
museums or directly from nature. These elements
are then drafted into his symbolic compositions. The
sketchbooks become a kind of dictionary or map of
his evolving visual language, which guides his frescos,
paintings and installation pieces.

TONAL NAGUAL

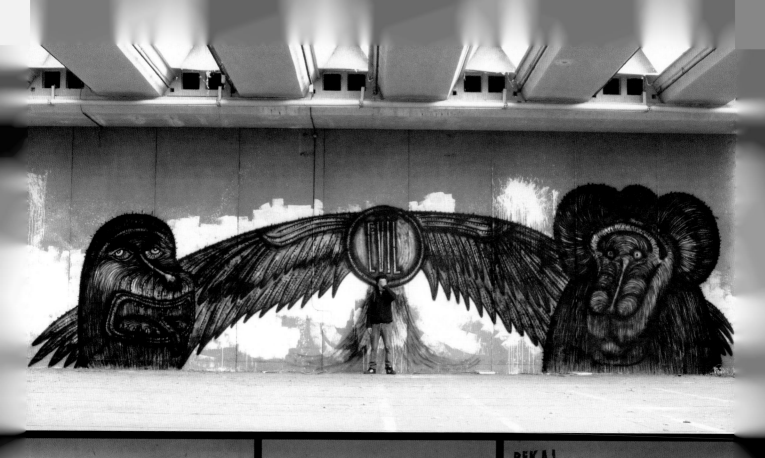

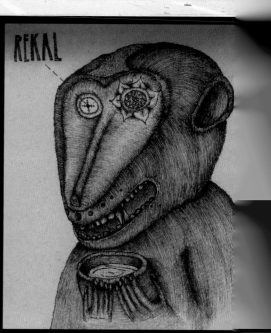

REKAL

London 2004

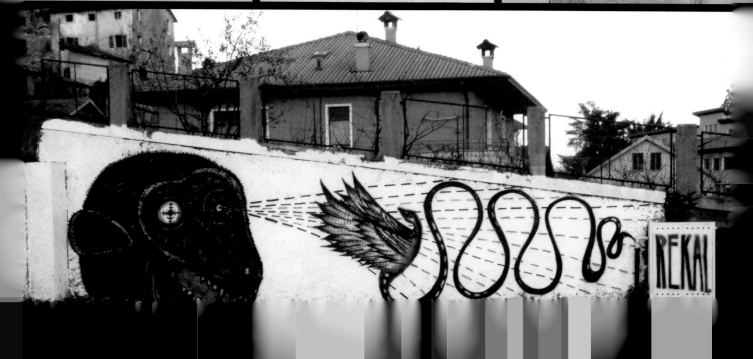

REKAL

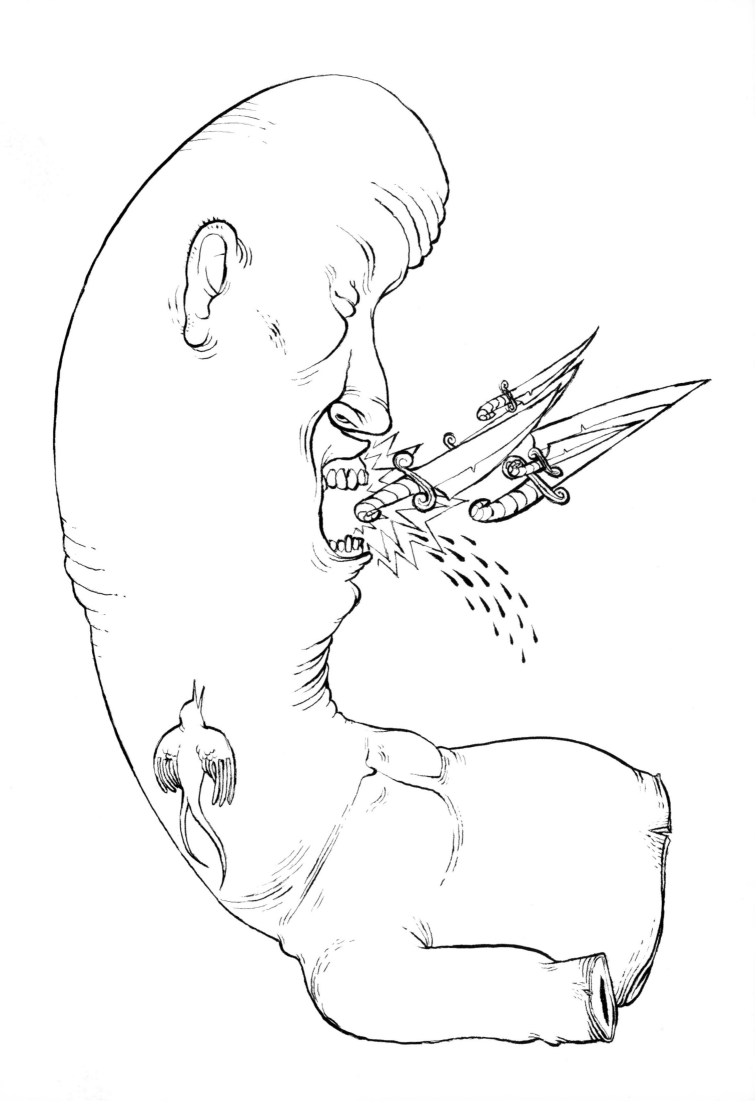

Royal

--

Juan Carlos Noria is a Venezuelan-born
Canadian artist living in Barcelona. Under
the name Dixon he's a painter both
traditionally on canvas and on the street,
particularly the metal plates on 'street
furniture' such as lamp posts, which he
removes and replaces with newly decorated
versions. On drawings and poster campaigns
he goes by the name Royal. While his
paintings are eclectic juxtapositions of
imagery, his drawings are more illustrative.

Using brush pens he draws 'to get the
kinks out of my joints, my eyes and my
creative brain'. In his brushwork, which owes
some influence to Chinese and Japanese
calligraphy, a fluid line, contrast and humour
are key to his work. His themes and subjects
are usually figurative and tackle socio-
political concepts. He often uses symbols
such as the knife: 'I use the knife because
of the free use of the word in our English
vocabulary. "A knife in the back" means
someone has deceived you or done you
wrong. It can be a source of pain.'

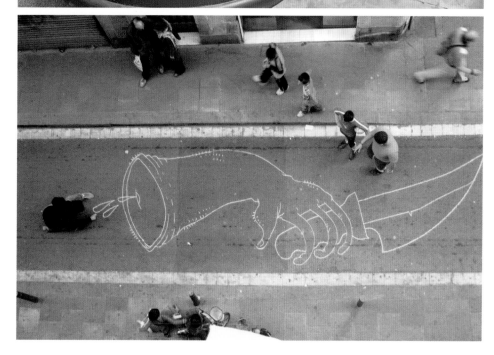

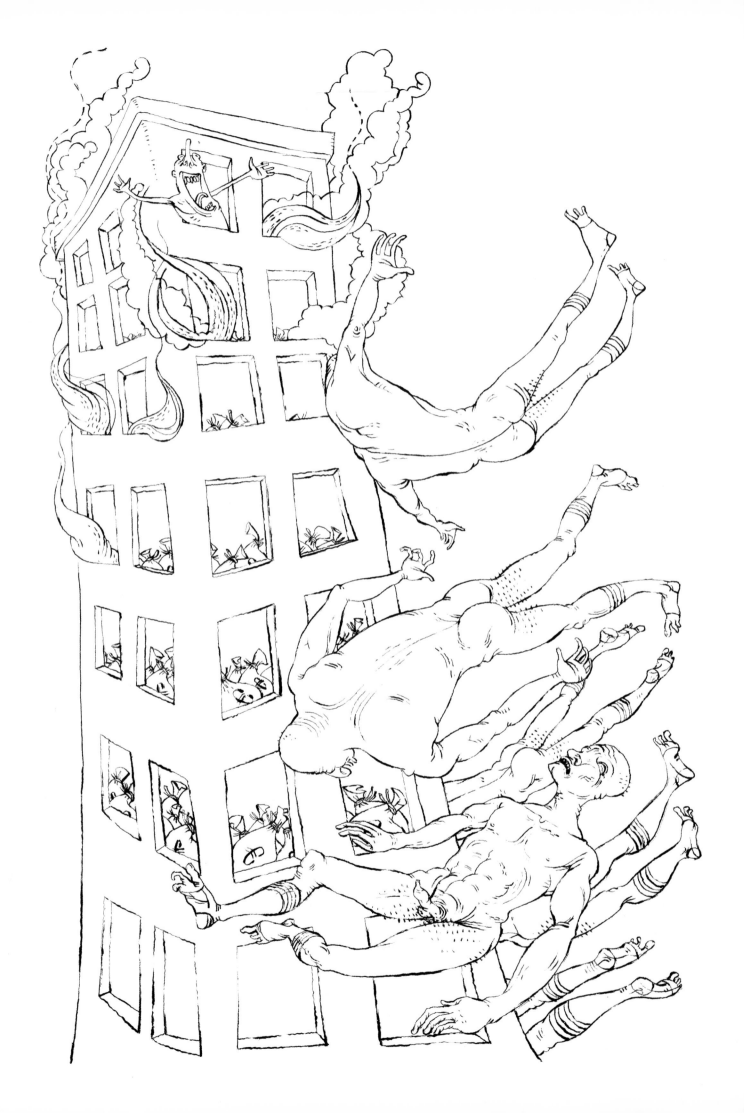

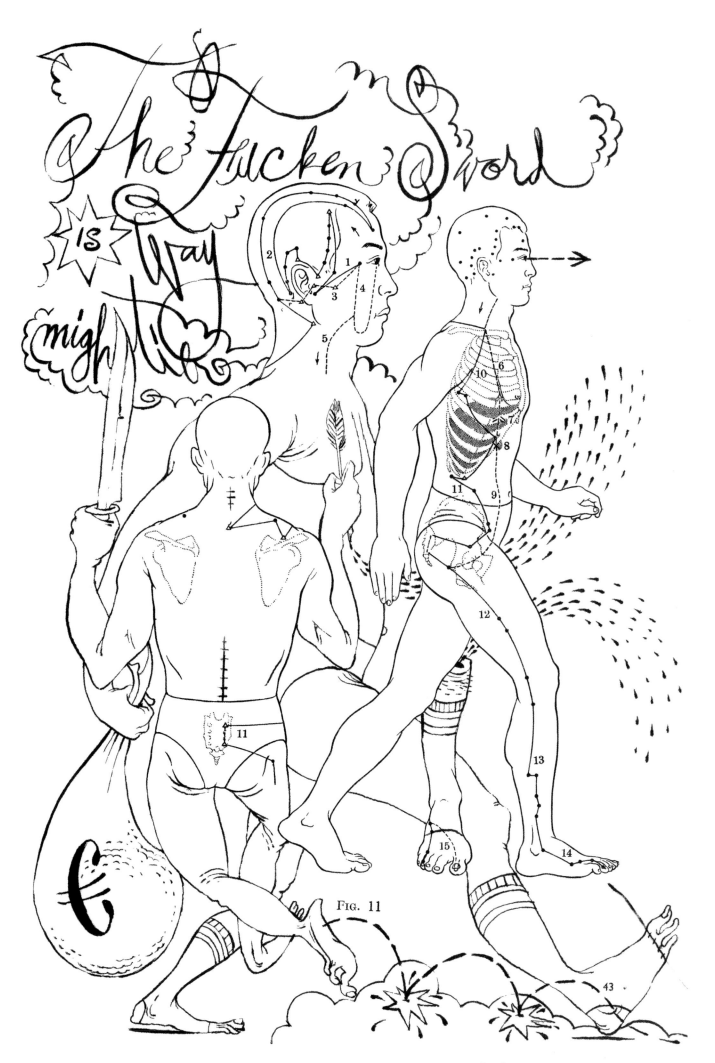

FIG. 11

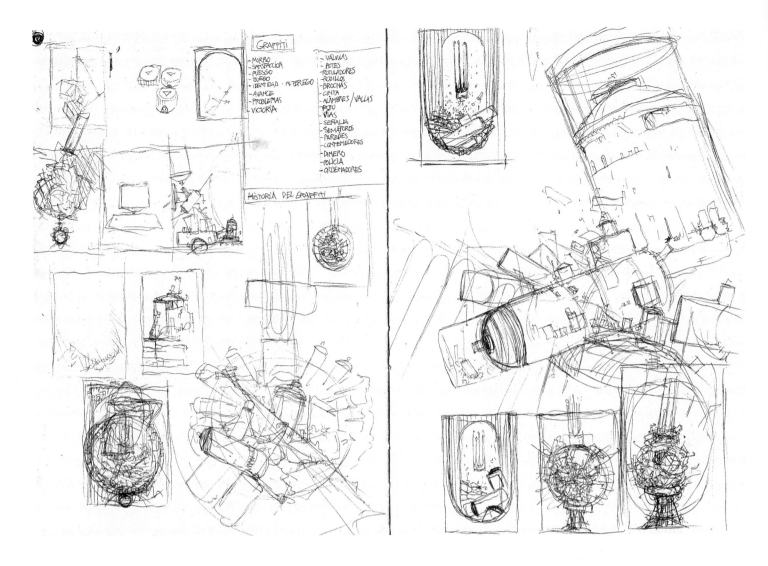

San

Conceptual ideas are central to San's work. 'I don't get aesthetic ideas,' he explains, 'just concepts that I need to work on and develop. I don't think about a shape, but how that shape can speak for itself.' The themes he tackles are always jokes about human life and behaviour, illustrated using symbols: 'I use symbols because my work developed on the streets, not in a studio. I've always tried to communicate something on walls, and this has influenced the form and content of my work.'

The Madrid-based artist has a rich technique. In his smaller sketchbooks he makes simple compositional and observational drawings, while on bigger sheets he produces ink drawings that are finished works of art. 'I have always been aware of the importance of sketching in any creative act,' he says, 'even in fields outside of visual art. I use drawing and sketching as a means of planning. Sometimes ideas come from some sort of outside stimulus, but most of the time they come when I'm sketching: it's like thinking with my hands.'

In all aspects of his work, sketches, finished drawings, paintings and graffiti, the materials he uses are very simple. He avoids complex effects and uses very few colours. Since most of his work is based on sketches, it is the strength of the line and the shapes that take priority.

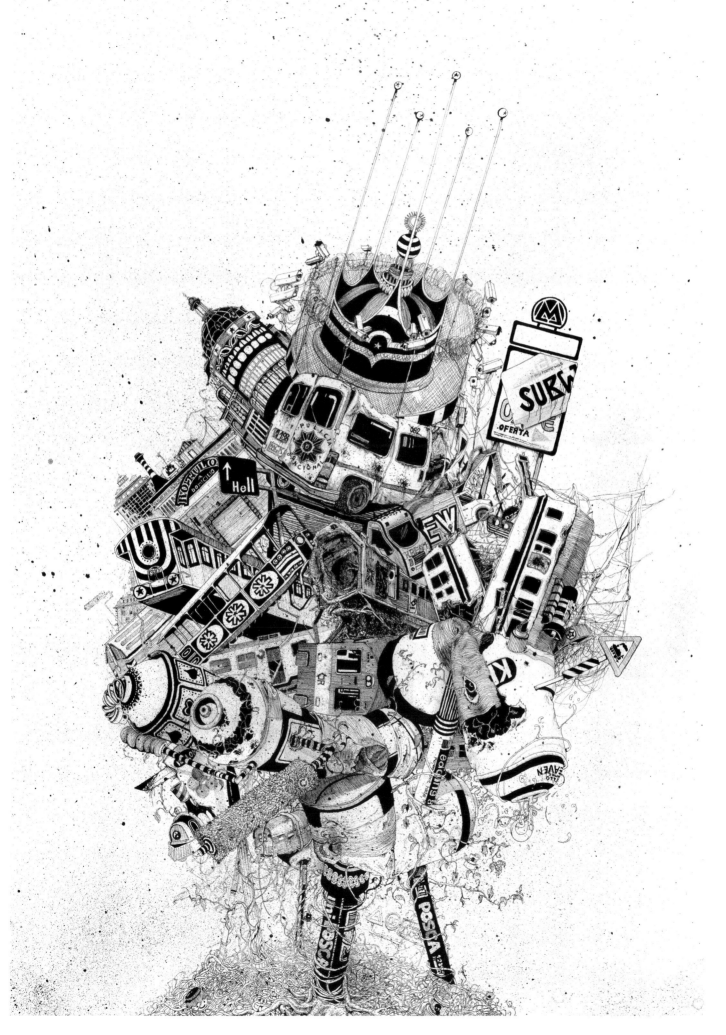

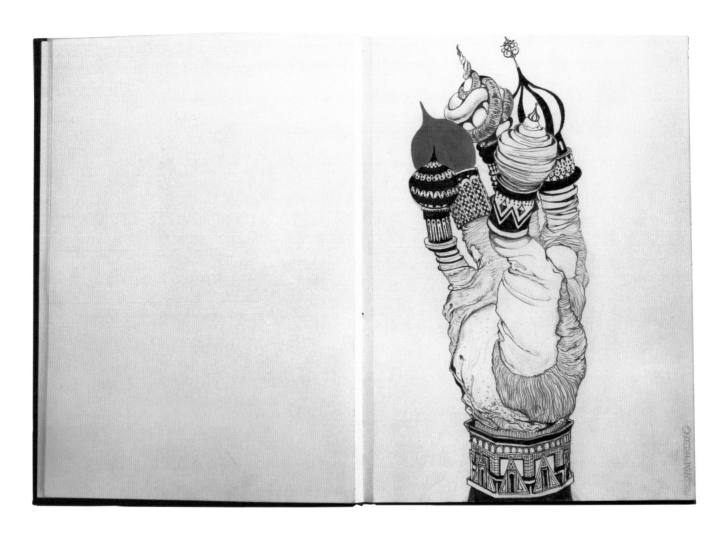

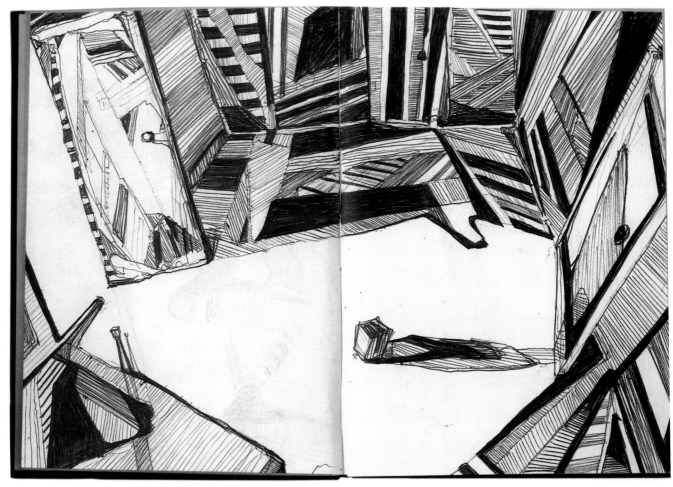

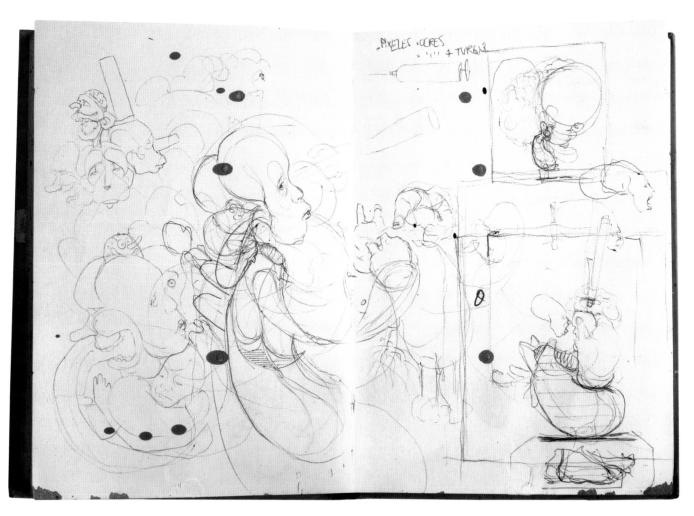

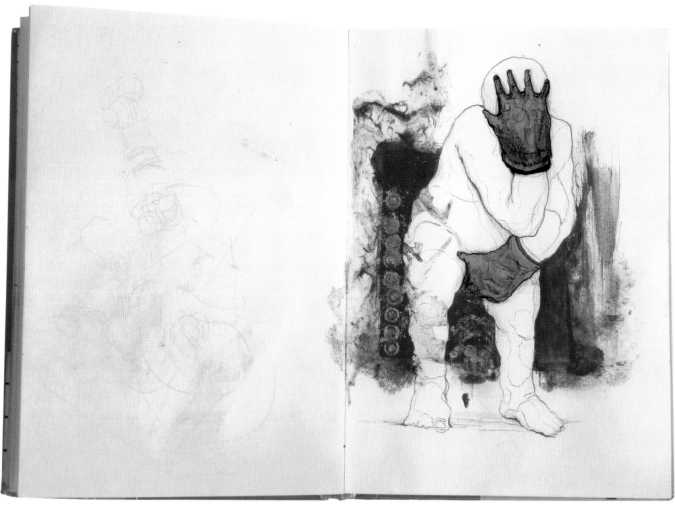

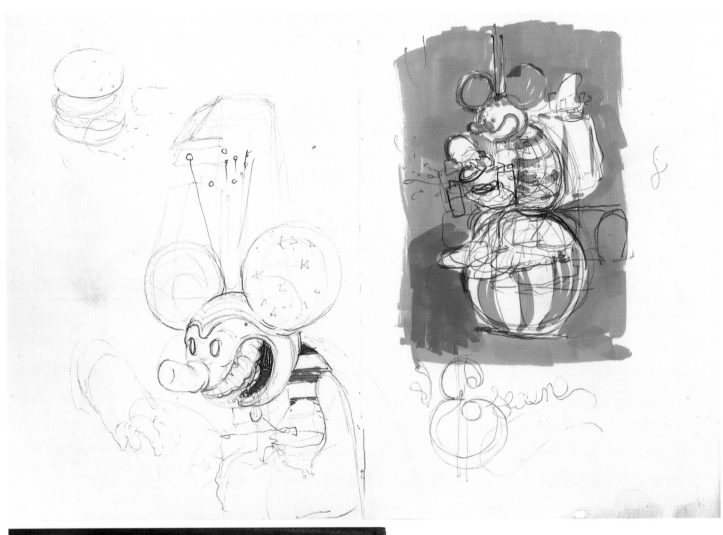

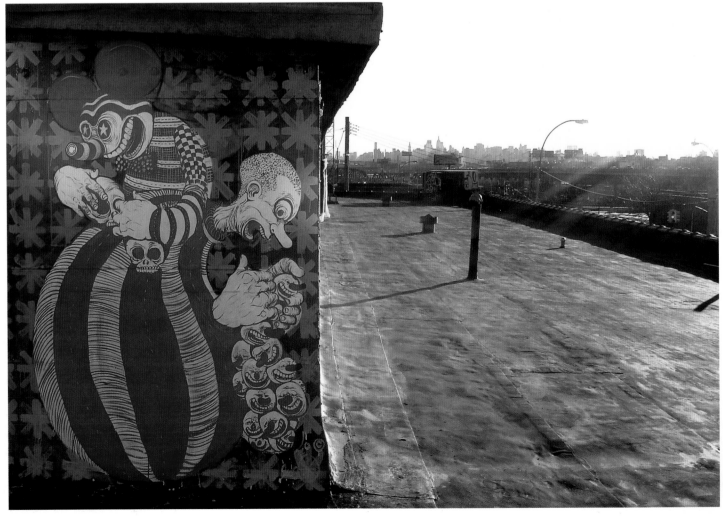

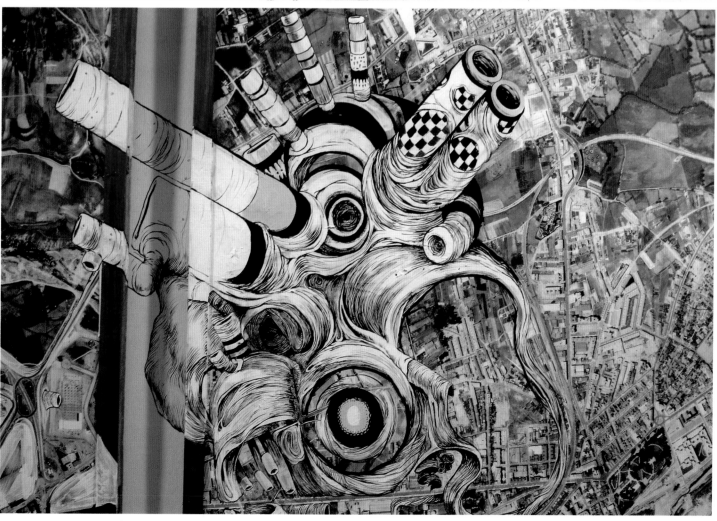

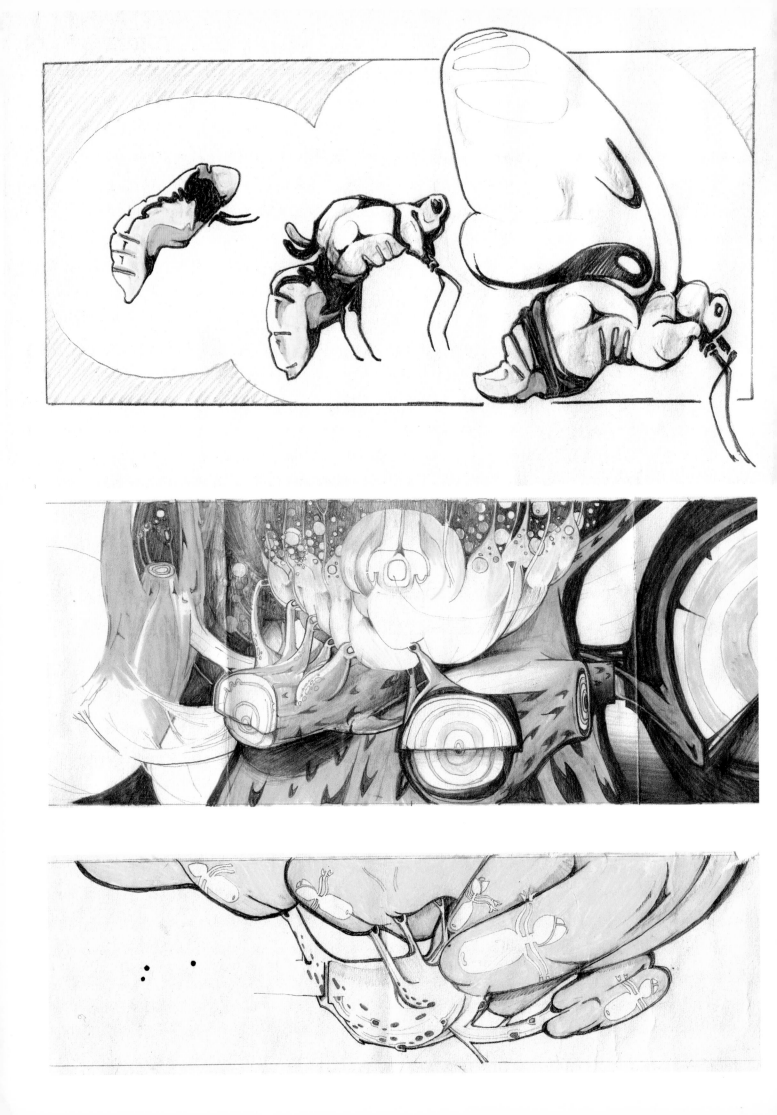

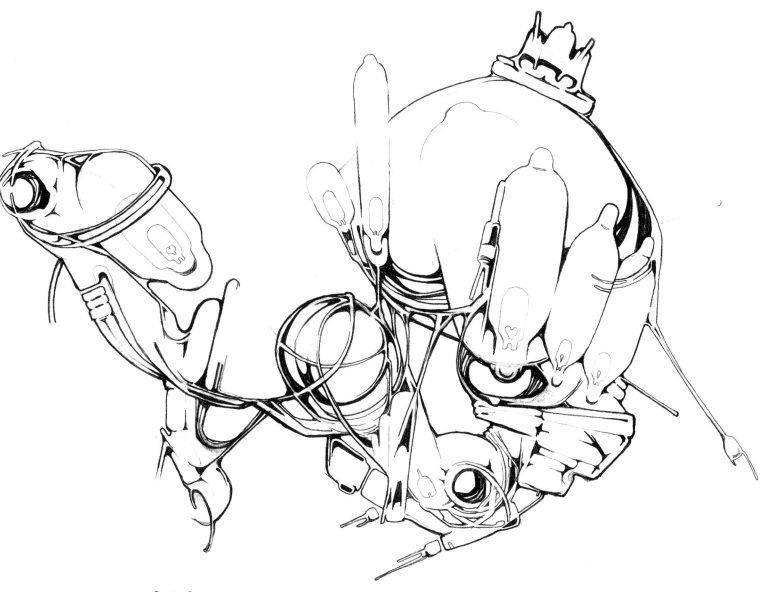

Sat One

--

Sat One is a freelance graphic designer, illustrator
and graffiti painter based in Munich. His strong
graphic sense of form and colour packs a punch
both on a wall and in his illustrations and designs.
He likens his sketches to a personal diary and
uses them to remind him of ideas he can work on
in the future; they are also the first stage for his
commercial projects.

When he is doing the preparatory work for
his murals, the Venezuelan-born artist doesn't
waste time with details and only prepares
his sketches in 'thumbnail' size. It's only the
essential composition he needs; the rest he
does spontaneously on the wall. He often uses
animals in his compositions as totemic mascots
or allegorically as part of his graphic symbolism:
'Nature and organic forms inspire me a lot in
my themes, because they don't have any strict
frame or given rules!'

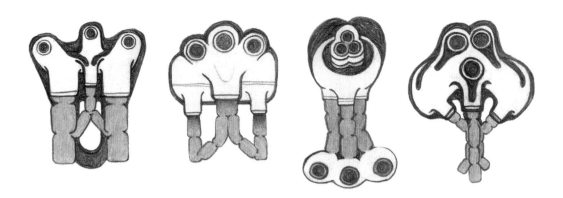

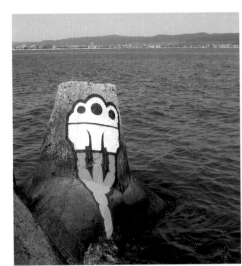

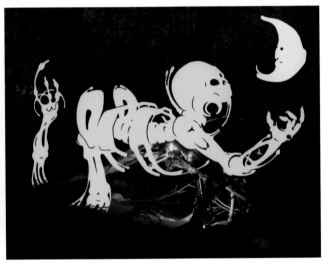

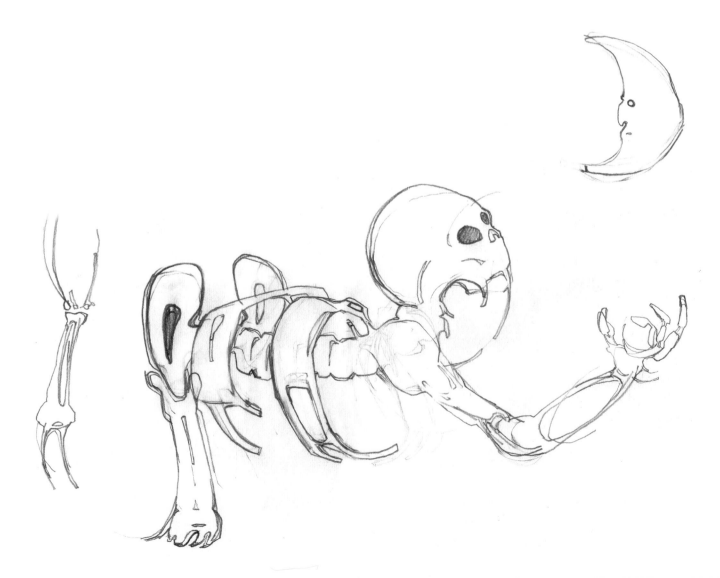

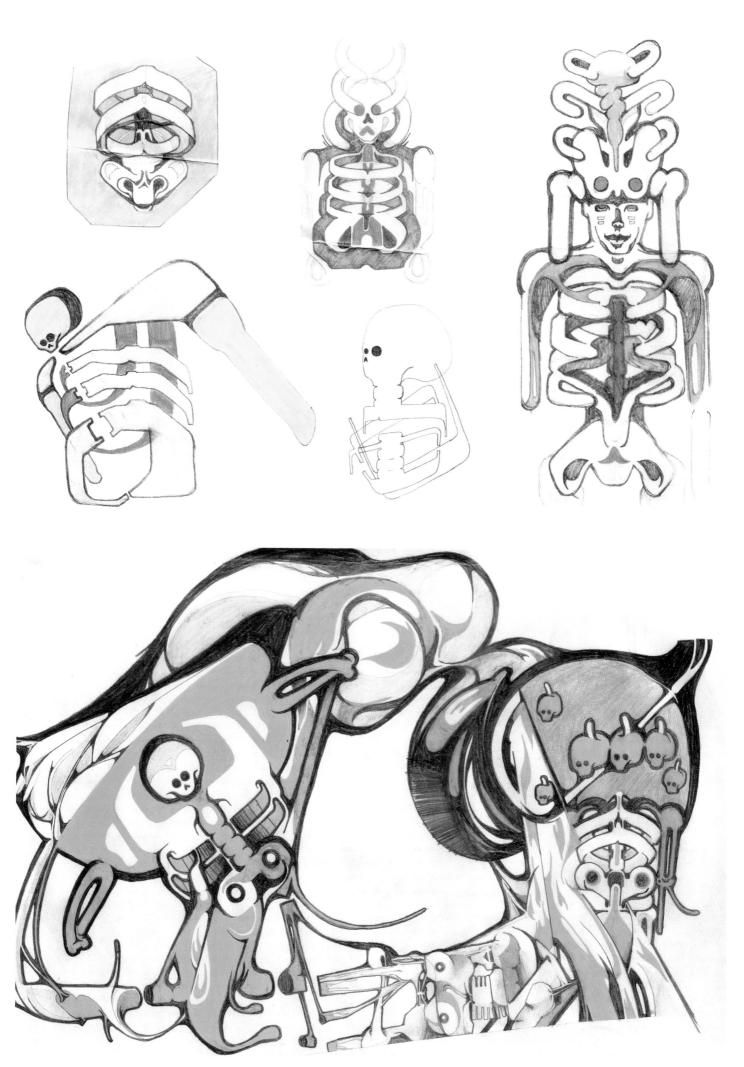

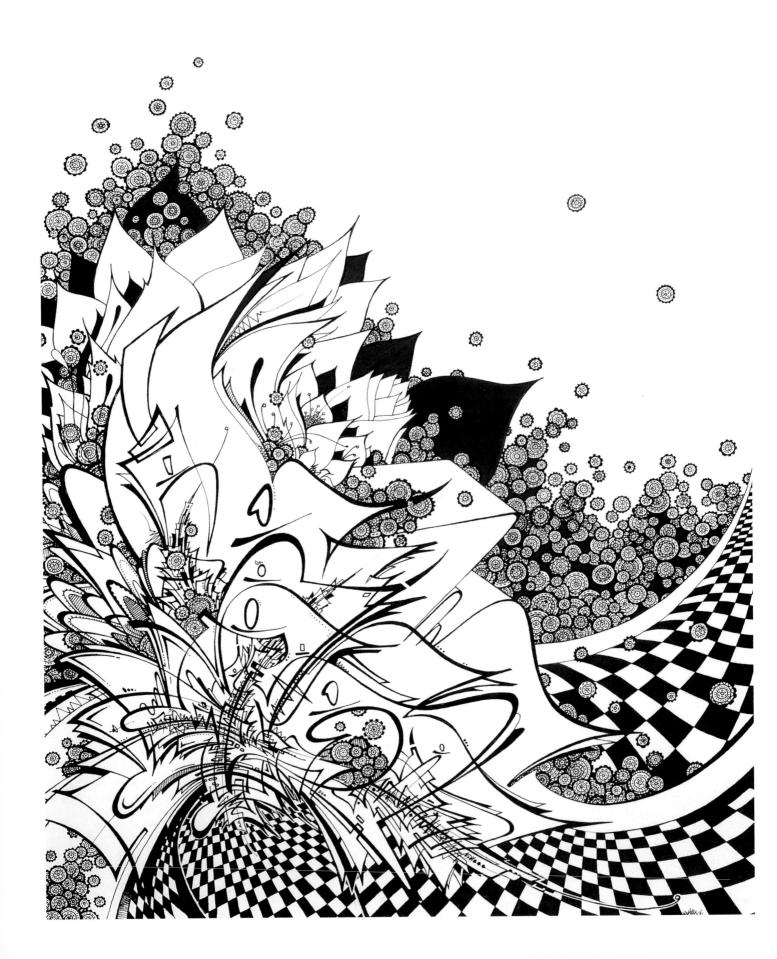

Spher

Calligraphy has been an essential influence on Spher, who is part of the Mercurocrom crew. A book by Claude Mediavilla proved the starting point, and gradually other artists such as Hassan Massoudy attracted his attention. All forms of writing interest him, including Arabic, Mayan, Aztec and Oriental, and he has an appreciation of abstract painting.

'In my sketches I always begin with a line, a form or a movement and I build from there,' he explains. 'Drawing with ink or paint is important because you can't change it if it doesn't work. I never know what my drawing will be before I finish it.'

Spher paints on walls, wood and his own ceramics using all kinds of paints and tools, including domestic items such as household brushes and brooms: 'Spraypainting has influenced my drawing method because it's trained me with certain gestures I could not find in other painting techniques. For example, in calligraphy to write an "O" with a quill you need two gestures. With a spraycan you can trace the most complex stuff you want in one shot. You do not have to load it, and you can use it in any direction you want.'

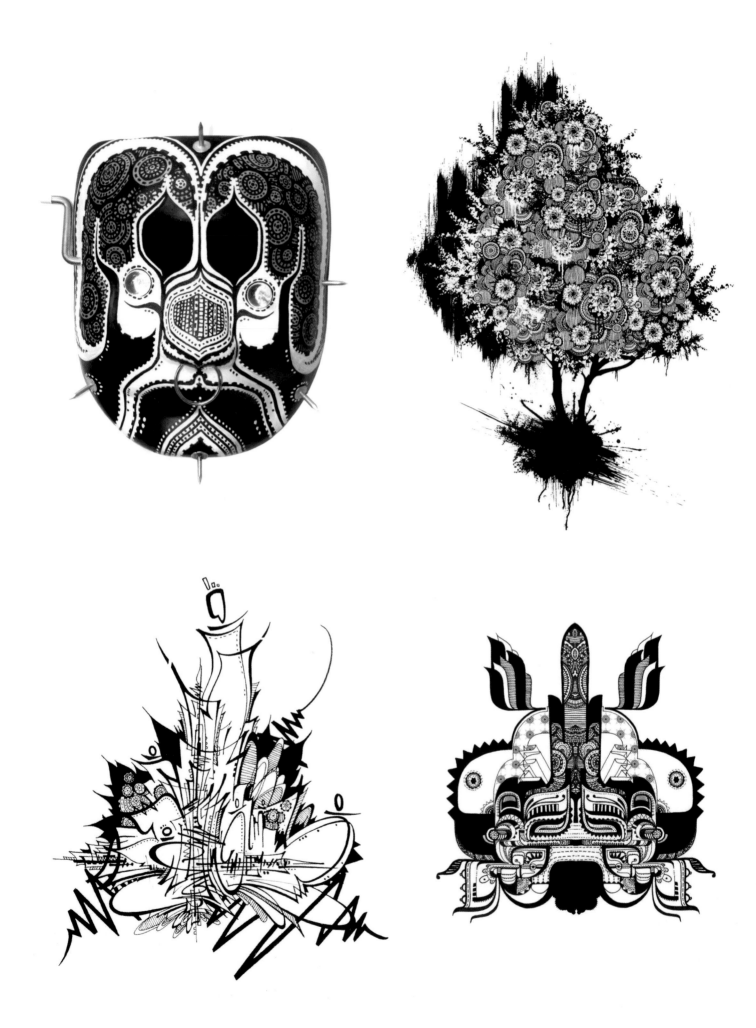

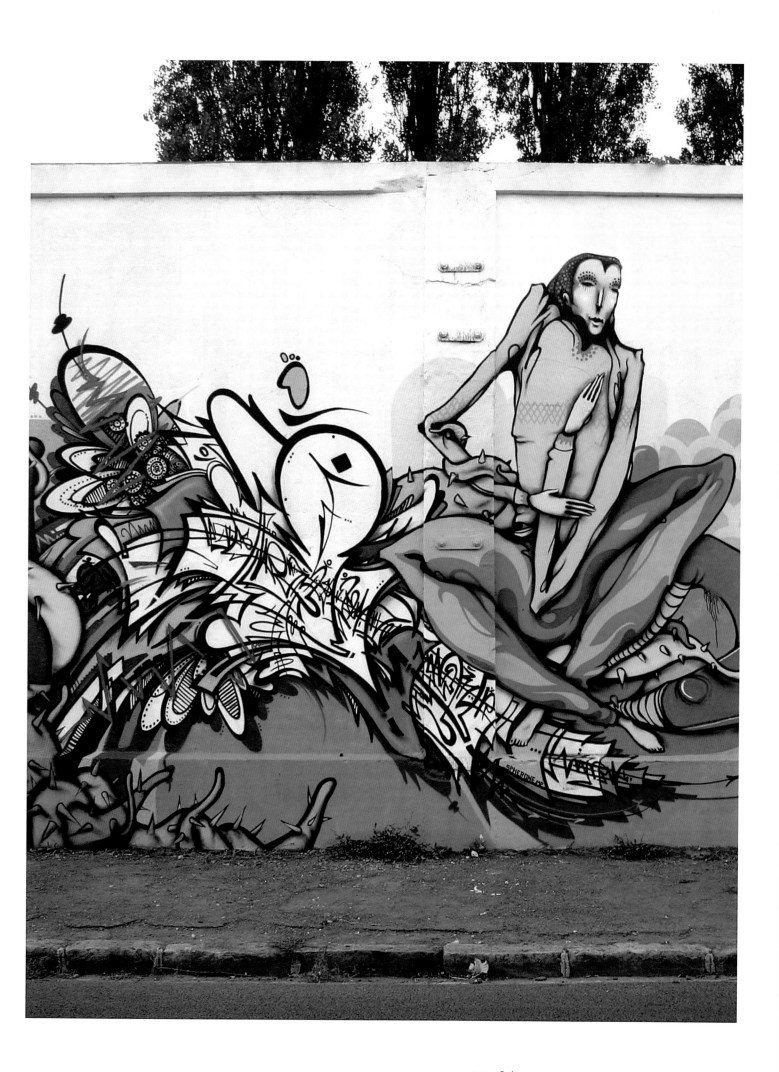

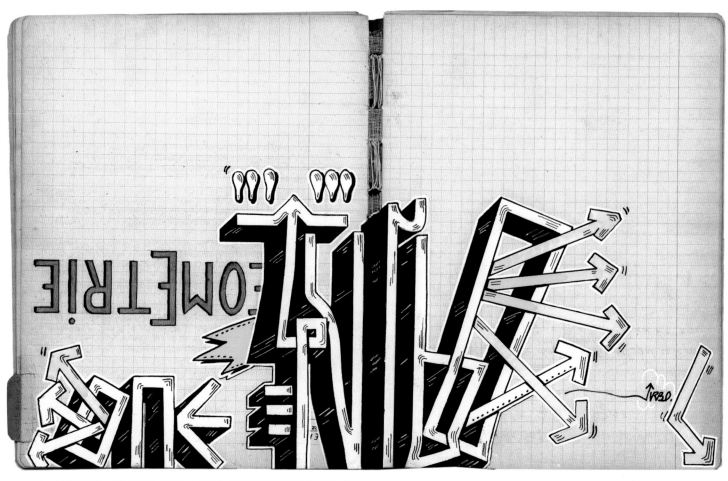

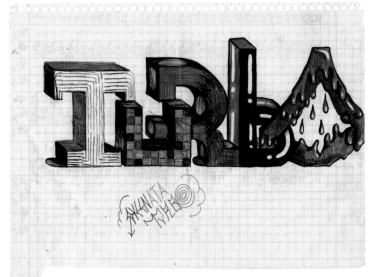

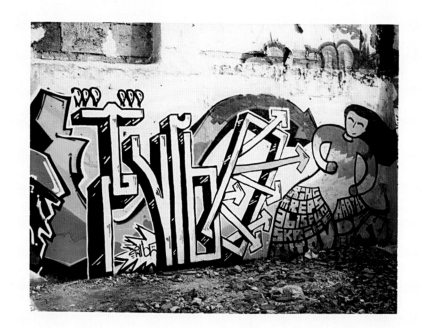

Turbo

Parisian graffiti writer Turbo (Mad crew) is a prodigious sketchbook artist. He likes to contrast the old with the new both on paper and on walls. Antique books and found papers clash with fresh colours. Crumbling walls merge with bulging letters. His style, too, combines a little old and new — the fun simplicity of old-school graffiti with up-to-date twists.

Painting and drawing for him are a form of therapy. The results must have humour and a simple visual idea. His only regret is that he doesn't improvise enough on walls; his paintings generally mirror his sketches.

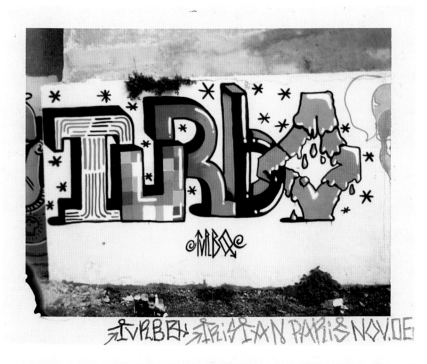

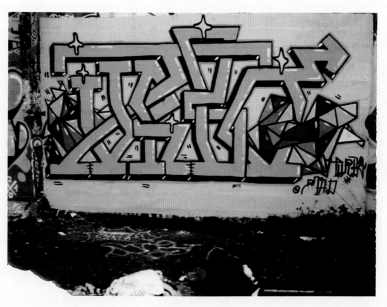

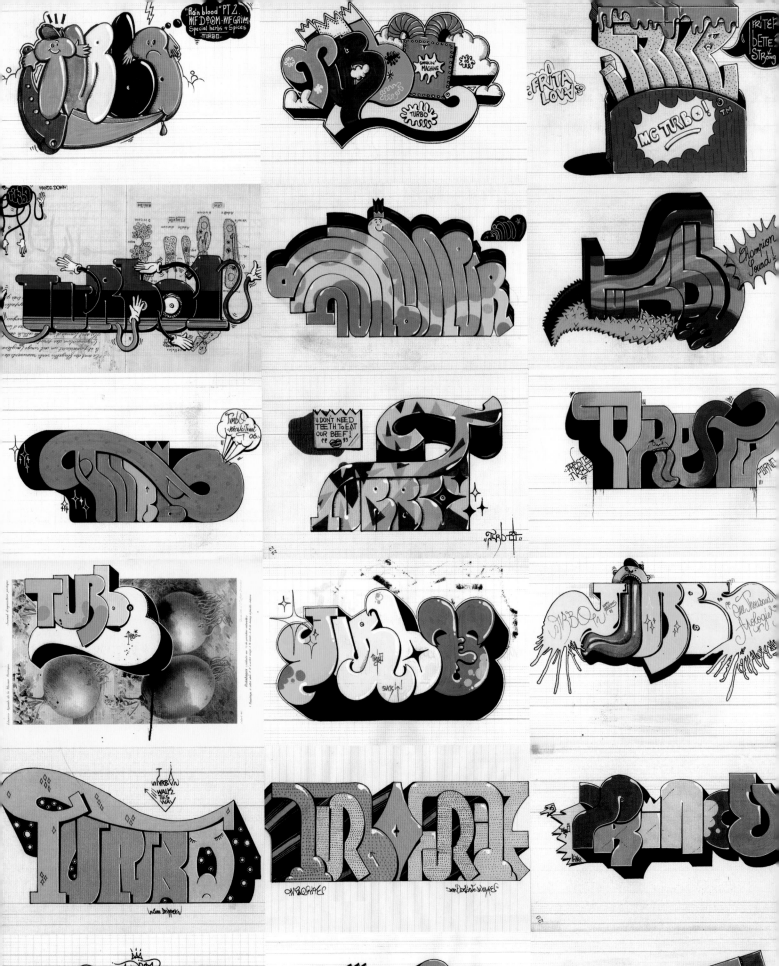

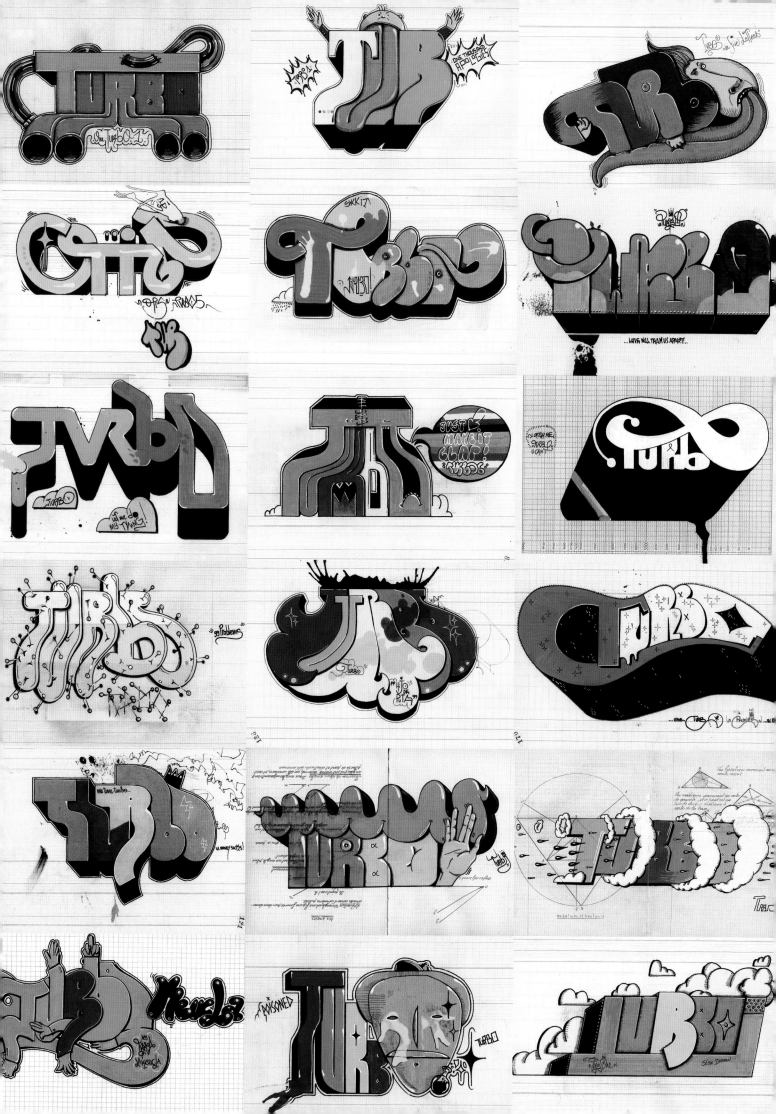

Xenz

--

In 1987 Xenz began painting graffiti in Hull and
he now makes his living as an artist in London.
His sketches are very loose, sometimes just a
quick scribble or a diagram of an idea. For a
piece or a canvas he might sketch out a few
details or make a general thumbnail sketch, but
his paintings are usually created spontaneously.
'Over the years I have learned that drawing is
simply about extracting, like sucking a straw,' he
explains. 'Many people assume a "drawing" has
to be in pencil and has to look exactly like what
you see...drawing is simply the research process
needed to gather information about why you're
thinking, feeling and seeing that way.'

Xenz's approach to painting is partly inspired
by Asian art, particularly the impressionistic
brush strokes used in Chinese painting. The
world around him, its nature, landscapes and
cityscapes are reoccurring themes in his work.
A sense of space and depth is also important:
'I love to create infinite depth, to divide a
surface with a few lines, stand back and keep
dividing it up until I can walk into it.'

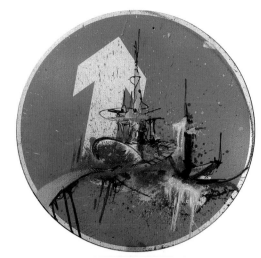

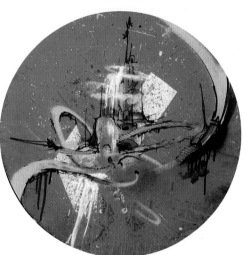

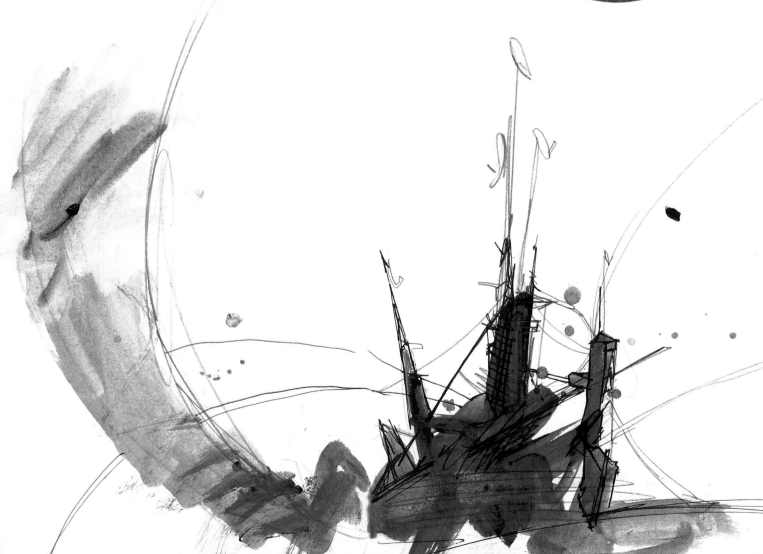

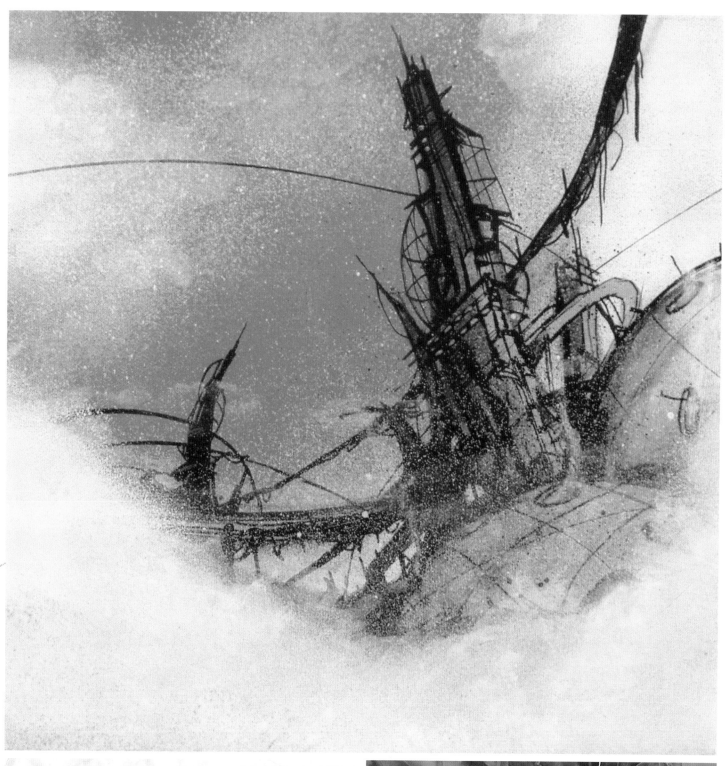

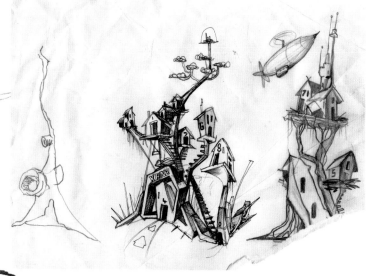

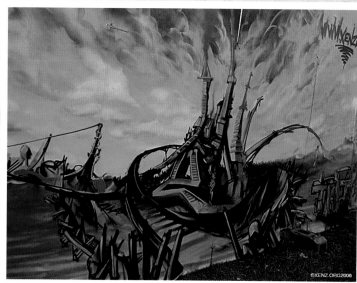

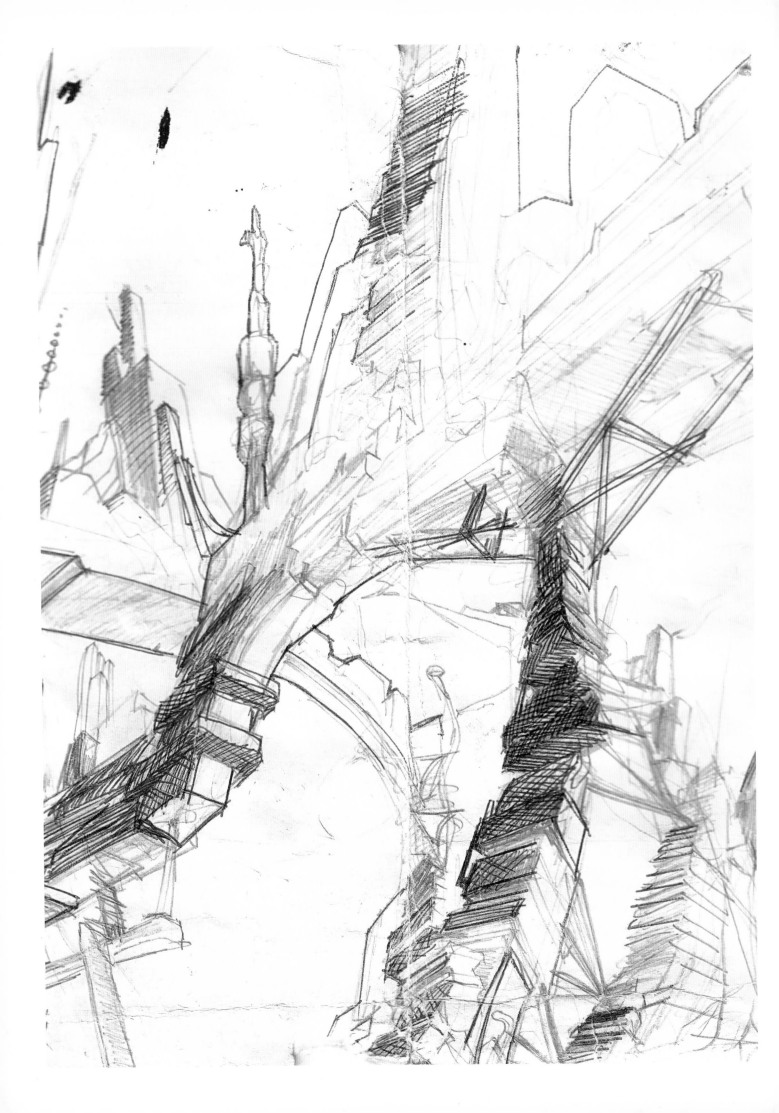

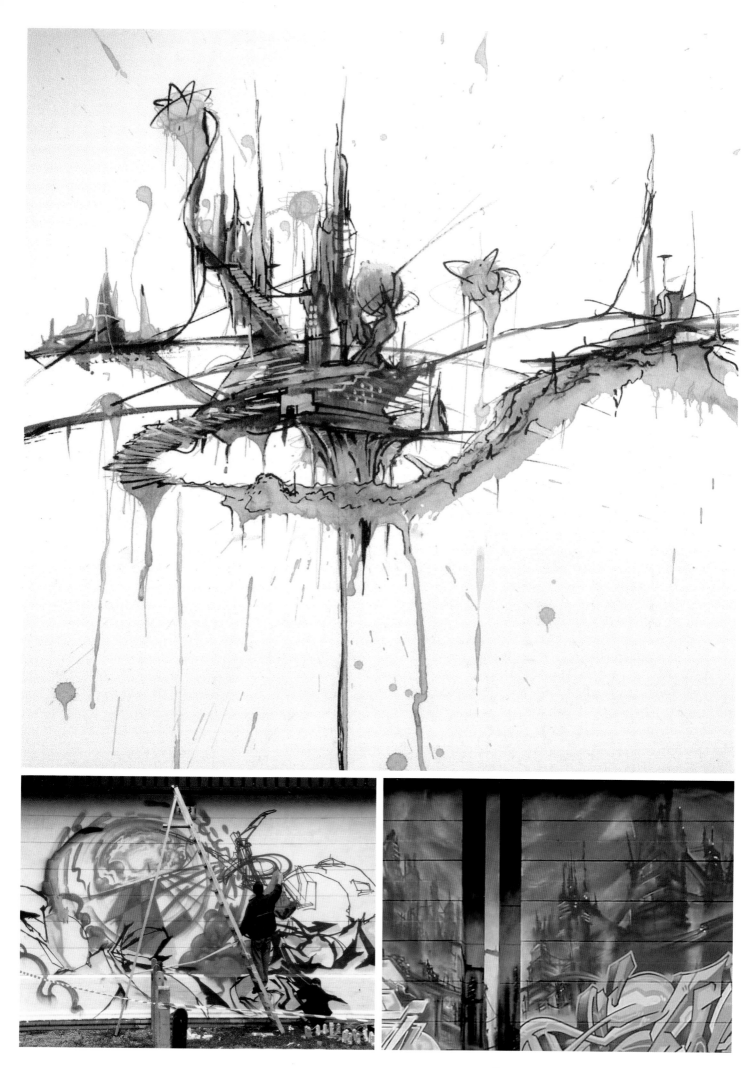

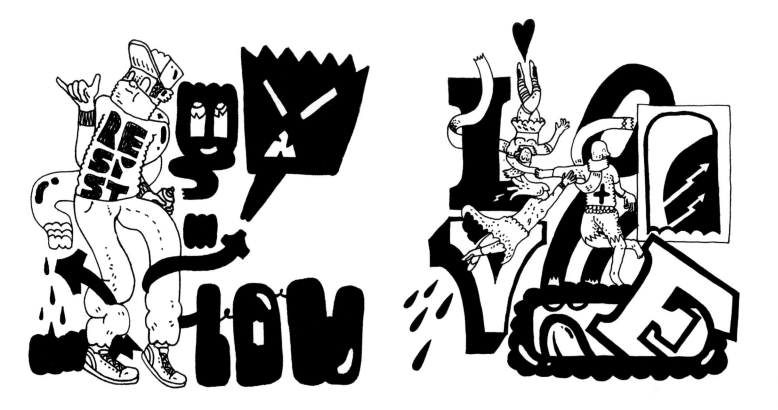

Zbiok

--

Zbiok is a Polish painter with a full tank
of comic imagination. With the naïve
exuberance of old-school graffiti his
work is also reminiscent of a modern-day
Fernand Léger, drawing on the language
of comic and graphic art with a little
constructivist surrealism thrown in. With
overlapping layers of coloured shapes,
figures and graphic symbols of modern
life, his paintings are full of energy,
humour and irreverence.

Zbiok's sketch pages begin with strong
black outlines, sometimes redrawn with
some colour ideas. The final canvases
and walls are not slavish copies of these
drawings, but he often refers to them
when painting.

259

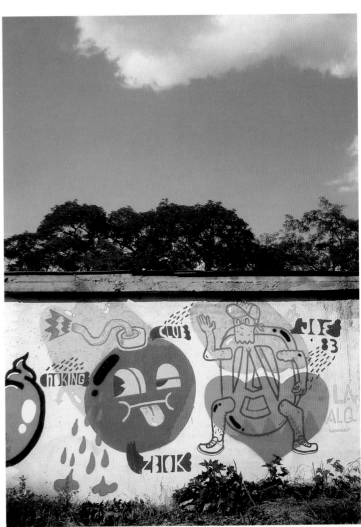

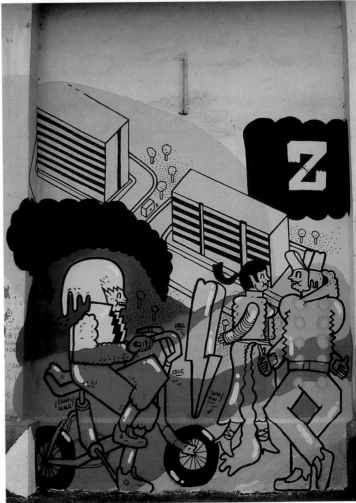

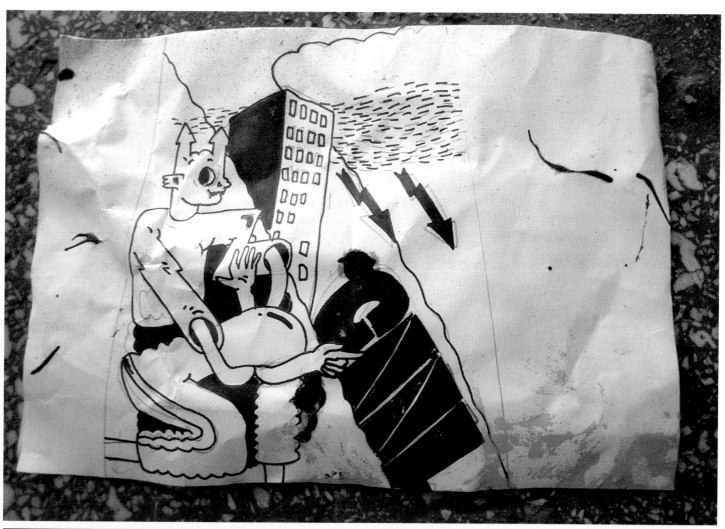

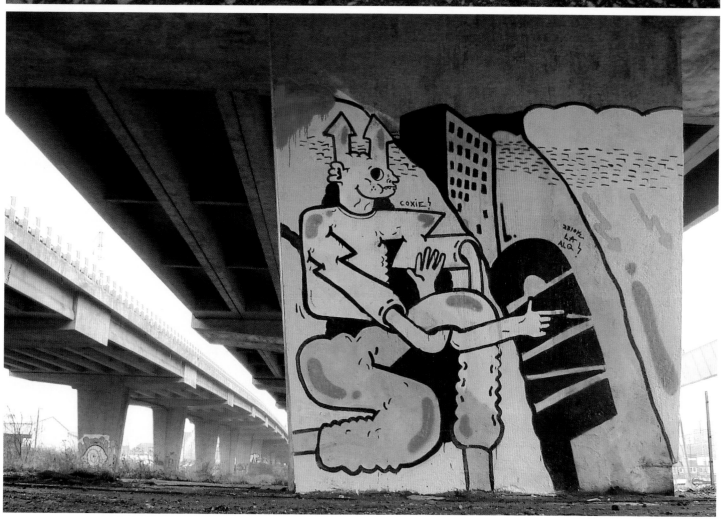

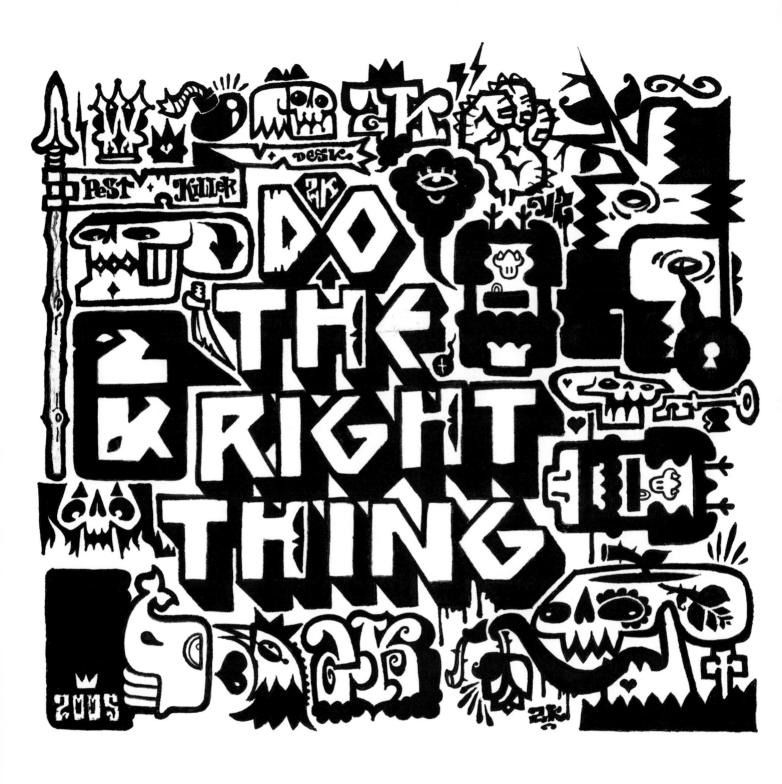

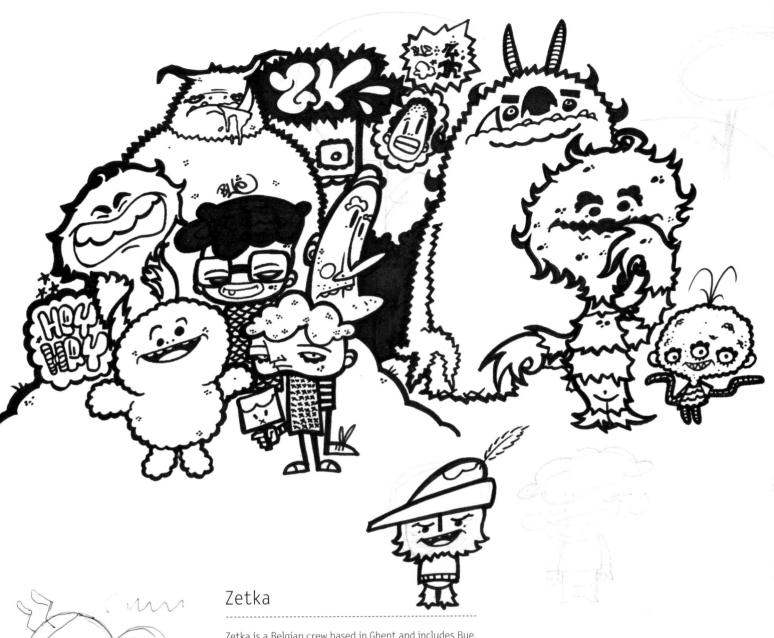

Zetka

Zetka is a Belgian crew based in Ghent and includes Bue, Pest, Pointdexter, Mr Fixit and Kaiser. Some of them also use the crew name GB and paint with other friends such as Spoy, Royel, Lens, Tarzan and Desk. They produce graffiti pieces under these aliases and most of them also work as graphic designers and illustrators.

Whether it's graffiti or graphic design, sketches play their part. Pest, who often paints a running mouse character, explains: 'When you're doing something illegal you don't have much time, so when you sketch this can limit you in some ways but it also gives you new ideas. For graphic design there are no limits and you can work in a more detailed way and take your time designing a nice sticker or print design.'

Colour and characters are key elements in Zetka's group work. Bue, who is known for his 'HeyHey the Bear' character, makes this point: 'I try to put as much colour and positive energy into my paintings as possible, coming as I do from a country where it's mostly wet and there's lots of concrete. I get satisfaction from putting smiles on people's faces, or giving them a heart-warming feeling.'

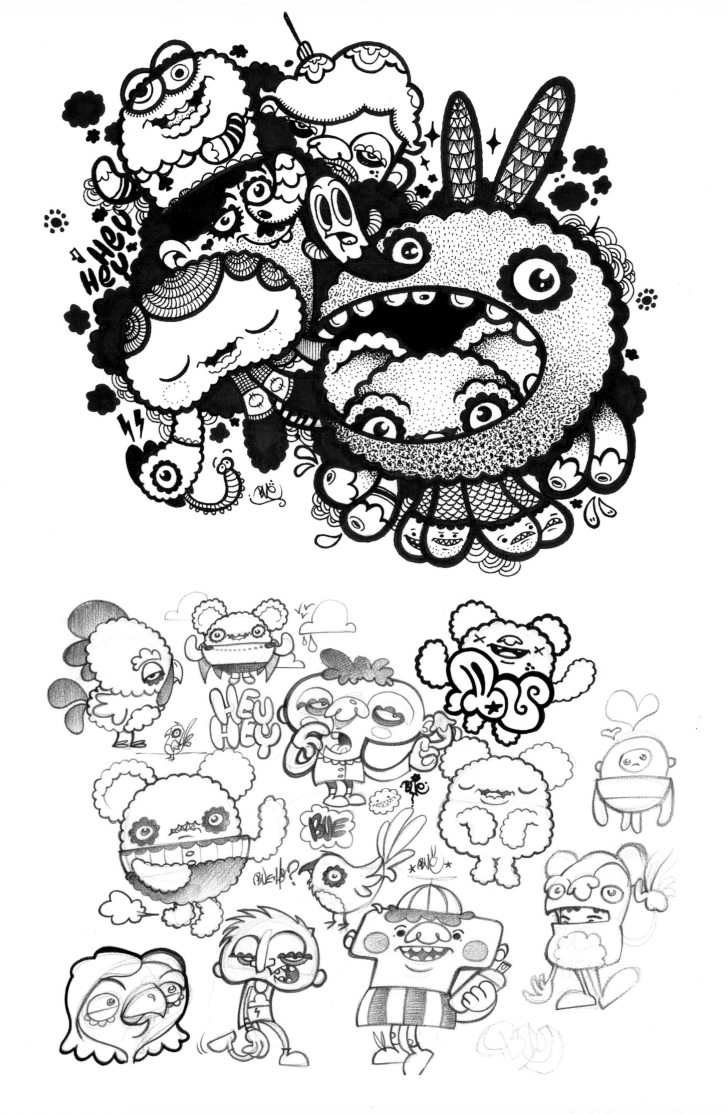

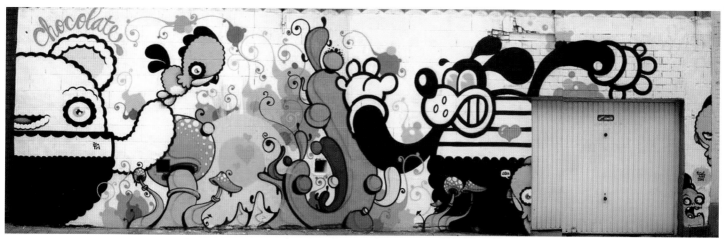

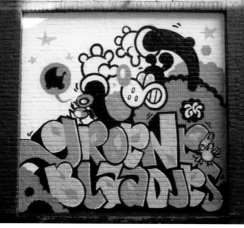

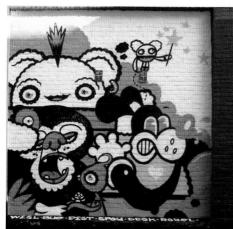

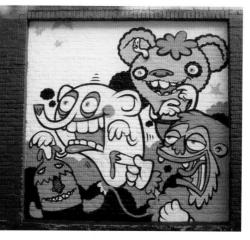

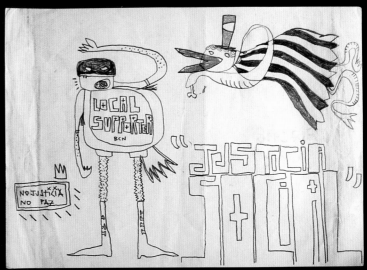

Zosen

Zosen (Tofu League) is originally from Buenos Aires but moved to Barcelona in 1990. As a member of the experimental ONG crew and with his own campaigns Zosen has been an influential part of Barcelona's unique graffiti culture. In recent years ONG disbanded but Zosen still collaborates with many artists, in particular Kafre.

The streets are where Zosen's work develops. The particular vibe of the day, the chosen spot where the action occurs, the people passing by and the interaction between friends painting are all part of the process. He feels he is more of a painter than an illustrator, and therefore his sketches are only an indication of the potential of paint and colour on a wall.

Making public art is essential to him; it gives him the impetus to be creative. His work often tackles issues such as squatters' rights or anti-fascism, but his politics don't overshadow his whole expression. His paintings are filled with references to naïf ideas, folklore, tribal art, friends, family, Latin and making up new words, painted with energy and saturated colours.

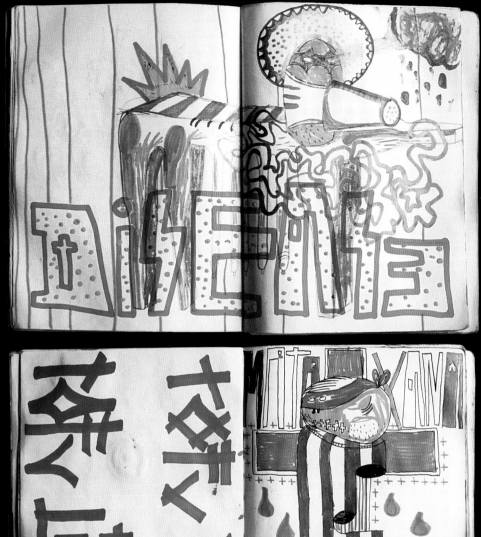

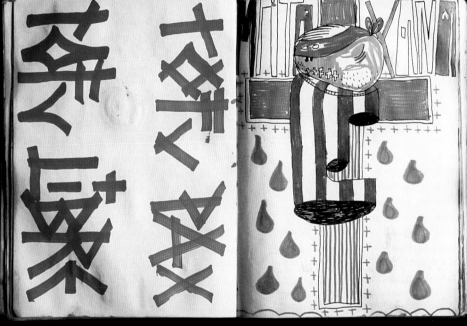

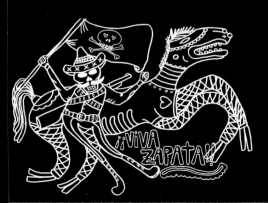

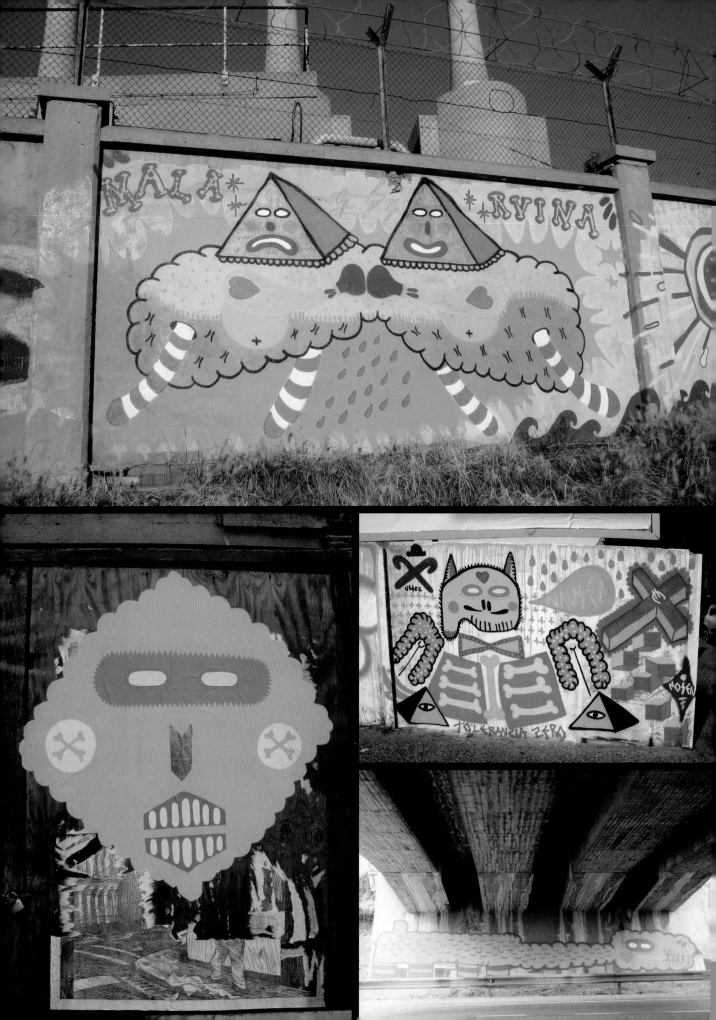

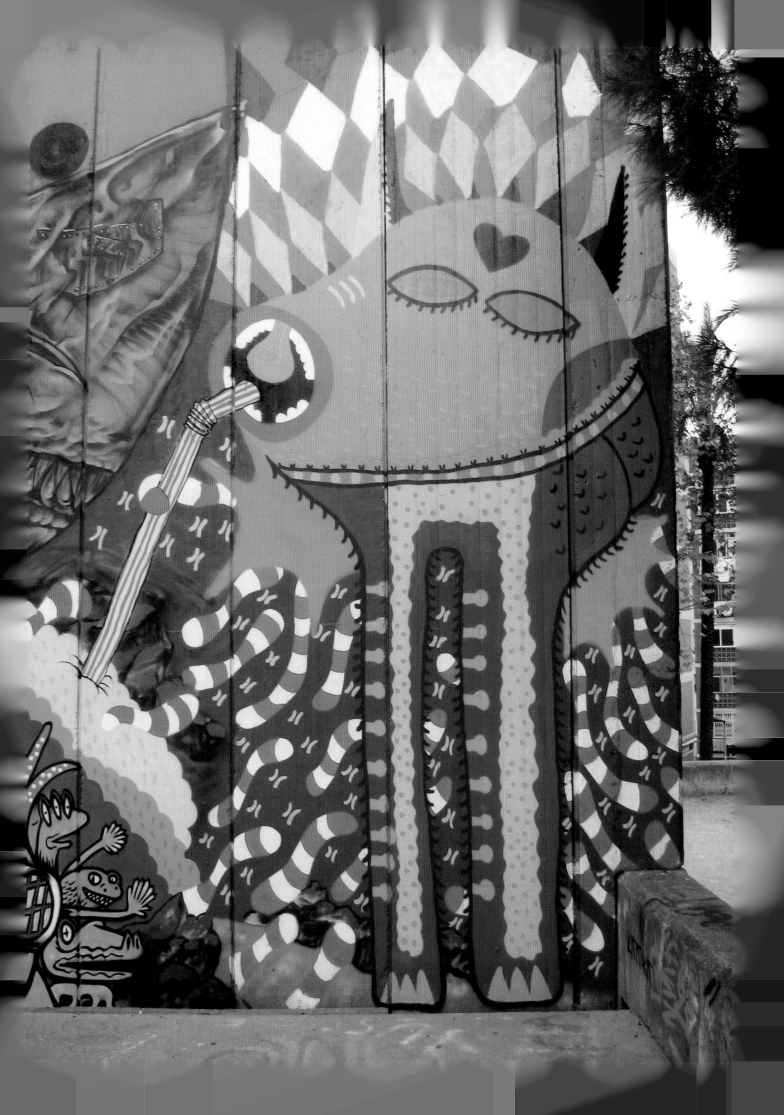

Websites

www.streetsketchbook.com

45rpm www.fotolog.com/45rpm,
 www.flickr.com/photos/whatcollective
Amose http://amose.free.fr
Banksy www.banksy.co.uk
Will Barras www.willbarras.com
Bfree www.bfreeone.com
Blu www.blublu.org
Bo130 www.bo130.org
Dem www.flickr.com/photos/dem666
David Earl Dixon www.distone.co.uk
Dreph www.dreph.com
Eco www.kuildoosh.com, www.flickr.com/photos/ecobandodo
Ekta www.fotolog.com/ekta, www.orosmoment.com
Elph www.akaelph.com
Ericailcane www.ericailcane.org
Eroné http://erone.grphk.free.fr
Erosie www.erosie.net
Escif www.flickr.com/photos/escif/
Hello Monsters www.fotolog.com/tatone,
 www.fotolog.com/ewg33, www.fotolog.com/blastus,
 www.fotolog.com/drdesro
Hitnes www.hitnes.org
Wayne Horse www.waynehorse.com
Jason Hsu www.imagebaker.com
Iemza www.wooperstudio.com
Duncan Jago www.mrjago.com
Edik Katykhin www.katyshka.narod.ru
Tanya Kochergina www.doclone.com
Kryot www.cancontrollers.net
Labrona www.flickr.com/people/labrona/
Laguna www.fotolog.com/lag1
Guy McKinley www.guymckinley.com
Melvin www.mistermelvin.be
Microbo www.microbo.com
Miss Lotion www.freakofnature.dk, www.misslotion.com
Mr Kern www.mrkern.com/
Mudwig www.dasmudwig.com, www.kuildoosh.com
Neb www.fotolog.net/the_strangler/
Other www.flickr.com/photos/other
PAL www.pal84.com
Paris www.kuildoosh.com, www.grahamdews.com
A. J. Purdy www.graphdrome.com
Luke Ramsey www.islandsfold.com
Remed www.myspace.com/remed
Andy Rementer www.andyrementer.com
Richt www.flickr.com/photos/richt
Royal www.juancarlosnoria.ca,
 http://dixon.them.ca, http://royal.them.ca
Sam www.kolchoz.com
San www.eseaene.com
Sat One www.satone.de
Showchicken www.showchicken.com
Sickboy www.sickboy.uk.com
Spher http://mercurocrom.free.fr,
 www.myspace.com/spherone
Turbo www.fotolog.com/tvrbo/
Turfone www.turfizm.com
Xenz www.xenz.org
Zbiok www.zbkool.com
Zetka www.myspace.com/zetka
Zosen www.tofulines.tk

Bibliography

Robert Klanten & Sven Ehmann, *Hidden Track: How Visual Culture Is Going Places*, Gestalten Verlag, 2005

Johanna Burton et al, *Vitamin D: New Perspectives in Drawing*, Phaidon: London & New York, 2005

Acknowledgments

A giant thank you to all the artists involved for their generous contributions and dedication to this project. Thanks to the following for their support, beer, tiramisu and lodgings: AAGH, Amose, Andy, Bobo, Jamie Camplin, Catherine, Sam Clark, Karen Dews, Ginny Liggitt, Jean Manco, Melvin, Miss Soul, Nano, Johanna Neurath, Nico, Kerrianne Orriss, Rebecca Pearson, Jill Phythian, Rachel Poli, Roby, Silvia, TCF, Tibo, Viva La Muralists! – M. A. Barnes-Wynters (aka Barney Doodlebug) and Johanna Kay, What collective and Zosen.

Picture Credits

All photographs by Tristan Manco unless specified. All artwork on artists' pages is credited to the artist unless otherwise stated. p. 1, Jason Hsu's sketchbooks, photos: Jason Hsu; p. 2, sketchbooks, left to right, from top: Richt, Rekel, Bo130, Elph, Ekta, Tanya, Richt, Kafre, Jason Hsu, Turbo, Ekta, A. J. Purdy, San, Richt, Miss Lotion & 45rpm; pp. 4–5, desk in Blu's studio; p. 7, drawing by A. J. Purdy; p. 8, watercolour by Melvin; p. 9, sketch by Wayne Horse; p. 10, drawing by Remed; p. 11, drawing by Elph; p. 12, clockwise from top left: Ekta, Spher (Ernest style), San, Duncan Jago, Hello Monsters with Neb (The Strangler), A. J. Purdy, Andy Rementer & Neb (The Strangler); p. 13, clockwise from top left: San, Mr Kern, Ekta, Luke Ramsey, Bfree, Jason Hsu, Ericailcane & Blu; p. 14, clockwise from top left: tea and doodles (Bristol), Bo130's studio space (Milan), beer and doodles (Bristol), Neb The Strangler painting (Brussels); p. 14, bottom right, photo: 45rpm; p. 17, clockwise from top left: Eroné's studio (Lille), drawing by Blastus (Hello Monsters), Miss Lotion's sketchbook, Desro drawing (Hello Monsters); pp. 20–21, collaborative sketchbook 45rpm and Richt (What collective); p. 75, sculpture and photograph by Bram Tuns (www.bramtuns.com); p. 134, photos: Remed and Fefe (São Paulo); p. 164, clockwise from top left: Sickboy, Ponk, Hello Monsters & Dibo painting piece at Manchester's 'Viva la Muralists!' event, Paris spraypainting (photo: Karen Dews), mural by Zbiok, Zbiok spraypainting; p. 167, clockwise from top left: Xenz sketchbook Dean Lane (Bristol) (photo: Karen Dews), Zosen & Kafre (Barcelona), Escif sketch & piece, Zosen painting; p. 173, top: Dem with Ericailcane, Blu & Rekel (Bologna, 2006), centre left: Dem, Kafre & Zosen (Modena, 2006), centre right: Dem, Kafre, Zosen & Ericailcane (Modena, 2006), bottom: Dem (Italy, 2005), photos: Dem; p. 176, left to right from top: Body Slanguage (with Benji Reid) (Manchester, 2005), Manchester (2006), Hamburg (2002), *Taste of Britain* (Manchester, 2006); p. 177, photo: Dreph; p. 178, sketchbook, 2005; p. 179, *Internal Reflections*, Paris, 2005; p. 184, collective drawing; p. 185, clockwise from top left: drawings by Tatone, Desro & Tatone; p. 186, all drawings by Tatone; p. 187, top mural by Hello Monsters, monster (centre left) by Tatone, Hello Monsters, detail by Blastus, bottom: Hello Monsters, Farm Prod., Remed; p. 195, bottom: mural with Xenz (Bristol), top photo: Duncan Jago; p. 198, Barcelona, 2005, p. 200, top left: Barcelona, 2006, bottom: Barcelona, 2005; p. 201, top left: Cordoba, 2005, bottom: Bologna, 2006; pp. 198, 200 & 201, photos: Kafre; p. 205, outdoor paintings in collaboration with Mosta, photos: Kryot; pp. 206, 208 & 209, photos: Labrona; p. 213, photos: Laguna; pp. 214–217, sketchbook photographs by Rachel Poli; p. 221, photos: PAL; p. 224, photos: Graham Dews; p. 225, *Avant Graff* screenprint by PandaMilk; pp. 226, from top, sketches for friends: Geko, Bomb, Venus & Ekoe; pp. 227, from top, sketches for friends: Jdee, Faser & Erosie; pp. 229, clockwise from top: Manchester (2006), Lisbon (2006), Manchester (2006) with Sickboy, Blast, Tatone & Dibo, Lisbon 2006 with Sickboy; p. 230, top: *Tending to infinity* installation, Venice; pp. 230–231, photos: Rekel; p. 233, photos: Juan Carlos Noria; pp. 240, rooftop, New York; pp. 240–241, photos: San; p. 244, photos: Sat One; p. 249, photos: Spher; p. 251, photos: Turbo; p. 255, photos: Xenz; p. 257, photos: Karen Dews; pp. 260–261, photos: Zbiok; p. 262, sketch by Pest and Desk; p. 263, top sketch by Bue; p. 264, sketches by Bue; p. 265, top to bottom, left to right, Zetka with Highraff (Brazil), Bue, Pest, buildings & waste bins by Bue, Zetka piece; pp. 262–265, photos: Zetka; p. 268, clockwise from top: Barcelona (2006), Girona (2006), Barcelona (2005), Brooklyn (2006), photos: Zosen; p. 269, Badalona (2006), photos: Zosen; p. 271, collaborative drawing, Andy Rementer & Dem; p. 272, collaborative drawing, Andy Rementer & A. J. Purdy

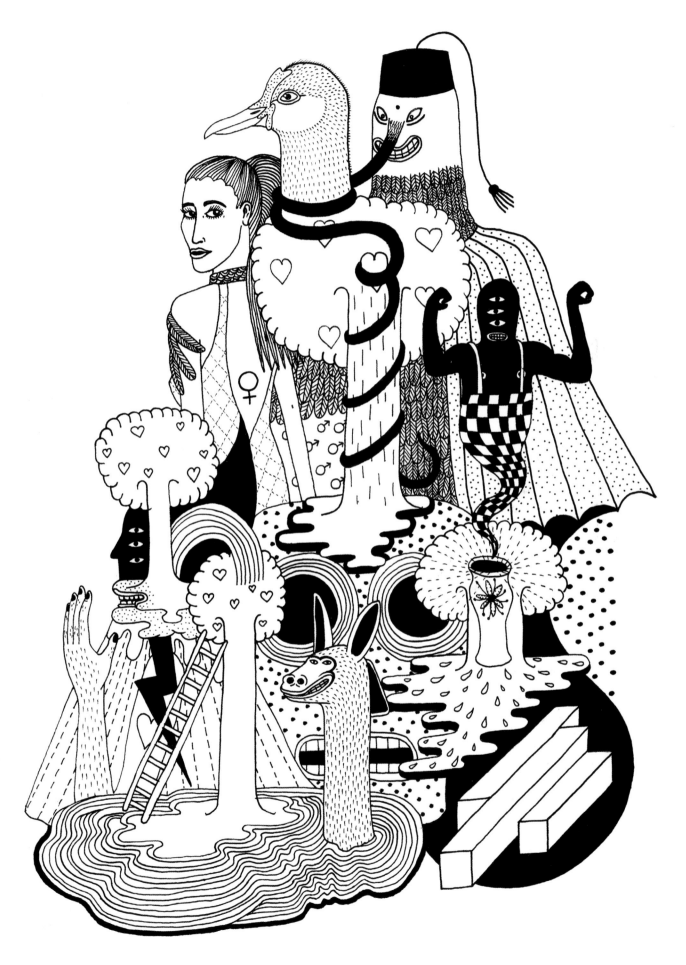

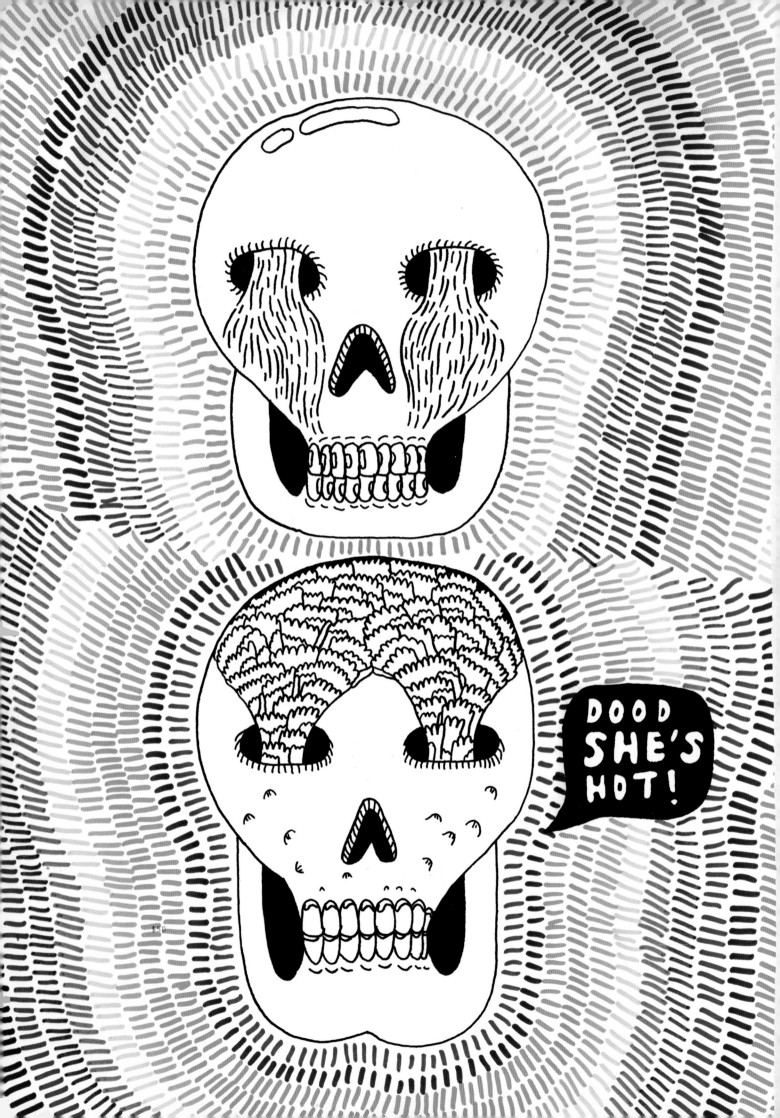